D1072377

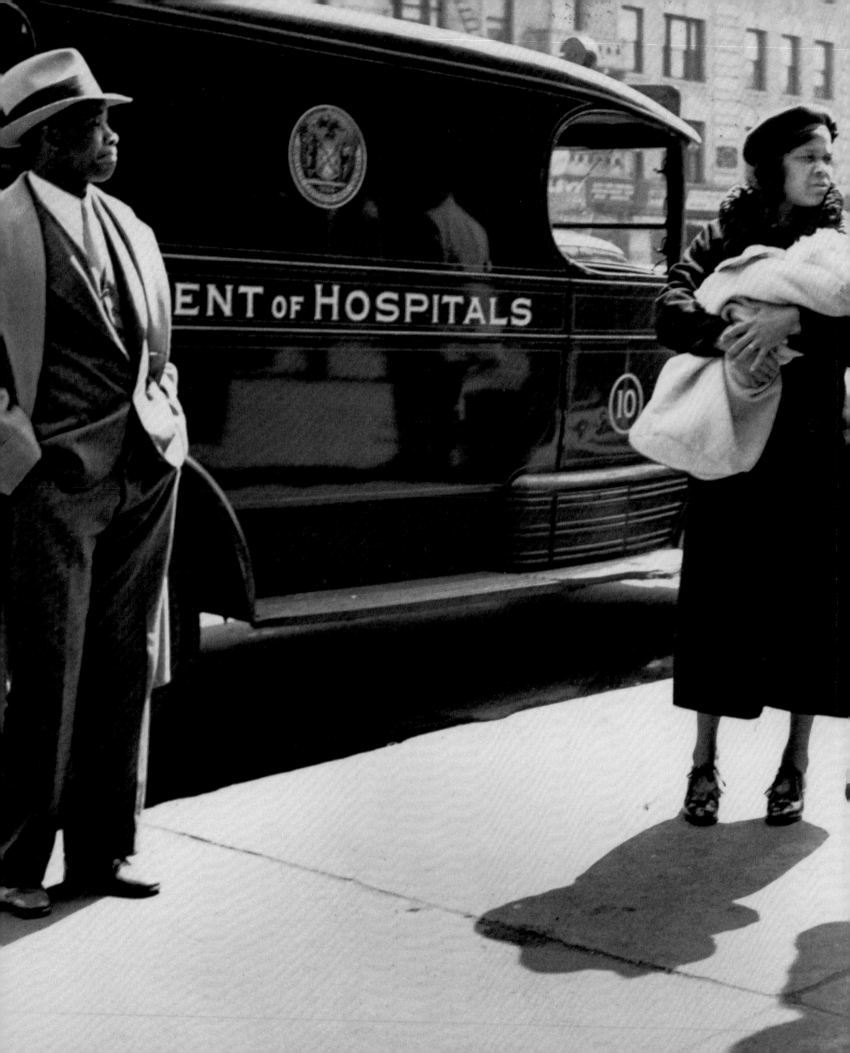

THE RADICAL CAMERA

New York's Photo League

1936–1951

Mason Klein and Catherine Evans

WITH CONTRIBUTIONS BY

Maurice Berger

Michael Lesy

Anne Wilkes Tucker

THE JEWISH MUSEUM, NEW YORK
UNDER THE AUSPICES OF THE JEWISH THEOLOGICAL
SEMINARY OF AMERICA

COLUMBUS MUSEUM OF ART
COLUMBUS, OHIO

YALE UNIVERSITY PRESS
NEW HAVEN AND LONDON

This book has been published in conjunction with the exhibition *The Radical Camera: New York's Photo League, 1936–1951*, organized by The Jewish Museum and the Columbus Museum of Art.

The exhibition is made possible by a major grant from the Phillip and Edith Leonian Foundation, with generous support from the National Endowment for the Arts and Betsy Karel.

ART WORKS.
arts.gov

The Dorot Foundation publications endowment and the Horace W. Goldsmith Foundation Exhibition Fund also provided important funding.

Media sponsor: WNET NEW YORK PUBLIC MEDIA THIRTEEN • WLIW21

The Jewish Museum, New York
 November 4, 2011–March 25, 2012
Columbus Museum of Art
 April 19–September 9, 2012
Contemporary Jewish Museum, San Francisco
 October 11, 2012–January 21, 2013
Norton Museum of Art, West Palm Beach
 February 9–April 21, 2013

Frontispiece: Lucy Ashjian, *Untitled (Group in Front of Ambulance)*, from *Harlem Document* (plate 27); page 5: Harold Corsini, *Playing Football*, c. 1939, from *Harlem Document* (detail; plate 35); page 6: Sol Prom (Solomon Fabricant), *Untitled (Dancing School)*, 1938, from *Harlem Document* (detail; plate 34); pages 86–87: Jack Manning, *Elks Parade*, 1938, from *Harlem Document* (plate 33)

The Jewish Museum
Director of Publications: Eve Sinaiko
Curatorial Publications Coordinator: Rebecca Shaykin
Text edited by Katherine Doyle and Eve Sinaiko
Photo Editor: Robin Sand

Yale University Press
Publisher, Art and Architecture: Patricia Fidler
Senior Editor, Art and Architecture: Michelle Komie
Manuscript Editor: Jeff Schier
Production Manager: Sarah Henry

Designed by Steven Schoenfelder
Set in Caecilia and Futura type
Printed in Malaysia by CS Graphics

10 9 8 7 6 5 4 3 2

The Jewish Museum
1109 Fifth Avenue
New York, New York 10128
thejewishmuseum.org

Columbus Museum of Art
480 East Broad Street
Columbus, Ohio 43215
columbusmuseum.org

Yale University Press
PO Box 209040
New Haven, Connecticut 06520–9040
yalebooks.com/art

Jacket illustrations: (*front*) Sid Grossman, *Coney Island,* c. 1947 (plate 74); (*back*) Ida Wyman, *Sidewalk Clock, New York*, 1947 (plate 118). Case illustration: Louis Stettner, *Men Looking at Concentric Circles, New York*, 1951 (plate 145)

Library of Congress Cataloging-in-Publication Data
Klein, Mason.
The radical camera : New York's Photo League, 1936–1951/
Mason Klein, Catherine Evans
p. cm.
Issued in connection with the exhibition organized by The Jewish Museum and the Columbus Museum of Art, held at The Jewish Museum, New York, Nov. 4, 2011–Mar. 25, 2012, and at three institutions at later dates.
Includes bibliographical references and index.
ISBN 978-0-300-14687-5 (hardback)
1. Photography, Artistic—20th century—Exhibitions.
2. Photography—New York (State)—New York—Exhibitions.
3. Photo League—Exhibitions. I. Evans, Catherine. II. Jewish Museum (New York, N.Y.) III. Columbus Museum of Art. IV. Title.
TR645.N532J394 2011 770.9747'1—dc23 2011020574

A catalogue record for this book is available from the British Library.

The paper in this book meets the guidelines for permanence and durability of the Committee on Production Guidelines for Book Longevity of the Council on Library Resources.

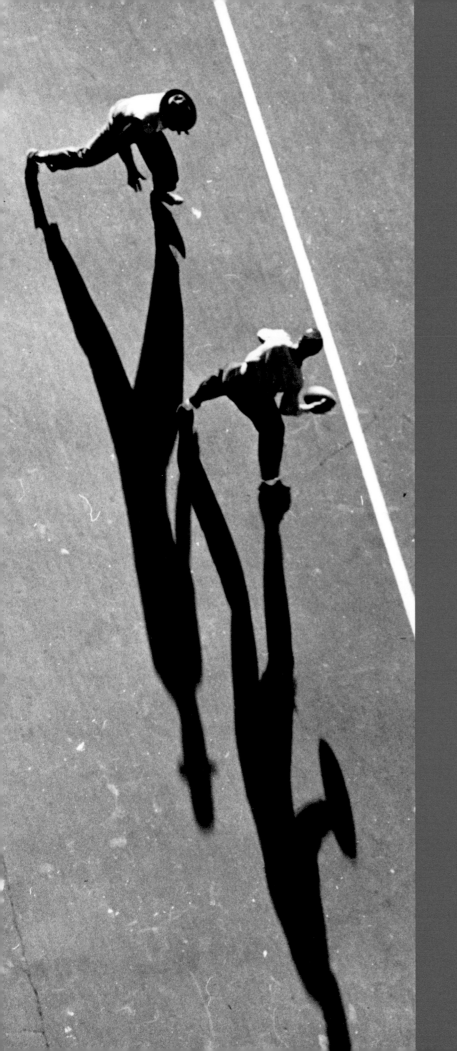

CONTENTS

PREFACE AND ACKNOWLEDGMENTS

The catalyst for undertaking this new project on the Photo League, organized jointly by The Jewish Museum and the Columbus Museum of Art, was the desire to merge two in-depth collections of work by the League acquired throughout the last decade. It provided a prime opportunity to reevaluate the League and challenge misconceptions that have been in place ever since it closed its doors in 1951, a victim of the postwar Red Scare. Both museums share a commitment to expanding the ways in which American art is understood to have evolved in relation to social, political, and economic forces, a context particularly relevant to the momentous times of the League's life (1936 to 1951).

With the increased flexibility afforded by the small handheld 35-mm camera in the 1920s, a new kind of "chance" photography—at once casual and purposeful —emerged in Europe and America. Propelled by this Zeitgeist, as well as by the extreme suffering of the Depression, the Photo League employed the documentary style of the 1930s, motivated by the need to authenticate and share in the experiences of others. But the League also championed a photography that was as much aesthetic as social-minded, and this dual identity defines its progressivism in a unique way. Its partisan and documentary concerns were matched by an equal interest in the subjective image, expressing a strong personal, even idiosyncratic, point of view. Both impulses were fostered at that time by a picture-hungry world of illustrated magazines, newspapers, and books, all of which were contributing to the advancement of the photographic arts.

The sheer variety of imagery featured in *The Radical Camera* reveals the wide-ranging approaches embraced by League photographers. Their strategies were expressed not only in the works themselves but also through innovative and, at the time, unprecedented programs at the League, from critical composition classes and lectures to the League's periodical, *Photo Notes*. The idea of what constituted a documentary image in still photography was itself evolving, and the form was scarcely considered art-worthy. Further, within such a diverse group of photographers, each had his or her own notion of what was meant by the term. *The Radical Camera* addresses this complexity. It also stresses the impact of the League's teaching and its role as a forum where the critical issues facing documentary photography could be discussed. In its relatively brief fifteen-year existence the political realities of the world changed profoundly, as the Depression and the politics of the New Deal inverted themselves into post–World War II prosperity and the Cold War.

The League was a pioneer in developing the idea that documentary photography must have a personal perspective—a concept that was to influence the photographers of the New York School in the 1950s and 1960s. *The Radical Camera* underscores the idealism of many who taught at the League, from Lewis Hine and Paul Strand to Walter Rosenblum, as well as the extreme disillusionment of those, like Lisette Model and Sid

Grossman, who over time questioned the truth and efficacy of the documentary image. Grossman was the linchpin in this debate. While numerous figures emphasized that photography involved a new manner of seeing, Grossman insisted that such ways of seeing hinged on the specific relationship between photographer and camera. He forced his students to discover not only what constituted a good photograph but, more importantly, their emotional relationship to it. In the end, the heritage of the League's diversity, born in a collective spirit, was the poetic, individualized perception characteristic of the New York School—Diane Arbus, Louis Faurer, Robert Frank, William Klein, Helen Levitt, and others. Ultimately, it is this profound shift that *The Radical Camera* encompasses: the League's gradual change in perception toward the interrogative and its move away from bearing witness and toward exploring one's own bearings in the world. To the earnest, socially minded, and leftist members of the League this was the world turned on its head: camaraderie was replaced by individualism—indeed, solidarity had become a position of the right.

As an individual brimming with contradiction and angst, Sid Grossman personifies this transition, marrying the idealism of ideologically grounded work with formal experimentation. His public denunciation as a Communist in 1949 served to obscure the League's influence, particularly the way in which it sparked a social movement toward art. Grossman's complex body of work, with its breakthroughs and insurrections, exemplifies the confounding nature of the League: a collective of artists who were unrelentingly suspicious of the purely aesthetic camera's claim to truth.

The five essays in this book each offer a critical reassessment of an aspect of the League: Mason Klein reconfigures the history of the documentary image as it moved toward the subjectivity of the New York School; Maurice Berger revisits the *Harlem Document* and considers it anew, reflecting on contemporary photography and the cultural activism of the African American community; Catherine Evans expands upon the historical role of women at the League; Michael Lesy discusses the sudden and dramatic arrival of popular picture magazines as both medium and shaper of art; and Anne Wilkes Tucker explores the demise of the League in an unstable political climate.

Many people have contributed to this project. We are indebted to all the authors, who were generous collaborators and advisers, especially Anne Tucker, who shared her extensive personal archive, comprising her foundational research on the Photo League and interviews with more than one hundred of its members conducted by her in the mid-1970s. The editors wish also to recognize the important contributions of other historians of the League: Naomi Rosenblum, Lili Corbus Bezner, Lisa S. Davis, and John Raeburn. We also are grateful to all the collectors, archivists, and Photo League members who have given of their time and willingly shared their historical documents, notably Sarah Corbin, Mary Engel of the Orkin/Engel Film & Photo Archive, George Gilbert, Hyman Kaufman, Marvin E. Newman, Naomi and Nina Rosenblum of the Rosenblum Archives, and Christine Tate.

This endeavor would not have been possible without the vision and encouragement of Nannette V. Maciejunes, Executive Director at the Columbus Museum of Art, and Joan Rosenbaum, Helen Goldsmith Menschel Director at The Jewish Museum. *The Radical Camera* project owes its genesis and realization to many donors and patrons, including the National Endowment for the Arts.

At the Columbus Museum of Art we extend our gratitude to The Columbus Foundation, the Greater Columbus Arts Council, Nationwide Foundation, and the Ohio Arts Council for their ongoing support. Special thanks to Arts Midwest for its critical and consistent support of Photo League projects. For their role in the watershed acquisition of the Photo League collection we are indebted to Elizabeth M. Ross, John S. and Catherine Chapin Kobacker, and the many Friends of the Photo League. Jaime Galbreath, Susan Kridler, Karen Nystrom, and Will Sherman provided essential research. Museum staff members contributed invaluable knowledge and talents: Cindy Meyers Foley, Director of Education; Jeffrey Sims, Educator for Adult Programs; Merilee Mostov, Manager for Creative Initiatives; Jessimi Jones, Educator for School Programs; Maureen Carroll, Grants and Corporate Relations Manager; Melinda Knapp, Chief Registrar and Exhibitions Manager; Jennifer Seeds Martin, Associate Registrar; Greg Jones, Exhibition Designer; and Christopher S. Duckworth, Director of Publications.

At The Jewish Museum we want to acknowledge the early, instrumental encouragement of Richard Menschel. We would like to express our deep gratitude to the Phillip and Edith Leonian Foundation for its lead gift in support of the exhibition, and to the Dorot Foundation for its support of the exhibition catalogue. We are grateful to the Paul Strand Trust, which provided major funding toward the acquisition of the Photo League collection, as well as to the Henry Luce Foundation for a Conservation Initiative grant. Generous support was also provided through endowed funds from the Horace W. Goldsmith Foundation; the William and Jane Schloss Family Foundation; Mimi and Barry J. Alperin; members of the Museum's Photography Acquisitions Committee; and other donors. Among the numerous staff members who have worked on this project, we are especially indebted to Curatorial Assistants Rebecca Shaykin and Jailee Rychen; Eve Sinaiko, Director of Publications; Susan Wyatt, Senior Grants Officer; Jane Rubin, Director of Collections and Exhibitions; Julie Maguire, Senior Registrar, Exhibitions; Jennifer Ayres, Exhibition Coordinator; Katherine Danalakis, Collections Manager; Jannette Mina, Collections Assistant; and intern Marisa Gertz.

Finally, Stephen Daiter and Howard Greenberg are gratefully acknowledged for their early recognition of the League's significance and their key role in fostering major collections at both institutions.

MASON KLEIN

The Jewish Museum

CATHERINE EVANS

Columbus Museum of Art

OF POLITICS AND POETRY

The Dilemma of the Photo League Mason Klein

> **I have always been more interested in persons than in people.**
>
> —*Lewis Hine*

At first glance, Lewis Wickes Hine's image of a newsboy jars (fig. 1). A seeming snapshot or early vernacular street photograph, this 1912 image is a combination of realism and aesthetic presence that prefigures the spirited course of the social-documentary photograph during the first half of the twentieth century. What began as the photographer's need to bear witness ended in the 1950s with the New York School's subjective rendering of the document itself. And it began essentially with the heroic efforts of an extraordinarily modest man.

By the first quarter of the twentieth century,

newsboys had become a ubiquitous symbol of immigrant poverty and exploitation, and few of Hine's reformist works better reveal his ability to nuance social criticism through the positive empowerment of his subject than this portrait of a newsboy. Though more explicit in its contrast of social class than much of the tactful exposé work Hine produced while employed by the National Child Labor Committee (NCLC), the photograph reveals a natural pedagogue who had found his niche as a teacher and sociologist turned photographer.[1] Hine's objective was clear: to educate the public by letting it see a burdened yet spirited child not abstracted in text but as "someone," titling the work *Danny Mercurio, Newsie, Washington, D.C.* His elevation of the medium by perfectly balancing aesthetic sensibility with ideological purpose offers an interesting contrast to the efforts of his reformist forebear, Jacob Riis.[2]

It is not just that this puckish urchin, removed from the seamy streets of urban grime, seems displaced, isolated, and dead center within the imposing space of the modern paved boulevards of the nation's capital. No more than ten or eleven years old, and dressed in the typical garb of a newsboy—knee pants, long black stockings,

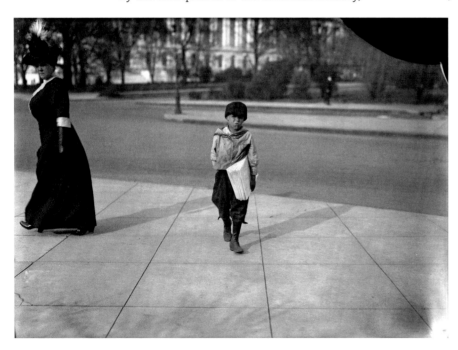

Fig. 1. Lewis Hine, *Danny Mercurio, Newsie, Washington, D.C.*, 1912, printed later. Negative, gelatin on glass, 5 × 7 in. (12.7 × 17.8 cm). George Eastman House, International Museum of Photography and Film, Rochester, New York. Gift of the Photo League: ex-collection Lewis Wickes Hine.

and cap—he comports himself well, walking with confidence toward the camera. He holds his papers comfortably in one hand while the other rests in his pocket, his lips pursed as he hawks the news. What disturbs is the manner and presence of the picture's other occupant, a sternly bourgeois woman whose gaze askance at the camera conveys a disdain as steely as her corseted posture. She moves in a direction perpendicular to his, their relationship accentuated through the grid of the pavement. Theirs is a choreography of disconnection: her strident march versus his cocky saunter, his cap a modest nod to her feather-festooned hat, his central presence at odds with her soon-to-be-absence. As she leans toward the edge of the picture, the photograph becomes a metaphor for the public indifference that frames the problem of child labor.

Hine's wish to bear witness involved a careful study of his medium in order to merge realism with a new sensibility, developing what has been referred to as a modern vernacular aesthetic. He seemed to have acquired this intuitive grasp as a teacher, conveying to his students the idea that understanding what made photography good required understanding what made good art. His blend of sociology and photography was unusual.[3] Hine had learned the social facts not only as a child laborer himself, but also as a student at the University of Chicago, where he studied with the principal adherents of Georg Simmel, a pioneering urban sociologist in Berlin. It was fitting that Hine would leave Chicago for New York to teach at the Ethical Culture School, whose ideals of acculturation and reform espoused by its founder, Felix Adler, had been born of the need to assimilate the tide of immigrants who had come to America toward the end of the nineteenth century.

No wonder, then, that Hine's work, testament to his empathy for the immigrant situation and his respect for and belief in the empowerment of the worker, would be bequeathed to the New York–based Photo League.[4] His passage to a sociologically informed photography is instructive in understanding the genesis of the Photo League as it began to formally address the documentary photograph—

largely through a socially attuned Jewish lens—within the polemical tenor of the 1930s.

The Photo League descended from the Film and Photo League, and, during its first handful of years, what clearly prevailed were the radical political ideals that had defined the original group. Founded in 1930 as an offshoot of Workers' International Relief (WIR), the Film and Photo League was committed to aiding striking workers worldwide.[5] Yet a cleavage eventually divided filmmakers and photographers, deepening when the filmmakers began to bicker over the degree to which documentary films ought to emphasize political content or aesthetic values.[6] Quarrels arose over whether photographs should assume a secondary role as mere agents to illustrate written accounts. The divisiveness proved insurmountable, and in 1936 the still photographers broke away and formed an autonomous group.

Fig. 2. Dziga Vertov, still from *Man with a Movie Camera,* 1929.

Yet photography continued to be enlivened by the theories espoused by cinematic theorists such as Sergei Eisenstein and Dziga Vertov. Vertov's ideas were first translated and published in English in the League's newsletter, *Filmfront,* as the League began to crystallize its own mode of "honest" documentary. Such issues were of paramount importance to Vertov himself, for whom the transparency between film and reality was essential: "Every instant of life shot unstaged, every individual frame shot *just as it is* in life with a hidden camera, 'caught unawares,' or by some other analogous technique—represents a fact recorded on film, a *film-fact* as we call it" (fig. 2).[7]

While much of the documentary photography of the Photo League's first five years was put to signature progressive use, impelled either by the trauma of the Great Depression, as in the work of the Resettlement Administration (RA) and Farm Security Administration (FSA), or by the interna-

tional worker-photography movement that emerged in the 1920s in Germany and Russia, its social subject differed from that of the FSA photographers. The latter's carefully defined archival work on the rural poor was essentially about "others," photo subjects doubly removed from their makers by significant oversight and editing.[8] And whereas the FSA had traditionally focused on the poor or the disenfranchised, the Photo League's investigation of the terrain of urban sociology involved a diverse social spectrum.

This new subject centered on New York, a city that was seen, unlike rural areas of the Dust Bowl or the old and dilapidated cities of Europe, as the budding capital of modernity.[9] Such scrutiny meant looking closely at the contemporary constituents of the city, ordinary people like themselves. This self-identification, of course, varied among members. For some, like Walter Rosenblum, focusing on the Lower East Side was profoundly personal. "We feel deeply about the people we photograph, because our subject matter is our own flesh and blood. The kids are our own images when we were young." He was aware of the League's lack of affinity for "the natural scene . . . not because they didn't recognize the emotional value inherent in such subject matter, but because they were brought up in an environment of crowded tenements."[10]

Other young photographers had begun to venture out of their immediate neighborhoods, indeed to lose their bearings, an evolution that would propel the Photo League toward its legacy in the work of the New York School. While much has been written on the League's preoccupation with what ailed society, the daily promise of the street yielded many images that could cheer as well as dismay, such as an early work of Robert Disraeli, *Untitled (German Street Band),* 1934 (plate 16), in which the city's architecture provides more than a scenic backdrop for its inhabitants. This stately picture of an otherwise modest brass band assumes a playful dignity, with the musicians uniformly capped and grouped together at different heights like notes on a page of music, framed by two trees and their protective bases that

open like a curtain. The sense of a proscenium is further conveyed by the measured row of windows and railing, whose tracery of staffs and clef signs provides the perfect backdrop for a portrait of a band.

Beaumont Newhall discerned the League's sociological orientation when he wrote a review in *Photo Notes* of a 1948 dual exhibition of student work from the League and the photography department of the California School of Fine Arts: "The Photo League students take their camera anywhere; they often push the process to technical limits. All of them feel people more strongly than nature; they want to tell us about New York and some of the people who live there . . . there was almost a sense of desperation in the desire to convey messages of sociological import."[11] Decades later, William Klein would extrapolate Newhall's sentiment and contrast "funky" Jewish photographers, drawn toward people, with gentile photographers' greater focus on nature.[12] Moreover, in 1940—when two million of the seven million New York residents were Jewish, according to later estimates—the ability to study the insular life of neighborhoods and to observe urban spaces was what Jews, perhaps better than any other segment of the population at that time, were equipped to do.[13]

Lou Bernstein, Consuelo Kanaga, Arnold Eagle, and Rebecca Lepkoff are but four of hundreds of photographers who were members of the Photo League, whose title alone evokes a group bound at least by a common cause. Many were first-generation Americans who came of age during the Depression and whose values were defined by the belief that what they were doing mattered. Unlike the small percentage of those who became well known, such as Lisette Model, or who were unabashedly self-promoting, such as Weegee, many neither sought fame nor achieved great success. They were mostly poor, some doing without "food and clothing for lenses and photographic paper."[14] They wanted simply to become photographers. The League charged meager dues and offered inexpensive darkroom privileges, as well as scholarships to those who could not afford its classes. It was this camara-

derie, embodying a spirit of sacrifice and unselfish-ness, that distinguished the Photo League.

Many members did not have the advantage of studying art or of going to college, and even those who did, like Sid Grossman—one of the founders and director of the League's school—often attended part-time night school. The effort required to move beyond one's neighborhood and escape the vestigial bonds of an internalized ghetto is something we cannot easily appreciate today. In addition to bring-ing people together to create, study, and socialize, the League was "unique in [its] progressive educa-tional method" and, in insisting that "the student learns by doing," sent them out in the street, armed with a single tool.[15] Photography, taught systemati-cally at the Photo League for the first time, was still not recognized as art worthy of purchase by muse-ums. Though the League was informed by a social-ist sensibility and advocacy, it gave its students an opportunity to see things in ways detached from prescriptive ideology, and to become subjects them-selves as they recorded the world about them.

With his early shots of Coney Island (plate 71) from the late 1930s, Morris Engel reflected the wish of some members to see beyond the populist need to emphasize social reality in the service of some higher purpose. Sometimes this entailed a formalist treatment of objectivity itself, as in John Vachon's *Freight Car and Grain Elevators, Omaha, Nebraska,* 1938 (plate 15), or Lucy Ashjian's *Untitled (Steps),* 1936–40 (plate 28), their subjects abstracted and elusive. More often it was the simple revelation of people at work or play, like the curious abandon of Walter Rosenblum's *Girl on a Swing,* 1938 (plate 19), from the *Pitt Street* Feature Group, or Sidney Kerner's bird's-eye view of a street game of stickball in *Pitt Street, New York,* 1938 (plate 22).

Like Hine's newsboy, whose sanguine self-possession belies the extreme conditions that such children had to endure, the kids that populate the work of the Photo League—like Ruth Orkin's *Boy Jumping into Hudson River,* 1948 (plate 111), or Arthur Leipzig's *Chalk Games, Prospect Place, Brooklyn,* 1950 (plate 93)—often seemed to own the waterfront

and the street. Sometimes they simply hung out, as in *Sullivan Midgets 1, Greenwich Village,* c. 1939, by Joe Schwartz (plate 45). Yet despite their ability to transcend, if only briefly, their grim reality, many were obliged to confront it on one level or another, as in the demonstration against slum housing in Schwartz's *Slums Must Go! May Day Parade, New York,* c. 1936 (plate 47).

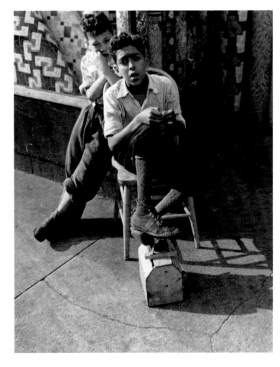

Fig. 3. Sid Grossman, *Shoeshine Boys, Harlem,* 1939. Gelatin silver print, 8¼ × 6⅞ in. (21 × 17.5 cm). Museum of Fine Arts, Houston. Museum Purchase.

Child labor is ren-dered differently in Sid Grossman's *Shoeshine Boys, Harlem,* 1939, a subject we know all too well from Hine (fig. 3). Whereas Hine focused on the boy's nonchalant, positive acceptance of his fate, Grossman deep-ened the psychological dimension. Capitalizing on the boys having set up shop in front of the corner of a linoleum-flooring store, Grossman shoots them close-up and from above to maxi-mize the contrast of their body language with the architectural thrust of the angle behind them. The younger child, languorous and bored, leans on the building, chewing idly on his finger; his older brother commands center stage, evoking the sculpted figure-head on a ship as he leans faintly forward, brow fur-rowed, mouth open, head tilted, hands together in supplication. Alert as well to the geometries of the shoeshine kit, the compasslike sweep of the cracks in the pavement, and the different arrangements of legs, Grossman takes an otherwise prosaic subject and produces a powerful image. He not only cap-tures the child's nonverbal capacity for expression, but hints at his own penchant for alighting on the anecdotal, animated, and complex subject.

Despite its humble status as a volunteer organiza-tion and the dilapidated condition of its first home

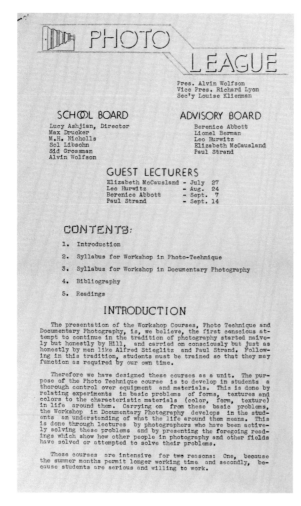

Fig. 4. Photo League school brochure contents page, summer 1938.

at 31 East Twenty-first Street in Manhattan, the Photo League formalized itself in 1938 as a school with a curriculum and began to expand its activities. Chief among these were its monthly meetings: sundry events, from print competitions to lectures and presentations, unpaid of course, by a constant stream of international notables. And on its walls was exhibited a similarly expansive range of work. The world had begun to register the growing presence of photography, the burgeoning of photojournalism, as well as the advent of picture magazines such as *Life*—born, significantly, in the same year as the League. In addition to providing exhibition space to its members, throughout its first five years the League represented and discussed the broadest examples of documentary photography, providing initial exposure to various modernists, including

László Moholy-Nagy, Berenice Abbott, Paul Strand, Ansel Adams, Edward Weston, and John Heartfield. The League was also fastidious in placing into historical perspective not only photography, but also its own practice as an organization. It developed a syllabus that defined the study of photography's past and kept track of League happenings in *Photo Notes* (fig. 4).

In 1939, a few years after its founding, the Photo League printed "A Statement on Exhibition Policy" in the December issue of *Photo Notes*. Signed by the chairman of the exhibition committee and one of its founders, Sol Libsohn, it enumerated a list of photographers who had "laid the basic foundations for photography as an art in itself." Clarifying the need to establish certain standards, the statement derided the empty values, "the 'ersatz' quality of the Salon exhibition," referring to those pictorialists who were less interested in the subject of their work than in its visual effects. It commended instead the lineage of David Octavius Hill, Mathew Brady, Eugène Atget, Alfred Stieglitz, Strand, and the Farm Security Administration photographers, and went on to extol Hine in particular.

The statement concluded with a preview of shows combining "the work of the great masters plus the work of some of our own Photo League members." Even acclaimed photographic figures were not elevated to genius status or celebrated for their fame, but rather were invoked as models for study, as people who were invested in making "photography . . . an art in itself." Such a mélange was clearly more an expression of veneration than of grandiosity, beguiling in its implicit acknowledgment of the need to study appropriate mentors. The early League's enthusiasm was something palpable. Even its newly "designed gallery and meeting hall . . . just painted" was modestly celebrated in a way that reflected the group's identification with the "workers" lauded by Hine for their "skill, daring and imagination."[16]

The *New York World-Telegram* that same month (December 1939) took note of the Photo League in a piece titled "Experts Show Prints at Photo League,"

commenting that, despite its "unimposing cardboard sign tacked on an old wooden door" and the "cardboard arrow" that points one up "a rickety stairway to the second floor," one finds there "the best work and the first that Lewis Hine ever did . . . and the first to take documentary pictures for a purpose." The article ended by describing the communal spirit of the League, where "groups work together," and though "the pictures belong to the one who takes them, [they] collectively are sent out," and everyone is able to "get the benefit of criticism, unsoftened but unequaled in constructiveness."[17] Such journalistic recognition of the collective enterprise reflected the ideals of the government-funded Federal Art Project of the Works Progress Administration (WPA), which had hired hundreds of artists, representing "a new orientation and a new hope and purpose based on a new sense of social responsibility."[18]

Thus, while the League may have initially emphasized a fairly narrow agenda of documentary work—largely a product of the 1930s and the international revolutionary Zeitgeist of the worker-photography movement—its real contributions are far more enmeshed in the period's transition toward the experimentation and spontaneity that came from using a 35-mm camera in the street. This exercise fostered the sense of artistic "presentness" associated with the New York School. The League, principally Sid Grossman in his postwar workshops, addressed critical questions about how to teach photography in ways that would force students to discover not only the meaning of photography but also, and more importantly, their relationship to it.

The Photo League should be recognized as a complex entity, engaged with and evolving through a range of historical shifts during its tumultuous fifteen-year tenure. These efforts culminated in a heroic stand for aesthetic and political freedom in its 1948 exhibition, *This Is the Photo League*. However, the organization has been marginalized in a way that deserves—indeed demands—investigation.[19] Since the facts of its demise have come to light only through the Freedom of Information Act, the story of the Photo League has been wrought in a way that

sometimes seems to assume the profile of some ancient community whose archaic beliefs, writings, and proceedings were only partially dug up and are yet to be fully interpreted. As a consequence, the Photo League's status as a monolithic "political" organization, narrowly defined by the documentary style and far-left associations of its beginnings, has largely endured to this day. Though the League existed for only fifteen years, that brief span witnessed a transformation in which the world became profoundly inverted: from the trauma and survival of the Great Depression and the defeat of totalitarianism to the prosperity of post–World War II America and the eruption of the Cold War. To reduce such a vitally boisterous and dynamic association to its earliest iteration is to echo the mindset of the U.S. attorney general's office, which falsely condemned and ultimately destroyed the Photo League as a subversive organization in 1947. Blacklisted, the Photo League shut its doors in 1951, prey to Sen. Joseph McCarthy's witch hunt (see Anne Tucker's essay in this volume).

Yet it is easier to codify history than to understand it in terms of its fluid, sputtering growth, its conflicts and multiplicity. And the Photo League, whose span was contemporaneous with the first efforts by various figures, such as Beaumont Newhall at the Museum of Modern Art, to chart and classify the history of photography, had numerous mentors and a complex genealogy. Beyond its overriding advocacy of straight, honest photography, and its derogation of work that lacked social content, the League exhibited a wide spectrum of modernist work, from Abbott to Moholy-Nagy, and addressed a diverse range of ideas in its periodical, *Photo Notes*. The Photo League was far more than a movement. When it emerged during the Depression in 1936 as a center for the practice, exhibition, and critique of photography, it was a unique establishment. Soon becoming a school, it served throughout its tenure as an important forum for the discussion of advanced photography. For many members it was an important social meeting place, if not a bona fide salon.[20]

As photojournalism became a ubiquitous part of modern life during the 1930s, from *Life* and *Look* to *U.S. Camera,* the gulf between art photography and straight documentary only widened. Left-wing purists, like Elizabeth McCausland, an art critic and member of the League's board of advisers, indicted photograms and rayographs, for example, as indulgent and irrelevant forays into abstraction. "Not the photographer's personality, not abstract formulas of what is 'beautiful' and 'effective,' rule this school of thought and practice," McCausland wrote, "but a modest and sincere desire to let the subject live in its own right. It may be that the subject is a row of stoops stretching interminably down a city street, or it may be city children playing in the rush of water from a hydrant, but the thing that exists, that happens, that is, is far more interesting and exciting than the observer's emotions about the thing. That is the primary documentary approach."[21] She lauded the social conscience of Hine and exhorted the League to study "the character of the city, probing into the forces and structures by which life is possible."

McCausland's early heralding of the birth of a "documentary school" spoke only to an era that called for art to have "social content" and "be a weapon" in the hands of a photographer, a "serious worker dealing in truth."[22] Her closed-minded sense of art's essential raison d'être, founded on the egregious inequities of the Depression and the exigencies of the war effort, was losing its commanding imperative even before the war ended. Such a hidebound view would gradually subside as the League entered a new decade, promising that differing perspectives, especially with new membership, would be able to coexist more constructively. The image of photographer as worker or artist would similarly become a theoretical vestige from the late 1930s.

Debates regarding aesthetic emphasis were of course a part of its early history and became especially raucous among the members of the League's *Harlem Document* Feature Group (see Maurice Berger's essay in this volume), in which ideology abutted artistic expression almost violently. The

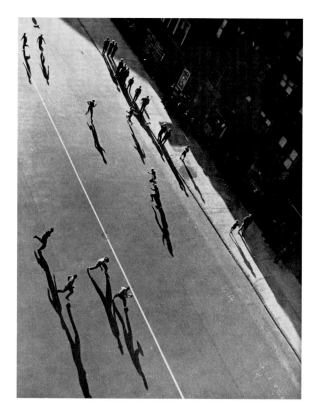

Fig. 5. Harold Corsini's *Playing Football,* reproduced in "The Year's Photography," *U.S. Camera Annual 1941;* the issue was edited by T. J. Maloney, and Edward Steichen selected the pictures (see plate 35).

minutes of their meetings transcribe the drama that surrounded the aesthetic conundrum of the documentary and the fear that formalist concerns might undermine its revelatory effectiveness. Disputes arose over how to achieve a "true" and "good" picture of the subject without subverting the photograph's social efficacy. That Harold Corsini's image of a group of street football players was considered too aestheticized, because of the emphasis he placed on the attenuated shadows of the figures in order to create an autonomous design, underscores how sensitive an issue this was (fig. 5; plate 35). Other images in the Feature Group project, such as *Street Market,* 1937 (plate 36), by Aaron Siskind, or *Untitled (Steps),* 1936–40 (plate 28), by Lucy Ashjian, which achieve a poetic reduction of the elements into a unified whole, similarly reveal the inclination of some members toward a more formal handling of the subject.

Such treatment, especially when it came to deemphasizing the bleaker aspects of Harlem, was

a source of frustration to some, like Grossman, who, during the Depression, at least, held to hard-line radical politics and took umbrage at those who sought to mollify him. Grossman, whose hotheadedness earned him the nickname "Commissar," almost came to blows with Corsini regarding his aestheticism. In reading such accounts it is never acknowledged, however, that this "founder" and head of the school, this impetuous ideologue, was all of twenty-three years old. Grossman's youthful intolerance tempered with time. Technical purists, like Strand, on the other hand, who resumed his teaching at the League after the war, insisted on the importance of "quality," even countering the shift toward the use of the popular lightweight Leica 35-mm camera, which encouraged spontaneity, to endorse the view camera, which necessitated a carefully studied approach.

But mostly the League and its *Photo Notes* writers thrived on debate. They were encouraged by figures such as Ansel Adams, who in a published letter to the League in 1940 raised many questions that he would address in person in 1948, concerning not only "technique vs. message," but also the vital impact of individual expression.[23] Adams's critique was offered as a constructive challenge to League photographers to demand "a real alive definition of Documentary Photography," an inquiry that would in the process help them resolve inevitable questions regarding technique. Such historical issues were either argued at the League or, along with articles, interviews, and reviews, printed in *Photo Notes,* touted by Edward Weston as "the best photo magazine in America today."[24] This constant public airing only encouraged more debate and inspired people who questioned basic documentary assumptions to experiment alone. But as League members matured, so did their medium.

Within photographic circles, the debate continued, with what was considered escapist, "pictorialist," or art photography pitted against engaged documentary photography. It did not abate even with the New Deal's gradual restabilization of the domestic economy, or with the broadening of perspective that came with the global dimension of

world war. Nor did it lessen with photojournalism's coming of age, which coincided with an explosion of picture-hungry tabloids and magazines (see Michael Lesy's essay in this volume). Any sense that American photography lay dormant during the war was contradicted by activity at the League. There was an exhibition of Henri Cartier-Bresson in 1940, followed by Lisette Model's first one-person show the next year, then Weegee's *Murder Is My Business* (fig. 6). As the country coursed through the shifting agendas of post-Depression recovery, war, and the affluence of victory, it was bombarded by images in picture magazines directed increasingly toward consumers' private domestic lives.

The accumulating view of the social subject, as real or ridden with fantasy, became a space to be negotiated privately. In Lou Stoumen's *Sitting in Front of the Strand, Times Square,* 1940 (plate 49), individuals, inundated with images of the lives of others,

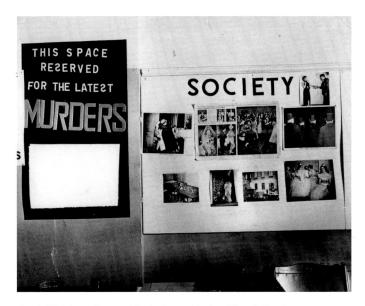

Fig. 6. "This Space Reserved for the Latest Murders," installation shot of Weegee's solo exhibition *Murder Is My Business,* held at the Photo League in the fall of 1941.

become more self-absorbed, if not voyeuristic; in Elizabeth Timberman's *Easter Sunday,* 1944 (plate 80), ordinary people take on an eccentric cast, such that the notion of normalcy is implicitly questioned. With this examination of identity emerged a more explicit psychological dimension, if only as an outgrowth of the solitary experience of the chaos of the

city. Numerous photographs were taken of multiply refracted images reflected in store windows: Nancy Bulkeley's *Madison Avenue,* c. 1946 (plate 77), for example; or *77 East 10th Street, New York,* 1949 (plate 109), by David Vestal, in which backlit silhouetted figures are seen from inside a shop. The rhythm only picked up during the postwar period as people returned to their routine lives. They were on the move, as in Model's *Running Legs, New York,* c. 1940 (fig. 7), or Ida Wyman's *Sidewalk Clock, New York,* 1947 (plate 118).

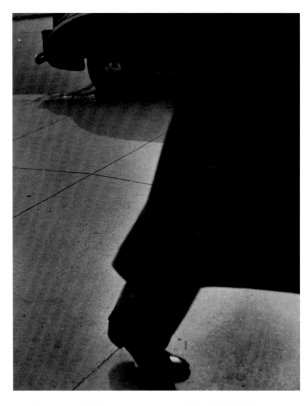

Fig. 7 Lisette Model, *Running Legs, New York,* c. 1940. Gelatin silver print, 13⅝ × 10¾ in. (34.6 × 27.1 cm). National Gallery of Canada, Ottawa

The subject was changing in other ways as well. In contrast to former, exclusive views of those who were victimized or deprived—as in the melodramatic portrait of a fifteen-year-old pregnant bride by Eliot Elisofon, c. 1940 (plate 48); the hungry young child in Myron Ehrenberg's *Untitled (Greek Girl),* c. 1946 (plate 89); or Marynn Older Ausubel's c. 1940 photograph of two children sitting alone on a porch (plate 46)—countless photographs contravene the League's earlier, dutiful bias in favor of the

neglected and the downtrodden. By the mid-1940s the Photo League was producing more images that revealed a broader range of emotions and behavior, as in Lou Bernstein's *Dancers in Shadows,* 1947 (plate 140), where dancers literally emerge from the dark. There was a new concern with human behavior and relationships untouched by exploitation, as in Max Yavno's *Muscle Beach, Santa Monica, California,* 1949 (plate 73), or with the wish or need for acceptance, as in *Woman at the Met,* c. 1943, by Weegee (plate 116). Other images project an existential quality, as in Sam Mahl's *Untitled,* 1949 (plate 148), a contrast to Strand's earlier landmark image of the dwarfing of human beings by the institution of capitalism, *Wall Street, New York,* 1915 (plate 4). And many photographs reflect an increasingly hermetic sense of identity, as in Marvin Newman's *Halloween, South Side,* 1951 (plate 100), or *Hester Street,* 1945 (plate 75), by Sol Libsohn, in which a group of people in front of a tenement stoop are caught in a moment, each seeming to look in a different direction and occupying a different space.

This postwar self-absorption was expressed in numerous ways, from images of privacy, as in Sy Kattelson's *Untitled (Subway Car),* 1949 (plate 119), to those that relate to a resurgent prosperity with its pervasive signs of an accelerated consumerism, as in his *Woman in Window Reflections,* c. 1950 (plate 78); Dan Weiner's *Women at Perfume Counter,* c. 1948 (plate 115); or *Lower Eastside Facade,* 1947 (plate 117), by Erika Stone. Juxtaposed in Stone's photograph is a facade of a tenement building, replete with laundry line and a hand-painted advertisement in which a woman's upward gaze clearly suggests longing— but her eyes are also directed away from the world of the Lower East Side, signaling the new order of social mobility.

In her book on the New York School of photography, Jane Livingston highlights the significance of 1936, a year that witnessed several events symbolic of the union of politics and art. Notable among them were the conference of the American Artists' Congress at Town Hall and the New School for Social Research,

and the formation of an association dedicated to "social egalitarianism," appropriately named the Photo League.[25] Six of the sixteen photographers she selects as representative of the New York School were active within the League, and of the four who "may be said to establish the conditions for the 'school,'" two—Sid Grossman and Lisette Model— were key members as well. Much of their work changed the course of documentary photography by challenging its earlier adherence to the honest principles of naturalism and by questioning, in the case of Grossman and Model, the narrative impulse.[26] In fleshing out the anecdotal moment in all its ambiguity, Grossman and Model sought to "operate beyond the gravitational field of Hine."[27] For though Hine was heralded by Abbott and influenced the FSA (as Roy Stryker, its director, attested in a lecture at the League), it would take time for Hine's work and that of the FSA to be acknowledged as art.[28] The elitist distinctions had been clearly drawn: institutional appraisal of photography's fine-art value would bear little on its social content. This official resistance to sanctioning documentary work remained until the late 1950s, when the documentary form became sufficiently subjectivized in the photography of Robert Frank to be read as art.

Many factors contributed to the waning belief in the efficacy of the documentary journalistic style and the corresponding move toward a greater autonomy for both photographer and work. Unappreciated in much of its history is the stress that the Photo League placed on the photographer's development of a greater self-awareness through the practice itself. Alongside issues of social content, style, or consideration of a diverse, international array of work there prevailed the broad question, How should photography be taught? It was a question raised repeatedly by those charged with the creation of the school's initial syllabus and those who taught and participated in the pivotal course on documentary photography (fig. 8). And much of the discussion on the topic was recapped in various issues of Photo Notes. Numerous voices, including those of Rosenblum and Dan Weiner, but chiefly that

of Grossman, contributed to the development of the new pedagogy. But throughout the 1940s many others, beyond illustrious figures such as Ansel Adams, Beaumont and Nancy Newhall, and Minor White, proffered critical insight and seriously raised and debated issues that might otherwise not have been engaged. When taken together, such evidence buttresses the notion of the League as a remarkably open forum that significantly advanced the field. This enlarged scope was also manifest in the more professionally produced Photo Notes, which by 1947 was no longer mimeographed but offset. In addition, its guest editors, such as Newhall, Adams, and Strand, encouraged more incisive articles, reviews, and rebuttals.[29]

Even Berenice Abbott addressed many of these issues. One of the few figures associated with the League who professed a modernist aesthetic, honed while she lived in Paris during the 1920s, Abbott appreciated the beautiful print. Yet she also understood, given her love of realism and the documentary approach, the need to recognize the ways in which such content expressed a viewpoint. In a

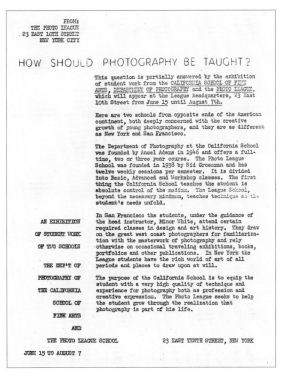

Fig. 8. *How Should Photography Be Taught?* Photo League pamphlet, June 1948.

series of articles she wrote in 1938 on the "aesthetics of photography," Abbott, despite her technical slant, pointed up the need to reconcile human sight and the camera's vision, reminding the reader that "since it is a 'mechanical eye,' the lens is not as flexible as nature's."[30] It was this mixture of the instinctual, human, and even voyeuristic impulses that, throughout the 1940s, inevitably surfaced among more and more members, encouraging a growing balance between conception and technique.

Though the polarization of art and politics within the League was of long standing, its late bitter display was felt intensely by a more mature and inclusive Grossman, as evident in one of his late-night salvos:

> I heard some very stupid and evasive talk about art in photography at a symposium at the Photo League . . . [from] people who should know better. One picked up his tommy-gun and let loose when he heard the word "art" and the other one ran like hell, and the third one dealt with it with a pair of white cotton gloves. The three reactions were very significant of the kind of attitudes toward art, and toward the question of realism and naturalism in art and photography. One guy [Roy Stryker] was afraid of art . . . [which he equated with] romanticism. . . . He doesn't understand that art is the catalyst which takes the photographer through the natural scene and helps him to bring an expression of reality onto the two-dimensional surface of a piece of photographic paper, so *that what you see is not naturalism, but reality.* [emphasis added][31]

This is not to imply that the League did not primarily stress photography's social value. In its expressed mission, as stated in the August 1938 issue of *Photo Notes,* "Upon the photographer rests the responsibility and duty of recording a true image of the world as it is today . . . he must [also] indicate the logical development of our lives." This last point suggests a concern with an individual's growth through photography, as though it were no less important a component than any other. It also relates to the holistic cinematic approach of Vertov, with its presumption of becoming one with one's

medium. Furthermore, these words appear right above the major announcement of the development of the League's school, and the prominent mention of Grossman's introduction of a documentary course, which promised to be "unique in photographic instruction," offering a critical opportunity where the student's work would be discussed.

This initial challenge to the photographer to take a position and defend it was something quite new, and would characterize Grossman's legendary role as a provocative teacher at the League. Not only did he help establish the school, but he was its director virtually throughout its existence, and his unrelenting emphasis on the need for his students to develop their own voices—while studying the diverse history of the medium—has been an overlooked contribution of the Photo League. Numerous figures emphasized that photography involved a new manner of seeing, one quite removed, say, from that espoused by the proponents of the *Neue Sachlichkeit* (New Objectivity) movement, who claimed that it was technology that had the power to heighten vision. But Grossman insisted that ways of seeing hinged on the specific relationship between photographer and camera.

Drawing on Grossman's ideas, Bernard Cole described the workshop in this way: "This class is designed to help the student make an individual interpretation of his immediate world. The student is taught to *see himself in relation to photography, photography in relation to society.* Through a progressively broadening understanding of the medium, the student eventually achieves a personal style of photography—his own, not the instructor's" (emphasis added).[32] In another issue of *Photo Notes,* member Hal Greenwald defined the League as "important because it is the only non-commercial photography school in America. It is unique in that it uses a progressive educational method: the student learns by doing. . . . That means that the teacher and his method of instruction must be such that there is not the usual humdrum routine of the student 'absorbing' knowledge, but rather a vital exchange between student and teacher which results in further knowl-

edge and insight for both. To Sid Grossman, our school director, must go the major credit for evolving this enriching method of teaching."[33]

Grossman increasingly insisted on the idea of being in the world in a particular manner, engaging with a certain consciousness as a photographer, and connecting to the camera in ways that made photographers question who they were. His hortative style of teaching was almost ten years in the making and had the gradual effect of forcing a new kind of thinking about what it meant to be a photographer. It was a gestalt entailing a convergence of the psychological, political, and artistic that Grossman demanded of himself more and more, a passionate overhaul of one's habitual way of living and acting. It required a

> completely new attitude toward the people you are dealing with, toward everything you do in this world. . . . You have to see to what extent you go through life with more or less complete boredom. Where are you seizing every experience as an experience of growth and where are you defying nature, defying your own wonderful instincts and impulses, where are you sitting and letting the circle go round instead of *moving by growing, by changing?* You live by gyrating [emphasis added].[34]

This transformative approach to pedagogy, which Grossman adopted after the war—and before his persecution began—has been largely overlooked and may in fact be, in terms of its legacy, one of the most radically innovative contributions of the League. It has generally been assumed that Grossman's thinking and the formal metamorphosis in his late work must have been influenced by his being blacklisted.[35] But sufficient evidence appears in *Photo Notes* to prove that Grossman's ideas had been maturing all along. Seen in this way, they anticipate the assertion of the photographer's identity that manifested itself later in the New York School, with the work of people such as Frank, Ted Croner, and Louis Faurer, among others. Almost a year before the blacklisting, in the February 1947 issue of *Photo Notes*, Greenwald wrote, acknowledging Grossman's unique influence: "It is Grossman's contention

that the *relationship between the art form and life is a living thing.*"[36] One has only to look at Grossman's photographs prior to this time to know that he was actively engaging these ideas (plates 24, 69).

Such a raw, prescient address of the personal and independent issues that would surface with the work of the next generation of the New York School was rare indeed. The only other instance may be Grossman's student Lisette Model, but she did not

21

Fig. 9. Lisette Model, 1949, photographer unknown.

start teaching at the New School for Social Research until 1951 (fig. 9). There were few serious photography schools during the 1940s. The Institute of Design in Chicago, founded by Moholy-Nagy after the Bauhaus, was hardly an option for those who believed in straight photography with a social edge, since its central concern was innovation in graphic design. Group f/64, on the West Coast, overseen by Ansel Adams, Willard Van Dyke, and Edward Weston, was, despite its antipictorialist position, focused on large format and technique, as its name suggests, and was notable for largely excluding the human figure from its images.

What distinguishes the League's treatment of photography was not the belief that its work could effect social change, as is generally surmised, but that its members—predominantly Jewish, working-class, and first-generation Americans living in a multiethnic city—were fascinated by the city's composite nature and strongly identified with it.[37] This intellectual and ethnic lineage informed the League's sociological fascination. The city became a classroom where social relations could be studied, or queried, as Max Kozloff put it, "not

so much a place to be described as a setting that poses a question" regarding the relationship between "seer and seen."[38]

Ultimately, this gradual alteration of perception toward the interrogative, the shift from bearing witness to determining one's own bearings, transcended traditional base issues of class or ethnic origin. Domestic economic stress and the threat of global fascism gave way after the war to a surreal

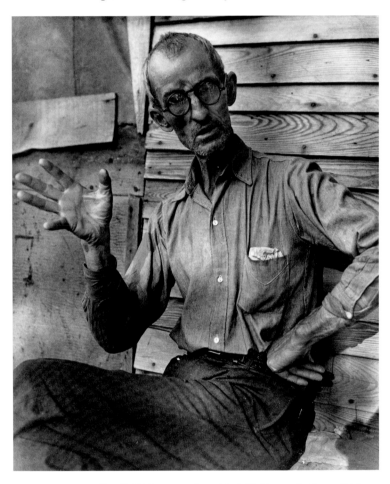

Fig. 10. Sid Grossman, *Henry Modgilin, Community Camp, Oklahoma,* 1940. Gelatin silver print, 12½ × 10⅝ in. (31.8 × 26.9 cm). Museum of Fine Arts, Houston, Gift of Sally and Joe Horrigan.

prosperity and the new challenge of upward mobility. For a generation that came of age during the Depression, such dizzying and paradoxical changes were often accompanied by a profound sense of disillusionment. The effect on the League of such rapid vicissitudes is a subject that has generally been neglected in the literature. Newer members, along with the many women who joined the League

during the war (see Catherine Evans's essay in this volume), were often less inclined to adhere to an uncompromising political agenda. But even as older members returned from the war, Rosenblum from Europe, for example, or Grossman from Central America, they brought with them transformed perspectives.

The League had changed in response to such chronic upheaval, and, ironically, just as this change was about to be formalized in the adoption of a new name—a Center for American Photography—the organization was blacklisted in December 1947. As a result, the League failed to realize this nominal but significant intention to signal not only the evolved status of photography both within and beyond it, but also the utterly changed status of all things cultural and economic. The tragedy of the League's aborted aspiration to transcend its past, acknowledge the richness of its present, and project a vibrant future is all the more poignant when one considers Grossman's own unfulfilled potential. Both the individual and the institution were victims of bias and persecution, which have persisted to this day in the form of a kind of prejudicial blind spot, a historical myopia.

No one figure better epitomizes the paradoxically amorphous identity of the documentary genre within the League than Grossman, who, as a founder, helped spearhead the group and remained, perhaps more than anyone else, its lasting and most visionary pedagogic voice. Grossman knew that the challenge of producing a good photograph involved far more than technique or the simple making of a pretty picture. According to Marion Hille, his first wife, he encouraged his students "to enjoy themselves right away, to get the feel of taking pictures without technique getting in the way."[39]

But his own censure and the immediate withering of the League must be understood in terms of the art world's subsequent need to distance itself from the League and its legacy: that is, to clarify the rupture that the artistic validation of the New York School in the late 1950s represents. Such eventual endorsement and universal legitimacy as

that which suddenly came to quite another band of outsiders, principally Frank and the late New York School, was marketed under a profoundly different generation's documentary rubric, one in which a psychological artistic solipsism began to prevail. Martha Rosler has described this shift as "the changed account of the documentary enterprise itself, from an outward-looking, reportorial, partisan, and collective one to a symbolically expressive, oppositional, and solitary one; the lionizing of Robert Frank marks this shift from metonymy to metaphor."[40] As the Beat Generation, it commanded, in contrast to the League, "the most deeply enforced artistic passivity." Such was yet another layer of the League's mature, unsung legacy.

It has been well observed that Grossman's major formal breakthrough occurred when he was in the air force, stationed in Panama as a photographer in 1945–46. In such work as his *Black Christ* series, 1945 (plate 69), one can see his clearly independent willingness to loosen himself from the moorings of objectivity, to fiercely skew the frame with Model-like angles, and, more significantly, to blur the image, as in *Jumping Girl, Aguadulce, Panama,* c. 1945 (plate 58). With these grainy pictures Grossman began to challenge the honest and straight documentary approach that he had long espoused. These works speak less to the exactitude of observation than to the underlying elusive character of their subjects. One can only wonder whether Grossman was in some way addressing his own youthful intractability, his earlier inability to break free from the stress of his socioeconomic circumstances.

Significantly, these stylistic changes occurred in his work while he was away, relieved of economic woes as well as pressures from the Communist Party and the League itself, as he seems to have made use of the distance and a certain independence to experiment and move on. Such a formalist stirring was triggered during his first major trip away from New York, in 1940, when he traveled through the Dust Bowl states to photograph both the life of the homesteader and union activities. In two portraits in particular, *Henry Modgilin, Community Camp, Oklahoma,*

1940, and *Emma Dusenberry, Arkansas,* 1940, Grossman attended to his subjects with a newfound sense of poetics (figs. 10, 11). Photographing Modgilin, a forthright union organizer and farmer, from below and close up, Grossman intensified his subject's already forceful, sinewy mien, one arm akimbo, the other dramatically gesticulating. Modgilin is seated in front of a facade of weathered, unpainted clapboard. But it is his expressive hand as it occupies its own quadrant, literally seen against a separate wall of fragmented patched and broken boards, that makes the picture burst.[41] In contrast, Emma Dusenberry, a well-known folksinger who became blind as an adult, is shown at a distance, seated in front of a modest dwelling, partially shaded by its eave, her gaze directed away from the camera along the diagonal, beyond which is another house. Along with the geometries of the buildings themselves and their playful angled shadows, the rippling texture of aging cedar shakes along the rooflines creates a formal simplicity worthy of Strand.

One can only assume that Grossman's detachment helped him to focus more resolutely on himself and to forge a new direction in his own work. In Panama, he plainly began to demand of himself what he would increasingly ask of others—to be

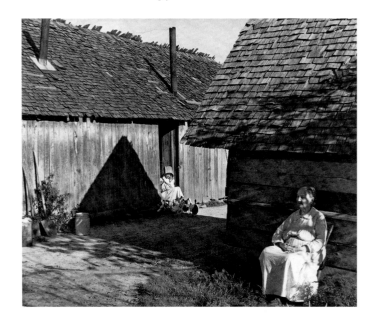

Fig. 11. Sid Grossman, *Emma Dusenberry, Arkansas,* 1940. Gelatin silver print, 10 × 11⅞ in. (25.4 × 30.2 cm). Museum of Fine Arts, Houston, Gift of Miriam Grossman Cohen.

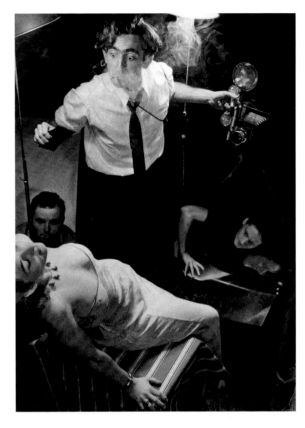

Fig. 12. Sid Grossman, *Lou Stoumen and Friends,* from *Gruesomes,* c. 1940. Gelatin silver print, 9⅜ × 6⅞ in. (23.8 × 17.5 cm). Columbus Museum of Art, Ohio, Photo League Collection, Museum Purchase with funds provided by Elizabeth M. Ross, the Derby Fund, John S. and Catherine Chapin Kobacker, and the Friends of the Photo League.

immersed and self-possessed in their work in order to "speak through their pictures," something he felt was lacking in much of photojournalism. The questions he would pose far more forcefully and notoriously in his workshops, on his return from the war, he seems already to have aggressively addressed himself.

Adopting a Speed Graphic 4 × 5 camera with a single flash, Grossman began to change his technique, photographing at night, animating his imagery by moving his camera, even manipulating his prints to achieve varied, surreal effects.[42] Many of the night scenes that he took of a Black Christ festival in Portobelo, Panama (plate 69), anticipate the frenzied imagery of his later crowd scenes, such as *Mulberry Street,* 1948 (plate 70), from his series on the Festival of San Gennaro, charged with the lively narrative of a film still. The cinematic had always intrigued Grossman, whether in the exuberance of a couple dancing in Harlem (plate 24) or in the odd series of staged satirical photographs that he began making in the late 1930s called *Gruesomes.* In these he would direct his friends, posing them in various

"gruesome" scenarios derived from detective stories and, perhaps later on, from film noir.[43] What gives this strange series its interest, apart from its quirkiness, is its audaciously inventive composition, as in *Lou Stoumen and Friends,* 1939 (fig. 12).

Though he was intractably caught within an unchanging world of habitual behavior, Grossman's one seemingly unconstrained activity was as a photographer and teacher. His relative lack of well-known prints and his general wariness of commercial photography were symptomatic of this inflexibility, an overriding fear of compromise in relation to commercial work. His compensatory belief in the liberating rewards offered by photography was one of his fundamental pedagogic principles. In his well-known exchange with Model, when she asserted that "in *Life* magazine there are excellent photographers," Grossman revealed his disdain for most of what passed as good popular photography. "How many *Life* photographers are real photographers?" he queried in response. "I don't believe there are an appreciable number of photographers in any sense, and particularly this is so for *Life* or any of the magazines. . . . They don't speak through their pictures. They tell us what we already know."[44]

The impassioned, often aggressive workshop critiques of the notoriously confrontational Grossman have been well described by numerous students, including Model, Rosenblum, Louis Stettner, and Helen Gee. Many of his students remained at his informal class gatherings until the wee hours, in the domestic grip of their caffeinated and chain-smoking teacher, as these sessions often took place in his Chelsea apartment.[45] Even the well-established Model stayed on, loyal to Grossman in many ways, and developed her own tough style of teaching at the New School for Social Research in 1951. Numerous others credit him with their life-changing decision to become photographers. Arthur Leipzig called him "probably the most fantastic teacher I ever knew."[46] Implicit in Grossman's comments to his students was not only that photography mattered and could change the world, but that time was not to be wasted. For him, photography was

not a passive medium to be employed in a hit-or-miss way, occasionally alighting on a subject, but one that required sustained vigilance and attention to both medium and subject.

Throughout his career he professed the conviction that one had to "live for photography," demanding a kind of psychological conversion. As he said to his students, to reach a certain point they were required to leave their comfort zone. To become a good photographer pretty much meant you had to change who you were, to think through and identify with your work. In a sense, Grossman's sustained belief in photography as a transformative practice rested in part on the salvation it provided for him and, as a teacher, on what he believed it could offer to others. Photography singularly liberated him, allowing him to exceed the limitations that he otherwise faced in his life.

Grossman's childhood was difficult, for reasons that involved more than just growing up during the Depression. His working-class parents had emigrated from Austria, and his father may have abandoned the family, leaving his mother as the sole supporter of their four children.[47] Grossman's penurious existence, which was born of the Depression but equally rooted in his asceticism, was described by his second wife, Miriam, who reflected on the subject years after her husband's death:

> How long can you run on this stream of idealism and youth . . . there comes a time when you get weary of that and you think you would like to have a record player in your house and things like that. . . . Sid was extraordinary in his ability to hold out. . . . He and I really owned nothing and we were happy, but we didn't have a big home to support. We didn't have a car, we never had a car. Never had a record player . . . but it was all right. But what was not all right . . . were the blows that they dealt him over this ideological thing.[48]

Friends have recollected numerous stories of his self-deprivation. Doing without, except for his cigarettes and coffee, became another of Grossman's unbreakable habits in an unencumbered world whose simplicity gave priority to his artistic mission.

Fig. 13. Sid Grossman, *Provincetown*, c. 1951. Gelatin silver print, 10¼ × 13⅞ in. (26 × 35.2 cm). Museum of Fine Arts, Houston, Gift of Mr. and Mrs. Cleves Delp.

"If someone calls me," he once explained to those in the commercial field, "and makes a proposal that's indecent financially and esthetically, I am now able to say 'no,' but if I were committed to a large overhead, I couldn't." In raising his own family in a loft in Chelsea he maintained his ascetic life. "Its one main room [served] as living room, dining room, studio, and classroom . . . the bathroom doubled as a darkroom, and prints were dried in the kitchen."[49]

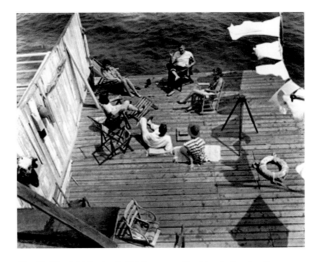

Fig. 14. Morris Huberland, *Sid Grossman Teaching in Provincetown*, 1954.

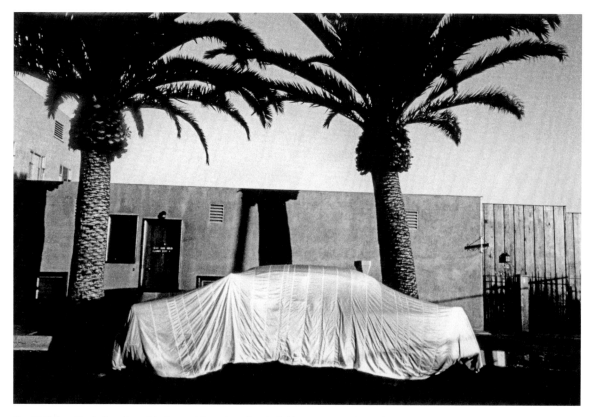

Fig. 15. Robert Frank, Americans 34, *Covered Car—Long Beach, California*, 1956. Gelatin silver print, 8½ × 12⅞ in. (21.4 × 32.7 cm).

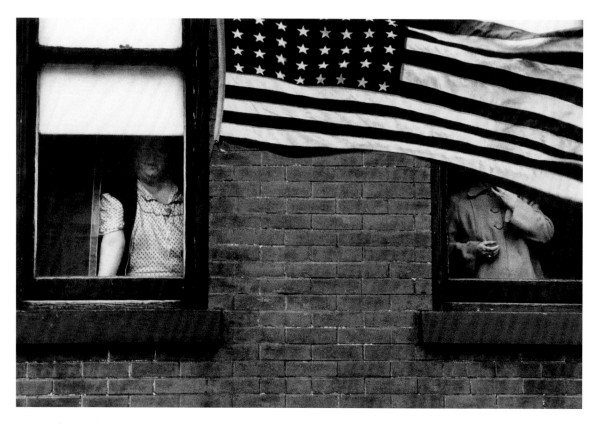

Fig. 16. Robert Frank, Americans 1, *Parade—Hoboken, New Jersey*, 1955. Gelatin silver print, 8⅜ × 12¾ in. (21.3 × 32.4 cm).

A photograph is as personal as a name, a fingerprint, a kiss. It concerns me intimately and passionately. I am not ashamed of that.
—*Sid Grossman*[50]

In one of his last classes, shortly before he died in 1955, Grossman referred with some irony to a late series of works as his "pictures of birds" and as scarcely the kind of relevant subject that he would have pursued earlier in his life (figs. 13, 14). "Yet this material," he said, "was quite harmonious with my past history as a photographer, visually and emotionally."[51] With their allover pattern of flickering light and agitated movement, the photographs, which he called *Provincetown,* convey at once the contemporary language of Abstract Expressionism but, more poignantly, in the seagulls' feeding frenzy, the poisonous atmosphere that had finally forced him out of the League in 1949.

Such was the person and pedagogy of Sid Grossman, who more than anyone else spoke to this ultimate mixture of passion and disillusionment that characterized part of the legacy of the Photo League—the highly subjectivized, poetic renderings of social impressions that define the work of the New York School. The transmutation of the documentary mode into an experimental, personal vision, a poetic sequence of documentary images, sees its subjective efflorescence in Grossman's late Provincetown work and reaches its transcendence in Robert Frank's book *The Americans* (1958). With the publication of the latter well into the Cold War, when "the faith in progress and the camaraderie of work had had its day," Frank upended the tenets of truth in photographic realism.[52] Questioning the certainty of American identity, in one metaphoric swoop he shrouded the idea of truth and transparency, literally: *Covered Car—Long Beach, California,* 1956 (fig. 15), presents the American four-wheel ideal and symbol of virility as a corpse, underscored by the pendant image of a victim of a fatal car accident. In other images such as *Parade—Hoboken, New Jersey,* 1955 (fig. 16), and *Fourth of July,* it is the ubiquitous flag that has become a symbolic veil, an object of obfuscation, and a darkening palette.

NOTES

Epigraph: Elizabeth Winthrop, *Counting on Grace* (New York: Random House, 2006), 220.

1. Lewis Wickes Hine, born on September 26, 1874, was forced to go to work in an upholstery factory after his father was killed in an accident. Over the next seven years Hine worked his way up to a clerical position at a bank, and then he met Frank Manny, a professor of education at the State Normal School in Oshkosh, Wisconsin. Manny persuaded the twenty-five-year-old Hine to begin college study there. After a year, Hine transferred to the University of Chicago, where he studied with one of the leading advocates of progressive education, John Dewey, among others, and took a broad range of courses in teacher's education. When Felix Adler, founder of the Ethical Culture School in Manhattan, in 1901 offered Manny the position of superintendent at the school, the latter invited Hine to teach there as well. In addition to his teaching, Hine earned a master's degree in education at New York University. He started working for the NCLC in 1906 on a freelance basis while still a teacher at the Ethical Culture School. Two years later, he left the school to assume a full-time position as a photographer for the NCLC.

2. Riis may have resisted achieving too much with his photographs at a time when publishers like William Randolph Hearst or Joseph Pulitzer commonly doctored them in the service of selling papers. This practice made people in the early part of the twentieth century distrust the veracity of photography. "[He] recognized from the very beginning, a picture made ineptly was more effective for his purposes" (Colin Westerbrook, *Bystander: A History of Street Photography* [Boston: Little, Brown, 1994], 241). Competitive publishers would go to extremes to masquerade their biases as objective fact and to manipulate published photographs. "Hine's photographs provided direct proof of the children's activities, but he had 'to be double sure that [my] photo-data was 100% pure—no retouching or fakery of any kind,' because of the public's reluctance to accept photographs as verifiable records of informa-

tion" (Daile Kaplan, *Lewis Hine in Europe: The Lost Photographs* [New York: Abbeville, 1988], 40).

In several articles, Hine clarified his goal to engage the photograph as an educational tool; and in the most direct, frontal manner he developed a style that privileged the subject over technique. Yet he was concerned with improving the aesthetic aspect of his work (Hine, "Photography in the School," *Photographic Times* 40, no. 8 [August 1908]: 230. Shortly before he died, Hine had decided to enroll in a class at the League in 1940 in order to improve his printing technique.

3. When he announced his decision to leave his teaching position at the Ethical Culture School and set up shop as a "social" photographer for the NCLC, an adviser cautioned him, "I'm afraid, Mr. Hine, that you haven't the broad sociological background required." "Nonsense," responded Arthur Kellogg, an advocate of Hine's and editor of the reformist social-work journal *Charity and the Commons.* "It's wonderful to find a photographer who has *any* sociological background." See Elizabeth McCausland, *Survey*

Graphic 27 (October 1938): 502–3.

4. Indeed, after Hine—having been excluded from Beaumont Newhall's Museum of Modern Art exhibition *Photography 1839–1937*—confronted the exhibition curator, Newhall redressed his belated introduction to Hine's work by embracing it and arguing for the serious reception of his photographs, which were distinguished, in his opinion, by "an extraordinary emotional quality [that] raises them to works of art" (Beaumont Newhall, "Lewis W. Hine," *Magazine of Art* 31 [November 1938]: 636–37). See also John Raeburn, *A Staggering Revolution: A Cultural History of Thirties Photography* (Urbana: University of Illinois Press, 2006), 226. Following such endorsement, Hine was given a retrospective exhibition at the Riverside Museum in New York in 1939 with a broad sponsorship, including Alfred Stieglitz, Paul Strand, and Edward Steichen. Yet his dream of wide critical reception, of receiving a Guggenheim fellowship, of a modicum of financial security, scarcely happened; he died the following year at sixty-four, his visibility barely increased and his career in decline. Despite McCausland's and Newhall's characterizations of Hine as the father of American documentary photography, signaling his historical place within American culture, Hine became a peripheral figure (Elizabeth McCausland, "Portrait of a Photographer," *Survey Graphic* 27 [October 1938]: 502–5; also see McCausland, "The Boswell of Ellis Island," *U.S. Camera* 1 [January–February 1939]: 58–62).

5. Headquartered in Berlin, the WIR was an organization offering international support to strikers and their families. For the history of the beginnings of the League, see the following essays, all published in the same issue of *History of Photography* 18, no. 2 (1994): Leah Ollman, "The Photo League's Forgotten Past," 154–58; Fiona M. Dejardin, "The Photo League: Left-Wing Politics and the Popular Press," 159–73; Anne Tucker, "A History of the Photo League: The Members Speak," 174–84; and William S. Johnson, "*Photo Notes* 1938–50: Annotated Author and Photographic Index," 185–95. The Film and Photo League was briefly named the National Film and Foto League in the mid-1930s.

6. For more on this period's conflicts regarding documentary film, see Russell Campbell, *Cinema Strikes Back: Radical Filmmaking in the United States 1930–1942* (Ann Arbor, MI: UMI Research Press, 1982); William Alexander, *Film on the Left: American Documentary Film from 1931 to 1942* (Princeton, NJ: Princeton University Press, 1981); *Filmfront: A Reprint Edition,* annotated by Anthony Slide, intro. by David Platt (Metuchen, NJ: Scarecrow Press, 1986); and *New Theatre and Film,* selections ed. and with com-

mentary by Herbert Kline (San Diego, CA: Harcourt Brace Jovanovich, 1985).

7. Vertov's writings appear for the first time in English in *Filmfront,* National Film and Photo League, January 7, 1935, repr. in Nathan Lyons, ed., *Photo Notes, February 1938–Spring 1950* (Rochester, NY: Visual Studies Workshop, 1977). For more on Vertov, see Dziga Vertov, *Kino-Eye: The Writings of Dziga Vertov,* ed. Annette Michelson (Berkeley: University of California Press, 1984), 57.

8. Roy Stryker, the director of the Historical Section of the FSA, maintained strict editorial control of its "documentary" purpose, overseeing his staff's assignments in order to emphasize that their handling of content would not be aestheticized. To ensure that this latter concern would not be undermined, he censored those images that were not selected by "killing" them with a hole-puncher, the subject of a recent book by William E. Jones, *Killed: Rejected Images of the Farm Security Administration* (New York: PPP Editions, 2010). For more on social-documentary photography during the 1930s, see William Stott, *Documentary Expression and Thirties America* (New York: Oxford University Press, 1973); and Maren Stange, *Symbols of Ideal Life: Social Documentary Photography in America, 1890–1950* (New York: Cambridge University Press, 1989).

9. For additional readings that touch upon the sociological significance of the Photo League, see Max Kozloff, *New York: Capital of Photography* (New York: The Jewish Museum, and New Haven: Yale University Press, 2002); and Deborah Dash Moore, "On City Streets," *Contemporary Jewry* 28, no. 1 (December 2008): 28.

10. *Photo Notes* (January 1948), 7. Page numbers for *Photo Notes* citations, when indicated, accord with the Visual Studies Workshop reprint pagination for the series.

11. *Photo Notes* (Fall 1948), 23–25.

12. Klein distinguishes "two kinds of photography—Jewish . . . and goyish," respectively, "funky . . . and the people who got out to the woods," as quoted in Kozloff, *New York: Capital of Photography,* 70.

13. See Moore, "On City Streets," 103 n. 3.

14. Letter from Morris Huberland to Anne Tucker, September 14, 1976; quoted in Tucker, "A History of the Photo League: The Members Speak," 175.

15. "Photo League School," *Photo Notes* (Spring 1949). But the insistent challenge to students to find out who they are and what mattered to them came from the pedagogic presence of Sid Grossman.

16. *Photo Notes* (December 1939), 5.

17. December 9, 1939.

18. Stuart Davis, "American Artists' Congress," in *Art for the Millions: Essays from the 1930s by Artists and Administrators of the WPA*

Federal Art Project, ed. Francis V. O'Connor (Greenwich, CT: New York Graphic Society, 1973), 249.

19. In "The Film and Photo League," *Ovo* 10, no. 40/41 (1981): 3, Anne Tucker has written: "While the League's history cannot be understood without reference to a broader social history, to perceive its activities as solely political is to create another organization, a Photo League that did not exist."

In "Cézanne's Apples in the Photo League," *Aperture* 112 (Fall 1988): 4, Photo League member Louis Stettner has similarly written: "One cannot help but be intrigued, even fascinated, by the contradictory fate history has meted out to the Photo League. Perhaps no other artists' organization in America has been so condemned by government officials, and yet so enthusiastically explored by those with a passion for photography as fine art. . . . The main essence of the Photo League seems to have been blurred or distorted. History has been rewritten into something the Photo League simply never was."

In addition to the extensive archival research undertaken by Tucker since the mid-1970s, additional significant efforts have been made to evaluate and assess the influence of the Photo League, chief among them Lili Corbus Bezner, *Photography and Politics in America: From the New Deal into the Cold War* (Baltimore: Johns Hopkins University Press, 1999), and Raeburn, *A Staggering Revolution.*

20. In 1938, after the Photo League school was founded by Sid Grossman, it actually expanded the initial curriculum of elementary and advanced technique classes to include a broader offering of courses and lectures on documentary work.

21. McCausland, *Springfield Sunday Union,* August 27, 1939, 6E. The British sociologist John Grierson, who first coined the term *documentary* in a review of Robert Flaherty's film *Moana* (1925), did not conceive of the form as pure objective record, but as social responsibility balanced with a consideration of art.

22. Ibid.

23. *Photo Notes* (June–July 1940).

24. *The Photo League,* brochure, 1947–48.

25. See Jane Livingston, *The New York School: Photographs, 1936–1963* (New York: Stewart, Tabori, and Chang, 1992), 262.

26. Ibid., 259. In addition to Grossman and Model, the other two photographers are Alexey Brodovitch and Helen Levitt. Despite Levitt's efforts to distance herself from the League, she was clearly part of its history (having shown her work there in 1943 and 1949), as noted in *Photo Notes:* "In the case of Helen Levitt's documentary work, we have an artist who sees 'clear to the point of hallucination.' The general traffic of the universe hardly exists for her except when some

scent of lurking danger arouses a sort of panther's instinct in her, and she stalks her prey to its lair"; Joseph Solman, "Helen Levitt," *Photo Notes* (Spring 1950).

27. In *New York: Capital of Photography*, 45, Kozloff cites the work of Model as "the first socially conscious photographer of New York to operate beyond the gravitational field of Lewis Hine, whose faith in progress and in the camaraderie of work had had its day."

28. Walter Rosenblum recalled that Roy Stryker, director of the FSA's Historical Section, invoked Hine's name as a key influence, and based the work of the FSA "on what Lewis Hine had done earlier." Yet Hine's relationship to the FSA and especially Stryker was fraught at best, the latter having found Hine difficult to work with. "It was impossible to make the type of arrangements which would be satisfactory to him." See Bezner, *Photography and Politics in America*, 49 and 229 n. 14. For Rosenblum quote, see Colin Osman's interview with Walter Rosenblum in *Creative Camera* 223–24 (July–August 1983): 1021. Beaumont Newhall failed to include Hine and all but two FSA photographers in his major 1937 exhibition at the Museum of Modern Art, but by the next year he would publish an essay on both Hine and social documentary photography. Only Walker Evans, whose work was scarcely ideologically invested, and Theodor Jung were included in Newhall's exhibition. (Jung's inclusion is mystifying since he was fired, and how Newhall was familiar with his work is a mystery.) See Raeburn, *A Staggering Revolution*, 85.

During the late 1940s, needing to raise money and knowing that it could not properly conserve the work, the League offered the collection to Edward Steichen, director of photography at the Museum of Modern Art, who declined the offer. In effect, Steichen confirmed that the museum's elitist distinctions had been drawn. On the history and influence of the Museum of Modern Art and its 1937 exhibition, see Christopher Phillips, "The Judgment Seat of Photography," *October* 22 (August 1982): 15–23.

29. In his review of Edward Steichen's *In and Out of Focus* exhibition at the Museum of Modern Art in 1948, for example, the art historian Milton Brown, a close friend of Walter Rosenblum's and a stalwart left-wing supporter of the League, lambasted the state of photography, which had been "captured" by the news and even more by fashion magazines, and "left without a shred of ethics or esthetics." While he derided the medium's descent into a "bag of clever tricks," he did allude to the overriding aestheticism in painting that was beginning to sweep through the art world. Despite his strong documentary bias, Brown acknowledged the need to reassess the status of Amer-

ican photography. He concluded that "the crisis" it faced today called for "the same kind of social and artistic purpose, the same fervor, the same insistence upon integrity, the same faith in photography as an art form which motivated the earlier generation of photographers." Brown's indictment, while reminiscent of McCausland's parochial antipathy to modernist abstraction, put Steichen's sampling of American photography in a critical context. See *Photo Notes* (June 1948), 5. *Photo Notes* published a response by David Vestal, another League member, in the fall 1948 issue of *Photo Notes*, 38.

30. Berenice Abbott, "Photography," Lesson 3, "Lenses: Optics of the Camera Eye" (New York: Art Adventure League, 1938), n.p.

31. Transcripts, Howard Greenberg Gallery, New York, n.p.

32. *Photo Notes* (Fall 1948), 22. Grossman often said, "I am not an instructor in any classical sense. I have experience as a photographer, I have made photography a study. But I won't bear the responsibility for making something out of you. You must take that on yourself. You have to be searching, you have to be finding the courage to speak"; quoted in Sid Grossman and Millard Lampell, *Journey to the Cape* (New York: Grove, 1959), n.p.

33. Hal Greenwald, *Photo Notes* (February 1947), 2–3.

34. Class session transcript; quoted in Livingston, *New York School*, 281.

35. See, for example, Bezner, *Photography and Politics in America*, 113, who writes, "It can be no mere coincidence that such consciousness coincides with Grossman's being named by [the League member and FBI informant Angela] Calomiris." It is a shame that the transcriptions that were made of Grossman's classes postdate the blacklisting and his being forced out of the League.

36. *Photo Notes* (February 1947), 3 (emphasis added).

37. Approximately 65 percent of white New Yorkers in 1930 were parented by immigrants or came from families with one foreign-born parent (Ira Rosenwaike, *Population History of New York City* [Syracuse, NY: Syracuse University Press, 1972], as cited in Moore, "On City Streets," 103 n. 2).

38. See Kozloff, *New York*, 70.

39. See Tucker, "A History of the Photo League: The Members Speak," 177.

40. Martha Rosler, "Lookers, Buyers, Dealers, and Makers: Thoughts on Audience," in *Art After Modernism: Rethinking Representation*, ed. Brian Wallis (Boston and New York: David R. Godine and New Museum of Contemporary Art, 1984), 330.

41. Grossman also experimented in print-

ing this image. According to a League member, David Vestal, "Almost every tone in the negative was changed drastically in printing . . . mostly to dramatize this gaunt man's eloquent face, body, and gesturing hand. Each finger, individually, is separated from the wall behind it by local manipulation in printing—fanatical and typical. No trouble was too great for a picture he cares about" (Vestal, "Sid[ney]Grossman," in *Contemporary Photographers* [New York: St. Martin's, 1982], 391–92, as quoted in Bezner, *Photography and Politics in America*, 81). Modgilin's hand graces the cover of the photographer's posthumously published book, *Journey to the Cape*.

42. See Livingston, *New York School*, 288.

43. He showed these *Gruesomes* as a form of entertainment at Photo League parties, constantly changing their narratives. According to *U.S. Camera Annual 1943*, he made illustrations for detective magazines (Anne Tucker archive, Houston, Texas).

44. Sid Grossman class session 2, 1949, transcript, Anne Tucker archive, quoted in Livingston, *New York School*, 282.

45. The sessions, which were variously recorded, dated from the period after Grossman left the League in 1949. See Helen Gee, *Limelight: A Greenwich Village Gallery and Coffeehouse in the Fifties* (Albuquerque: University of New Mexico Press, 1997), 24–25, 150; see also "Louis Stettner," interview with Colin Osman, *Creative Camera* 223–24 (July–August 1983): 1021; and Walter Rosenblum, "A Personal Memoir," in *Paul Strand: Essays on His Life and Work*, ed. Maren Stange (New York: Aperture, 1990), 139.

46. Anne Tucker archive.

47. Grossman's second wife, Miriam, insists that Grossman's father deserted the family while his wife was pregnant with Sid; see Bezner, *Photography and Politics in America*, 245–46 n. 1.

48. Miriam goes on to say in this regard that certain people took this as a reproach. Transcribed interview between Anne Tucker and Miriam Grossman [Cohen], side three, 1, Anne Tucker archive.

49. Les Barry, "The Legend of Sid Grossman," *Popular Photography* 47, no. 5 (November 1961): 51.

50. *Journey to the Cape*, n.p.

51. Grossman class section 3, 1950, quoted in Livingston, *New York School*, and partial transcripts, Howard Greenberg Gallery.

52. The quote is from Kozloff, who cites Model as "the first socially conscious photographer to operate beyond the gravitational field of Lewis Hine, whose faith in progress and the camaraderie of work had had its day"; see *New York: Capital of Photography*, 45.

MAN IN THE MIRROR

Harlem Document, Race, and the Photo League **Maurice Berger**

In 1936, the Photo League was founded in New York. In the same year, one of its charter members, Aaron Siskind, brought together a "Feature Group" of young photographers whose goal was to produce extended studies of the city's neighborhoods. By the time it disbanded in 1940, the group had documented a range of urban phenomena—including a Manhattan tenement (1936), the Bowery (1937–38), the wealthiest and poorest precincts of Park Avenue (1937), and the Catholic Worker movement (1939–40). One project, which preoccupied it for nearly four years, remains its largest and most comprehensive: *Harlem Document,* an unpublished book of photographs with a sociological study by the writer Michael Carter.[1]

The principal objective of the book, organized into eight chapters—labor, health, housing, religion, recreation, society, youth, and crime—was to provide evidence of a community in peril and advocate that its rampant poverty and poor living "conditions . . . should be improved." Carter's text would advance this agenda by providing empirical analysis and hard statistics, bolstered by expert testimony and detailed "suggestions for improvement of specific conditions."[2] Harlem provided "unmatched opportunities to dramatize the era's social problems."[3] While the neighborhood was the cultural "nerve center of black America," it was also one of New York's most disadvantaged.[4] A disproportionate number of its residents depended on government aid, its housing stock was poor and rents were inflated, its death rate well exceeded the city average, and its schools were substandard and overcrowded (plate 29).

The chapter on crime posed a daunting challenge for the Feature Group: how to represent on film activity that was, by its very nature, hidden from public view, perpetrated behind closed doors, in secreted alleyways, or in darkness. One solution was to "illustrate the crime problem" through a meticulous "photographic study" of a switchblade knife, then the weapon of choice for many urban criminals. To facilitate the assignment, Carter provided the group with articles on delinquency in Harlem. Several weeks later, as the group discussed other ways of credibly representing crime, some questioned the necessity of devoting a whole chapter to it, since Carter's statistics indicated that "there was no greater proportion of crime in Harlem than in any other section in the city." The group concluded that the chapter was necessary, "because even if Harlem does not have a greater proportion of crime, a good many people are under the impression that it does."[5]

The Feature Group's handling of the subject of crime is troubling on several fronts, especially its resolve to focus on the issue not because it was more pervasive in Harlem, but because the public perceived it as such. Its interpretation of the issue was based neither on statistics nor on observation in the field, but rather on a stereotypical preconception of Harlem as a hotbed of illicit activity, a view that could not be substantiated by the camera. This limitation was exacerbated by the decision to symbolically represent a social pathology through an inanimate object rather than through the stories of its human perpetrators and victims. The group's dispassionate,

clinical approach to the switchblade study—aptly described as "scientific" by its members—threatened to further simplify a complex societal problem underwritten by multiple causes, motivated by a range of psychological issues, and responsible for incalculable loss and suffering.[6]

The recounting of this episode is not meant to suggest that the *Harlem Document* was universally stereotypical or synthetic, but rather that the Feature Group's political agenda sometimes fostered a limited, even programmatic, understanding of its subjects. The problem was compounded by the group's unself-conscious view of itself as an objective, but also uniquely insightful, chronicler of a people unwilling or unable to take charge of its public image. With the exception of Carter, who was African American and lived in Harlem, the project team was exclusively white and predominantly Jewish. The history of black *self*-representation that it ignored or did not know—particularly the longstanding use of photographs, taken by and for Africans Americans, to educate, motivate, and empower—was august and consequential. Work by these photographers rendered aspects of the *Harlem Document* and its methodology nearly obsolete by the time of its completion.

The political objectives of *Document* photographers—who, in addition to Siskind, included Lucy Ashjian, Harold Corsini, Morris Engel, Beatrice Kosofsky, Richard Lyon, Jack Manning, Miller Simon, and Sol Prom—mirrored those of the larger Photo League. The organization was born of Depression-era radical politics rooted in Communism and the Russian Revolution. Typical of this orientation, members referred to themselves not as photographers or artists but as "workers."[7] For artistic inspiration, they looked to Lewis Hine. Hine's groundbreaking and uncompromising photographs of urban poverty and blight earlier in the twentieth century—images that aspired to an empirical social "truth" that could "educate viewers about injustice"—led to moral indignation and concrete social change.

The use of compelling images to sway public opinion was central to the greater photo-documen-

tary movement that, by the 1930s, offered stark visual confirmation of human suffering and injustice. The documentary genre allowed photographers to transform distant, troubling events—which could easily have remained hidden from public view for reasons of politics, taste, or propriety—into shared, public experiences that were, by the nature of the medium's evidentiary power, difficult to deny or refute. During this time, a new "information era" was dawning "in which knowledge [was] power and photography a crucial form of knowledge." Popular pictorial magazines emerged as the foremost venue for the dissemination of news, information, and images, affirming the extent to which "popular trust in photographs increased as faith in the printed word declined."[8] And numerous groups and organizations employed pictures to motivate social change—from the Photo League and the National Association for the Advancement of Colored People (NAACP) to the documentary units of federal agencies, including the Farm Security Administration (FSA), Civilian Conservation Corps, and Office of War Information.[9]

Although the Feature Group's archives were eventually dispersed, and no record of Carter's manuscript exists, it is nevertheless possible to grasp the scope and sensibility of the *Harlem Document* through the minutes of the group's weekly meetings, the extant photographs from the project, and a few published writings by Carter. The most important surviving artifact, "244,000 Native Sons," is a six-page photo-essay published in *Look* in May 1940. Based almost entirely on Feature Group content, the article depicts various aspects of life in the community, including housing, religion, labor, health care, and leisure activities. A short introduction by *Look*'s editors reveals its topical hook: the recent and much celebrated publication of Richard Wright's novel *Native Son*. "Bigger Thomas, tragic hero of *Native Son*, was a victim of the environment," the magazine declares. "Here, in a study of Harlem, *Look* portrays the kind of environment that produced him."[10] In addition to unattributed Feature Group images, texts and captions were written by Carter and were based on his manuscript for the book.[11]

HARLEM'S PEOPLE AT WORK—ON JOBS THAT KEEP THEM "IN THEIR PLACE"

A FEW HARLEMITES, exceptionally gifted or lucky, have won good jobs, high pay and a limited acceptance into white society. But for most of them, such attainment is only a pipedream. The vast majority of Negroes find themselves consigned by their color to the most menial tasks, at poor pay, under daily fear of abuse and humiliation. They are the boot-blacks, ditchdiggers, janitors, porters, window washers and housemaids, and for them, there is little joy in life. One Harlem woman, graphi-cally represented by the picture below, summed up her story and the story of many others like her, with the simple declaration: "My knees are hard from prayin' and scrubbin'"

Fig. 17. "244,000 Native Sons," *Look*, May 21, 1940, page 13, photographer unknown.

The story Carter tells is grim, paralleling *Native Son*'s brutal account of Chicago's South Side ghetto in the 1930s and the corrosive effect of racism and poverty on its black residents. A text on employment, for example, stresses that few Harlem residents have "won good jobs, high pay [or] limited acceptance into white society." A photograph of a cleaning woman, stooped over and washing a floor —"my knees are hard from praying and scrubbin," she reports—is meant to typify the work that keeps African Americans "in their place" (fig. 17). Photographs of "typical Harlem boys" characterize them as "delinquents in the making" (fig. 18). An otherwise ebullient image by Jack Manning of residents gathered on the fire escapes of a tenement to watch an Elks parade is transformed by its caption into a consideration of the neighborhood's overcrowded living conditions, "the worst housing problem in New York" (fig. 19; plates 29, 33). A photograph by Siskind of boys playing in an abandoned tene-

ment is rendered more poignant and dramatic, as its caption points out, by the warning of danger scrawled across the ramshackle front door. And images of leisure activities—teenagers dancing, a family shopping for clothes, a man playing pool—are tempered by the reminder that the citizens of Harlem "burst for relief from drudgery."[12]

On one level, "244,000 Native Sons" is remarkable for its unwillingness to sugarcoat the interrelated effects of poverty and racism. By refusing to relegate these problems to stories about the segregationist South, a popular conceit in mainstream publications, *Look* exposed its predominantly non-southern audience to shameful conditions that were closer to home and in one of the nation's most tolerant urban centers. The photo-essay was undoubtedly discomfiting to white readers, confronting them with stark evidence of human suffering and daring them to ignore it. Just as extraordinary, the article adopted the explicitly Marxist posture of Wright's *Native Son*, arguing forcefully for the need to remedy class inequity and the bigotry that exacerbates it.

To its detriment, however, "244,000 Native Sons" represented Harlem as joyless and dysfunctional. By transforming even positive experiences and conditions into social pathology, the article mired the African American community in failure, ignoring myriad examples of personal achievement and triumph over adversity that were also a part of Harlem's story. Portraying the citizens of the neighborhood as virtually helpless and dependent on the largesse and generosity of white people, it sim-

244,000 NATIVE SONS . . . continued

HARLEM DELINQUENTS IN THE MAKING

EVERY CHILD, no matter how fortu-nate, finds it hard to adjust himself to his environment. The Harlem child finds it doubly hard. His problem is complicated by poverty and race discrimination.

The one generates a desire for better-ment; the other kills opportunities to ful-fill the desire. As the Harlem youth ma-tures and discovers his social plight, he may accept it or fight against it. To accept is deeply humiliating; to fight is to court trouble, for the odds are against him.

FIVE SOCIAL PROBLEMS. These are typical Harlem boys. They have survived Harlem's infant mortality threat which kills one of every 20 in early childhood. They go to one of Harlem's 23 schools, where, ac-cording to teachers, their aptitude varies directly with their health. They play in Harlem's streets which have the highest accident rate in the city (there are few playgrounds, only one Y.M.C.A.) They don't know that they will probably be living within Harlem's boundaries for the rest of their lives.

Fig. 18. "244,000 Native Sons," *Look*, May 21, 1940, detail of page 10, photographer unknown.

ultaneously perpetuated stereotypes about black inferiority and fostered pessimism by depicting a community in inexorable decline, with little means to resolve its daunting problems.

The article's negativity was underscored by *Look*'s focus on *Native Son*, a novel criticized by many commentators for "its failure to render African American cultural experience with any of its actual richness or complexity."[13] While the extent of the magazine's editorial input remains unclear—the thirteen photographs were chosen by its editors from more than one hundred submitted by the Feature Group—the political agenda of the *Harlem Document* was clearly manifest in the article. There is no evidence that the group saw the photo-essay as inconsistent with its objectives. Interestingly, in reassessing the *Harlem Document* years later, Siskind came to see its political agenda as a liability, criticizing it for the very problems endemic to the *Look* piece: "I think we were angled toward revealing conditions in terms of how poor they were. Our study was definitely distorted. We didn't give a complete picture of Harlem. There were a lot of wonderful things going on in Harlem. And we never showed most of them."[14]

Some of Harlem's most discerning citizens were inclined to agree with this assessment. In February 1939, the Feature Group mounted an exhibition of forty photographs at the Harlem branch of the YMCA—*Toward a Harlem Document*. At this point in its process, the group sought the approval of the community, which they hoped would see their work as "fair and unbiased."[15] To this end, a guest book was set up not only to solicit visitor responses, but also to assure publishers that the project would not receive "a hostile reception in Harlem."[16] While many comments were supportive—"a collection of documentary evidence that should move all to action," wrote one visitor—others criticized the exhibition's emphasis on the downward mobility of its subjects.[17] "The pictures are true and factual, but why show one side of life in Harlem?" observed one visitor. "What about the intellectual and cultural side?"[18] Another complained that the photographs

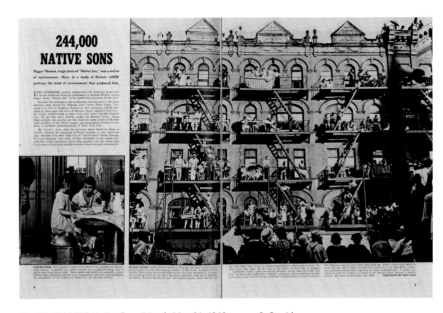

Fig. 19. "244,000 Native Sons," *Look*, May 21, 1940, pages 8–9, with photographs by Aaron Siskind (left) and Jack Manning (right) (see plates 29 and 33).

"only show the lower living conditions of Harlem," urging the group to "show Negroes in a better light."[19]

The Feature Group took this criticism to heart. After the YMCA exhibition, shooting scripts for the project's photographs called for more constructive images, such as pictures of "good looking" houses and churches, or shots of local artists and performers. The community's disapproval of the *Harlem Document* no doubt also informed Siskind's retrospective view of it—a reevaluation put into place more than forty years later with the publication of his own, updated version of the project, *Harlem Document: Photographs, 1932–1940* (fig. 20). Siskind's book departs considerably from the original. Gone are the clinical chapter headings, sociological statistics, and images of despair, replaced by nine impressionistic photo-essays—"Show Girl," "Rent Party," and "Conjuring," to name a few—composed exclusively of Siskind's photographs and excerpts of interviews and street rhymes collected in Harlem in the 1930s by the novelist Ralph Ellison and other members of the Federal Writers Project. This artful remake of the *Document* positions Harlem as a place of hope and possibility—a neighborhood, to quote the venerated African American photographer Gordon Parks in the book's foreword, "where loftier dreams were fostered;

Harlem Document
Photographs 1932-1940: **Aaron Siskind**

Foreword: Gordon Parks Text Collected and Edited: Ann Banks

Fig. 20. Cover of Aaron Siskind's 1981 book, *Harlem Document: Photographs, 1932–1940.*

where now and then some of those dreams were realized."[20]

Some historians have questioned Siskind's criticism of the original *Harlem Document*, arguing that the Feature Group, despite its desire for social change, sought to represent the neighborhood comprehensively—focusing not just on dire living conditions, but also on the community's diversity.[21] An accounting of the *Document's* extant photographs would appear to confirm this theory: the imagery covers a broad range of social and cultural activities and conditions, from the ordinary, life-sustaining rituals of everyday life to the events of cultural, religious, and political organizations. Some of these photographs focused on everyday workers, including the specialized labor of artists and performers, such as Richard Lyon's *Cabaret Dancer Going on the Stage*,

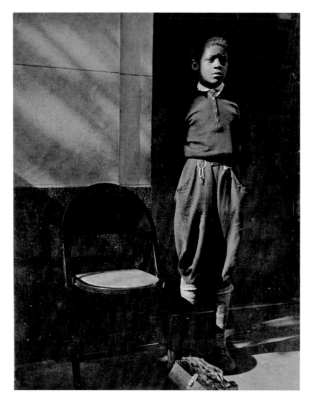

Fig. 21. Sol Prom (Solomon Fabricant), *Untitled (Shoeshine Boy),* 1937, from *Harlem Document,* 1936–40. Gelatin silver print, 10 × 7⅞ in. (25.4 × 20 cm). Columbus Museum of Art, Ohio, Photo League Collection, Museum Purchase with funds provided by Elizabeth M. Ross, the Derby Fund, John S. and Catherine Chapin Kobacker, and the Friends of the Photo League.

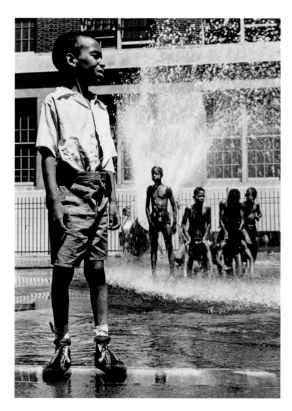

Fig. 22. Morris Engel, *Street Shower, New York,* 1938. Gelatin silver print, 9¼ × 6½ in. (23.5 × 16.5 cm). Columbus Museum of Art, Ohio, Photo League Collection, Museum Purchase with funds provided by Elizabeth M. Ross, the Derby Fund, John S. and Catherine Chapin Kobacker, and the Friends of the Photo League.

1937 (plate 23); others concentrated on children, including Sol Prom's *Untitled (Shoeshine Boy),* 1937 (fig. 21), Jack Manning's *Untitled,* c. 1939, and Morris Engel's *Street Shower, New York,* 1938 (fig. 22). Some images celebrated personal style, typified by Lucy Ashjian's depiction of elegantly attired men and women gathered around an ambulance, 1936–40 (plate 27), while others explored the aesthetics of the neighborhood's physical environment, such as Siskind's *Crazy Quilt (Jones Barber Shop), New York,* 1938 (fig. 23).

But as Siskind's redo of the *Harlem Document* suggests, hindsight and selective memory may have muddled the historical record. The surviving photographs that some point to as evidence of the project's diversity represent a relatively modest sample of an archive that has all but disappeared. Additionally, such images do not explain the crushing negativity of the *Document*'s most faithful contemporaneous iterations: the *Look* photo-spread and the YMCA exhibition, the latter criticized by Harlem residents for ignoring, to paraphrase Siskind, the "wonderful things" that were going on. The minutes also suggest that by the time *Toward a Harlem Document* closed on March 3, 1939, it may have been too late to overhaul the proposed book's content and methodology. Carter was well into writing the manuscript. The book's structure and chapters were decided. And many of its images were selected.

The publication of "244,000 Native Sons" fourteen months later, in May 1940, suggests that the problems inherent to *Harlem Document* remained unresolved by the time the Feature Group disbanded later that year. Most challenging was the group's failure to consider the ways in which Harlem saw and represented itself, and its lack of awareness that the project of empowering African Americans through the strategic use of images was well under way in the community. From the nineteenth century on, the neighborhood's cultural figures were diligently at work, crafting a parallel universe of words and images designed, in part, to counter the deleterious effects of mainstream stereotypes and invisibility. "The history of black liberation movements

in the United States," as the cultural critic bell hooks observes, "could be characterized as a struggle over images as much as it had also been a struggle for rights, equal access."[22] This imagery served the multiple needs of these movements, from bolstering black pride and morale in the face of demoralizing prejudice to helping convince white Americans of the severity of racism and the ways it endangered democracy. Nevertheless, while a number of black photographers were actively documenting Harlem

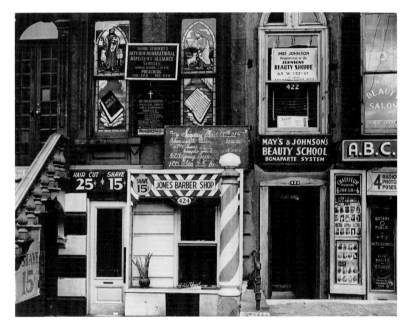

Fig. 23. Aaron Siskind, *Crazy Quilt (Jones Barber Shop),* 1938, from *Harlem Document,* 1936–40. Gelatin silver print, 7⅛ × 9¼ in. (18.1 × 23.5 cm). The Jewish Museum, Purchase: Photography Acquisitions Committee Fund.

life in the first half of the twentieth century—James VanDerZee and Morgan and Marvin Smith, to name a few—they were apparently neither involved with nor consulted by the *Harlem Document*'s exclusively white photographers.

At the dawn of the twentieth century, a national network of African American studio photographers, often operating in difficult economic and social circumstances, had generated pictures that could, as Angela Davis writes, "expose and condemn the evolving visual mythology of racism."[23] In the late nineteenth century, before the widespread use of snapshot cameras, these studios were principal sources of local black imagery.[24] In Harlem in the

1920s and 1930s, the photo studios of VanDerZee and the Smith brothers, for example, actively documented the community and recorded the rapid changes in one of the country's most important black urban centers (fig. 24). Commissioned by businesses, organizations, churches, families, and individuals, these photographers captured the activities of private citizens and public figures alike—from weddings, baptisms, and holiday celebrations to political demonstrations, performances, and galas.

African American pictorial magazines further established self-representation as an important

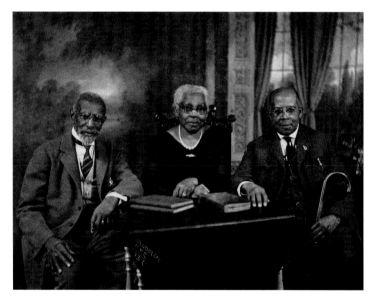

Fig. 24. James VanDerZee, *Portrait of Two Brothers and Their Sister, Harlem*, 1931, printed later. Gelatin silver print, 7¼ × 9½ in. (18.4 × 24.1 cm). Minneapolis Institute of Arts, Stanley Hawks Memorial Fund.

strategy in the struggle for racial equality. Convinced that African Americans needed a publication to better serve their needs and aspirations, W. E. B. DuBois at the turn of the twentieth century envisioned a widely circulated and visually oriented magazine. Armed with "knowledge of modern publishing methods" and "knowledge of the Negro people," his earliest ventures in publishing employed up-to-the-minute technology, including the inexpensive printing of black-and-white photographs and graphic images.[25] In 1909, along with other intellectuals, black and white, DuBois founded the NAACP. In 1910, under its auspices, he launched the influential monthly *The Crisis*.[26]

The goal of *The Crisis* was to "set forth those facts and arguments" that revealed "the danger of race prejudice" in order to rouse and motivate black resistance to racism and segregation.[27] The magazine's deft balance between word and image, a cornerstone of DuBois's editorial vision, contributed greatly to the magazine's success.[28] In an effort to enhance the publication's ability to motivate and inspire its readers, DuBois devised an ingenious strategy. He alternated strident articles and editorials about the reality and effects of racism with stories about black accomplishment, focusing on many of the community's most illustrative figures. In the former, pictures served as persuasive evidence, as in the gruesome photographs that illustrated pieces about violence against black people (fig. 25). In the latter, pictures celebrated or commemorated: photographic portraits accompanied obituaries, profiles, or the "Men of the Month" column (fig. 26). For DuBois, the stark depiction of bigotry alone was insufficient to lessen its destructive effects on the black community; more affirmative images were also necessary. In other words, the subtle interaction between images of suffering and images of achievement was "crucial to the impact of the magazine," allowing it to graphically report racial prejudice while simultaneously demonstrating, by example, the ability of black people to triumph over it.[29]

The Feature Group innately understood the need for a more diverse range of images, especially after the criticism it received. But the apparent focus of *Toward a Harlem Document* on the everyday lives of nameless working-class and poor people—and the economic forces that diminished their existence—may have inadvertently turned off the very community the group had hoped to win over. The exhibition failed to "create a large stir in Harlem." African American cultural figures virtually ignored it. And local newspapers did not review it, despite the fact that it was sponsored by the Urban League, "one of Harlem's most influential organizations, and held in one of its most visible institutions."[30]

The Feature Group's emphasis on the prosaic failed to grasp that the burden of responsibility

inherent in documenting impover-
ished African Americans differed
from that of portraying poor white
people, for whom racial discrimina-
tion was neither an issue nor an
impediment. To focus one's camera
on underprivileged whites was to do
so in an environment abundant with
representations of white power,
wealth, and accomplishment. In this
context, the self-image of white
Americans, no matter their standing
in society, was shaped against a cul-
tural backdrop of myriad role models
and stories of personal triumph over
adversity, depictions that proffered
hope and the promise of a better life.

Fig. 25. "Mineola McGee Shot by Soldier and Policeman, Her Arm
Had to Be Amputated," *The Crisis*, September 1917, photographer
unknown.

Fig. 26. "Men of the Month," *The Crisis*, November 1912,
photographer(s) unknown.

In the decades leading up to the modern civil-
rights movement, African Americans were mostly
invisible in popular culture. When blacks were
depicted in magazines, newspapers, films, and
newsreels, their image was inevitably stereotypical
and regressive: a panoply of buffoons, clowns, fools,
and servants designed to keep them in their place
while entertaining and playing to the prejudices of
white people. The richness and complexity of black
people's lives, let alone the achievements of their
leaders, were never reflected back to them in the
culture at large.

During a period when the Harlem community
was assertively representing itself in numerous cul-
tural venues—from church choirs and local newspa-
pers to amateur night at the Apollo Theater—*Toward
a Harlem Document* was no doubt dispiriting to an
audience who, unlike its white counterpart, was
accustomed to seeing only negative reflections of
itself in the culture at large. Missing from the exhibi-
tion and the *Document*'s later iteration in *Look* were
the idols, heroes, achievers, and elders who were
representing the race at its finest—the "Talented
Tenth," as DuBois named them, poised to uplift the
community by the outstanding example they set.[31]

Despite the inequality of representations of
blacks and whites in mainstream culture, the Photo
League's loyalty to the masses was unyielding and
color-blind. Exhibiting a study of Martha's Vineyard
at the League in 1941, for example, Siskind was "con-
demned" by its members "for taking pictures of
middle class and rich people."[32] The Feature Group's
relative disinterest in Harlem's "Talented Tenth,"
however, was not just the result of its allegiance to
League orthodoxy; it also represented a dramatic
misreading of African American culture. In an essay
for an exhibition of the *Harlem Document* at the New
School for Social Research in New York in May 1939
(fig. 27), Carter made a remarkable assertion: "The
white world discovered Harlem in the early 1920s.
Writers coined the phrase 'mecca of the New Negro'
—an expression never used by Harlemites, who see
little poetry in their shabby district. Other writers
exploited whatever exotic manifestations an impov-
erished race can demonstrate. In the general rush to
visit Harlem 'hot spots' the real workaday Negro and
his numerous problems were overlooked."[33]

Carter's view of the arts as irrelevant to the peo-
ple of Harlem was profoundly inaccurate. While the

neighborhood's nightclubs and cabarets had become a mecca for affluent white people, these venues represented only a small fraction of the area's artistic activity. During the 1920s and 1930s, the community had witnessed a dramatic resurgence of the arts—a Harlem Renaissance, as it was called, in which visual and performing artists, novelists, poets, composers, playwrights, and directors enlivened the black community and served its cultural interests. Their work was part of an unprecedented effort to create an updated and self-assured model of black identity—a "New Negro," who would exemplify

TOWARD A HARLEM DOCUMENT

An exhibition of photographs by the PHOTO LEAGUE at the New School for Social Research, 66 West 12th Street, New York City — May 8th to 21st, 1939.

TOWARD A HARLEM DOCUMENT

Fig. 27. *Toward a Harlem Document,* cover of the pamphlet for an exhibition at the New School for Social Research, New York, May 1939.

the modernity of his time as well as the noble history of his people.

The concept of the New Negro, contrary to Carter's assertion, was born not of white exploitation, but of the desire of black cultural leaders to take charge of their representation.[34] Popularized in the 1920s by the black philosopher Alain Locke and influenced by the writing of DuBois, the concept sought to replace a regressive model of black identity, typified by the compliant and accommodating "Old Negro" of the Jim Crow South, with a new, more assertive and self-confident conception of the race. To some in the black cultural scene, the New Negro model was poised to empower the community by dramatically reshaping its self-image; to others, the dissemination of its imagery into the nation at large could improve race relations, helping to

undo the stereotypes employed by white people to justify their prejudices.

While racial pride had long been a part of black artistic and political self-expression, it found a new purpose and definition in the work of artists associated with the Harlem Renaissance, otherwise known as the New Negro Movement. Their work endeavored to transform the stereotypical image of African Americans as "ex-slaves, members of an inherently inferior race—biologically and environmentally unfit for mechanized modernity and its cosmopolitan forms of fluid identity—into an image of a race of culture-bearers."[35] It is not surprising, then, that Carter, in keeping with the Feature Group's Marxist orthodoxy and "categorical, rather than particularized interpretation" of the black community, rejected the subjective, individualistic, and hierarchical version of identity central to the New Negro.[36]

This misreading also contributed to the group's conception of its own identity. Significantly, Carter's critique of racial trespassing did not extend to his white colleagues. Within the moral hierarchy established by him, the affluent white people who flocked to Harlem hot spots were plunderers of an exotic culture crafted especially for them; his white partners were selfless "workers" descending upon an imperiled community in order to rescue it. Despite this rationalization, the group's unself-conscious trespassing into a neighborhood it did not entirely know or understand alienated some of its residents while doing little to motivate white Americans to examine their own complicity in the dynamics of racism.

At the core of the problem was the Feature Group's conception of itself as a team of benevolent outsiders with no personal stake in the conditions they were photographing. Its photographers saw their subjects as largely anonymous actors who served to illustrate broad social categories and conditions, much like the inanimate object of the infamous switchblade study. They saw themselves as neutral observers akin to social scientists "doing fieldwork."[37] In the end, they looked to Harlem as a microcosm of the problems of black America, an exemplary place to document and analyze "the essentials of Negro exis-

tence," as *Look* described it.[38] Their status as white Americans and cultural intruders, however, made them more than just objective witnesses. It also implicated them in the complex social dynamic they were documenting. Thus, in more subjective and introspective hands, Harlem might also have served as a place to study some of the essentials of white existence—especially the white racial attitudes and beliefs that infiltrated and conditioned the lives of virtually every one of its residents.

As the minutes of its meetings suggest, the Feature Group was disinclined to engage in this kind of self-inquiry. "It didn't matter to me. I was never conscious of race," was Siskind's reply when asked about the absence of black photographers in the *Harlem Document*.[39] In proclaiming his lack of racial consciousness, Siskind invoked one of white liberalism's preeminent metaphors—color blindness—and its self-congratulatory implication of racial tolerance. His remarks underscored the ease through which progressive whites could absolve themselves of the responsibility of scrutinizing their personal biases or exploring the differences that set them apart from racial others.

That race did not matter to Siskind raises the question of how racial empathy and self-awareness might have improved the *Harlem Document*. Robert Frank's magisterial book-length photo-essay, *The Americans* (1958), provides some insights. Published nearly twenty years after work ended on the *Harlem Document*, Frank's project was the product of a very different time. The civil-rights movement and the Cold War were in full swing, and the focus of the New York art scene had shifted from the communal ethos of Marxism and social realism to the more individualistic ideals of Abstract Expressionism, surrealism, and existentialism.[40] Frank's impressionistic, subjective vision of America of the mid-1950s—captured on an epic cross-country road trip—was the result not of a predetermined ideological agenda, but of a process of visual discovery and introspection: "It is fair to assume that when an observant American travels abroad his eye will see freshly, and the reverse may be true when a Euro-

pean eye looks at the United States," wrote Frank in his 1954 Guggenheim fellowship application for *The Americans*. "I speak of the things that are there, anywhere and everywhere—easily found but not easily selected and interpreted."[41]

In one of *The Americans*' most striking and disturbing photographs, taken in San Francisco in 1956, Frank shoots an unsuspecting black couple from behind (fig. 28). Seated alone on the grass in a park overlooking the city, the startled pair turns to acknowledge their intruder. The woman appears annoyed. The man crouches defensively. His eyes are locked on the photographer, his expression hardened into a scowl. As the curator Sarah Greenough rightly suggests, the photograph serves as an allegory of the camera's potential to invade the privacy of others.[42] But the situation it represents is also racially charged. Frank situates the couple in the lower register of the image as if to underscore his towering and aggressive presence. Rather than being a neutral observer, he positions himself as a significant participant—a commanding yet unseen player who serves as a jarring reminder of the ever-watchful, intimidating whiteness that overshadows the lives of black Americans, no matter how tolerant their environment. But Frank does not stop at self-incrimination. The couple's upward, implicating gaze also meets the eyes of the viewer, who now looms over them, too, a surrogate for the absent photographer.

In another image, a tightly cropped shot of a trolley car in New Orleans in 1955, Frank allegorizes the social space of the Jim Crow South, foregrounding the physical and psychic boundaries that inevitably separate its citizens (fig. 29). Moving from front to back, the passengers in the windows of the trolley assume their positions in segregation's social order: enfranchised white adults, then white children, followed by a black man—who looks wearily toward the camera, as if to acknowledge his alienation—and, finally, a black woman. In a photograph of an African American nanny and her ward in Charleston, South Carolina, in 1955, the stark contrast of the infant's chalk-white skin and the woman's dark

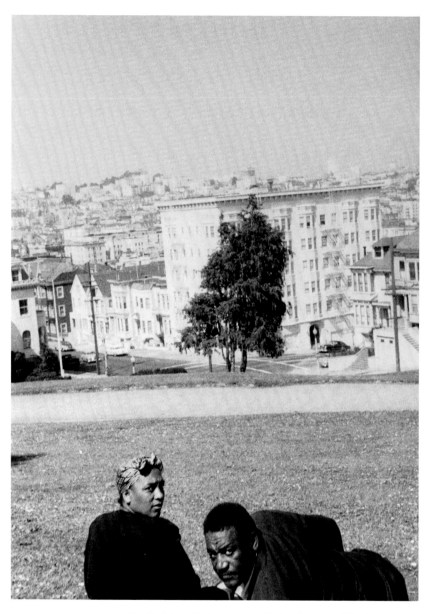

Fig. 28. Robert Frank, *Americans 72, San Francisco,* 1956. Gelatin silver print, 13¾ × 10 in. (34.9 × 25.6 cm).

complexion read as a metaphor of the insurmountable legal gulf between them, despite their physical intimacy—a divergence mandated by laws so absurd that the baby is inherently more empowered than its caretaker.

It may seem unfair to compare the *Harlem Document* with *The Americans,* given their vast generational differences. But as the art historian Jane Livingston suggests, aspects of the Photo League's aesthetic experimentation and political philosophy anticipated the work of New York School photogra-

phers of the 1950s, such as Frank.[43] This observation extends even to the issue of race. In the decade after the Feature Group disbanded, other members of the League—such as Lou Bernstein, Rosalie Gwathmey, Sol Libsohn, and Marion Palfi—continued to engage the issue of African American disenfranchisement. Casting aside the limiting shooting scripts and narrow ideological agenda of their former colleagues, they produced some of the most sensitive and aesthetically sophisticated commentaries about race in America by any white artist of the period (plates 56, 131). Perhaps no member was more successful than Gwathmey, who devoted much of her artistic career to examining racial discrimination and its effects, especially in her native South.[44] Raised in Charlotte, North Carolina, Gwathmey studied painting at the Pennsylvania Academy of the Fine Arts in Philadelphia and the Art Students League in New York, where she specialized in portraiture. She began photographing in 1938 and joined the Photo League in 1942.

The best of Gwathmey's photographs—such as her *Untitled (Sunday Dress),* c. 1945 (plate 132)—went beyond sociological reporting. Here, rather than representing the elderly woman as the personification of a societal category or problem—a "workaday Negro," as Carter would say, poised to illustrate the troubles of the race—Gwathmey renders her as a unique and expressive individual. Reflecting her formal training, Gwathmey produces an image that is an artful and dynamic portrait, a window onto the corporeal and psychic details of the woman's being: the inner life and wisdom that register on her face, the regality of her bearing, and the elegance and immaculateness of her clothing. In her grace and self-possession, she confidently assumes her place in the pantheon of exemplary African Americans envisioned by DuBois.[45]

Gwathmey's *Shout Freedom, Charlotte, North Carolina,* c. 1948 (plate 55), achieves a level of social analysis and formal complexity reminiscent of Frank's trolley-car picture. In the image, a black girl walks past a vacant lot. Plastered on the wall behind her is an advertisement for a local production of

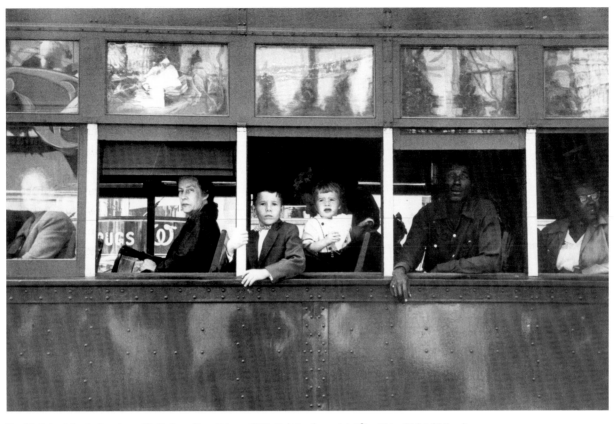

Fig. 29. Robert Frank, Americans 18, *Trolley—New Orleans*, 1955. Gelatin silver print, 8⅝ × 13 in. (21.9 × 33.2 cm).

Shout Freedom, a musical about Charlotte's role in the American Revolution. Its letters dancing triumphantly across the surface of the announcement, the show's title serves as a sardonic commentary on the child's intrinsic lack of freedom. Through cropping and other formal devices—the entire right side of the photograph, for example, is taken up by the edge of a brick wall—the space around the child appears to be closing in on her. She is cornered not only by her crumbling physical environment but also, metaphorically, by the oppression of a South that constricts her every move. Her stilted, tentative steps contrast with the charging revolutionary pictured on the poster—a warrior for liberties that, more than a century and a half later, are still not available to her.

A significant feature common to both photographs is that their subjects face the photographer, implying a direct physical and psychic relationship between the two: the girl's cautious glance at a photographer she presumably does not know, for example, or the old woman's serene acceptance of a process that entrusts her representation to a stranger. By contrast, the images in Siskind's *Harlem Document: Photographs 1932–1940* are notable, as the cultural historian Joseph Entin writes, for "their heaviness of tone, the awkward poses and strained expressions of their human subjects, the contentious glances offered by several individuals [Siskind] captures on film."[46] The annoyed expressions and sidelong looks caught by Siskind's camera, unlike those of Frank's San Francisco couple, are relatively marginal to his photographs. They are more the result of his own lack of self-awareness than a self-conscious desire to explore his role as a racial outsider (fig. 30). Further distancing himself from his subjects, the photographer habitually shoots them from oblique angles and perspectives, excluding the possibility of eye contact or direct psychological connection: in one image an actor in costume is shot from the side in a narrow hallway, his eyes looking up and away (fig. 31); and in another the

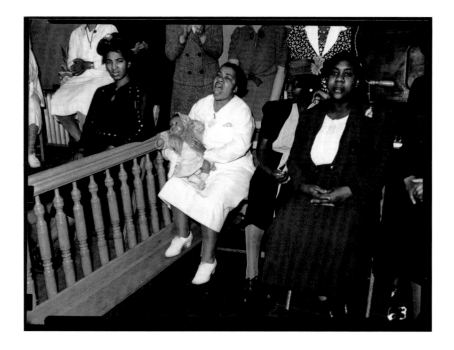

Fig. 30. Aaron Siskind, *Church Singer,* c. 1938, from *Harlem Document,* 1936–40. Negative, gelatin on safety base sheet film, 3½ × 4¾ in. (9 × 12 cm). George Eastman House, International Museum of Photography and Film, Rochester, New York, Gift of Aaron Siskind.

eyes of a child standing in front of a pile of wooden planks are averted (plate 31).

In the book's most troubling photograph—that of a black man apparently asleep in his bedroom—Siskind's lack of psychic connection to his subject is taken to the extreme (fig. 32). The man has no conscious awareness of the photographer. He is passive and defenseless, his body, within the context of the image, assuming the prone, "feminized" pose common to art history, from Titian's *Venus of Urbino* (1538) to Manet's *Olympia* (1863).⁴⁷ The photograph's peculiar interpersonal dynamic renders both Siskind and the viewer complicit in what appears to be an abject violation of privacy. But without any reaction possible from the sleeping man, Siskind's intrusive presence and its broader psychological and social implications remain unchecked and unexamined. This stands in contrast to the fraught and self-conscious exchange set up by Frank in his San Francisco photograph.

The photographer Louis Stettner, in his memoir about the Photo League, observed that the organization's commitment to documenting the social problems of the day should not obscure the fact that the work it produced was inevitably "a subjective interpretation of reality." League images, he concluded, tell us "as much about the photographer as the sub-

ject matter."⁴⁸ In this regard, the *Harlem Document* has much to say about its photographers' lack of insight and self-awareness about race. This is not to say, of course, that the Feature Group did not grapple with the issue of how best to represent a community it did not entirely know. Nor were its members—as Jews, as the children of immigrants, or both—oblivious to the anti-Semitism and xenophobia that constricted their lives and denied them access to society's most powerful institutions.⁴⁹

Ironically, even as the Feature Group rejected the ethos of the New Negro, it struggled with the very notions of self-construction and self-identity that were at the heart of the concept. There is perhaps no greater evidence of this than the fluid and contingent identities of some of its members. In the milieu of the League, for example, Sol Prom was a gifted photographer. But in a parallel life, he was the respected social scientist Solomon Fabricant, who taught economics at New York University. Jack Manning, a student at New York's prestigious Stuyvesant High School when he joined the League, was born Jack Mendelsohn, the son of Romanian Jewish immigrants.

No identity, it turns out, was more amorphous than Michael Carter's. He presented himself to the Feature Group as a "professional sociologist interested in the analysis of the effects of poverty and segregation," and at various times he was said to be, or called himself, a sociologist, a social worker, a scholar, and a writer.⁵⁰ In fact he was neither a sociologist nor a social worker, but a journalist trained at Columbia University. He routinely changed the spelling of his first name, alternately referring to himself, both in public and private situations, as Michael, Mikel, and Mikal.⁵¹ But it was his surname that concealed the greatest secret of all. Carter's real name was Milton Smith. In the years after he left the Feature Group, he wrote for some of the nation's most important African American newspapers, including the *Baltimore Afro-American, Pittsburgh Courier,* and *New York Amsterdam News.* He also worked outside of the Negro press for such publications as *PM,* a New York newspaper; the *Brooklyn Eagle,* at which he covered the African American beat and Harlem; and *Parade,* a popular

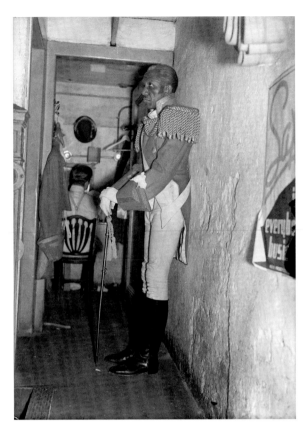

Fig. 31. Aaron Siskind, *Lafayette Theatre Soldier,* c. 1938, from *Harlem Document,* 1936–40. Negative, gelatin on safety base sheet film, 4¾ × 3½ in. (12 × 9 cm). George Eastman House, International Museum of Photography and Film, Rochester, New York, Gift of Aaron Siskind.

syndicated magazine supplement for Sunday newspapers. At the time of his death in 1952 from a cerebral hemorrhage—he was only forty years old—Smith was an associate editor at the Johnson Publishing Company in Chicago, assigned to three of its magazines, *Ebony, Jet,* and *Tan,* the last-named being the first African American magazine for women.[52]

It is possible to speculate that Smith's malleable identity may have damaged his credibility and made him an unlikely candidate—as the *Harlem Document*'s guide to the black community—to encourage the kind of honesty and self-inquiry necessary to elevate the project to more than just an altruistic form of racial tourism. The same, of course, can be said of Prom, Manning, and others who chose, in some way, to complicate their identities. In the end, however, their mutable and contingent conceptions of themselves, especially in Smith's case, may also have served as an act of political resistance. The scholar

Sara Blair suggests that Smith, as a means of survival in a cultural world that rarely gave minorities a chance, may have transformed himself into an authority on the then-popular social sciences in order to gain credibility in, and access to, the liberal institutions of publishing and media.[53] It is clear from Smith's résumé that he was talented and ambitious. He was also only in his early twenties at the time he began work on the *Harlem Document.* He probably saw his relationship with the Feature Group, and the opportunities it provided, as a stepping-stone to a career in journalism and publishing. His array of pseudonyms also suggests another form of defiance: the refusal to be definitively named or categorized and thus stereotyped. That Smith and his Feature Group colleagues did not associate their own struggle with discrimination and self-identity with that of the New Negro is difficult to understand. But the ideological orthodoxy of the Photo League, and their youthful allegiance to it, may have clouded their judgment.[54]

While the original *Harlem Document* was never published, within months after the Feature Group dispersed, a book-length photo-essay about the effect of racism and poverty on the African American

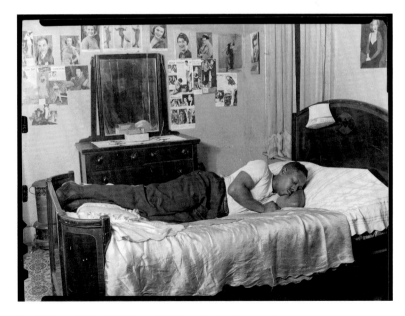

Fig. 32. Aaron Siskind, *Untitled,* c. 1940, from *Harlem Document,* 1936–40. Negative, gelatin on safety base sheet film, 3½ × 4¾ in. (9 × 12 cm). George Eastman House, International Museum of Photography and Film, Rochester, New York, Gift of Aaron Siskind.

community was issued by Viking Press. Titled *12 Million Black Voices,* it juxtaposed text by Richard Wright with photographs from the archives of the FSA. Passionately and powerfully written, the book presented Marxist themes and dour imagery that echoed "244,000 Native Sons," a work that was itself a tribute to Wright. The volume's picture editor, the Photo League member Edwin Rosskam, had originally proposed using the *Harlem Document* images but in the end rejected the idea because the Feature Group insisted that Carter's text accompany them.[55] Ultimately, the publication of *12 Million Black Voices* may have sealed the fate of the *Harlem Document* as much as its own shortcomings did. Wright's book was a literary phenomenon, selling an astounding 300,000 copies in its time.[56] In the context of an insular and discriminatory publishing world, the era's great black photo-essay had arrived, rendering obsolete and redundant the need for another major document about African American life.

NOTES

1. Although some historians suggest that the idea of documenting Harlem was Carter's, the origin of the *Harlem Document* remains unclear. As early as 1932, Siskind actively photographed the neighborhood, later ascribing some of these pictures to the *Harlem Document.* For more on this issue, see Lili Corbus Bezner, "Aaron Siskind: An Interview," *History of Photography* 16, no. 1 (1992): 29; and John Raeburn, *A Staggering Revolution: A Cultural History of Thirties Photography* (Urbana: University of Illinois Press, 2006), 234.

2. Feature Group meeting minutes, September 20, 1939, n.p., Aaron Siskind Archive, Center for Creative Photography, University of Arizona, Tucson.

3. Raeburn, *A Staggering Revolution,* 234.

4. Fiona M. Dejardin, "The Photo League: Left Wing Politics and the Popular Press," *History of Photography* 18, no. 2 (Summer 1994): 164.

5. Feature Group meeting minutes, March 22, 1939, March 29, 1939, September 20, 1939, n.p.

6. The study is referred to as "scientific" in the Feature Group's minutes of March 22, 1939, n.p.

7. This affectation was especially prominent in the late 1930s and early 1940s, the period of the *Harlem Document.* For an extended analysis of the politics of the Photo League and the Feature Group, see Lili Corbus Bezner, *Photography and Politics in America: From the New Deal to the Cold War* (Baltimore: Johns Hopkins University Press, 1999), 16–72.

8. Vicki Goldberg, *The Power of Photography: How Photographs Changed Our Lives* (New York: Abbeville Press, 1991), 61, 34.

9. For a critical assessment of the use of documentary photographs by the FSA and other government agencies of the period, see Maurice Berger, "FSA: The Illiterate Eye," in *How Art Becomes History* (New York: Harper Collins, 1992), 1–22. For more on the photo-documentary strategies of the NAACP, see Berger, *For All the World to See: Visual Culture and the Struggle for Civil Rights* (New Haven: Yale University Press, 2010), 36–57.

10. Michael Carter, "244,000 Native Sons," *Look,* May 21, 1940, 8.

11. "To get this story, *Look* sought out Michael Carter," the magazine writes ("244,000 Native Sons," 8), a "young Negro writer who for the last two years has made a study of Harlem with members of the Photo League." For more on Carter's text for "244,000 Native Sons," including a contemporaneous article about it in the *New York Amsterdam News,* one of Harlem's preeminent newspapers, see "Harlem Pictures Shown in Magazine," *New York Amsterdam News,* May 11, 1940, 11; Sara Blair, *Harlem Crossroads: Black Writers and the Photograph in the Twentieth Century* (Princeton, NJ: Princeton University Press, 2007), 320; Joseph Entin, "Modernist Documentary: Aaron Siskind's *Harlem Document,*" *Yale Journal of Criticism* 12, no. 2 (Fall 1999): 361; and Carl Chiarenza, *Aaron Siskind: Pleasures and Treasures* (Boston: Little, Brown, 1982), 42. For questions about *Look's* editorial input into the article, see Raeburn, *A Staggering Revolution,* 238.

12. Carter, "244,000 Native Sons," 13, 10, 8, 12.

13. Raeburn, *A Staggering Revolution,* 239.

14. Bezner, "Aaron Siskind," 29. Commensurate with Siskind's observation, the Feature Group not only favored imagery that accentuated the plight of African Americans, it also rejected images that lacked disquieting content. Richard Lyon's portrait of James H. Hubert, executive secretary of the New York Urban League, for example, was rebuffed because a shadow obscured a bust on the civil-rights leader's desk of a black man with an agonized expression. "The point of the picture," the group concluded, instructing Lyon to retake it, "was to have been the contrast between the genial, smiling look of Mr. Hubert . . . and the tortured look of the statuette, representing the life of many Negroes" (Feature Group meeting minutes, February 9, 1939, n.p.).

15. Feature Group meeting minutes, February 9, 1939, n.p. The exhibition traveled to five additional venues, including the New School for Social Research (1939), the Photo League (1939), the Blyden Book Shop in Harlem (1940) in a show sponsored by *Look* to commemorate the publication of "244,000 Native Sons," Adam's Pageant of Photography in San Francisco (1940), back to the Photo League (1941), and as part of a joint exhibition that included FSA and other historical photographs, *The Negro in American Life,* at the Fur, Floor, and Shipping Clerks Union, a Congress of Industrial Organizations (CIO) affiliate, in New York.

16. Ibid.

17. Ida Holden, guest book, *Toward a Harlem Document,* Harlem YMCA, as published in *Photo Notes* (April 1939), n.p. In lieu of a review of the YMCA exhibition, *Photo Notes* published a selection of comments from the guest book.

18. B. Bryan, in ibid.

19. E. H. Davis, in ibid.

20. Gordon Parks, "Foreword," in Aaron Siskind, *Harlem Document: Photographs, 1932–1940* (Providence, RI: Matrix, 1981), 5. For more on Siskind's updated version of the *Harlem Document,* see Entin, "Modernist Documentary," 357–82, and Diane Dillon, "Focusing on the Fragment: Asymmetries of Gender, Race, and Class in the Photographs of Aaron Siskind," *Yale University Art Gallery Bulletin* (1990): 53–54.

21. Raeburn, *A Staggering Revolution,* 234.

22. bell hooks, "In Our Glory: Photography and Black Life," in *Picturing Us: African American Identity in Photography,* ed. Deborah Willis (New York: New Press, 1994), 46.

23. Angela Davis, "Underexposed: Photography and Afro-American History," in Valencia Hollins Coar, *A Century of Black Photographers, 1840–1960* (Providence: Museum of Art, Rhode Island School of Design, 1983), 27.

24. A very partial list of photographers includes James Presley Ball (Minneapolis), Florestine Perrault Collins (New Orleans), Andrew T. Kelly (Atlanta), Calvin Littlejohn (Fort Worth, Texas), Paul Poole (Atlanta), Richard S. Roberts (Columbia, South Carolina), Marvin and Morgan Smith (New York), Addison Scurlock (Washington, DC), A. C. Teal (Houston), James VanDerZee (New York), and Ellie Lee Weems (Jacksonville, Florida).

25. W. E. B. DuBois, "A Proposed Negro Journal," unpublished essay (1905), as quoted in Anne Elizabeth Carroll, *Word, Image, and the New Negro: Representation and Identity in the Harlem Renaissance* (Bloomington: Indiana University Press, 2005), 22. DuBois's first magazine, *Moon Illustrated Weekly*, survived for a year; his second, *Horizon: A Journal of the Color Line*, lasted for nearly three.

26. DuBois remained editor of *The Crisis* until 1934, when he resigned from the NAACP, because he was unwilling to advocate racial integration in all aspects of life, a position adopted by the organization.

27. W. E. B. DuBois, "Opinion," *Crisis* 1, no. 1 (November 1910): 7.

28. DuBois's emphasis on photographs and drawings was popular with readers: within a few months of its launch, *The Crisis* announced that it would "increase the number and quality of the illustrations" so as to render it "a pictorial history of the Color Line." In its first decade, subscriptions to the magazine increased tenfold.

29. For more on the interrelationship of these two types of images and stories, see Carroll's perceptive analysis in *Word, Image, and the New Negro*, 15ff. By 1945, with the premiere of *Ebony*, the first of many pictorial magazines marketed exclusively to black readers, this strategy had become commonplace in African American publishing. Other visually oriented publications include *Hue, Sepia, Brown, Our World, The Urbanite*, and the highly influential magazines of the Johnson Publishing Company, which, in addition to *Ebony*, included *Jet, Ebony Jr., Tan*, and *Black Star*. For more on the role of pictorial magazines in the modern civil-rights movement, see Berger, *For All the World to See*, 51–63.

30. Raeburn, *A Staggering Revolution*, 232.

31. "The Negro race, like all races, is going to be saved by its exceptional men," wrote DuBois. "The problem of education, then, among Negroes must first of all deal with the Talented Tenth; it is the problem of developing the Best of this race that they may guide the Mass away from the contamination and death of the Worst, in their own and other races" (DuBois, "The Talented Tenth: The Negro Problem," in Booker T. Washington, et al., *The Negro Problem:*

A Series of Articles by Representative Negroes of To-day [New York: James Pott, 1903], 1).

32. Siskind, as quoted in Bezner, "Aaron Siskind," 29.

33. Michael Carter, *Toward a Harlem Document* (New York: New School for Social Research, 1939), n.p.

34. For more on the concept, see Caroline Goeser, *Picturing the New Negro: Harlem Renaissance Print Culture and the Rise of Modern Black Identity* (Wichita: University Press of Kansas, 2007).

35. Henry Louis Gates, Jr., "Harlem on Our Minds," *Critical Inquiry* 24, no. 1 (Autumn 1997): 10.

36. For more on the inherently categorical, rather than individualistic, slant of American documentary projects of the 1930s, see Maren Stange, "'Symbols of Ideal Life': Technology, Mass Media, and the FSA Photography Project," *Prospects* 11 (1987): 98.

37. For more on the socio-scientific nature of the photo-documentary projects of the 1930s, see Judith L. Goldstein, "The Flaneur, the Street Photographer and Ethnographic Practice," *Contemporary Jewry* 28, no. 1 (December 2008): 123.

38. Carter, "244,000 Native Sons," 8.

39. Bezner, "Aaron Siskind: An Interview," 29.

40. For more on this shift, see Bezner, *Photography and Politics in America*, 37–38; Serge Guilbaut, ed., *Reconstructing Modernism: Art in New York, Paris, and Montreal, 1945–1964* (Cambridge, MA: MIT Press, 1992); and Francis Frascina, ed., *Pollock and After: The Critical Debate* (New York: Harper and Row, 1985).

41. Robert Frank, fellowship application form, John Simon Guggenheim Memorial Foundation, October 1954, n.p.

42. See Sarah Greenough, *Looking In: Robert Frank's The Americans* (Washington, DC: National Gallery of Art, 2009), 130–31.

43. See Jane Livingston, *The New York School: Photographs, 1936–1963* (New York: Stewart, Tabori and Chang, 1992). For more on this issue, see Mason Klein's essay in this volume.

44. "I am particularly interested in photographing the Negro . . . because of the problems that face him—housing, jobs, discrimination," Gwathmey observed at the time. "These are the things I would like to see bettered." See *Rosalie Gwathmey: Photographs from the Forties* (East Hampton, NY: Glenn Horowitz Bookseller, 1994), 5.

45. The image's one significant convergence with Feature Group method is that the woman is unnamed. It remains unclear, of course, whether this omission was by choice or at the request of the sitter.

46. Entin, "Modernist Documentary," 358.

47. Ibid., 362.

48. Louis Stettner, "Cézanne's Apples and the Photo League: A Memoir," *Aperture* 112 (Fall 1988): 32.

49. Ultimately, there is no question that the Feature Group viewed its subject with compassion and empathy. While Jews, as a minority long subjected to discrimination and abuse, often identified with African Americans, the cultural plight of American Jews was not identical to that of African Americans, no matter how strong their mutual affinity. This is especially so, given the extent to which most Jews could claim a provisional whiteness and a provisional relationship to white role models that remained unavailable to blacks. Blair, *Harlem Crossroads*, 19.

50. Carter refers to himself as a "sociologist" in his catalogue essay for the New School. Others in the Feature Group called him a "social worker." *Look* described him as a "scholar," the *New York Amsterdam News* as a "writer." For the multiple iterations of his professional status, see Carter, *Toward a Harlem Document*, n.p.; Carter, "244,000 Native Sons," 8; Bill Chase, "All Ears," *New York Amsterdam News*, May 27, 1939, 21.

51. In a May 11, 1940, blurb on the *Harlem Document*, the *New York Amsterdam News* listed him as Michael; a year earlier, the same newspaper in another mention of the *Document* referred to him as Mikel. In his New School essay, he referred to himself as Mikel; in the two articles he published in *Ebony* in the mid-1940s, his byline was "Michael Carter." See "Harlem Pictures Shown in Magazine," 11; Chase, "All Ears," 21; Carter, "A Day at Home with a Chorus Girl," *Ebony* 1, no. 4 (February 1946): 18; Michael Carter, "Biggest Art Show," *Ebony* 1, no. 9 (August 1946): 23.

52. See Smith's obituary in *Jet*, "The Week's Census," *Jet* 3, no. 2 (November 6, 1952): 56. I thank Susan Wyatt for pointing me to this article, as well as to several early writings by Smith.

53. Blair, *Harlem Crossroads*, 19–20.

54. Smith's politics seem to have been in sync with the hard-left orientation of the early Photo League. Richard Wright, for example, reported that the journalist was "once close to the [Communist] party." See Hazel Rowley, *Richard Wright: The Life and Times* (Chicago: University of Chicago Press, 2001), 301.

55. See Dejardin, "The Photo League," 165.

56. For more on the publishing history of *12 Million Black Voices*, see Blair, *Harlem Crossroads*, 75.

AS GOOD AS THE GUYS

The Women of the Photo League Catherine Evans

On December 4, 1947, Sonia Handelman (later Meyer), a photographer in the Photo League and secretary of the organization, received a telephone call from a *Herald Tribune* reporter, who told her that the United States Department of Justice had just listed the League as a subversive organization. "Heavens to Betsy," she later recalled thinking. "What have we done now?"[1] The next day the *New York Times* ran a front-page story blacklisting ninety organizations named by the United States attorney general, Tom C. Clark (see fig. 55).[2]

Handelman Meyer was one of a large number of women who participated in the Photo League during its fifteen-year existence.[3] Many from this heady period figure prominently in the history of photography as practitioners and were important mentors—Doris Ulman, Dorothea Lange, Margaret Bourke-White, Berenice Abbott, Lisette Model, Consuelo Kanaga, Helen Levitt, Barbara Morgan, Ruth Orkin, and Nancy Newhall, among others—but quite a few remain overlooked. These women merit attention for their intense engagement with the medium, their contribution to the Photo League's success, and their ability to deftly merge incisive content with aesthetic sensibilities.[4] They were a crucial component of the League from its earliest days to its demise.

Women were a visible and vital presence in the League. Between 1938 and 1951 over one hundred participated in League activities, roughly one-third the number of men.[5] Women served in many positions beyond secretary: treasurer, vice president, and president, as well as in other key roles, including

Photo Notes editor, chair of various committees (exhibition, file, membership, parties, publicity, school board), and advisory-board member, and as lecturers, teachers, writers, and critics.[6] Most significantly, the women of the Photo League were prolific and prominent artists working in documentary photography at a time when the arts, criticism, social commentary, and indeed most other professional fields still belonged largely to men.

Since photography's infancy, women have been active and important practitioners of the medium. The Victorian era saw the proliferation of amateur photography clubs that included both men and women and offered opportunities for them to interact socially. As has often been noted, the aftermath of World War I fostered the democratization of gender roles, and women had an increasing presence outside the home. From the 1920s until the advent of the Cold War women were drawn to photography in large numbers. In part this mirrors a general rise in women's visibility during the suffrage and labor movements; for example, women journalists founded the Women's National Press Club in 1919, although the National Press Club did not admit women until 1971. Hollywood's early film industry was also very open to women. The film historian Cari Beauchamp notes that "women were thriving at every level of movie making, as directors, editors, and writers," and that "almost half of all films written between 1912 and 1925 were written by women."[7]

Meanwhile, photography itself was increasingly taught in schools. It was a popular subject at the

Bauhaus in Weimar, Germany; the Institute of Design in Chicago; the Clarence H. White School of Photography (whose founding in New York City in 1914 predated that of the Bauhaus by five years); the New School for Social Research (founded in 1919), where both Berenice Abbott and Lisette Model taught; and the Ethical Culture School.[8] The student population at the German Bauhaus included as many women as men in the 1920s and 1930s, and photography was the second largest field for women.[9] Indeed, all these institutions enrolled many women as students, but only a few had women on the faculty. The Photo League, too, included women to a degree, especially given the involvement of figures like Berenice Abbott and Elizabeth McCausland; over time they came to have a strong presence, holding positions of authority and status. During World War II, while many men were in military service, the women came to the fore. They worked for magazines and newspapers as well as independently; they wrote incisive and influential criticism and reviews; and they taught. When *Life* produced its first issue in 1936, the photograph on the cover was by a woman (see fig. 53). In the pages of *Photo Notes,* the League's own publication, women had a strong voice. Their critical writing helped to establish them as a legitimate professional presence in the field.

The important art critic and curator Elizabeth McCausland was a frequent contributor to *Photo Notes;* in her first article, "Documentary Photography," she emphatically championed the social document over earlier photographic styles and practice: "We have all had a surfeit of 'pretty' pictures, of romantic views of hilltop, seaside, rolling fields, skyscrapers soon askew, picturesque bits of life torn out of their sordid context. It is life that is exciting and important, and life whole and *unretouched.*"[10]

Berenice Abbott's book *Changing New York,* originally intended as a guidebook for the 1939 New York World's Fair, was published as part of an ambitious project to systematically and comprehensively record the city during an era of massive and rapid expansion; McCausland wrote the accompanying

captions.[11] Meanwhile, established photographers such as Dorothea Lange, Lisette Model, Lotte Jacobi, Barbara Morgan, Margaret Bourke-White, Consuelo Kanaga (mentioned in the first known issue of *Photo Notes,* February 1938), and Abbott were giving lectures, participating in symposia, and teaching at the League as early as 1938 (as was McCausland). The less-well-known Lucy Ashjian wrote for *Photo Notes* early on and served as its editor at one time.[12] Nancy Newhall was an influential writer and adviser to her husband, Beaumont, the first curator of the fledgling photography department (founded in 1940) at the Museum of Modern Art. During his three years of military service she was named acting curator.[13] McCausland, Newhall, Ashjian, Marynn Older Ausubel, Jo Chasin, Elizabeth Timberman, Jacquelyn Judge, Grace Mayer, Sandra Weiner, and Rosalie Gwathmey all wrote book and exhibition reviews, as well as essays on current and historical issues affecting the medium. With a roster of impressive women in high-profile roles, it is no wonder that the League was a draw to others.

After the war, in many areas of American culture women shifted back into more domestic roles, leaving the field clear for men returning from the battlefields of Europe and Asia. For example, Nancy Newhall had to relinquish her job to her husband, despite his efforts to create a continuing curatorial role for her. But at the Photo League the membership of women *increased* dramatically: between January 1946 and September 1947, forty-one joined as new members.[14] Despite this notable rise in the number of women photographers in the group, the overall postwar cultural and social scene was not altogether encouraging: the dominant narrative was of an American economic boom driven by heroic returning (male) soldiers and supported by nurturing and domestic wives; this no doubt contributed to the eclipse of many women from the photographic canon. While a few reinvented their photographic careers, many simply disappeared from the medium's history.[15]

The motives for women to join the Photo League were wide-ranging; many praised its pluralism and

inclusiveness. Ann Cooper stated, "I joined the League in 1946, just as soon as I could get my son into nursery school." Erika Klopfer (later Stone) joined for the inexpensive darkroom privileges, saying, "The League inspired me so . . . one day a week I let my husband babysit." Ida Wyman began her photography career at the agency Acme Newspictures, where she was the "first girl mailroom boy"; in fact, she was the first woman to work as a photo printer there. Rebecca Lepkoff noted that very few women with cameras were to be seen on the streets and quipped that "being a woman was a great advantage to me" because she wasn't perceived as a threat. Several recall the ease with which they traversed the city, never worrying about their safety or status as women.[16] At the same time, many members certainly were keenly aware of gender inequities. Klopfer remembers that, although she felt very welcome at the League, it was difficult to compete with men for commercial assignments. "Editors didn't trust women. They didn't think they were technically good enough."[17] Abbott emphatically stated, "Talk about male chauvinism, I never saw it as badly expressed as there."[18]

It is typical of these women—pragmatic professionals all—to recall practical reasons for having joined. But the Photo League represented something more than a cheap darkroom. They found it a congenial place because its focus was on insightful, empathic realism and its politics were reformist. This drew women interested in an approach to photography based not on pure aesthetics or on capturing famous people and grand events, but on engagement with ordinary life—an impassioned, politically aware, and activist engagement. Rosalie Gwathmey, who joined the League in 1942, described this feeling of deep compassion: "I wanted to take pictures of the human condition. I wanted to show how the poor have to live in the squalor that they live in, no money for food or clothes or anything."[19]

Under photography's relatively inclusive and gender-neutral umbrella, addressing human and social ills and expressing fellow feeling for those who suffered seemed the special province of

women—and with the Depression at its height, there was plenty to be documented. In the inner city, the Photo League's particular bailiwick, poor African Americans were frequent subjects. There were none behind the camera at the Photo League, but as Sally Stein has noted, "a surprising number of white women made a heightened consciousness of race integral to their photographic pursuits. . . . Arguably owing to their own experience of gender inequality, women were predisposed to identify with another group subject to deep-seated prejudice."[20] Social documentary photography necessarily features recurring themes of poverty and social malaise, both urban and rural. With Lewis Hine and his groundbreaking photographs of child labor as potent precursors, some of the most memorable photographs made by members of the Photo League, regardless of gender, are of children. Examples by Rosalie Gwathmey, Sandra Weiner, Rae Russel, Marion Palfi, Vivian Cherry (plates 42, 95, 96, 126–28), and others portray their subjects with empathy but without overt sentimentality, as do works by Aaron Siskind, Jack Delano, Jerry Liebling, Sid Grossman, and Arthur Leipzig (plates 38, 57, 58, 93).

If Abbott and Model are among the League's most prominent members—and indeed among the most influential photographers of their time—attention to the lesser lights among the women is long overdue. We may begin that project by briefly surveying the careers of four: Lucy Ashjian, Sonia Handelman Meyer, Vivian Cherry, and Rae Russel. Each of these women was a member during a different time, from the early, formative years to the League's demise. They are of particular interest for the roles they served and for their intense and passionate engagement of the medium. They represent a range of stylistic approaches that reflect the breadth of the League's vision.

Lucy Ashjian

Lucy Ashjian (1907–93) has been all but absent from the history of the Photo League (fig. 33).[21] Her surviving work, including more than two hundred negatives and one hundred twenty vintage prints, was

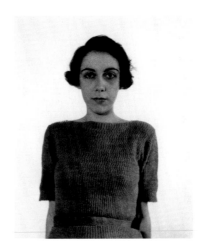

Fig. 33. Lucy Ashjian, *Self-Portrait*, c. 1936. Gelatin silver print, 6½ × 8½ in. (16.5 × 21.6 cm). Center for Creative Photography, University of Arizona, Tucson, Gift of Gregor Ashjian Preston.

discovered in 2003 by her niece, the art historian Christine Tate.[22] Subsequently, Ashjian's considerable contribution to the League and to the history of American photography has begun to unfold. She worked with the *Harlem Document* Feature Group at the League, under Aaron Siskind, creating a number of remarkable photographs. One of these, *Untitled (Group in Front of Ambulance)*, 1936–40 (plate 27), which has often been attributed to Siskind, has now been definitively credited to her, along with a second photograph of the same subject taken the same day (fig. 34).[23]

Ashjian, like many of her contemporaries at the League, was a first-generation American, the daughter of Armenian refugees who settled in Indianapolis. Unlike some of her New York counterparts she attended college, receiving a bachelor's degree in English from Butler University. The limited information that can be gleaned from the school's records shows us an ambitious and accomplished student, active in many extracurricular groups and very much in the mainstream: president of her sorority for four years; member of Scarlet Quill, a women's honorary society, and of a comedy troupe; and a participant on the debate team and the college newspaper.[24] Nothing in this portrait suggests her leftist political interests. In the early 1930s she joined the Communist Party. She no doubt experienced both the optimism and the frustrations of her status as the child of working-class immigrants; with her dark coloring and foreign name she would have been well aware of discrimination, especially in

the Midwest. Perhaps these circumstances were a factor in her politics.[25] Around this time she met Charles Smith Preston, a writer, journalist, and fellow member of the party. When he moved to New York City, she followed. There she pursued photography at the Clarence H. White School of Photography, graduating in June 1937, one of ten women in a class of twenty-eight.[26] She and Preston married that year.

Ashjian joined the Photo League perhaps as early as 1936. We know from the March 1938 issue of *Photo Notes* that she introduced a question-and-answer column into it titled "Advice to the Photo-Lorn." Just a few months later, in May, she was listed as the editor of *Photo Notes* and by December as board chairman of the League's school. In January 1939 she wrote an illuminating history of it: "Giving impetus to the whole idea, of course, has been the great need for classes, which would organize photographic knowledge and present it to the amateur, with an idea content to fill the vacuum in which many young workers are forced to operate." She credited her fellow member Max Drucker for recognizing the need for classes and for offering the first advanced course, which required a yearlong commitment.[27]

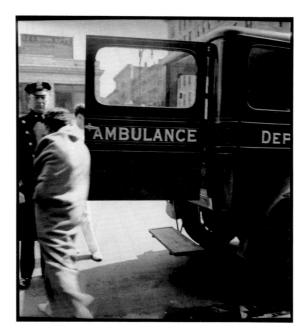

Fig. 34. Lucy Ashjian, *Back of Ambulance*, from *Harlem Document*, 1936–40. Gelatin silver print, 10 × 10½ in. (25.4 × 26.7 cm). Collection of Christine Tate, Wilmington, DE.

In addition to managing the school, she was pursuing her own photography during this time. In February 1939 she took part in the exhibition *Toward a Harlem Document* at the 135th Street YMCA in Harlem. The show was sponsored by the National Urban League and included forty photographs by Aaron Siskind's *Harlem Document* Feature Group.[28] This pivotal, if problematic, exhibition was one of the Photo League's significant early achievements. Ashjian's participation suggests that she drew a profound connection between her art and her politics. Overall her photographs reflect her ideology: her work made visible issues of injustice and oppression within the currency of modernism.

Interestingly, of the eight artists in the show, one other was a woman: Beatrice Kosofsky, of whom almost nothing is known (fig. 35). Eleven of her prints are in the collection of the George Eastman House in Rochester, New York.[29]

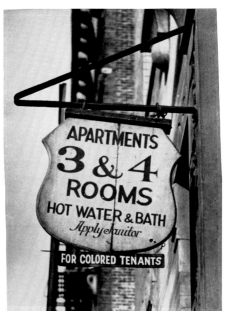

Fig. 35. Beatrice Kosofsky, *Apartment Rental Sign*, c. 1939, from *Harlem Document*, 1936–40. Gelatin silver print, 6¼ × 4½ in. (15.8 × 11.5 cm). George Eastman House, International Museum of Photography and Film, Rochester, New York, Gift of Aaron Siskind.

On May 10, 1940, Ashjian was elected to a six-month term as vice president of the Photo League; on November 29 her term was renewed.[30] Over the course of some six years, she produced a cohesive and compelling body of work, informed by an acute eye and a committed leftist political stance (fig. 36). She successfully mediated the divergent positions within the League between aesthetics and social context. Her images are confident, characterized by an enigmatic stillness and a spare depiction of space. Like her peers Abbott and Bourke-White, she adopted a modernist aesthetic to great effect, engaging dynamic formal elements such as bird's-eye views and muscular lines (plate 28). She was keenly attuned to the eerie street surrealism of Eugène Atget's Parisian documents and, in his manner, cannily used unexpected juxtaposition, framing, and vantage points to create nuanced, sometimes unsettling, pictures.

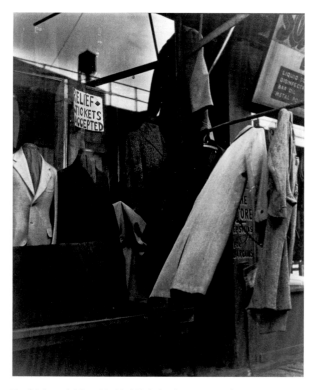

Fig. 36. Lucy Ashjian, *Untitled (Relief Tickets Accepted)*, c. 1939. Gelatin silver print, 9¼ × 7½ in. (23.5 × 19.1 cm). Columbus Museum of Art, Ohio. Photo League Collection, Gift of Gregor Ashjian Preston.

Ashjian last appeared in *Photo Notes* at the end of 1943.[31] Sometime after the birth of her son, Gregor Ashjian Preston, in February 1943, her husband suffered a nervous breakdown requiring hospitalization. The demands of family effectively ended Ashjian's career in photography. The Prestons returned to Indianapolis, and at the end of the 1940s she left the Communist Party. Following the family's departure from New York, Ashjian held a number of jobs, mostly clerical. The family moved to York, Pennsylvania, in 1966 and retired to Davis, California, in 1980.

Sonia Handelman Meyer

Like Ashjian, Handelman Meyer (born 1920) was college educated, graduating in June 1941 with a degree in English as a member of the first class of Queens College, City University of New York (fig. 37). In a weak job market (and just two days before the Japanese attack on Pearl Harbor) she moved to San Juan, Puerto Rico, as a civilian employee of the United

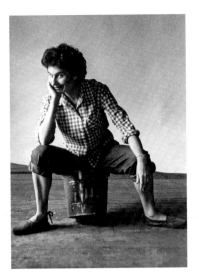

Fig. 37. Sy Kattelson, *Portrait of Sonia Handelman Meyer,* c. 1950. Gelatin silver print, 6 × 7⅝ in. (15.2 × 14.3 cm). Collection of Sonia Handelman Meyer, Charlotte, North Carolina.

States Army Signal Corps. It was there that she learned about the Photo League from Lou Stoumen, who was in San Juan working as a staff photographer and later as director of the National Youth Administration, a branch of the Works Progress Administration.[32] Upon returning to New York she worked in the Office of War Information as a broadcast engineer, sending news in many languages to the European theater.[33]

Wanting to learn photography from the ground up, Handelman Meyer joined the Photo League in late 1943 or early 1944 at about age twenty-three. She took classes and workshops with John Ebstel and Sid Grossman, and her work was well received. Jacob Deschin, then photography editor of the *New York Times* and a fellow member of the League, included her photograph *Park Avenue Market, 125th Street, New York City,* c. 1946, in an article entitled "Best Work of League" (fig. 38).[34] Handelman Meyer produced a distinctive body of work, including a series with Morris Huberland on the progressive Sydenham Hospital in Harlem (1947). Asked in later years about her status as a woman within the group, she said that she had "had no consciousness of being a woman at the Photo League, never felt we were ignored in any way." She cited Bourke-White, Lisette Model, and Berenice Abbott as important mentors, particularly admiring their tenacity and talent. "Helen Levitt, with her lyrical quality, was my greatest influence."[35] In particular, Handelman Meyer's

photographs of children framed within and around doorways echo Levitt's poetic examples.

For many Photo Leaguers, children were a frequent and obvious subject. They were readily accessible in parks and on the stoops and streets of New York City, and they offered opportunities to explore some of the themes dear to the interests of League members: the symbolism of innocence in a rough world, the expression of insouciance and playfulness in unexpected or harsh contexts, and the pathos and anxiety of the vulnerable individual. Handelman Meyer's haunting picture of a masked boy in Harlem, 1945 (plate 99), is an example of the combination of potent imagery and savvy compositional strategies that distinguishes her work—in this case close cropping and a perspective angled from above. The vantage point mimics the relative height of photographer to subject. She printed the image in midtones and cropped it to show only the child's face and shoulders, so that his gaze, directed at the camera, is emphasized and the context is reduced to what appears to be the corner of a room cast in soft shadow. The effect is melancholy and disconcerting, even grim. The boy's eyes, intense and almost accusatory, catch our own. When the photograph is seen uncropped, in its full negative printing (fig. 39), the effect is no less striking but quite different. We see that the boy is sitting outside on a stoop and may guess that he is taking a break from the game of cops and

51

Fig. 38. Jacob Deschin, "Best Work of League: Members Show Pictures Their Own Way," *New York Times,* December 5, 1948, accompanying photograph by Sonia Handelman Meyer.

BEST WORK OF LEAGUE

Members Show Pictures In Their Own Way

By JACOB DESCHIN

"BLEECKER STREET MARKET"

Sonia Handelman's picture from the Photo League's show makes use of abrupt perspective to record an impression.

robbers that so frequently occupied boys. But in the cropped version a lingering sense of unease, provoked by his seriousness and stillness, leads us to wonder further about that mask, and to think of less cheerful possibilities for its presence. In both iterations, the mask takes on a powerful resonance, suggesting a stifling of speech.[36]

When asked about the two versions, Handelman Meyer was cagey, saying, "Maybe I saw the full print as a sweet picture of a boy, a little wary, tying his sneaker. And perhaps when I came in close to him I saw a boy, *very* wary, who had been playing out a cops-and-robbers situation, when along came a white woman taking pictures? Maybe I latched onto that; maybe I just loved that boy up close."[37] At the time, she chose to print only the more intimate cropping.

Women who joined the League during the war years and after were decidedly less political than earlier members and seem to have been driven more by an innate sense of justice and empathy than by a specific ideology. Handelman Meyer's 1946 photograph of an antilynching rally in New York is a case in point: its political context is not visible (plate 125). In late July of that year she attended a large demonstration in New York City and made several photographs. The protest had been prompted by the horrific mass lynching of four African American sharecroppers on July 25 in Walton County, Georgia: George Dorsey, 28; his wife, Mae Murray Dorsey, 23; his sister, Dorothy Dorsey Malcom, 20, seven months pregnant; and her husband, Roger Malcom, 24. Although lynchings had been rampant in the South since the end of the Civil War, they had been somewhat in decline since about 1930 (though hardly rare), and the crime attracted national outrage.[38] Dorsey was a World War II veteran who had served nearly five years in the Pacific. A white mob brutally beat and repeatedly shot the family. No one was ever prosecuted.[39] Handelman Meyer remembers the demonstration as moving and peaceful, and that it most likely took place a few days after the incident, together with many other such protests across the country.[40]

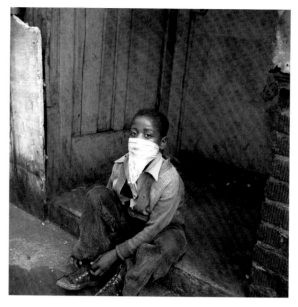

Fig. 39. Sonia Handelman Meyer, *Boy in Mask, Harlem* (full negative), 1945. 2¼ × 2¼ in. (5.7 × 5.7 cm). Collection of Sonia Handelman Meyer, Charlotte, North Carolina.

This, then, is a subject that for Photo League artists of the early years would have been presented in narrative and perhaps polemical terms, in order to convey the details of the event and its political import. But as in *Boy in Mask,* Handelman Meyer chooses a tight cropping and focus on individual faces, excising all incidental information that might identify the location of the three men portrayed or explain what they are doing. Regardless of the space they occupy in the picture plane, all three—the man who covers his face with a hand in grief, a second civilian to his right, who looks directly at the camera, and a policeman, who averts his troubled gaze away from the camera—partake in the narrative in equal measure. Their perspectives of concealment, confrontation, and aversion, together with their bearing, collectively communicate the range of emotions that African Americans would have experienced, especially at such a rally. The officer, whose lapel pin indicates that he is from the 42nd Precinct in the Bronx, might well have been called to midtown Manhattan to quell a potentially riotous and predominantly African American crowd. Instead of standing as a powerful symbol of law and order, his status and local authority appear negligible in the face of the gross racial violence that had been per-

petrated in a distant state. This photograph, then, is as strong as any image of a mass antilynching rally might be, but it delivers its message rhetorically.

Although Handelman Meyer remained active at the League until its demise, by 1950 marriage and family were drawing her attention elsewhere. A steady career in photography was unsustainable, and she, like many of her contemporaries, disappeared from the medium's canon.[41]

Vivian Cherry

Vivian Cherry (born 1920) was an accomplished photographic printer by the time she joined the Photo League in 1946 (fig. 40). Like Rebecca Lepkoff, a fellow Photo League member, she came from a background in dance. A native New Yorker, she graduated from Walton High School in the Bronx in 1938 and then attended the University of Wisconsin in Madison. In 1940 she returned to New York and danced professionally with the Helen Tamiris Group. She worked on Broadway and in nightclubs until a knee injury ended her stage career. Cherry credits her understanding of photographic space to her training as a dancer, comparing the choreography of a stage to the choreography of the street.[42]

Cherry began her second career, in photography, by responding to an advertisement for a contact printer. World War II was under way and she noted that although "darkrooms were the domain of men, [once] men were drafted, printers were needed terribly, so they even trained me, a woman."[43] After a brief return to Broadway in a revival of *Show Boat,* she chose photography over dance, attracted by an art form so closely connected to ordinary life. She quickly immersed herself in the Museum of Modern Art's photography collection, where she was especially drawn to Dorothea Lange's Farm Security Administration photographs, Helen Levitt's unvarnished pictures of children (plate 20), and the work of Lewis Hine (plate 1; see fig. 1).[44] When she realized that her favorites were all connected to the Photo League, she "hightailed it [there]; Sid Grossman gave me a scholarship—a whole $6.00!" Cherry went to

the League nearly every day, augmenting her darkroom skills with Grossman's emphatic lessons in how to see photographically and "in making the camera a part of you."[45] At the same time, she was successfully selling her pictures to popular magazines.

Cherry, like many others at the Photo League, was drawn to children as subjects, especially to their ubiquitous street games. In the days before mass-media entertainment, and when urban streets were not clogged with cars, gardenless inner-city children played stickball and hopscotch, jump rope and tag, and myriad other games in the streets. For example, Helen Levitt caught children dancing in the street (plate 20), and children's street games were a particular focus for Arthur Leipzig (plate 93). But the image of play that Cherry captured is less familiar and far more startling: it is a lynching game, which Cherry happened upon in East Harlem in 1947 (plates 127, 128). As Handelman Meyer's photograph of a 1946 antilynching rally indicates, this heinous act was still all too common and, though it occurred almost entirely in the South, New York children were apparently quite aware of what a lynching was.

Interestingly, as Cherry's photographs show, black and white children played the game together, and, as she recalled, it wasn't always an African American child who played the victim.[46] The set was one component of a larger project: "The Lynching Series was part of a series I did of Violent Games children played in 1947," she later explained, "which included gun games, war games, and fighting, as well as lynching. I used a 2¼ × 2¼-format camera and shot approximately 12 rolls of film for the whole series. A roll consisted of 12 negatives."[47] They have the appearance of being made almost casually, without planning, yet a number of details catch the eye. Here, as in Handelman Meyer's work, most of the street context has been

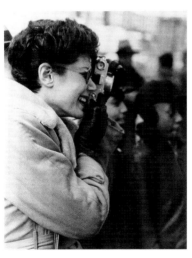

Fig. 40. Vivian Cherry, photographed in 1952 by Bob Henriques.

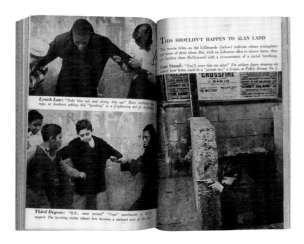

Fig. 41. Vivian Cherry photographs reproduced in *'48: The Magazine of the Year,* May 1948.

cropped out so that we see the children against a wall in what may be an empty lot, strewn with litter and weeds. That it is urban and rough is suggested by the graffiti on the wall, but the scrawled words are indecipherable, so that we cannot know if they have any connection to the game or its players. In *Game of Lynching, East Harlem* (plate 128), the pose of the pretend victim is eerily accurate, mimicking the angled neck and slouching shoulders of a corpse hanging from a tree with a precision that implies that he has perhaps seen real lynching photographs. The cool, journalistic tone of these children's game photographs adds realism to the scene, so that only the captions reassure us that this is not an actual attack.

In May 1948 *The Magazine of the Year,* a short-lived monthly magazine owned and published by leading writers, artists, and photographers, repro-duced a number of Cherry's photographs (fig. 41). Those chosen included *Game of Lynching, East Harlem* (plate 127) in a story headlined "Bang! Bang! I Got-cha! Kids' Games Feature Violence, with Gestures by Hollywood." The photograph bore the caption, "Lynch Law: 'Take him out and string him up!' Even without tree, rope, or Southern setting, this 'lynch-ing' is a frightening act of imitation."[48] Cherry's photographs show how seamlessly contemporary events—in this case, perhaps, the multiple lynch-ings in Walton County—are absorbed into the culture's popular consciousness.

The response to these unnerving pictures must have been positive, because Cherry later submitted the lynching game series to other publishers. It was rejected by the monthly women's magazine *McCall's.* The editor explained that the images were "a little too real for magazine use. We try to identify the reader with the story, try to say to him that this is he and his problem shown in the pictures. I'm a lit-tle afraid he'll refuse to identify himself with the people and backgrounds here, would prefer to see himself a bit idealized. It's different, I think from reporting the goings on of other people, where real-ism is fine."[49] In 1952 *Photography,* less cautious than *McCall's,* finally reproduced the lynching-game pho-tographs in a story called "Game of Guns."[50] Today, these pictures still retain their power to shock.

Cherry's work has received critical attention in recent years, perhaps because she, unlike the majority of women associated with the League, continued her photographic career. At ninety, she continues to photograph on the streets of New York City.[51]

Rae Russel

Rae Russel (1925–2008), one of the later members of the Photo League, was born Rae Schlussel in Brooklyn. As a young woman she changed her name (fig. 42).[52] By the time the twenty-two-year-old Rus-sel joined the Photo League in 1947 she had already held a number of photography jobs. She had worked as a darkroom technician at Weiman and Lester, a photo processing house in Manhattan, and as a printer at the Pix photo agency, which counted the magazines *Life, This Week,* and *Collier's* among its cli-ents; there she was soon promoted to photographer. To supplement her income she made portraits of children on weekends, as did Erika Klopfer Stone, and then began to freelance as a photojournalist. She joined the agency Scope Associates and the American Society of Magazine Photographers (ASMP). ASMP was founded in 1944 but, as Naomi Rosenblum points out, "Only a handful of women had belonged to the organization during its first two decades."[53]

Russel heard of the Photo League through word of mouth and joined during a flurry of new memberships at what turned out to be the last phase of the organization's life. At the League she studied with Sid Grossman, and her work was included in two of its exhibitions.[54] *Young Boy and Fire Hydrant*, 1947 (plate 96) is Russel at her best: a portrait of a child that captures his sweetness and melancholy, with no sense of stilted formality or archness. Her technical skill as a printer is visible here as well: the work's tonalities are modulated and the background, with its softened focus, is carefully calibrated so that the advertisements behind the boy do not dominate the scene; they remain just on the edge of legibility, allowing us to draw our own connections between the protagonist, with his downcast eyes and casual pose, and the commercialized image of a white baby behind him. Like many of the later members of the League, Russel was less directly political in her work, allowing the facts of her vernacular photography to speak for themselves. League photographers have been all too easily pigeonholed as mere social documentarians; this little-known work reminds us that in the hands of these artists there is nothing "mere" about social documentary. The women of the Photo League had to contend not only with the dismissive criticisms, but also with the common assumption that their work was less professional than that of the men. Russel knew better. "I know I'm a good photographer," she commented in her diary, "as least as good as one of the guys who are taking pictures."[55]

Russel had successfully established herself as a freelance photographer before joining the League and had continued selling work to magazines during and after her time there.[56] In 1953, two years after the League folded, she made the series *Eviction Family*, which documented a young mother's plight as she and her five children were being evicted from their cold-water tenement (figs. 43–45). At the time, Russel was taking photographs of the Henry Street Settlement, a homeless shelter, service organization, and arts complex on the Lower East Side of Manhattan, for a possible book project.[57]

Although these three images were not pub-

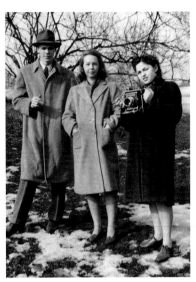

lished, they clearly draw upon the principles of the Photo League artists as well as the photographic vocabulary established by W. Eugene Smith's photo-essays for *Life,* made between 1938 and 1955. When he applied for the job Smith said his work was best expressed as "photo-stories." He elaborated on this later: "I think that two pictures, three pictures, four pictures can say things that the single picture, full page, full bleed, cannot. . . . And two pictures with their two separate thoughts can cause another quite different thing to happen, quite off the page, in the mind of the beholder."[58] Likewise, Russel's series tells its story not through time-based narrative but through interconnected, individual captured moments. The tone is sympathetic but not overly rhetorical or excited. The presence of the photographer is not hidden, but is understood to be part of the scene.[59]

The images were meant to be seen as a set, but just as Dorothea Lange's iconic *Migrant Mother* has been separated from the group of images Lange made on one day in 1936—and subsequently canonized— Russel's picture of the daughter alone (see fig. 45) has been presented in isolation. In fact, it is the only photograph of the three that has been reproduced.[60] Viewed together, they offer a more complete context to depict the harrowing day.

In the 1950s and 1960s Russel raised a family and in 1969 moved from New York City to suburban Westchester County, and later to Petaluma, California. In later decades she photographed Delaware and Seminole Native Americans, making an extended portrait of disappearing indigenous cultures. She taught photography for many years and exhibited in galleries until her death.

One woman in the Photo League has left a less than illustrious legacy. Angela Calomiris (1916–95) joined

Fig. 42. Rae Russel with two unidentified friends in 1943.

Fig. 43. Rae Russel, *Eviction Family, New York*, 1953. Gelatin silver print, 8⅝ × 11⅜ in. (21.9 × 28.9 cm). Columbus Museum of Art, Ohio, Museum Purchase, Derby Fund.

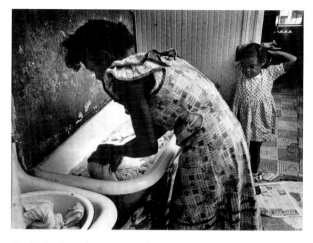

Fig. 44. Rae Russel, *Eviction Family, New York*, 1953. Gelatin silver print, 9½ × 13 in. (24.1 × 33 cm). Columbus Museum of Art, Ohio, Museum Purchase, Derby Fund.

the League in 1942, collaborated with the Federal Bureau of Investigation (FBI) to label it a subversive organization, and testified in an infamous 1949 trial of accused Communists, where she denounced Sid Grossman, decisively ending his career and the League's existence.[61]

Born on New York's Lower East Side to Greek immigrants, Calomiris became a professional photographer after some years of study at Brooklyn College and the City University of New York.[62] Though a thorough analysis of her work has yet to appear, she is generally not considered to be on a par with the League's most talented members, and few of them remembered her as a presence there.[63] Nevertheless, she pursued photography; indeed, the money she earned as an FBI informant permitted her to open a studio of her own, where, according to the *New York Times,* she specialized in animal pictures.[64]

In the years following the end of World War II, the United States was all too eager to embrace the Cold War hysteria of McCarthyism. It seems likely that in acting as a secret informant Calomiris was an opportunist rather than an ideologue: she infiltrated not only the Photo League but also other leftist groups targeted by the FBI, and there is some evidence that she did so largely for the substantial money she was paid.[65] Later, she wrote a rather self-aggrandizing autobiography, which became a best seller (fig. 46). Her career as a photographer did not

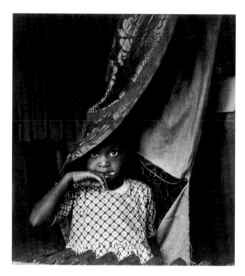

Fig. 45. Rae Russel, *Eviction Family, New York*, 1953. Gelatin silver print, 11¼ × 10⅜ in. (28.6 × 26.4 cm). Columbus Museum of Art, Ohio, Museum Purchase, Derby Fund.

flourish, and in the 1960s she owned a bed-and-breakfast inn in Provincetown, Massachusetts. As a photographer her contribution is negligible, but there is no question that she assisted materially in bringing to an end a thrilling and immensely fruitful era in which women photographers thrived (fig. 47).

Thanks to the efforts of contemporary scholars, as well as the recollections and records of the photographers themselves, a clearer, more inclusive picture of the women who participated in the League has slowly been emerging. Of tremendous importance in completing this work are the historical texts produced by women who wrote about the

Photo League as members and critics: Elizabeth McCausland, Nancy Newhall, Berenice Abbott, and Rosalie Gwathmey, among others. Their voices—perspectives, opinions, and approaches to criticism—are a valuable element of the story.

The women photographers were not as numerous as the men, but their numbers and the quality of their production were nevertheless remarkable, given the times. Working women in the first half of

Fig. 46. Angela Calomiris's autobiography, *Red Masquerade*, 1950.

the twentieth century did not enjoy the same economic and social freedoms as men, and those with families had far less leisure time. For the most part, women photographers were in their late teens and early twenties when they came to the League. Some were well educated; most came from impoverished back-

grounds. They may not have seen themselves as protofeminists—the vocabulary was not yet in place—but they seized roles in the slowly emerging universe of opportunities.

Photography seems to have been a medium peculiarly welcoming of women—perhaps because it was itself new and not burdened with centuries of tradition. The League inevitably reflected the gender biases of the period: it encouraged women but did not entirely support them. After its demise some continued in professional careers in the medium and some did not; some made it into the canon while some disappeared. The reasons for these varying tales of success and obscurity are, of course, myriad and complex, and offer a rich subject for further research and exploration. The legacy of these women endures.

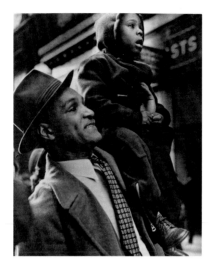

Fig. 47. Angela Calomiris, *Father and Son*, c. 1940. Gelatin silver print, 13⅜ × 10⅝ in. (34 × 27 cm). The Jewish Museum, New York, Gift of Howard Greenberg.

NOTES

1. Sonia Handelman Meyer, presentation at Association of International Photography Art Dealers, March 21, 2010. Handelman married Jerome Meyer in 1950.

2. Lewis Wood, "90 Groups, Schools Named on US List as Being Disloyal," *New York Times*, December 5, 1947, 1.

3. As secretary of the Photo League, Handelman was its only paid employee. Other women mentioned as serving in this role in *Photo Notes*, the League's monthly newsletter, include Mrs. Benjamin Mandel (1938), Sally Cunningham (1940), Angela Calomiris (1942), Jane Wegner (1945), Bea Pancoast (1946), Elizabeth Timberman (1947), and Yvette Neufeld (1948).

4. Lili Corbus Bezner and Bruce Lineker, *Women of the Photo League*, exh. cat. (Charlotte, NC: Light Factory, 1998). The following women are identified in *Photo Notes* as having been associated with the League: Berenice Abbott, Ida Abelman, Cora Alsberg, Lucy Ashjian, Marynn Older Ausubel, Ruth Bernhard, Zena Borod, Margaret Bourke-White, Henrietta Brackman, Evelyn Branson, Nancy Bulkeley, Angela Calomiris, Helen Caplan, Jo Chasin, Vivian

Cherry, Amy Clampitt, Ann Cooper, Cornelia Cotton, Ruth Crystal, Sally Cunningham, Phyllis Dearborn (Massar), Adele Diamond, Janet Dublon, Jeanne Friedberg Ebstel, Miriam Eichelman, Ruth Eligman, Florence Exler, Grace Fein, Regina Fisher, Eleanor Goldstein, Mary Nelle Griffith, Rosalie Gwathmey, Amelia Harris, Katherine Hauseman, Wynna Helm, Marian Hess, Marion Hille, Margaret Horwath, Harriet Houloose, Eunice Jackson, Cherry Jeronimo, Ruth Joseph, Jacquelyn Judge, Consuelo Kanaga, Ellen Kaufman, Louise Kleinman, Delores Ann Knapp, Roslyn Koslow, Beatrice Kosofsky, Dorothea Lange, Gabriella Langendorf, Rita Leisten, Rebecca Lepkoff, Vera Lester, Helen Levitt, June Linder, Mavis Lyons, Mrs. Benjamin Mandel, Estelle Marks, Josephine Marks, Edna Marshall, Thelma Martin, Elizabeth McCausland, Louise McDonald, Sonia Handelman Meyer, Lisette Model, Barbara Morgan, Marjorie Mortrude, Lida Moser, Yvette Neufeld, Nancy Newhall, Yolla Niclas, Ruth Orkin, Marion Palfi, Nancy Palmer, Bea Pancoast, Betty Popken, Clara Port, Jane Rabinowitz, Elizabeth Rosenthal, Louise Rosskam, Rae Russel, Helen Salomon, Ruth Schwartz, Berenice Seigmeister, Ann Zane Shanks, Phyllis

Shapiro, Lee Sievan, Rebecca Snyder, Adelaide Solomon, Erika Klopfer Stone, Maryland Stuart, Betty Swanton, Gizelle Szabo, Elizabeth Timberman, Beryl Toder, Doris Ulman, Peggy Vaughn, Hattie Wade, Gloria Nandin Watts, Jane Wegner, Sandra Weiner, Marcy Weissman, Katherine Ann White, Joan Whitney, Wilma Wilcox, and Ida Wyman; see *Photo Notes (February 1938–Spring 1950)* and *Filmfront (December 1934–March 1935)*, repr. in Nathan Lyons, ed., *Photo Notes, February 1938–Spring 1950* (Rochester, NY: Visual Studies Workshop, 1977).

5. The precise number of Photo League members is impossible to determine, as *Photo Notes* did not always indicate status and not everyone who participated was necessarily recorded. There has been some disagreement on the number and importance of women in the group, notably between the League photographers Morris Engel and Walter Rosenblum; see Anne W. Tucker, "The Photo League: A Center for Documentary Photography," in *This Was the Photo League: Compassion and the Camera from the Depression to the Cold War* (Chicago: Stephen Daiter Gallery, and Houston: John Cleary Gallery, 2001), 12.

6. Bezner and Lineker, *Women of the Photo League,* 12–13. In 1943 Marion Hille, wife of the League photographer Sid Grossman, served as president. Many of the men were away at war.

7. Cari Beauchamp, "Historical Directors and Women Behind the Camera," www.moviesby women.com/article_001_historical_directors. php, accessed January 11, 2011. For figures on women in journalism, see Library of Congress, *Women Come to the Front: Journalists, Photographers and Broadcasters of World War II* (Ann Arbor: University of Michigan, 1995).

8. The Institute of Design was founded in 1937 as the New Bauhaus; see Elizabeth Siegel and David Travis, eds., *Taken by Design: Photographs from the Institute of Design, 1937–1971* (Chicago: Art Institute of Chicago, 2002); the Clarence H. White School, the first in America to teach photography as an art, closed in 1942.

9. Leah Dickerman, "Bauhaus Fundaments," and Adrian Sudhalter, "14 Years Bauhaus: A Chronicle," in *Bauhaus 1919–1933: Workshops for Modernity,* ed. Barry Bergdoll and Leah Dickerman (New York: Museum of Modern Art, 2009), 15, 323–37; Ulrike Muller, *Bauhaus Women: Art, Handicraft, Design* (Paris: Flammarion, 2009), 11.

10. *Photo Notes* (January 1939), 6–9 (emphasis in original).

11. Bonnie Yochelson, *Berenice Abbott: Changing New York* (New York: New Press and Museum of the City of New York, 1997), 9.

12. *Photo Notes,* (March 1938), 3; (April 1938), 3; (October 1938), 1; (December 1938), 4.

13. Sally Stein, "Women and Photography Between Feminism's 'Waves,'" in *Modern Women: Women Artists at the Museum of Modern Art,* ed. Cornelia H. Butler and Alexandra Schwartz (New York: Museum of Modern Art, 2010), 195; Nancy Newhall was paid half of Beaumont's salary.

14. And sixty men; as listed in *Photo Notes.* According to one source, in 1947 Photo League membership hit its peak at two hundred; see Lili Corbus Bezner, *Photography and Politics in America: From the New Deal into the Cold War* (Baltimore: Johns Hopkins University Press, 1999), 39. This huge increase in membership preceded the League's listing as a subversive organization in December 1947. After the August–September 1947 issue of *Photo Notes,* no new members were specifically listed.

15. For example, in the standard art-history survey textbooks of the time very few women photographers—or indeed women artists of any kind—were represented. The first editions of H. W. Janson's *History of Art* (1962) and H. H. Arnason's *History of Modern Art* (1968) had works by zero and twenty-three women, respectively. Beaumont Newhall's *Photography: A Short Critical History* (1937) included fewer than ten women, and the landmark 1955

Museum of Modern Art exhibition *The Family of Man* contained works by two hundred and seventy-three photographers, of whom about forty were women—a respectable but not spectacular number. Helmut Gernsheim's *Concise History of Photography* (1965) included eight women, while in John Szarkowski's *Photography Until Now* (1989) only fifteen of the one hundred and eighty-three named photographers in the exhibition checklist were women. For an excellent overview of this issue and more statistics, see Naomi Rosenblum, *A History of Women Photographers* (New York: Abbeville, 1994), 7–10.

16. Letter, Ann Cooper to Anne W. Tucker, November 15, 1976, Anne W. Tucker archive, Houston, Texas; recollection of Ida Wyman at Association of International Photography Art Dealers presentation, March 21, 2010; Claire Cass, "Bibliographies," in Tucker, *This Was the Photo League,* 175; Sonia Handelman Meyer, Vivian Cherry, Erika Klopfer Stone, and Rebecca Lepkoff in filmed interviews with the author and Mason Klein, March 19–20, 2010, Columbus Museum of Art archive.

17. Recollection of Erika Klopfer Stone, filmed interview with the author, March 19, 2010, Columbus Museum of Art archive.

18. Berenice Abbott, transcript of 1975 interview by James McQuaid and David Tait for the Oral History Project of the International Museum of Photography at the George Eastman House, George Eastman House archive, Rochester, NY, c. 1978, 433.

19. Erika Duncan, "Encounters: 'I Just Quit,' Rosalie Gwathmey Said. And She Walked Away," *New York Times,* September 4, 1994, posted online at www.nytimescom/1994/09/04/nyregion/encounters-i-just-quit-rosalie-gwathmey-said-and-she-walked-away.html, accessed December 12, 2010.

20. Sally Stein, "Women and Photography Between Feminism's 'Waves,'" 204.

21. The meager literature on Ashjian includes a photograph by her reproduced in *Ovo* 10, no. 40/41 (1981): 49, with her name misspelled as Lucy "Ashjean." Her work was included in *Photographic Crossroads: The Photo League,* a 1978 exhibition co-organized by the Visual Studies Workshop, Rochester, New York, and Anne W. Tucker and that opened at the National Gallery of Canada, Toronto, and then traveled extensively throughout the United States.

22. Tate is a professor of the history of photography at Delaware College of Art and Design, Wilmington; my thanks to her for generously sharing her research on Ashjian.

23. Its attribution has shifted from time to time. A print of the image was included in a donation of Photo League material by Siskind in 1973 to the George Eastman House,

where it is identified as Ashjian's. It was exhibited under her name in *Photographic Crossroads* in 1978 and first published in William S. Johnson, Mark Rice, and Carla Williams, *1000 Photo Icons of the George Eastman House Collection,* ed. Therese Mulligan and David Wooters (Los Angeles: Taschen, 2000), and again in *The George Eastman House Collection: A History of Photography from 1839 to the Present* (Los Angeles: Taschen, 2005), 608. In 2003 Tate confirmed the attribution from Ashjian's negatives for both photographs.

24. Sally Childs-Helton, Special Collections/Rare Books librarian, Butler University Libraries, Indianapolis, correspondence with Christine Tate, February 25, 2004.

25. Christine Tate, correspondence with the author, January 9, 2011.

26. Photograph of graduating class, Lucy Ashjian Estate papers, Wilmington, Delaware.

27. *Photo Notes* (March 1938), 3; (May 1938), 2; (December 1938), 3; (January 1939), 3.

28. Ibid. (February 1939), 1.

29. Kosofsky, who appeared three times in *Photo Notes* (October 1938, 2; February 1939, 1; February 1940, 2), was mentioned as one of several photographers whose work was published in the October 1938 issue of *Fight,* a publication of the American League for Peace and Democracy, and again when her work was included in an exhibition at the American Artists' Congress, an organization of the U.S. Communist Party; *Photo Notes* (October 1938), 2; (February 1940), 2. A third woman, Vera Lester, was listed as having been admitted to the Feature Group as a field assistant, but her status with the League remains unclear; *Photo Notes* (April 1939), 1.

30. *Photo Notes* (December 1940), 1; (January 1941), 1.

31. Ibid., (December 1943), 1.

32. Cass, "Bibliographies," in *This Was the Photo League,* 72.

33. Handelman Meyer, e-mail correspondence with the author, December 6, 2010.

34. Jacob Deschin, "Best Work of League: Members Show Pictures in Their Own Way," *New York Times,* December 5, 1948, X21; the photograph's caption is incorrect, according to Handelman Meyer, e-mail correspondence with the author, December 15, 2010.

35. Filmed interview with the author and Mason Klein, March 20, 2010, Columbus Museum of Art archive.

36. Asked about the possible politics of the image, Handelman Meyer responded simply that she had been photographing in Harlem because a friend who lived there let her use her darkroom: filmed interview with the author, March 20, 2010, Columbus Museum of Art archive.

37. Handelman Meyer, e-mail correspondence with the author, November 29, 2010.

38. "Across the South, someone was hanged or burned alive every four days between 1889 and 1929, according to the 1933 book *The Tragedy of Lynching*" (Isabelle Wilkerson, *The Warmth of Other Suns: The Epic Story of America's Great Migration* [New York: Random House, 2010], 39, citing Arthur F. Raper, *The Tragedy of Lynching* [Chapel Hill, NC: University of North Carolina Press, 1933], 36).

39. Kathy Lohr, "FBI Re-Examines 1946 Lynching Case," radio broadcast, National Public Radio, July 25, 2006; Doug Gross, "New Evidence Collected in 1946 Lynching Case," CNN broadcast, July 1, 2008.

40. Handelman Meyer, e-mail correspondence with the author, November 29, 2010. In fact, two rallies took place in New York on July 30, after another man, Leon McTatie, was lynched in Florida; one, in midtown Manhattan at Madison Square Park, attracted five thousand participants; the other, in Harlem, was "the largest mass meeting held [there] in a decade"; see Laura Wexler, *Fire in a Canebrake: The Last Mass Lynching in America* (New York: Scribner, 2003), 113–14.

41. Through the efforts of the Photo League historian Lili Corbus Bezner and the gallerists Carolyn DeMerritt, Christie Taylor, Kim Bourus, and Howard Greenberg, Handelman Meyer's work is now receiving much-deserved attention. In 2007 Bezner, DeMerritt, and Taylor organized *Into the Light: Sonia Handelman Meyer, The Photo League Years,* an exhibition and catalogue at the Hodges Taylor Gallery in Charlotte, North Carolina. Bourus's exhibition at her New York gallery, Higher Pictures—*The Women of the Photo League* (March 19–May 5, 2009)—included Handelman Meyer, along with twenty-five other women.

42. Lepkoff was a member of the Experimental Dance Group in the 1930s; filmed interview with the author and Mason Klein, March 20, 2010, Columbus Museum of Art archive.

43. Filmed interview with the author, March 19, 2010, Columbus Museum of Art archive.

44. For further discussion of this see Mason Klein's essay in this volume.

45. Filmed interview with the author and Mason Klein, March 19, 2010, Columbus Museum of Art archive.

46. Ibid.

47. Cherry, e-mail correspondence with the author, January 11, 2011.

48. *'48: The Magazine of the Year* (May 1948): 95–99. The magazine was published between 1947 and 1948; it folded after sixteen issues.

49. Walter Adams, associate editor, *McCall's,* letter to Vivian Cherry, November 8, 1950, Vivian Cherry papers. Though it rings oddly to our ears, he uses the masculine pronoun and possessive exclusively—standard English at the time—despite the fact that *McCall's* was the epitome of a women's magazine.

50. Arthur A. Goldsmith, Jr., "Game of Guns: The Camera Teams Up with Sociology in Vivian Cherry's Vivid Picture Story of Violence in Children's Play," *Photography* (July 1952): 66–69.

51. While photographing at an anti–Iraq War protest in 2002, Cherry was trampled by demonstrators and broke her hip, wrist, and ribs. Incapacitated temporarily, she began writing about her life as a photographer. She continues to write and has resumed making photographs.

52. Jack Gescheidt, Russel's son, conversation with the author, December 11, 2010.

53. Rosenblum, *A History of Women Photographers,* 234. The ASMP (now the American Society of Media Photographers), was and is an important agency for photographers. As *Photo Notes* pointed out (November 1947, 8), it had its own problems with women: "Big fuss at the Society for Magazine Photographers: benefits for women fotogs in their group insurance plan were to be half as much as for the men, although the premium rates are equal. The males, wishing to play cavaliers, offered to share an increased premium so that the benefits would be equal. The offer was spurned by the fair sex who wanted equal benefits without any increase. The insurance agent neglected to explain that the insurance firms say that women are ill twice as many times as men."

54. *Three Members Show* (January–February 1948); *This Is the Photo League* (1948–49).

55. Rae Russel, unpublished diary, January 30, 1950, in possession of Andrew Gescheidt (Russel's son), San Francisco, CA.

56. In her diary entry of August 25, 1948, Russel indicates that she has secured her first assignment from *Life:* "Tonite Daniel called and said I'd an assignment for *Life.* This will be my first. That has been one of my leading ambitions for a long, long time." On the verso of figure 44 there is a stamp for Scope Associates, indicating that Russel continued her relationship with the picture agency into the 1950s.

57. Rae Russel website http://raerussel.shutterfly.com, accessed December 12, 2010.

58. Jim Hughes, *W. Eugene Smith, Shadow and Substance: The Life and Work of an American Photographer* (New York: McGraw-Hill, 1989), 52 n. 18; 281–82 n. 25. The remark is from around 1968.

59. In a review of an exhibition of Russel's work (shown with photographs by Jerry Liebling and Bill Cotton), John Ebstel commented on her approach: "Rae Russell's [sic] pictures of children at a nursery school rely a great deal on the photo-story principle of each picture supporting the next for narrative effect, rather than a unified and complete statement of a truly visual nature" (*Photo Notes* [March 1948], 12–13).

60. *Photographing Children,* Life Library of Photography series (New York: Time-Life Books, 1971), 164. Russel is identified by her married name, Rae Russel Gescheidt.

61. The eleven accused all were convicted and jailed. See Lisa E. Davis, "Undercover Girl—The FBI's Lesbian: A Note on Resources," in *CLAGS News* (Center for Lesbian and Gay Studies, Graduate Center, City University of New York) 13, no. 2 (Summer 2003): 8–10; and "The FBI's Lesbian, Eleanor Roosevelt, and Other Tales from the Red Scare," in *Rethinking Marxism* 21, no. 4 (October 2009); Fiona Dejardin, *The Photo League: Aesthetics, Politics, and the Cold War* (Ph.D. diss., University of Delaware, 1993). Many thanks to Davis for generously sharing her thoughts and sources for her ongoing research in preparation for a book on Calomiris.

62. HerstoryArchives in Brooklyn, New York, houses Calomiris's papers.

63. Davis calls her photographs unremarkable and maintains that their sole purpose was to help the FBI identify people at Communist Party demonstrations and other leftist gatherings (Lisa Davis, e-mail correspondence and telephone conversations with the author, December 13, 2010–January 5, 2011; see also Lili Corbus Bezner, *Photography and Politics in America,* 62, 243 n. 82).

64. Russell Porter, "Girl Aide of FBI Testifies of 7 Years as Communist," *New York Times,* April 27, 1949, 1.

65. According to Davis, Calomiris's FBI file shows that she was paid "$25 per week, with periodic raises to $30 and $40, then $180, $190, and $225 per month throughout the trial and beyond. At the outset, her FBI salary immediately doubled her income, allowing her to open her own studio and dedicate herself full time to photography. On the witness stand, she lied about the salary and claimed she had only been reimbursed for expenses (see Davis, "Undercover Girl," 624–25). In interviews, Arthur Leipzig and Sonia Handelman Meyer both suggested that the FBI may have coerced Calomiris to act as an informant. Leipzig noted, "My feeling is that she was caught in a compromising situation. She was a lesbian. The FBI put pressure on her." Handelman Meyer recalled, "The story is that she was a lesbian and that the FBI was after her for that" (see Arthur Leipzig, filmed interview with the author and Mason Klein, March 18, 2010, and Handelman Meyer, filmed interview with the author and Mason Klein, March 20, 2010, Columbus Museum of Art archive).

PAPER WORLD

Michael Lesy

The members of the Photo League were born into a world of printed words and printed images, a book and newspaper and magazine world ruled by publishers. Before World War I, editors in command of the biggest American magazines and the largest-circulation dailies lived like princes of the Fourth Estate.[1] Well-known authors who wrote articles for the largest magazines were treated—and paid—like celebrities; fashionable illustrators earned fees for a series of two-page spreads that equaled the annual average income of a factory worker.

The events of World War I, the drama of its news photographs, and the precise way such photographs were mechanically reproduced changed how the real world appeared in print. By the 1920s, newsstands, papered with smiles and headlines and pretty girls, beckoned from the street corners of every big city (fig. 48).[2]

As League members grew into adolescence, silent movies turned into talkies and families gathered around their radios, but the paper world—in the form of inexpensive illustrated magazines and tabloids thick with photographs—still prevailed.

Antecedents

In Europe, the venerated illustrated weeklies that before the Great War had published dense amalgams of engravings, lithographs, halftone photographs, and images derived from photographs were supplanted by news and entertainment weeklies, illustrated almost entirely with photographs. In Germany, Stefan Lorant, the brilliant émigré editor of the *Münchener Illustrierte Presse (Munich Illustrated Press),* began to lay out photo-essays that narrated events in cinematic ways.[3]

In Paris in 1928 Lucien Vogel launched the most innovative and iconoclastic of all European illustrated weeklies—the magazine *Vu*.[4] Week after week, over the course of six hundred issues, *Vu's* editors and designers laid out articles that integrated words and images to form gestalts of information, every article's content meshed with its design.

The political and ideological counterpoint to what Lorant and Vogel were doing commercially was the German Communist weekly *AIZ,* an acronym for *Arbeiter Illustrierte Zeitung (Worker's Illustrated Newspaper).* By 1928, *AIZ* had a circulation of four hundred and fifty thousand and a readership of one million. John Heartfield produced collages for its front and back covers; George Grosz and Käthe Kollwitz illustrated its articles; George Bernard Shaw and Maxim Gorky wrote for it. Documentary photographs—particularly photographs made by German workers beset by layoffs and inflation—filled its pages.

AIZ grew out of the efforts of a German Communist Party organizer (and later *Reichstag* delegate) named William Münzenberg. In 1921, Münzenberg founded an international aid organization (its acronym, IAH, stood for *Internationale Arbeithilfe*) to send famine relief to Russia. To advertise these relief efforts—and to publicize Soviet Russia itself—he also started an illustrated monthly called *Soviet Russia in Pictures.* He believed that Germany's big illustrated weeklies were biased in their reporting on the Rus-

Münzenberg's solution was to do two things at once—in March 1926 AIZ announced a photo contest for its readers: "Pictures of the proletariat are unknown and not produced, since their dissemination does not correspond to the interest of the capitalist/employer."[6] At the same time, Münzenberg—with the help of Communist Party organizers in Hamburg—founded the first of what became a national network of workers' camera clubs. Not only did members of the new Association of German Worker Photographers (the *Vereinigung der Arbeiterfotografen Deutchlands*) produce pictures of their own lives, they produced an unlimited supply. Better yet, according to Münzenberg, the camera clubs themselves gave their members—particularly their unemployed members—something meaningful to do. "No longer," he wrote, "may they dawdle away their valuable time with more or less useless diversions. Our principal duty must be to keep them away from indifference and dullness."[7] If, in addition to learning how to take pictures of sunsets and demonstrations, camera-club members learned about Marx and Lenin and the new factories and dams being built in Russia by people just like themselves, so much the better.

In September 1931, AIZ published a photo-essay titled "Twenty-Four Hours in the Life of the Filippov Family." The Filippovs didn't live or work in Germany, and the photographs that depicted their lives weren't made by them, nor by their friends or fellow workers. In fact, the fifty-two images that constituted this day-in-the-life photo-essay were made over the course of four days by a team of three Russian documentary photographers assigned to the task by an editor of the Foreign Department of Soyuz-Foto, the Soviet government's own news-photo and public-relations agency.

AIZ published the Filippov story for the same reason that *Soviet Russia in Pictures* had first published pictures of Russian farmers and factory workers in 1921. There was nothing remarkable about the Filippov story in itself—what was remarkable was how the story integrated words and images to con-

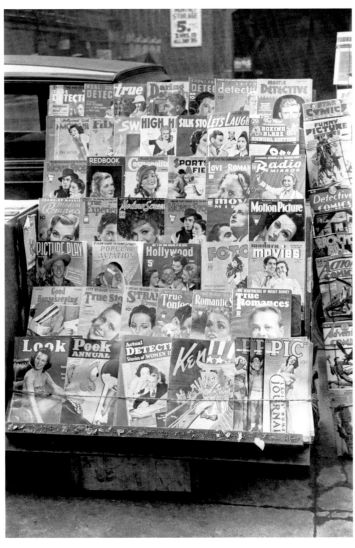

Fig. 48. Arthur Rothstein, *Magazines at Newsstand, Saint Louis, Missouri*, 1939.

sian famine and the country's new Soviet government. Münzenberg understood the weeklies' agendas: by saturating their readers with well-rendered trivialities, the weeklies tried to distract them from the real news: injustice, inequity, and class war.[5]

By 1924, Münzenberg had turned *Soviet Russia in Pictures* into an illustrated weekly and changed its name to AIZ. To begin his missionary task he needed photographs of what was actually happening in the world—strikes, demonstrations, turmoil, poverty, and privation. AIZ's staff sorted through the same piles of photo-agency images as Lorant and Vogel, but found few photos that bore witness to the hard facts of daily life.

vey meaning: "Twenty-Four Hours" rivaled any of the photo-essays *Vu* published. No American magazine even attempted what *AIZ* did until *Life* was launched five years later.

Within a month of its publication, copies of *AIZ*'s Filippov issue reached Europe and America. A year later, a Russian journal hailed the Filippov photo-essay as "a new art form."[8] A Russian Jew named Lazar Mezhericher was the Soyuz-Foto Foreign Department editor who created this new art form. Mezhericher spoke and wrote frequently about how the Soviet state could use the visual idioms of Western advertising photography to raise the political consciousness of its own citizens. In an article titled "Serial Photography as the Highest Stage of Photographic Propaganda," he advocated the use of sequenced images embedded in a narrative text that didn't bother describing the photographs (captions could do that). He used sequenced images *cumulatively* to create a state of mind that seemed self-evident.[9] In 1937, in the midst of the Great Terror, Mezhericher was arrested and purged. In 1938, *AIZ*, which had tried to escape Hitler by moving to Prague and then to Paris, ceased publication.[10]

Eight years before *AIZ* vanished (and one year after the New York stock market crashed), representatives of Münzenberg's original international-relief organization, the IAH (the same organization that had spawned *AIZ*'s predecessor, *Soviet Russia in Pictures*), traveled to New York. Their plan was to replicate Münzenberg's Association of German Worker Photographers in America. If all went well in New York, the organization would spread to other cities. Worker-photographers would learn how to take pictures of their own lives; as they learned, they would have the opportunity to hear the latest good news from Soviet Russia. Soon, they'd start sending their pictures to "progressive periodicals"—newspapers such as the *Daily Worker* and journals such as the *New Masses*. One success would lead to another. Workers would begin to show one another—and the world—the way things really were.

Organizing efforts began rather modestly. Münzenberg's Workers' International Relief (WIR) repre-

Fig. 49. Milton Meltzer, "Behind the Candid Cameraman," *Daily Worker*, October 27, 1941, reproducing photographs by Walter Rosenblum (above) and Sid Grossman (below, *Henry Modgilin, Community Camp, Oklahoma*; see fig. 10).

sentatives rented space in a Worker's Art Center on East Fourteenth Street and began recruiting members for a New York Workers' Camera League. After a few months of recruiting worker-photographers, WIR organizers realized that teaching workers how to take pictures that the *Daily Worker* could publish wouldn't produce as big or as broad an effect as they'd anticipated (fig. 49).

The problem was an American one: the *Daily Worker* may have been the largest and best-known Communist daily in the United States, but its circulation never exceeded forty-five thousand, one-tenth the circulation the Communist weekly *AIZ* had achieved in 1928 in Germany.[11]

Movies were the best American solution.

In 1930, WIR organizers changed the name of the New York Workers' Camera League to the New York

Film and Photo League. They also gave it new goals: 1) to "struggle against and expose reactionary film"; 2) to "produce documentary films reflecting the lives and struggles of the American worker"; and 3) to "spread and popularize the great artistic and revolutionary [accomplishments of Soviet film] productions."[12]

In 1933, the reorganized League began publishing a newsletter called *Filmfront* (fig. 50). Film and photo leagues in Boston, New Haven (Connecticut), Paterson and Perth Amboy (New Jersey), Philadelphia, Washington, Chicago, San Francisco, and Los Angeles posted fraternal greetings to one another. Filmmakers shared ideas about newsreel production. Critics wrote well-informed accounts of pre- and postrevolutionary Russian cinema or made invidious comparisons between such Hollywood thrillers as *Devil Dogs of the Air* and enlightened Soviet films like *Three Smiles for Lenin*. Successive issues of the newsletter carried translations of a lecture given in Paris in 1929 by the innovative Soviet filmmaker Dziga Vertov (see fig. 2).

An article in the January 7, 1935, issue of *Filmfront* summarized the new League's successes and failures:

> During the past year, the New York League had an unprecedented call for photos from the worker's press, from magazines and book publishers, and from picture services. We were able to supply an average of 60 photos per month. The demand is so great that we feel we could easily place three times as many pictures. This we were not able to do in the past due to the local nature of our photos. Publications soon became glutted with local material. Our photos have appeared in the *Daily Worker, Der Arbeiter, Labor Unity, Labor Defender, Better Times Magazine, Fortune* magazine, *The Jewish Daily Bulletin, The Survey Graphic*, and other publications too numerous to mention.
>
> With a view to adequately overcome this condition and bring our photos before the broadest masses, our National Photo Exchange was established shortly after our Chicago conference last September. Already we are receiving photos from our branches all over the country. On the whole, the general class of social subjects which the

members are taking is very good. However, the NEWS photo is very rare from out of town. The labor press had to go to the regular picture services when it needed photos of the West Coast Marine Strike, the Agricultural Workers strike, the San Francisco [Trolley] Car Strike, etc. [These] were places where the Los Angeles Film and Photo League should have been active.

> The following will serve as a guide to what photos to submit to the Exchange:
> One: General Photos of Social and Economic Implication. For example: unemployed workers, child misery, bread-lines, prostitution, housing conditions, destruction of crops, manpower-replacing machinery. Two: Labor Actions. For example: Strikes, demonstrations, protest meetings. Three: Demonstrations against War and Fascism. The latter two classifications represent spot news. This material is perishable; that is, it becomes of little value if a print is unduly delayed.[13]

One year after this report appeared, the Film and Photo League broke apart. Newsreel and documentary filmmakers went their separate ways.[14] The League's photographers—who had been pushed aside in 1930 when WIR organizers renamed and reorganized the League—took possession of what remained of it. It became the Photo League.[15] Whatever alliances had been formed with film and photo leagues outside of New York, whatever efforts had been made to create a radical news-photo agency based in Chicago—all this ended.

In 1936, the photographers who constituted the League were like survivors in a lifeboat, surrounded by an ocean of magazines and tabloids.[16]

Tabloids and True Stories

To walk past a New York newsstand, whether small or large, was like walking past a radio tuned to an opera composed by lunatics: soloists singing in tongues, accompanied by musicians playing music

Fig. 50. Cover of *Filmfront*, March 15, 1935, photographer unknown.

from different pages of different scores (fig. 51). At the high end of the register were the tabloids. "A Hearst paper," one reporter said, "is like a screaming woman, running down the street with her throat cut."[17]

The *Daily News* was the biggest tabloid in the city. By 1925, its editorial mix of crime, scandal, heroic deeds, cute kids, and pretty girls—enhanced with photographs and amplified by headlines—raised its circulation to 800,000, making it the biggest daily paper in the country. By 1930, the *News's* circulation reached 1.3 million.[18]

In 1937, the *News* commissioned a marketing survey of its readers. The results surprised its critics—and its advertisers. Many of the people who read the *News* (or its competitor, Hearst's *Mirror*) had never before bought and read a newspaper *of*

any kind during the day. These new readers were mostly women. Contrary to what highbrow critics assumed, only 9 percent of the *News's* readers were working-class. Eighty percent were middle-class. The remaining 11 percent were upper-class.[19]

By 1940, the *News's* circulation reached two million.

The primal music played by the *News* and the *Mirror* and all the other tabloids in the country (by 1936, there were forty-seven of them) reached far and wide.[20] The novelist John Dos Passos made word collages by combining popular song lyrics with headlines clipped from the *New York World* and the *Chicago Tribune* to form the "Newsreel" sections of his *USA* trilogy (1930, 1932, 1936); Nathanael West used imaginary letters sent to a tabloid advice columnist to form his novel *Miss Lonelyhearts* (1933);

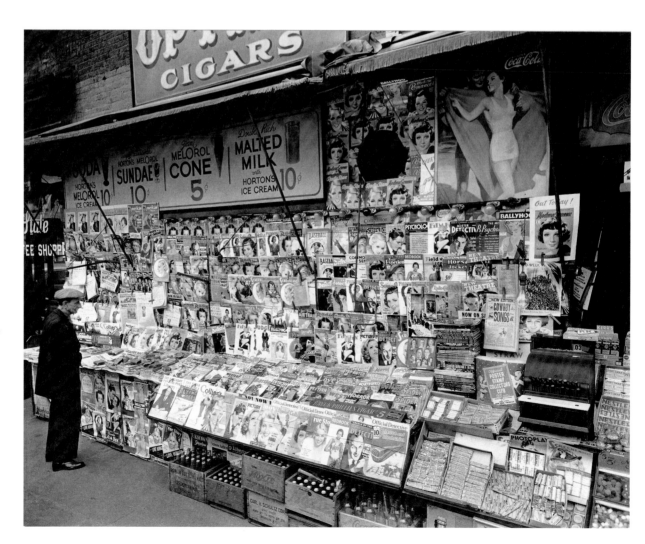

Fig. 51. Berenice Abbott, *Newsstand, 32nd Street and Third Avenue*, 1935, from *Changing New York*, 1935–39. Gelatin silver print, 9⅝ × 7½ in. (24.4 × 19.1 cm). Museum of the City of New York.

James Agee quoted the Dadaesque lyrics he'd seen pasted on the wall of an Alabama tenant farmer's shack in *Let Us Now Praise Famous Men* (with photographs by Walker Evans, 1936).

Confession magazines sang in unison with the tabloids. These spoke to their readers as if they were confiding in them, sharing secrets with them, speaking as friends, unburdening themselves. The stories they told—of transgression and remorse, temptation and seduction, recrimination and forgiveness—were read by millions of women, young and old, working-class and middle-class, who took what they read as lessons of the heart. The stories were usually illustrated with dramatic drawings or photo tableaus. Confession magazines did in print what soap operas would do on the radio.[21]

True Story and *True Romance* (and the dozens and dozens of other, competing magazines they spawned) were the creation of Bernarr Macfadden, a man as single-minded and as hugely influential as his contemporary Henry Ford.[22] Macfadden created his first magazine—*Physical Culture*—in 1898. He used it to preach a regimen of strenuous exercise, pure food, cleansing fasts, guilt-free sex—and eugenics. Readers who followed his advice not only would live to age 125, but would, through proper breeding, revitalize the human race.[23] *Physical Culture* routinely published testimonials from its readers. Macfadden's wife, Mary, had the job of reading the mail. Many of the letters were *very* personal. She tried to persuade Macfadden to publish them. He refused. The letters kept coming.

In 1919, Macfadden started a new magazine just for Mary's letters. "Call it *True Story*," Mary said. Within ten years, *True Story* and its offspring—a total of ten magazines and ten newspapers, including a tabloid called the *Daily Graphic*—had made the Macfaddens very, very rich. By the early thirties, Macfadden's magazines were receiving a hundred thousand unsolicited personal stories and manuscripts a year. Editors routinely rewrote parts of whatever they chose to publish. Over time, such rewriting became actual writing. New writing. Macfadden reluctantly agreed to this—but only if every published story was based on a real, unsolicited one. He also insisted that the language of every story remain as personal, unadorned, and colloquial as the language that a friend, speaking heart-to-heart with another, would use.

Willi Münzenberg and the staff of *AIZ* wouldn't have approved of Macfadden's populist strategies. *True Story*'s readers may have been working-class and middle-class women—but they weren't the workers *AIZ* would have preferred. The stories in Macfadden's magazines were too personal—too devoid of class-consciousness—to meet the approval of any progressive publisher. Worse yet, by the mid-1930s, confession magazines and tabloids seemed to have become the only printed matter that the "new masses" read.

Life, Look, Fortune, and PM

In March 1938 the Photo League invited Lotte Jacobi, the eminent German portrait photographer (who'd fled Germany in 1935 after Joseph Goebbels's Propaganda Ministry had made it impossible for her, a Jew, to work), to present a lecture. "This charming and attractive woman readily agreed," the League's newsletter reported, "comparing the Photo League to a camera club in Berlin before the advent of Hitler."[24]

In May *Photo Notes* published an essay titled "The Photo Magazine Craze," which could have been written by a member of a Berlin camera club. Its author was a League member named Edward Hunt. "The time may be soon opportune," wrote Hunt, "for progressive documentary photographers to establish their own pictorial magazine similar to the German workers' *AIZ*." To encourage League members, Hunt reminded his readers that the "amazing popularity" of such magazines as *Life* and *Look* "demonstrate the greater power of the photograph over the printed word to entertain and instruct" (fig. 52). Pictorial magazines must all

fulfill their ostensible function as public servants. Since their circulation is supported by the masses of the people, workers and middle classes, they should be progressive in character and should oppose fascism and dictatorship wherever it exists, abroad or in our own country. . . . [They]

Fig. 52. John Vachon, *Newsstand, Omaha, Nebraska*, 1938.

should preserve our tradition of free press. Above all, they should be honest. Difficult standards to maintain when the advertiser is always present.

If these were the standards—"the proper functions"—that photo periodicals should maintain, then Hunt judged *Life* and *Look* to be failures. "The classic example of the pictorials," he wrote,

is *Life,* published by Henry Luce, publisher of the strictly "class" magazine, *Fortune. Life* exerts a tremendous influence on the thoughts of millions of American people. . . . Generally speaking, the [editorial] policy of *Life* is reactionary. True, occasionally a progressive note slips in, but *Life* is often dishonest, as when the editors placed in juxtaposition photographs of Hitler, Mussolini, Roosevelt, and Stalin, thus implying that all were dictators. Glorification of the armed forces, false polls, etc.—all display the pro-fascist tendencies of Luce.

Look, the next most important picture magazine, has done excellent work in presenting [such] social problems as War Propaganda, Slum Housing, etc. In contradiction to *Life,* which, with slick paper and high speed presses, necessarily costs more to produce than *Look. Look* is able with its cheaper paper and lower production costs to rely less on advertising and more on circulation.[25]

Whatever Hunt's opinions were, he did understand the facts: Henry Luce and his advisers had planned *Life* to be a high-end glossy aimed at a middle-class and upper-middle-class readership. Luce had spent four years planning what he referred to as "a weekly or fortnightly [magazine of] events . . . heavily illustrated." In May 1936, he wrote a prospectus, describing his new illustrated magazine to potential advertisers:

To see life, to see the world, to eyewitness great events;

to watch the faces of the poor and the gestures of the proud; to see strange things—machines, armies, multitudes, shadows in the jungle, and on the moon, to see man's work—his paintings, towers, and discoveries, to see things thousands of miles away, things hidden behind walls and within rooms, things dangerous to come to; the women that men love and many children; to see and to take pleasure in seeing, to see and be amazed; to see and be instructed.

Thus to see and be shown is now the will and new expectancy of half mankind. To see and show is the mission now undertaken by *Life*.[26]

Luce's prospectus sounded as if he'd been spending too much time reading *Leaves of Grass*. But *Life*'s immediate sell-out newsstand sales and an avalanche of subscriptions proved that he had underestimated his original target audience of 250,000. By the end of 1937, *Life*'s circulation had reached 1.7 million and was still growing.[27]

In December 1938 Time Inc. surveyed *Life*'s readers. The raw numbers were so high—especially *Life*'s "pass along" number (a multiple that counted people who looked at an issue of a magazine even though they themselves hadn't bought it)—that the company lowered its numbers before releasing them to advertisers. Even then the survey indicated that seventeen million people—15 percent of all American adults—read *Life*.[28]

Life's direct, ink-on-paper precursor was *Fortune*. It was Luce's plan from the beginning to create a business magazine that would be as expensively produced, as lavishly illustrated, and as great a status symbol as *Vogue*. *Fortune* was his business-is-fashion magazine. He recruited two people for *Fortune* whose work carried them to *Life*—and then beyond *Life* to a connection with the Photo League.

The first was Margaret Bourke-White. Luce hired her after he saw the photographs she'd made of steel mills in Cleveland in 1929. By all accounts, he *felt* her images as much as he *understood* them. Luce himself carried Bourke-White's equipment on one of her first *Fortune* assignments.[29] Years later, as *Life*'s first issue took shape, it was Luce—not his

editors—who sent Bourke-White to Montana to photograph the dam that became *Life*'s first front cover (fig. 53).[30]

In the 1930s and 1940s, Bourke-White made no secret and felt no guilt about her political sympathies. She not only subscribed to the *Daily Worker*, she even judged the paper's weekly "Snap America" contest. Many of her closest friends were Marxist intellectuals. A few of them—including the editor of the *New Masses*—were Communist Party members. In 1933, she contributed to a strike fund started by an organization called the Photographic Worker's League. In 1934, she helped sponsor a gala for the Film and Photo League, before it broke in two. In 1940, she joined Paul Strand, Berenice Abbott, and others on the Photo League's board of advisers.[31]

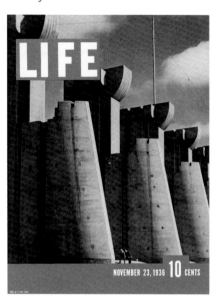

The second of Luce's *Fortune* recruits was a well-bred, well-connected recent Yale graduate named Ralph Ingersoll. In 1931, after *Fortune*'s editor-in-chief jumped off the roof of an apartment building, Luce chose Ingersoll to replace him. In 1932, Ingersoll published the mini-camera photographs of Erich Salomon and then hired him as a staff photographer. In 1934, Ingersoll published an article (about a summer resort for Jewish Communists) illustrated with the first of many photographs made by Walker Evans for *Fortune*.[32] Nearly every issue of *Fortune* that Ingersoll edited also included photos by Margaret Bourke-White. Editor and photographer developed an intense professional rapport.

In 1935, Luce promoted Ingersoll to the right-hand-man post of general manager for *Time*. Not long after, Ingersoll invited Bourke-White to lunch and disclosed a secret to her: the plan for *Life*.

"I remember the excitement with which Ralph Ingersoll took me to '21' and told me about it," Bourke-White recalled.

Fig. 53. Cover of the first issue of *Life*, November 23, 1936, photograph by Margaret Bourke-White.

In recent years, Ralph had been Harry Luce's chief assistant and this new magazine was his special charge. It was mid-afternoon and '21' was almost empty and very quiet. We sat in a shadowy corner and both talked our heads off for the rest of the day. . . . As when *Fortune* was in the planning stage, now again, with this new magazine waiting to be born, I would almost feel the horizon widening and [a] great rush of air sweeping in. This was the kind of magazine that could be anything we chose to make it. It should help interpret human situations by showing the larger world into which people fitted. It should show our developing, exploding, contrary world and translate it into pictures. . . . The new magazine would absorb everything we photographers had to give: all the understanding we were capable of, all the speed of working, the imagination, the good luck; everything we could bring to bear would be swallowed up in every piece of work we did. . . . We would go out and push back those horizons even farther and come back with something new.[33]

In 1940, Ingersoll quit Time Inc. to start his own magazine. What began as an idea for a magazine became an illustrated daily paper, shaped like a tabloid, but unlike any tabloid on the stands. Ingersoll called his paper *PM*—an acronym for "Photo Magazine" (fig. 54). *PM* was stuffed with photos, accepted no advertising, and cost only pennies more than the *Daily News*. (PM could afford to do this because it was underwritten by Marshall Field III, one of the richest men in America.) *PM* was pro-labor, pro-Jewish, anti-racist, anti-fascist, *and* anti-Stalinist.[34] It lasted eight years.

Look was the other national news-photo magazine that Edward Hunt had critiqued in his *Photo Notes* essay. He had judged it to be more progressive— or at least less reactionary—than *Life*. One reason was its origin: Gardner Cowles and his older brother, John, who started *Look,* were Progressive newspaper publishers based in Iowa, not Manhattan. Their grandfather had been an abolitionist Methodist minister. Their father was the publisher of the Des Moines *Register and Tribune*—a paper read by half the people in Iowa.[35] It was prolabor, antitrust,

Fig. 54. Cover of *PM* weekly, July 21, 1940, photograph by Morris Engel.

and antiwar. "Attaining an enforceable peace, controlling human fertility, and cultivating better relations between the races" became its core editorial policies.[36]

In 1925, the Cowles family hired George Gallup to conduct a survey of their readers. Gallup's results showed that *Register and Tribune* readers resembled the readers of New York's *Daily News:* they liked pictures more than text.[37] The Cowles family took the hint: the *Register and Tribune*'s Sunday magazine began to use photographs in groups or in series rather than singly as illustrations.

Gardner Cowles tried to convince his father and brother to start a new Sunday magazine "devoted exclusively to picture stories." They vetoed the idea: too much work for too little money. Gardner wasn't discouraged: "The way around the problem was obvious: a separate picture magazine—costing ten cents [equivalent to $1.70 today] I reckoned—to be sold on newsstands."[38]

Cowles knew about Lucien Vogel's *Vu;* he also knew about the *Münchener Illustrierte Presse* and the

Berliner Illustrierte Zeitung. More importantly, he'd heard rumors that Henry Luce was planning a national illustrated weekly of his own. (Gardner's brother had been college roommates with Roy Larsen, the Time Inc. man who'd developed the "March of Time" radio shows and newsreels.) In 1936, Gardner Cowles decided to pay a call on Henry Luce to show him the dummy for *Look.*

> Luce examined with great interest the crude dummy I had brought along. . . . Then he pulled out a dummy for *Life* . . . which at one point had been tentatively named *Look.* We discussed our respective editorial plans and philosophies which turned out to be quite different. . . . Because the two publications seemed to aim at quite different markets [*Look* anticipated most of its sales would be newsstand sales; *Life*'s business plan anticipated subscribers], Luce decided to make what I recall was a $25,000 investment in *Look.*[39]

The Cowles family waited to see the public's reaction to *Life.* Five weeks after *Life*'s first issue sold out, *Look* hit the stands. Its front cover featured a picture of Hermann Goering bottle-feeding a lion cub, accompanied by the caption, "Germany's Strange Bridegroom" and an article titled "Will Former Dope Fiend Rule Germany?" Inside were such feature stories as "Mishandled Paroles— America's Shame," "A Psychologist Reveals the Secret of Roosevelt's Popularity," and "Auto Kills Woman Before Your Eyes." An article about a trained goldfish was followed by a profile of Joan Crawford. *Look*'s back cover carried a striking head-and-shoulders shot of Greta Garbo.

The first four hundred thousand copies of *Look* sold out within a week. Cowles ordered a second printing. Three hundred thousand more copies sold in the next few days. Cowles wanted to know why. His distributors told him it was Garbo, not Goering, who'd made the sales. He was puzzled: how could a back cover—even a Garbo back cover—do what a front cover couldn't? "It turned out," he later wrote,

> that when the back cover was folded in half, the result looked much like a female crotch. Word of this curiosity spread with amazing speed. It was said, in fact, that the

> fold-over effect had been discovered by some telegraph operator who had quickly alerted fellow telegraphers throughout the country. Police in Montreal actually seized several hundred copies.[40]

The Cowles family bought back every copy of *Look* their distributors still had. They paid the equivalent of $1.5 million to make their first issue disappear.

Look's circulation hit 1.3 million by April 1937. It reached two million by February 1938.

During the brief interval (eighteen months, perhaps) between the infighting that divided the Film and Photo League and the appearance of the first issues of *Life* and *Look,* the paper world that surrounded members of the League changed shape.

Tabloids and confession/true-story magazines had spread across a wider social and cultural landscape, but they were now overshadowed by the big, new, illustrated magazines, which rose like mountains from the plain. The mass-circulation magazines and newspapers that made huge profits by telling stories of blood and folly were now matched by the illustrated weeklies (*Look* was a biweekly) that used captioned photographs and short, illustrated articles to tell a different kind of story—that amalgam of fact and cliché, prejudice, inference, preconception, and omission that, seventy-five years later, is still called "the news."

Members of the Photo League tried to find their way and their place in this altered landscape—as (mostly) second-generation immigrants, as young adults, as politically progressive Jews, as unemployed or underemployed workers, and as would-be photographers intent on bearing witness to what they saw, close at hand.

Outcomes

Of the sixty-eight photographers identified as League members in its last exhibition, three became staff at *Life,* two went to work at *Look,* and two others joined *PM,* which often featured the work of League members. Eleven more sold their work, over the course of their freelance careers, to *Time, Life, Fortune,* and *Sports Illustrated.*[41]

NOTES

1. The *Saturday Evening Post* was America's biggest magazine. In 1910, it had a circulation of two million.

2. In 1924, when most members of the League were still children, sociologists from Columbia University went to Muncie, Indiana, to find out how average Americans lived. One of the many questions that the sociologists asked was about which magazines people read. Muncie's public library subscribed to more than two hundred magazines, but the list of magazines to which people subscribed or bought issue to issue seemed almost endless: *The Saturday Evening Post* and *Movie Thriller; Ladies' Home Journal* and *Physical Culture; True Story* and *Women's Home Companion; Adventure* and *Correct Eating; Cosmopolitan* and *Country Gentleman; Good Housekeeping* and *Dream World; Modern Marriage* and *True Romance; Motion Picture* and *National Geographic; Popular Science, Triple X,* and *True Confessions; Collier's* and *True Detective; Whiz Bang* and *Vanity Fair; Vogue* and *Hot Dog; Love Story* and *The New Republic; The Survey* and *Secrets; Mind Power* and *The Atlantic Monthly; Breezy Stories* and *The Dial; Argosy* and *Jim Jam Jems . . .* "The list of periodicals received in various homes in the city extends indefinitely," the interviewers wrote. See Robert and Helen Lynd, *Middletown* (San Diego: Harvest Books, 1957), 239 n. 29.

3. Once Hitler came to power, Lorant, who was a Hungarian Jew, fled to England. In 1938, two years after Henry Luce published the first issue of *Life,* Lorant founded its British equivalent, the *Picture Post.*

4. Vogel was the son of a draftsman, born in Alsace. He launched his first magazine, a luxury fashion magazine called the *Gazette du Bon Ton,* in 1912. Coco Chanel, André Gide, Blaise Cendrars, Ferdinand Léger, and Vladimir Mayakovsky were among his friends. In 1922, Condé Nast asked Vogel to assume the directorship of Nast's own Parisian magazine, *Jardin des Modes.* Vogel held that post until his death in 1954.

5. Quoted by Leah Ohlman, "The Photo League's Forgotten Past," *History of Photography* (London) 18, no. 2 (Summer 1994): 154 (published by Taylor and Francis, London and Washington, DC).

6. Ibid., 115.

7. Ibid.

8. B. Zherebstov, "Arrangement of a Photo Series," *Proletarskoye Foto* 9 (1932): 10; quoted by Leah Bendavid-Val, *Propaganda and Dreams* (Zurich: Stemmele, 1999), 60.

9. Ibid., 57–62.

10. Mezhericher, who had fled to Paris along with his magazine, was shunned by French Communists and then assassinated, perhaps by German agents, perhaps by Stalinists.

11. By the late 1930s, there were Communist dailies in San Francisco *(The People's World)* and Chicago *(Midwest Daily Record).* There was also the *Catholic Worker,* an antiwar, anti-Communist, social-justice daily headquartered in New York. Almost all the other prolabor papers in the United States were controlled by labor unions. Whether they were local or regional, weekly or daily, these papers were published by unions affiliated with either the American Federation of Labor (the AFL) or its more confrontational rival, John L. Lewis's Council of Industrial Organizations (the CIO). *Time* estimated (February 28, 1938) that there were seven hundred union weeklies in the United States. One of the largest was the *People's Press,* a CIO-affiliated paper based in Chicago that published thirty-six regional editions with a combined circulation of three hundred and ten thousand.

A pro-union news agency called Federated News (based in New York) supplied the largest union papers with news stories and special features. Federated had been founded during the labor turmoil—the general strikes, wildcat strikes, and shootouts—that had engulfed the United States in 1919. Thirty-two union newspaper editors had founded Federated in response to the mainstream press's virtual blackout of national labor news, as violent strikes spread from Seattle to Pittsburgh to New York to eastern Kentucky. Ironically (or not so ironically), the photographs that Federated sent to its subscribers in the thirties were generated by the Wide World photo agency—which was owned and operated by the *New York Times.*

12. Quoted by Anne Tucker in "The Photo League: Photography as a Social Force," *Modern Photography* 43, no. 9 (September 1979): 60.

13. *Filmfront,* January 7, 1935. The *Survey Graphic* was a descendant of the *Survey,* a Progressive-era magazine based in Pittsburgh that had published the child-labor photographs made by Lewis Hine for the National Child Labor Council.

14. Twenty-minute "March of Time" newsreels, produced by Time Inc. had begun playing in American movie theaters in 1935. Before then, newsreels (produced, for example, by the Hearst Corporation) were ten-minute collections of marching men, grinning politicians, and bathing beauties. "March of Time" newsreels were scripted and edited narratives devoted to single subjects (for example: "The FBI," "Child Labor," or "Huey Long"). By 1936, an estimated twelve million people watched a new "March of Time" newsreel every month at the movies. In 1937, "March of Time" newsreels won a special Oscar for essentially reinventing the genre. See John Kobler, *Luce: His Time, Life and Fortune* (Garden City, NY: Doubleday,

1968), 90–91; and James Baughman, *Henry Luce and the Rise of American News Media* (Baltimore: Johns Hopkins University Press, 2001), 77–81.

15. By 1938, before wartime enlistment and conscription affected it, League membership reached eighty. See Anne Tucker, "A History of the Photo League: The Members Speak," *History of Photography* (London) 18, no. 2 (Summer 1994): 174.

16. How big was this ocean? In 1935, the total yearly circulation (that is, the total number of copies sold singly or by subscription) of all magazines published, weekly or monthly, in the United States was 179 million. In 1939, as the United States' population approached 132 million, that total rose to 240 million. Of the approximately 3,700 monthly magazines published between 1930 and 1940, 27 had monthly circulations of between 1 and 3 million copies. Among the largest of these monthlies were *Liberty* (a "general interest" magazine published by Bernarr Macfadden that provided its readers with the time it would take for them to finish a given article); *American Magazine* (a short-fiction and serialized long-fiction magazine); *Cosmopolitan* (a short-fiction and novella magazine published by the Hearst Corporation); *Readers' Digest* (begun in 1922 by Dewitt Wallace, the son of a Presbyterian minister from Saint Paul, whose criteria for selecting and publishing articles were "applicability, lasting interest, and constructiveness"); *True Story* (a confession magazine begun by Macfadden and his wife, Mary, in 1919); *Saturday Evening Post* (published weekly by Cyrus Curtis and known for its "name brand" fiction and uplifting real-life stories); *Ladies' Home Journal* (also published by Curtis); *Collier's;* and *McCall's.* All of these magazines had circulations of between 2.5 and 3 million. See Theodore Peterson, *Magazines in the Twentieth Century* (Urbana: University of Illinois Press, 1964).

The debut of *Life* and *Look* affected the circulation numbers of every other magazine in the United States. *Life's* first issue appeared in November 1936; *Look* first appeared in January 1937. *Life* began as, and remained, a glossy oversized weekly, printed on special paper produced by the Meade Company and using a fast-drying ink perfected by the Donnelly Company of Chicago. Planners at Time Inc. had anticipated that *Life's* circulation would be 250,000 but its numbers soared past 1 million by February 1937.

Look started as a monthly, printed on uncoated stock befitting the newspaper heritage of its founders, the Cowles brothers. It remained a monthly for its first four issues, then became a biweekly. By its tenth month its circulation reached 1.7 million. See Peterson,

Magazines, 211, 345–54; and Baughman, *Henry Luce,* 82–102.

17. This was Arthur Pegler, a reporter for William Randolph Hearst's *Chicago American* newspaper, writing during World War I, but the music he remembered never went out of style. The remark is quoted by many, including Hal Higdon, *Leopold and Loeb: The Crime of the Century* (Urbana: University of Illinois Press, 1999), 27; on the tabloids see also William Young and Nancy Young, *The 1930s* (Westport, CT: Greenwood Press, 2002), 160–64; and Simon Michael Bessie, *Jazz Journalism: The Story of the Tabloid Newspapers* (New York: E. P. Dutton, 1938), 79–133.

18. Bessie, *Jazz Journalism,* 99, 147.

19. Ibid., 220–29.

20. Ibid., 227.

21. Between 1930 and 1940, the number of radios in the United States increased from fourteen million to forty-four million. See Young and Young, *The 1930s,* 163.

22. *Modern Romance, I Confess, Cupid's Diary,* and *Western Romance* were created by the publisher George Delacorte; *True Confessions* was begotten by a Minnesota army veteran named W. H. "Captain Billy" Fawcett. Fawcett's first magazine, full of off-color jokes and stories, was called *Captain Billy's Whiz Bang.* Its name was based on a variety of World War I artillery shell.

23. Peterson, *Magazines,* 255–58; William Hunt, *Body Love: The Amazing Career of Bernarr Macfadden* (Bowling Green, OH: Bowling Green University Press, 1989), 296–300. In 1931, Macfadden started a pure-food Penny Restaurant chain (based on an earlier penny restaurant he had opened at the beginning of the century), with outlets in Manhattan, Brooklyn, Washington, and Chicago. The chain served complete meals of "vital health foods" for less than twenty cents (the equivalent of $2.80 today); it sold single servings for a penny (equivalent to fourteen cents).

24. *Photo Notes* (March 1938).

25. With good reason the League was more amenable to *Fortune* and *Look* than to *Life.* The political beliefs of many of *Fortune*'s best writers—Dwight McDonald, Archibald MacLeish, James Agee, Alfred Kazan, John Kenneth Galbraith, and Daniel Bell—ranged from left-of-center to Marxist. The magazine's 1934 investigation of European munitions makers resulted in a U.S. Senate investigation into those merchants of death. By 1932, *Fortune*'s principal photographer, Margaret Bourke-White, had made three trips to the Soviet Union to photograph its new factories and dams. Sergei Eisenstein had written letters of introduction for Bourke-White before her first trip in 1930; her second trip, in 1931, was at the invitation of the Soviet government itself.

A pretty brunette on a swing, wearing a smile and a halter top, decorated the cover of the May 21, 1940, issue of *Look,* two years after Hunt's essay in *Photo Notes.* The issue featured images from the Photo League's *Harlem Document* project along with an article about Richard Wright's *Native Son.* The headline of the article was "The Story Behind *Native Son,*" subtitled "Most Discussed Novel of Negro Life Since *Uncle Tom's Cabin.*" At the time of the article, Wright had not yet resigned from the American Communist Party.

Many of the *Harlem Document* images, juxtaposed in much the same way as they appeared in *Look,* but captioned differently, had been published in the *New Masses* in May 1939. *Fortune* also published three *Harlem Document* images in its June 1939 issue, only a month after they appeared in the *New Masses.*

26. Kobler, *Luce,* 105.

27. *Look*'s circulation reached the 1.3-million mark soon after; see Peterson, *Magazines,* 351–52. In 1936, a former news-syndicate executive bought *Midweek Pictorial* from the *New York Times* (the *Times* had started *Midweek* in 1914 as a photogravure "national war pictorial"). *Midweek*'s new owner redesigned it, added sixty pages of pictures to it, and had it printed on good paper. The new *Midweek Pictorial* hit the stands one month before *Life* did. *Midweek* disappeared in 1937, just as *Look* published its first issue.

28. By comparison, the *Collier's* reader and "pass along" number was sixteen million. As an early illustrated weekly, *Collier's* had a nearly fifty-year head start on *Life.*

29. Vicki Goldberg, *Margaret Bourke-White: A Biography* (New York: Harper and Row, 1986), 101–10.

30. It was a front cover that could just have easily served the Soviet propaganda magazine *USSR in Construction.*

31. Fiona M. Dejardin, "The Photo League: Left-Wing Politics and the Popular Press," *History of Photography* (London) 18, no. 2 (Summer 1994): 165–67; Goldberg, *Margaret Bourke-White,* 54, 156.

32. James Mellow, *Walker Evans* (New York: Basic, 1999), 225–26.

33. Margaret Bourke-White, *Portrait of Myself* (Boston: G. K. Hall, 1985), 116–17.

34. The *Chicago Tribune* called PM "the uptown edition of the Communist *Daily Worker.*" See David Margolick, "PM's Impossible Dream," *Vanity Fair* 461 (January 1999): 129. Earl Bower, the head of the American Communist Party, thought PM was reactionary. Unfortunately, said Bower, PM reported the news "in such a charming and innocent and interesting fashion that even members of our [Party], I am sorry to say, often prefer PM rather than the *Daily Worker.*"

35. Gardner Cowles, *Mike Looks Back* (New York: G. Cowles, 1985), 7–15.

36. Ibid., 23, 41.

37. Peterson, *Magazines,* 351.

38. Ibid.

39. Cowles, *Mike Looks Back,* 59. The sum of $25,000 is equivalent to nearly $400,000 today. Another proposed name for the magazine had been *Parade;* see Peterson, *Magazines,* 348.

40. Cowles, *Mike Looks Back,* 60.

41. See Anne Wilkes Tucker, Claire Cass, and Stephen Daiter, *This Was the Photo League: Compassion and the Camera from the Depression to the Cold War* (Chicago: Stephen Daiter Gallery, and Houston: John Cleary Gallery, 2001), 165–75.

A RASHOMON READING

Anne Wilkes Tucker

The end was a disappointment, but not a shock, for the remaining members of the Photo League. The shock had come four years earlier, when, on December 5, 1947, U.S. attorney general Tom C. Clark issued a compendium of about ninety organizations judged to be "totalitarian, fascist, Communist, or subversive" and included the Photo League among them (fig. 55). Prepared by a special board under the direction of President Harry S. Truman's Executive Order 9835, the list would be used for examining the loyalty of federal government employees. Cited associations ranged from the Communist Party to the Ku Klux Klan and the German-American Bund, and included civil-rights groups, labor councils, schools, and cultural organizations such as the Photo League and the League of American Writers. Anyone belonging to these organizations was deemed a disloyal American. The League's response was to categorically deny the accusation in press releases, meetings, petitions, letters, articles, and eventually an exhibition, whose aim was to prove the group's purpose as cultural, not political. The disclaimers worked for a while, but as the blacklisting grew in intensity and reach, membership declined and the Photo League dissolved on October 30, 1951.

Fear of Communism was a cyclical issue in American politics for most of the twentieth century, beginning just after the Russian Revolution in 1917. The first serious period became known as the Red Scare. In 1918 the U.S. House of Representatives began to conduct hearings that investigated both fascist and communist organizations. On November 7, 1919, the second anniversary of the revolution, Alexander Mitchell Palmer, President Woodrow Wilson's attorney general, ordered the arrest of over ten thousand suspected Communists and anarchists, charging them with "advocating force, violence and unlawful means to overthrow the Government." Palmer and his assistant, John Edgar Hoover, found no evidence of a proposed revolution, but many of the suspects were held without trial for extended periods. While the majority was eventually released, over 250 people were deported to Russia. Adamant support of the government's attacks on Communists came from churches, some labor unions, and conservative politicians as well as self-appointed crusaders. One such was Elizabeth Dilling, who in 1934 published *The Red Network—A Who's Who of Radicalism for Patriots,* in which she listed both the Workers' International Relief (WIR) and the Workers' Film and Photo League (precursor of the Photo League), as well as the National Association for the Advancement of Colored People (NAACP), *New Republic,* the American Civil Liberties Union, both the YMCA and YWCA, the photographer Margaret Bourke-White, and First Lady Eleanor Roosevelt as threats to the United States. In the following years various other investigative congressional committees were constituted, the most prominent being that formed in May 1938 as the House Committee on Un-American Activities (HUAC), led by Congressman Martin Dies.[1] There was, of course, a détente during World War II, when the Soviets were allies of the United States.

The episode in American history generally known

Fig. 55. *New York Times*, December 5, 1947, front page and page 18 with the headlines, "90 Groups, Schools Named on U.S. List as Being Disloyal; Clark Cites Communist Party, 'Totalitarians, Fascists' to Guide Federal Agencies; 3 New York Schools Hit" and "These Are Among 11 Classed as Adjuncts of Soviet—Klan and Film Body Accused."

as the "Blacklist," when for the first time being Communist was illegal, began with a speech by former British prime minister Winston Churchill to Westminster College in Fulton, Missouri, on March 5, 1946.[2] Churchill warned against the threat of Soviet expansionism, describing the lands it occupied as being behind an "Iron Curtain." He identified the need for Western countries to cooperate and stand unified in the Cold War against the Soviet Union. In the following year the attorney general issued his list and HUAC, now led by J. Parnell Thomas, ramped up its hearings in Congress with the public investigation of Hollywood writers, directors, and actors. Later HUAC hearings in March 1951, led by John S. Wood, and the 1952 Internal Security Subcommittee, headed by Senator Pat McCarran, initiated the practice of "naming names" to be added to the ever-expanding lists of disloyal Americans. In 1950

Senator Joseph McCarthy began his own hearings to investigate alleged Communists and Soviet spies and sympathizers inside the federal government of the United States. The term *McCarthyism* was coined in reference to McCarthy's sweeping accusatory practices, which involved personal attacks on individuals via widely publicized and unsubstantiated charges, and was soon applied to any comparable anti-Communist activities. Not until the highly publicized and televised Army-McCarthy hearings of 1954 did McCarthy's support and popularity begin to fade.[3] With the censure of McCarthy by the Senate that same year and a libel lawsuit filed by John Henry Faulk in 1957—and finally won in 1962— against the self-appointed blacklist organization AWARE, the era was over, but not the havoc that it had brought to lives and careers.

There is some truth and some irony, as well

as tragedy, in the accusation that the Photo League was an organization led by Communists for political gain. But in a time when careers can be ruined and lives damaged by unproven accusations, irony has no place on the field of play. The League was a photographic organization: it was a small, local group, joined by people interested in photography and committed to its growth. Its members were serious about themselves as photographers and had high ambitions to make their mark in the world. Photography had been central in all its programs and publications since its founding in 1936. No one ever officially asked where any member stood politically, but their political persuasions ranged from apolitical through Democrat and Socialist to Communist, and some of the most active League leaders were members of the Communist Party. Nevertheless, it was the League's parent organization, not the Photo League itself, that had international ties and direct affiliation with Soviet Communism.

The WIR was a leftist Red Cross, founded in 1921 and headquartered in Berlin, that offered international aid to strikers and their families. To publicize its efforts and the causes of the class struggle, it organized Workers' Camera Leagues in major European and American cities; the New York Film and Photo League was one such group. Although the majority of the League's seventy-five to one hundred members were still photographers, the film division dominated the organization.[4] The still section offered classes and lectures, held exhibitions of its work in 1931, 1934, and 1935, and supplied photographs to labor and leftist publications such as the *New Masses* and the *Daily Worker.* Their subjects tended to be union activities, protest marches, and the Depression's unemployed selling apples on the street and living in Hoovervilles (tent cities named in "honor" of President Herbert Hoover). In 1934 the film division split into two groups: those who preferred to cover the daily struggles of the working classes in short, easy-to-distribute newsreels and those who preferred to seriously explore documentary filmmaking with longer productions, perhaps employing actors, and offering more in-depth analy-

sis of social issues. The latter group, which was led by the filmmakers Leo Hurwitz, Irving Lerner, and Ralph Steiner (plate 14) and joined by Paul Strand (plates 4, 5, 62) and the screenwriter Ben Maddow, reorganized as Nykino and then as Frontier Films. Throughout its history the Photo League was loosely associated with members of Frontier Films.[5]

After a bit of internal conflict of their own, the still-photography group from the Film and Photo League emerged as the Photo League, keeping the Film League's old headquarters at 31 East Twenty-first Street in Manhattan. It built on the earlier League's structure, with classes, lectures, exhibitions, and a newsletter, *Photo Notes,* but all were managed on a more regular and regulated basis. The school expanded in 1938 to include a series of classes progressing from beginner to advanced, with students hopefully graduating to work in documentary-project groups. The organization's commitment was to documentary photography, and its desire was to make the camera eloquent as members responded to the people and places around them. At the time, few places in New York offered study in documentary photography and no other school or program offered classes or darkroom access with fees as low as the League's. As the League developed its programs, its evolution was affected by political and social forces as well as the life experiences of its members, many of whom joined young and continued to participate as they raised families and pursued careers. One cannot understand the events that occurred between 1947 and 1951 without considering these forces as well as the increasing diversity of the League's membership over time.

Jack Lessinger (plate 103), a self-taught photographer who had opened a portrait studio in 1944 and joined the League in 1947, compared the history of the Photo League to "the Japanese tale and film *Rashomon,* an incident, or series of incidents, seen through different eyes and described in different ways."[6] He cautioned that "the road to truth is rarely straight and narrow," with little "documentary evidence to check against the reported word." What information exists about the last years of the League

comes primarily from governmental investigative files, from the League's publication *Photo Notes,* from letters, and from memories recorded forty to fifty years after the events. As Lessinger predicted, the places and events described in the documents and memories do not coalesce.

At the crux of the differences are the chroniclers' understandings of photography. There were those who feared it as a tool for spying and propaganda and those who believed in its expressive capacity as an artistic medium. For the former, the reading of a photograph was limited to identifying the subject matter and questioning any possible political links. For the latter, photographs could be complex and personal visual statements; learning to be a good photographer included deepening one's understanding of expressive potential as well as acquiring technical skills.

Equally important in sorting out the different perspectives on the League is whether the chronicler thought that the political affiliations of the League's photographers were important. At one extreme were the government agents and unnamed informants, who may have reported on photographic activities, but who valued only those aspects of them that might be linked to politics—or be perceived as linked to politics. At the other extreme were people who were oblivious to the political affiliations of members. Between these poles were many gradations of viewpoint, including that of people who knew that some members were Communists and didn't think it was important. Relative to those various postures, the positions of individual members shifted over time in light of events and perceived threats to their lives and professions.

Of course, whether someone was surprised by the League's inclusion on the 1947 list depended on the nature of one's own opinions about both photography and politics and on the individual's powers of observation. Those who were not surprised included the economist Solomon Fabricant (plate 34), who already had a bachelor's degree in accounting from New York University and a master's degree from Columbia University. Fabricant was working on a

Ph.D. in economics at Columbia when he joined Aaron Siskind's documentary Feature Group at the League in 1936, using the pseudonym Sol Prom.[7] He was first attracted to the League by an advertisement for the school and then, like many members, participated in some of the smaller documentary projects, such as photographing the May Day parade for International Workers' Day. His father-in-law was in the furriers' union, and Fabricant made sure to photograph him as part of his documentation of the parade. Fabricant registered for his first class under his own name but adopted a pseudonym when he realized that some members were Communists. He recalled various kinds of pressure at the League to participate in clearly leftist causes, including discussions of the "Great Trials" in Russia, the circulation for signatures of petitions against "war and fascism" during League meetings, and other such activities, citing these as the reason for the pseudonym, as well as the fact that he was beginning to publish papers as an economist under his own name.

Aaron Siskind, who led the Harlem Document Feature Group, knew that the League's roots were based in leftist politics because he had been a member of the Film and Photo League and had resigned when pressured to join the Communist Party.[8] Sidney Grossman had convinced Siskind to return to it with the promise that he would not have to participate in any activities other than his documentary-production group. Siskind's biographer Carl Chiarenza wrote, "When Siskind rejoined in 1936, he found less overt political activity; it apparently declined steadily afterward so that by the 1940s the Communists, and other political units, were minor factions within the larger organization. These groups began to meet independently and apparently no longer affected policy."[9] Siskind later confirmed that in its last period after World War II the League was not at all a political organization.[10]

The Feature Group regularly met at Siskind's apartment, not at the League, and worked as an exclusive unit from 1936 to 1940. Given that, plus Siskind's sensitivity (indeed, overt antagonism) to any layering of politics into discussions of photogra-

phy, other members besides Fabricant may have been aware of the political views of individual League members—be they Communists, Socialists, or Democrats—but without feeling that politics were vital to their interests. Jack Manning (plates 32, 33) and Harold Corsini (plate 35) both said they moved away from any political discussions they might have heard at the League. Feature Group members tended to feel more allegiance to the Feature Group than to the League itself and credited their accomplishments in those years and later to it. Their successes were among the most impressive in the League's history, and certainly the most sustained of any of the documentary groups.[11] Most of

Fig. 56. Jacob Deschin, photography critic for the *New York Times,* and Angela Calomiris at the Photo League in 1946, photograph by George Gilbert.

them, except Morris Engel, left the League before or soon after the Feature Group disbanded in 1940, although Siskind and Richard Lyon (plate 23) rejoined briefly after the war. Jack Manning said he left specifically because Sid Grossman had warned him that the League was being investigated by the FBI.[12]

Members who were not surprised by the League's being listed included Myron Ehrenberg (plate 89), who studied photography at the League in 1939 after serving during the Spanish Civil War as a volunteer ambulance driver in the antifascist Abraham Lincoln Brigade, composed largely of American leftists. As a veteran of the brigade he was already on government lists and later had trouble getting a passport for overseas jobs as a photographer. When he joined the League, he recognized that some of the causes it endorsed were also supported by the Communist Party and other politically left organizations, but said that he still thought it puzzling that the FBI could consider the League a subversive threat.[13] Arnold Eagle, who joined during World War II, also realized that some members, particularly Angela Calomiris, were "always injecting their [left] point of view," and their pressures eventually drove him

away from the League's activities (fig. 56).[14] Henry Rothman, who joined in 1938 and edited the League's newsletter, *Photo Notes,* in 1938–39, acknowledged that "the Communists were actually in the minority as far as membership numbers go, but they dominated because they were the most active and they took over the leadership. Of course, a lot of people in the Photo League were sympathetic, but you had to be awful stupid or dense not to know that the orientation of the Photo League was Communist."[15]

Some members cited only occasional instances that alarmed them. The photographer and filmmaker Rudy Burckhardt (plate 113) said that only once had the League done something that he thought was too political. It had, he felt, forced through a petition protesting "some abstract paintings that were being refused by somebody in Washington. They were supposed to be shown somewhere. . . . And they wouldn't send them."[16] The protest was in 1947 over a State Department decision to stop a Latin American tour of American abstract art after a campaign by right-wing newspapers (owned by the Hearst and McCormick chains) and certain radio commentators, who accused some of the artists of belonging to organizations on the attorney general's list. In 1948 the State Department's considerable collection of art was sold as "surplus war assets."[17]

Other members were shocked by the accusations. Marynn Older Ausubel studied with Sid Grossman in 1938 and worked for seven years managing the Lewis W. Hine Memorial Collection. She was very surprised by the blacklisting but said that her energies had been focused mostly on what little they could afford to do to preserve Hine's negatives and prints.[18] Clemens Kalisher, who joined the League in 1947, remembered occasional petitions being introduced and feeling pressure in some classes to photograph "poor and simple people." He recalled being in the darkroom on the evening when the news of the blacklisting arrived and feeling very angry at the League's leadership, whom he felt had not been straight with him. "If there had

been another place for photography like that, I would have joined it instead. I liked the relaxed atmosphere and the dedication to photography at the League."[19] Like many others, he also frequently made use of the League's darkrooms and regretted having to borrow time in other people's darkrooms after he left the organization. Henry Rose, who also joined in the forties, earned his living as a carpenter and volunteered to direct the remodeling of the League's last headquarters in the basement of the Hotel Albert (figs. 57, 58). Rose was surprised by the blacklisting, responding, "I had never seen the slightest iota of political activity there, and I was an insider, you know. As a matter of fact, when I read about it, I said, that couldn't be us."[20]

Some members joined the League despite the Blacklist, or even because it was blacklisted. Lou Bernstein (plates 56, 140) said that the Blacklist designation did not bother him. He studied with Sid Grossman at the League and, after Grossman left, attended the classes that he held in his apartment until his death.[21] Jack Lessinger remembered that "people were alarmed by the listing, but also angered and were seeking ways to do something about it. I know I was, and thought it was time to do what I had already been thinking of doing. I joined the League. Quite a few other photographers joined at about the same time. It was like jumping into a small frying pan, but I don't think most of us realized that the pan was in the middle of a big fire."[22] Nevertheless, Lessinger also remained a member until it closed.

The comments above reflect the three distinct periods in the League's history: 1936–41, 1942–47, and 1948–51. Each period reflects the international and national events that shaped the lives of its members: the Depression and recovery from it; World War II; and the Cold War. Just before the publication of the attorney general's list, the League's membership hit its peak of 178 members. In the first period a League editorial proposed that "the Photo League's task was to put the camera back into the hands of honest photographers, who will use it to

photograph America."[23] After the war the League redefined its mission more nebulously as "contributing to the growth of individual artists and to the community," with the goal to become "a Center for American Photography."[24] In 1947 the League began a national fund-raising and membership campaign, and for the first time placed priority on improving its headquarters. That self-conscious attention to its physical appearance, and the upgrading of its newsletter, *Photo Notes,* from a mimeographed monthly to an offset quarterly, also reflected the shift from a belief in photography's social value to a belief in its

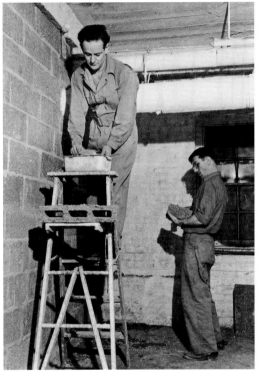

Fig. 57. Walter Rosenblum (on ladder) and Ed Schwartz remodel the League's quarters in the Hotel Albert, c. 1948, photographer unknown.

Fig. 58. Jacob Deschin, "The Photo League: Members Busy Building New Quarters," *New York Times,* February 22, 1948

THE PHOTO LEAGUE

Members Busy Building New Quarters

By JACOB DESCHIN

MEMBERS of the Photo League have become amateur plumbers, electricians, carpenters, masons and painters overnight to bring to realization the dream of years—a photographic center. Recently they leased 2,600 feet of space in the basement of the Albert Hotel, on Tenth Street, but they were faced with the problem of building their quarters without funds to hire professional help. Those with any experience among the members offered to coach others, and now volunteers contribute evenings and week-ends, spending spare hours in laying the cinder-block walls, setting up doors, installing electrical appliances, painting and other chores.

Plans for the center were drawn

worth as a tool of creative individuals (figs. 59–62). The League was not rejecting its past; it still perceived photography's role as "revealing the real world," but individual growth was considered more important than the group documentary projects. No documentary groups formed at the Photo League after the Second World War, other than one project completed by a class led by Paul Strand in 1949.[25]

The League had always sought to bring to its members prominent figures in photography. No one

Fig. 59. *Photo Notes*, August 1938.

Fig. 60. Cover of *Photo Notes*, Fall 1948, with a photograph by Eugène Atget.

Fig. 61. *Photo Notes*, Spring 1949.

Fig. 62. *Photo Notes*, Spring 1950.

was paid to lecture, but noted photographers who lived in or visited New York were invited to speak at the League, and few refused. Lewis Hine, Ansel Adams, Margaret Bourke-White, Edward and Brett Weston, and Robert Frank all spoke at the League at least once. When the League showed photographs from the Farm Security Administration, it asked the FSA director, Roy Stryker, to speak; when the League showed photographs by photographers of the Magnum agency, it sponsored a symposium on photojournalism. Filmmakers who screened their films at the League and then answered members' questions included Henri Cartier-Bresson, Paul Strand, Julian Roffman, Leo Hurwitz, and Rudy Burckhardt. Some of the speakers were already members of the League; others joined after their appearance. Berenice Abbott participated in programs at the League every year from 1938 until she resigned in 1949. Weegee first spoke there and became a member in 1941 (fig. 63). Dorothea Lange attended Eliot Elisofon's lecture at the League in June 1939 and was prompted afterward to donate money for a scholarship to the school.[26] And based on her

Fig. 63. Weegee lecturing, c. 1941, photographer unknown.

enthusiasm, Ansel Adams included the Feature Group's *Harlem Document* as one of the photography exhibitions in the San Francisco World's Fair in 1939. But Adams did not join the League until July 1947, when the League had its national membership campaign, probably at the urging of his friends Beaumont and Nancy Newhall. The Newhalls had supported the League in various ways since 1938 but joined at the same time as Adams, as did another mutual friend, Barbara Morgan.[27] Edward Weston offered his name as sponsor, but declined membership due to "a state of pecuniary embarrassment."[28] What the League was promising to become was something these and other prominent people wanted to support with time and advice as well as with occasional lectures and articles in the newsletter. The Newhalls joined Frontier Film members Leo Hurwitz, Ben Maddow, and Paul Strand as well as Jacquelyn Judge, picture editor of *Photography*, on the masthead of *Photo Notes* as contributing editors.

When the League was blacklisted in 1947, many established photographers, critics, editors, and curators rallied in its support. Beaumont Newhall helped the League's then-president Walter Rosenblum draft a letter to the attorney general demanding that the exact charges against the League be made known (fig. 64). W. Eugene Smith (plates 133, 134, 136), who had also joined in July 1947, lent his name as president of the League in 1948 and kept his name on the masthead through the last issue of *Photo Notes*,

which appeared in the spring of 1950. With no specific charges beyond the attorney general's list, the best defense seemed to be to publicize all that the League had accomplished in the name of serious photography and to emphasize how important the League could be to the future of American photography. It was agreed that the best form of publicity would be a retrospective exhibition reflecting the League's past and present talent. This survey, *This Is the Photo League,* opened on December 2, 1948, with the work of ninety-four artists (fig. 65). A catalogue was printed and included an essay by Nancy Newhall and nine halftone reproductions (fig. 66). Although the exhibition was well received by the photographic press, it was an inadequate defense against the increasingly shrill accusations and punitive laws.

Then, in April 1949, during a trial of Communist Party officials, Angela Calomiris revealed herself as an FBI informant and referred to the League as a Communist front organization. She testified that members of the Photo League had introduced her to the Communist Party, naming Sid Grossman and his wife, Marion "Pete" Hille (fig. 67). Calomiris had joined the League in 1942, when membership was beginning to drop as members were drafted or drawn away by war jobs.[29] According to the June 1942 issue of *Photo Notes,* she was elected executive secretary, but most members couldn't remember her presence at the League, except for Arnold Eagle (plates 9, 144), who recalled her as the person who had pushed him to join the Communist Party. A few remembered going to her studio to have their portraits made, which they later learned had been submitted to the FBI. At the trial, Calomiris testified that some of the League's members reported its activities to "higher ups" in the Communist Party and that Grossman was the "guiding light" of the League.[30] Friends of Sid Grossman also remembered that he had been her guiding light, helping her with jobs and once working through the night to get usable prints from poor negatives. His friend and League member Susie Harris had liked Calomiris, describing her as "a friendly person, pleasant, out-going, frank.

Fig. 64. Statement released by the Executive Committee of the Photo League in response to being named a subversive organization, December 1947.

She came to meetings, to Sid's apartment after meetings, to parties, and to one of the League's balls" (figs. 68, 69).[31] Her testimony, Harris recalled, had been devastating to Grossman. She herself had been deeply angered: Calomiris was one of the people, Harris said, who "owed everything to Sid, their artistic being, their creative soul."

Twenty-eight years later Calomiris was interviewed about these events and acknowledged that Grossman was a "marvelous teacher. . . . I learned a great deal from taking the lousiest pictures ever and bringing them to class."[32] Yet she was unrepentant about working with the FBI, explaining, "I testified because I believed in what I was doing." She was very careful in the interview not to speculate that anyone other than Grossman was a Communist, nor did she mention the names of other informants in the League. She also said "that the majority of the Photo League members were in no way aware how they were being manipulated," and she cited members, particularly Arnold Eagle, whose names

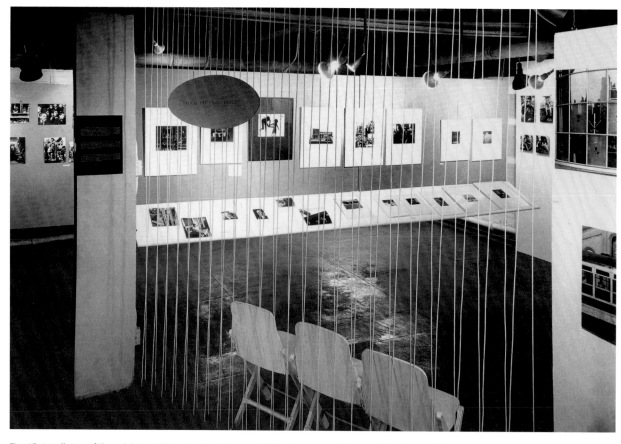

Fig. 65. Installation of the exhibition *This Is the Photo League,* 1948, photographed by John Ebstel, printed later by Marvin E. Newman.

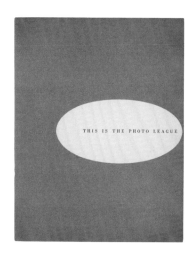

Fig. 66. *This Is the Photo League* exhibition catalogue cover, 1948.

she later helped to clear from suspicion. She also speculated that she had been recruited as an informant because she was a photographer, and "as a member of the Photo League, you could photograph at mass meetings because people knew you were with the Photo League." That is, she was able without suspicion to take photographs of leftist activities for purposes of identifying participants. (On Calomiris see Catherine Evans's essay in this volume.)

The FBI had recruited Calomiris to join the League, and probably to get close to Grossman, after it began a general investigation on him based on a tip received in 1940.[33] At the time, he and Hille were accompanying her brother Waldemar on a trip through Oklahoma and Arkansas to record folksingers. Grossman photographed the singers, rural

farmers, and craftspeople on the trip. The first page of his file at the FBI states that a person whose name is blanked out was "doubtful as to the patriotism of both Grossman and his wife, and that she had noted several photographs of poor people in tents and shacks, as well as negatives of oil well pumps and equipment."[34] The informant also noted that Grossman was an Austrian Jew and his wife was German. Because he received mail from the Photo League during that trip, the FBI also opened a file on the League, as well as on any League members who corresponded with him that summer. A discarded letter that the informant had pieced together "referred to their photographic business and a school. Numerous remarks were made of the peace movement which was alleged to be gaining great momentum in New York."[35] Subsequent reports in FBI, U.S. Army Intelligence, and New York City Police Department files stated that Grossman read a lot, including the liberal newspaper

PM and the Communist organ the *Daily Worker.* Army Intelligence concluded that "Grossman's reading and conversation are concerned mostly with photography."[36] One report also noted that he played marbles. Additional reports recorded the names of people who wrote to him and summaries on investigations of those individuals.

The army's reports, which began immediately after his induction into the armed forces in 1943, were more measured and took care to separate evidence from subjective opinion.[37] The army was also more thorough than the FBI, checking birth and marriage certificates; scrutinizing school, bank, medical, and voting records; and interviewing every listed employer and landlord of Grossman, as well as at least thirty different people who knew him.[38]

Grossman's membership in the Communist Party had never been in doubt. What changed from report to report was the evaluation of its importance. The oddest fact is that although the Film and Photo League had been under surveillance since 1930, its relationship to the Communist Party had not been ascertained.[39] Its link to the Photo League was first noted in a 1945 report. Instead, the FBI concluded that the percentage of League members who were Communist was increasing, not shrinking, after World War II. A report received by the army from "a reliable federal agency" on April 6, 1943, stated that after the League's founding, it had "gradually come under the control of the Communist faction until now the major portion of its members are Communists." This and other reports mentioned that "members of the League met occasionally and secretly at Grossman's home and that at one of the meetings, he gathered reports from various members attending to be consolidated and forwarded to an Officer of the Communist Party."[40] Across the agencies the same information, such as the League's listing by the attorney general, was repeated in successive reports. Further, they used the same phrases, such as "Sid Grossman seems to be the guiding light of the League."

Such public and publicized accusations of "un-American" activity and "association with known

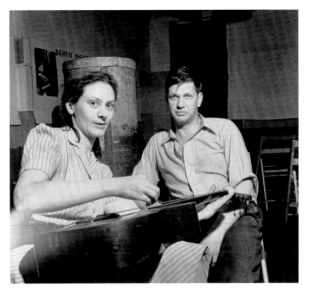

Fig. 67. Marion Hille and Sid Grossman at the Photo League loft, c. 1946, photographer unknown.

Communists" were more than was necessary to irretrievably damage the League's reputation. Newspapers and magazines would no longer review the League's exhibitions or promote its events. Without media coverage, the League couldn't reach its audiences, which led to a painful loss of new students for the school, the League's primary source of revenue. The writer and critic Ferdinand Reyher spoke at the League in the fall of 1949, although he had to leave a sickbed to attend. As Walter Rosenblum wrote to Nancy Newhall, Reyher said he would never have come, "if it hadn't been for the fact that the League was labeled a subversive organization."[41] But few could afford to be so defiant. Anyone whose job required national-security clearance, bonding, or a passport—all of which were necessary for photojournalists—could not belong to an organization on the attorney general's list.

Rudy Burckhardt remembered that "in 1949, they were supposed to send all the names of members to Washington. . . . That's when to my eternal shame I decided to resign because I wouldn't be able to get a passport and I wanted to go to Italy."[42] Burckhardt was referring to the Internal Security Act, also known as the McCarran-Wood Act, which Congress passed over President's Truman's veto by wide margins on September 23, 1950. Marion Palfi (plates 126, 131)

81

A RASHOMON READING

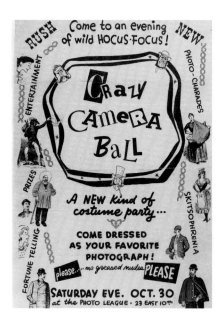

Fig. 68. Crazy Camera Ball flyer, October 1948.

resigned at the same time because she was afraid that under the terms of the act she might be deported. "Today, I wouldn't do it," she said in 1974. "Then I was too young and too stupid . . . to say, if they throw me out, I'm homeless. So I'm homeless. Some people will be kind. There will be others who accept me."[43] Palfi's impression was that Lisette Model (plates 40, 64, 67, 79) did not resign, although she, too, was a recent citizen. Jerry Liebling (plates 57, 123, 137) remembered that, while he was member-

ship secretary (June 1948–spring 1949), "There were people who came to me and said, 'Look, you've got to take my name off and send an official letter,' because they were teaching or in some other position. We would send out this letter saying, 'As of this day ___ is no longer a member of the Photo League.'"[44]

The naming of Grossman was most unsettling to those who had lent their name and their occasional energies to the League, but who were not day-to-day participants. Nancy Newhall wrote to the League's executive committee in August 1949, "I deeply regret the necessity for this letter [questioning the loyalty of the League], but it is our lives, our work, our beliefs and our freedoms that are at stake. And they are not unconnected with what happens to the world."[45] As the exchange of letters among the Newhalls, Barbara Morgan and her husband, Willard, and Ansel Adams, as well as other friends, continued over the summer after Calomiris's testimony, they increasingly leaned toward resignation and dissociation. Some resigned in 1949. For others, the congressional debates on the McCarran Act in 1950 made it clear that membership could damage one's career.

Fear crept into members' lives in different ways. Lester Talkington remembered being accused of working for the FBI while photographing a debate in Union Square. "I never saw another big discussion group in Union Square," he reported. "It was the sunset of free speech."[46] Arnold and Timmie Newman recalled racing around their apartment just before the arrival of intimate friends for dinner, checking their shelves for incriminating books (plate 51).[47] Sid Grossman reported to his second wife, Miriam, that old friends crossed the street if they saw him on the sidewalk. Paul Strand moved to France, and League member Joe Balcombe moved back to his native England. Elizabeth Timberman (plate 80) moved to Mexico because, having been blacklisted, she couldn't get

Fig. 69. W. Eugene Smith, Weegee, and Elizabeth Timberman at the Photo League Photo Hunt, 1947.

work with magazines that used to employ her. She stayed in Mexico for four years.[48] Jack Lessinger described how "the League was changing. It was hard to raise money just to stay alive. Photographers were no longer dropping in so often when in New York. . . . People were working just as hard, but we kept losing members. In some cases, we were told, with regrets; in others, they just stopped showing up. . . . The League died a little bit every time a photographer dropped out and felt compelled to conceal membership in the League. . . . In the face of all the madness all around it, the Photo League finally found it impossible to continue. A statement was drawn up in 1951 and sent out to the membership as a final farewell."[49]

The irony of the government prosecution was that the League had certainly become significantly less—not more—political after World War II. Even Calomiris admitted that Grossman, like many League members, had been changed by his military service. Grossman's wife, Miriam, said that soon after his military discharge he resigned membership in the Communist Party, though not without difficulty. After the war, the League had wanted change, but not the kind that greeted them in 1947.

With never more than 178 members, the League was a small organization that various government agencies investigated and pursued at enormous cost in both time and money. Over and over the members questioned why. Arthur Leipzig (plates 92, 93, 98), who joined in 1942 and taught in the League's summer school in 1946, "knew that there were plenty of radical people and there were plenty of non-radical people" in the League, but felt that the politics discussed were "no more and no less than any other group" of intelligent people at the time, and that these discussions were similar to those he had heard in other organizations. So why blacklist the League?[50] It was partly happenstance that an investigation of Sid Grossman led to an investigation of the League. But were there larger reasons? On December 4, 1947, Paul Strand was the keynote speaker at the League's meeting to protest the attorney general's listing. Strand, like other members of

Fig. 70. Promotional booklet produced by the Photo League, c. 1948.

the League, noted in an interview that the arts and culture were often the first realms to be attacked by rising conservative powers. "A lot of other people in America," he said, "are being prevented from discussing the things nearest them, things which relate to their creative work and creative lives. Instead, they are faced with the necessity of talking politics" (fig. 70).[51] Some members questioned whether lack of understanding of photography and fear of photography were elements. None of these questions can be settled based on the documents available. Each person will bring to the documents his or her personal perspectives and individual conclusions. It is as Jack Lessinger proposed: like reading the Japanese tale *Rashomon*. But *Rashomon* was fiction: a story written by Ryūnosuke Akutagawa and made famous by Akira Kurosawa in his 1950 film.[52] The Photo League's blacklisting, whatever its various roots and tellings, had real and injurious consequences for individuals, affecting their livelihoods, friendships, health, and artistic vision. For some, it replaced hope with fear, and, when interviewed thirty years later, they were still reluctant to talk about the experience. Others were openly accusatory of the people and process that had damaged an organization and people they loved.

Unless otherwise noted, all interviews, letters, and reports are from the author's archives in Houston.

1. This committee lasted until 1975, but its power waned in the late 1950s.

2. The McCarran Internal Security Act (1950) required members of the Communist Party, and any of the two hundred organizations claimed by the government to be "Communist Fronts," to register with the government and to provide lists of their members.

3. The most famous incident in those hearings, watched by millions on the new medium of television, was an exchange between McCarthy and the army's chief legal representative, Joseph Nye Welch, who in response to a relentless attack by McCarthy on a man in Welch's office, responded: "Let us not assassinate this lad further, Senator. You've done enough. Have you no sense of decency, sir, at long last? Have you left no sense of decency?"

4. The organization's name went through several iterations; "Photo" was for a time spelled "Foto" in the European manner.

5. Hurwitz, Lerner, Strand, and Maddow were all affected by the Blacklist. As early as 1936 Hurwitz reported that he couldn't continue to work on Pare Lorentz's film *The Plow That Broke the Plains* because someone had reported him as "red" and he had lost his bond, which was necessary to work on a government-subsidized film; interview with the author, June 3, 1975. Lerner said that in the 1940s he was only on a "gray list" because he wasn't important enough; he just had important friends; interview with the author, July 31, 1975.

6. Letter to the author, June 20, 1978.

7. His name appears in *Photo Notes* variously as Saul and Sol. Although Fabricant was one of the more educated members of the League, his background was similar to that of many others: he was born in Brooklyn and had worked his way through college.

8. As a young man, Siskind had been a Socialist. He explained that in his childhood neighborhood one's choice was to be either a Socialist or a Communist. By the time he reached the Film and Photo League, and certainly in his days at the Photo League, he was sick of the position that "art is the weapon of the working class." He wanted nothing to do with anything doctrinaire, but wanted to explore new possibilities in photography; interview with the author, December 17, 1973.

9. Carl Chiarenza, *Aaron Siskind: Pleasures and Terrors* (Cambridge, MA: Harvard University Press, 1973), 52. By "overt political activity" Chiarenza may be referring to an actual "trial" at the Film and Photo League that expelled a member for denouncing conditions in Russia. Siskind said the member was tried for "spreading lies about the worker's homeland"; interview with the author, December 17, 1973. No such trials were reported as occurring at the Photo League.

10. Interview with the author, December 17, 1973.

11. See Maurice Berger's essay in this volume.

12. Interview with the author, October 23, 1974. In 1941 Manning needed security clearance for a *Saturday Evening Post* assignment on submarines. He was questioned by the FBI as part of his application for clearance, and when they asked if he was a Communist he said, "No, I'm a Democrat." He had still been in high school when he was at the League, and too young to vote. Nevertheless, Manning received only a partial security clearance and never did get to the highest level.

13. Interview with the author, July 1975.

14. Ibid.

15. Interview with the author, March 3, 1975.

16. Interview with the author, June 6, 1975.

17. Lloyd Goodrich, "Politics and Policies in American Art," *Art Digest* 26, no. 3 (November 1, 1951): 63.

18. Interview with the author, July 17, 1975. Ausubel was chairperson of the Hine Committee from 1942 to 1949.

19. Interview with the author, March 16(?), 1975.

20. Interview with the author, July 8, 1975. Rose was an independent carpenter, so his livelihood was not threatened by his association with the League; he remained a member until it closed.

21. Interview with the author, April 29, 1975.

22. Letter to the author, June 20, 1978.

23. "For a League of American Photography," *Photo Notes* (August 1938), 1.

24. Photo League brochure, 1947.

25. This paragraph and some other information in this essay was first published in Anne Tucker, "Photographic Crossroads: The Photo League," *Journal (National Gallery of Canada, Ottawa)* 25 (April 1978), and special supplement in *Afterimage* 5, no. 10 (April 1978). See also Anne Wilkes Tucker, "The Photo League: A Center for Documentary Photography," in *This Was the Photo League: Compassion and the Camera from the Depression to the Cold War* (Chicago: Stephen Daiter Gallery, and Houston: John Cleary Gallery, 2001), 9–19.

26. The scholarship was given to Lou Stoumen, who later became an Academy Award–winning documentary filmmaker.

27. Newhall joined no organizations, including the League, while he was a curator at the Museum of Modern Art, and resigned his membership in August 1948 when he became the director of the George Eastman House. He wrote to Walter Rosenblum when he paid his 1948 dues in July that he wanted to "retire in good standing and as a paid-up member"; Newhall to Rosenblum, August 19, 1948; this and other letters from Rosenblum to the Newhalls and to Paul Strand are in the Center for Creative Photography, University of Arizona, © Estate of Beaumont and Nancy Newhall, quoted by permission of Scheinbaum and Russek Ltd., Santa Fe, New Mexico.

28. "Letters to the League," *Photo Notes* (July 1947), 3.

29. In her book, *Red Masquerade: Undercover for the F.B.I.* (Philadelphia: Lippincott, 1950), Calomiris is vague about this. She writes of taking classes with Sid Grossman (identified in her book only as Joe) before she began to work with the FBI in February 1942. But her name does not appear in *Photo Notes* until the May 1942 issue, when she is listed on the committee for a Photo League party.

30. Russell Porter, "Girl Aide of FBI Testifies of 7 Years as Communist," *New York Times*, April 27, 1949, 11.

31. Interview with the author, June 4, 1975.

32. Interview with the author, July 8, 1975.

33. Calomiris said, "When it was suggested to me that I join the party, it was directly with contacts in the league"; ibid.

34. Federal Bureau of Investigation report, October 21–December 12, 1940, filed December 18, 1940, from the Oklahoma City office. When cataloguing Grossman's prints and negatives in 1983 the author found neither photographs nor negatives of oil wells or people in tents.

35. Because of the Nazi-Soviet Non-Aggression Pact, signed on September 9, 1939, Communist Party members were opposed to the United States entering World War II, a policy that changed when Germany invaded the Soviet Union in June 1941.

36. Military Intelligence Service, filed from Atlantic City, May 13, 1943.

37. Grossman was initially listed as medically unfit for the army for unknown reasons. However, most interviews reported that he was never without a cigarette and a cup of coffee and that his army physical was the first medical exam he had ever had. He died at age forty-two of a heart attack.

38. It is difficult to count the interviews, as all names are blanked out in the documents and some are merged.

39. As early as December 12, 1930, there was a query from the Department of Immigration and Naturalization to the FBI asking for information about the Workers' Camera League of the Workers' International Relief, Local No. 10, East Seventeenth Street, New York City. The FBI

responded that it had no information at that time. Another FBI document noted that the Film and Photo League "essentially was a non-political [organization that] afforded artists and photographers opportunity to display their work. During the late 1930s," it observed, "the Communist[s] attempted and finally succeeded in taking over this organization and it later became known as a Communist front organization." That document is presumably from the 1940s or perhaps late 1930s. A memorandum in government files from D. A. Ladd, FBI, dated April 24, 1942, records that the Film and Photo League was among thirty-three organizations whose names had been submitted on October 31, 1941, to the Department of Justice for a ruling as to whether they should be part of any investigation of government employees under Public Law No. 175, 77th Congress. Ladd noted, however, "There is in no instance substantial evidence which would indicate that any of the above-mentioned organizations are dominated or controlled by the Communist Party. It may well be they are considered 'front' organizations and their particular functions may well serve the interest of the Communist Party in the United States, although this fact may not be susceptible as proof."

40. Army Service Forces report, Governor's Island, New York, April 6, 1943.

41. Letter, October 1, 1949, Beaumont and Nancy Newhall papers, Getty Research Institute, Los Angeles.

42. Interview with the author, June 3, 1975.

43. Interview with the author, August 21, 1974. Palfi was not without courage. In 1974, at age sixty-seven, she focused her documentary work on prison conditions; she took ten years off her age to gain access to prisons.

44. Interview with the author, March 17, 1975.

45. Letter, August 8, 1949, Beaumont and Nancy Newhall papers, Getty Research Institute, Los Angeles, © Estate of Beaumont and Nancy Newhall, quoted by permission of Scheinbaum and Russek Ltd., Santa Fe, New Mexico.

46. Interview with the author, October 26, 1976.

47. Interview with the author, June 4, 1975.

48. Phone interview with the author, September 15, 1977.

49. Letter to the author, June 20, 1978.

50. Interview with the author, April 16, 1974.

51. "Address by Paul Strand," *Photo Notes* (January 1948), 1.

52. Actually the film is based on two of Akutagawa's stories: "Rashomon," 1913, and "In the Grove," 1922, which were, in turn, based partly on Japanese folktales.

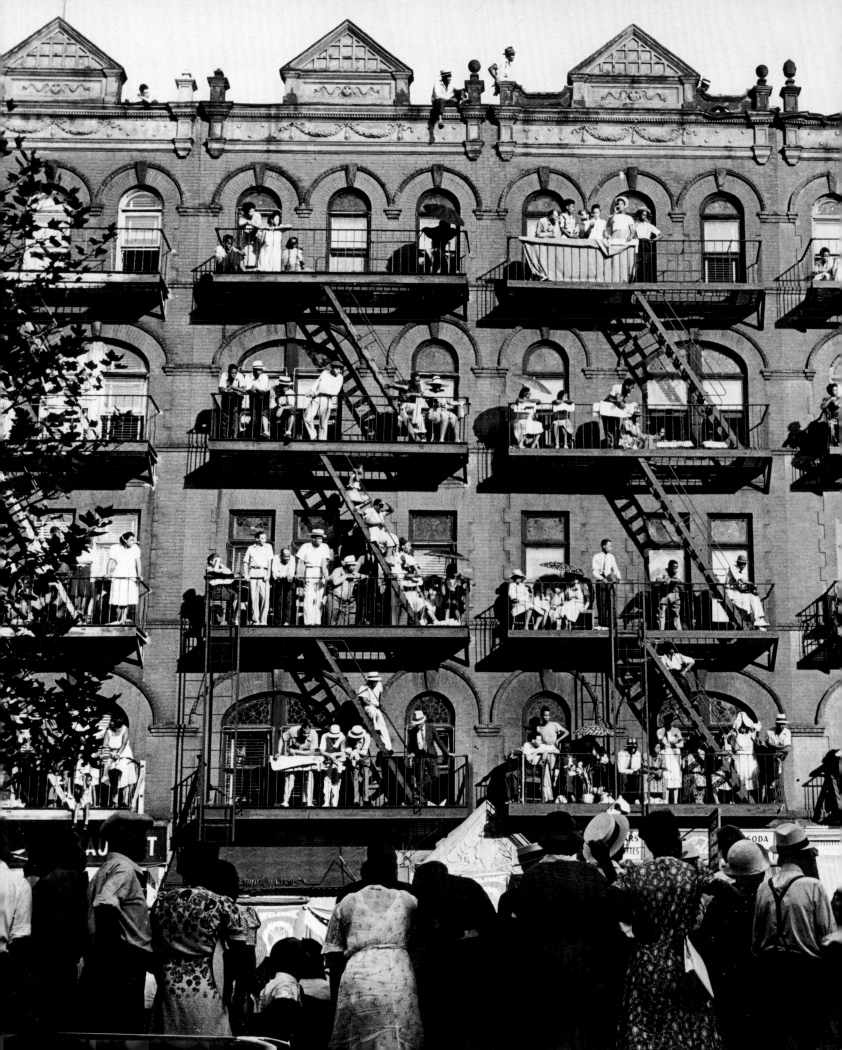

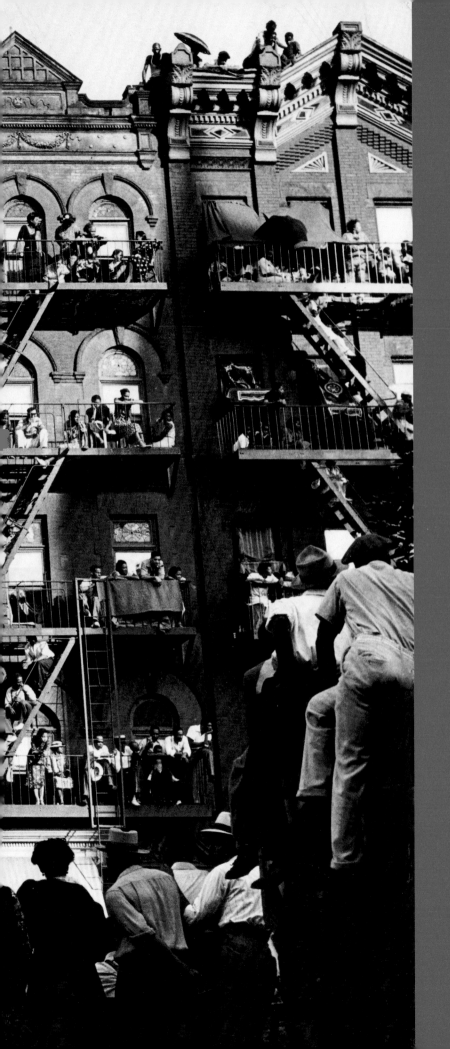

PLATES

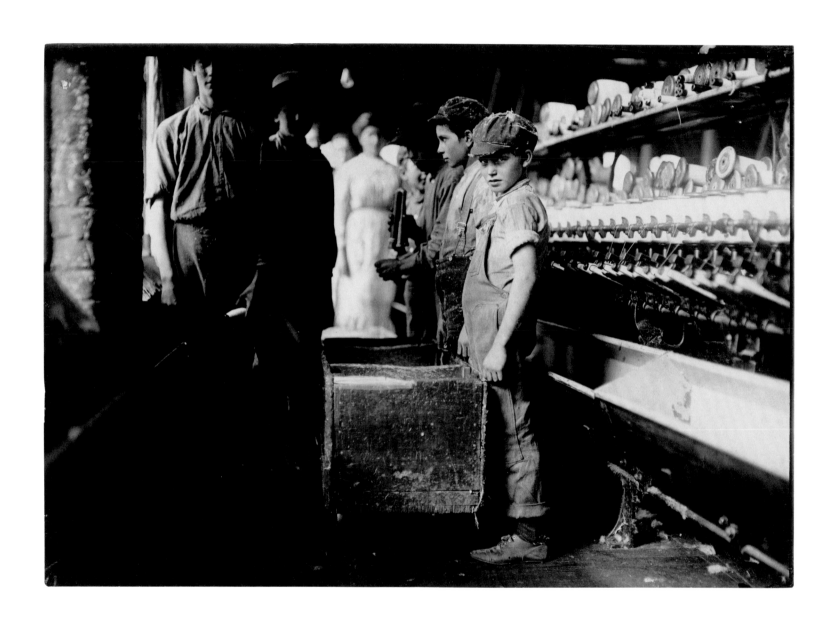

Plate 1. **Lewis Hine** *Young Doffers in the Elk Cotton Mills, Fayetteville, Tennessee,* 1910
Gelatin silver print, 4¾ × 6⅝ in. (12.1 × 16.8 cm). The Jewish Museum, New York, Purchase: The Paul Strand Trust for the benefit of Virginia Stevens Gift

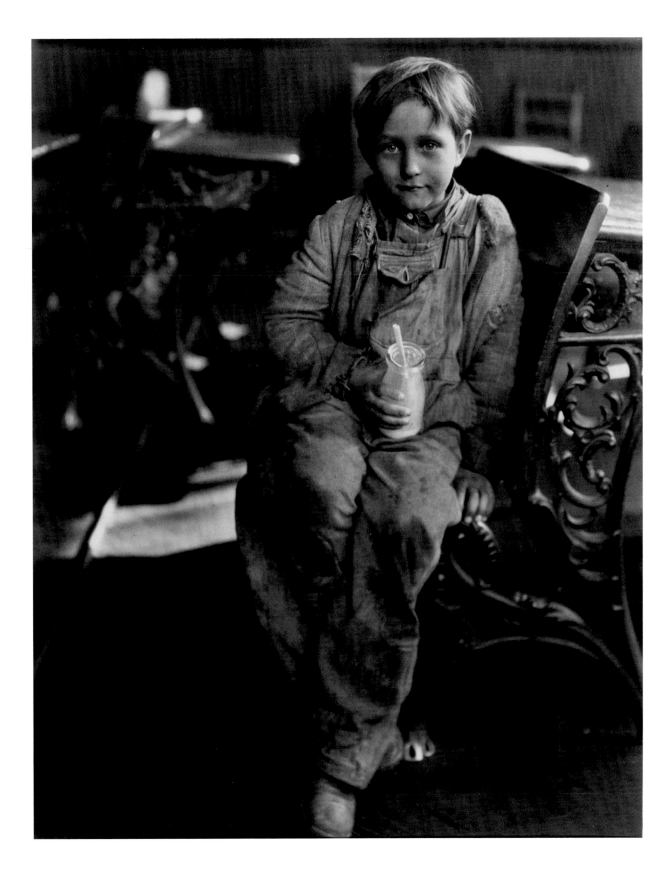

Plate 2. **Lewis Hine** *Schoolboy Receives Aid from Red Cross During Drought, Kentucky,* c. 1930
Gelatin silver print, 9¼ × 7¼ in. (23.5 × 18.4 cm). Columbus Museum of Art, Ohio, Photo League Collection, Museum Purchase with
funds provided by Elizabeth M. Ross, the Derby Fund, John S. and Catherine Chapin Kobacker, and the Friends of the Photo League

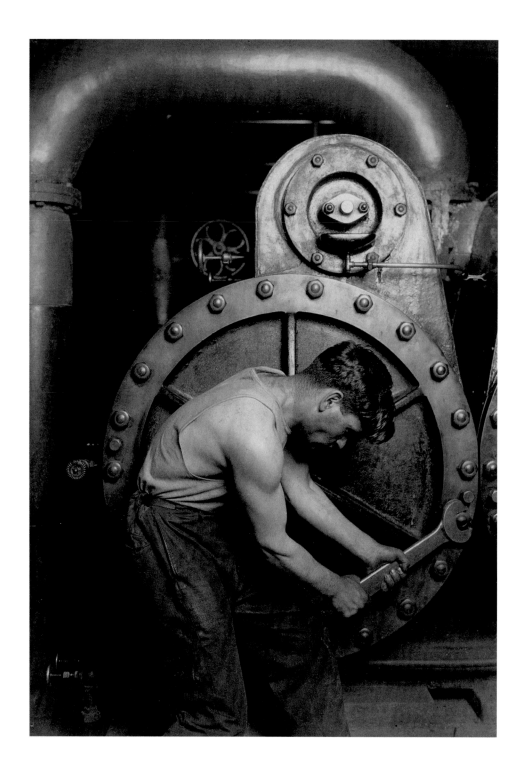

Plate 3. **Lewis Hine**. *Steamfitter*, 1920
Gelatin silver print, 6⅝ × 4⅝ in. (16.8 × 11.7 cm). Howard Greenberg Gallery

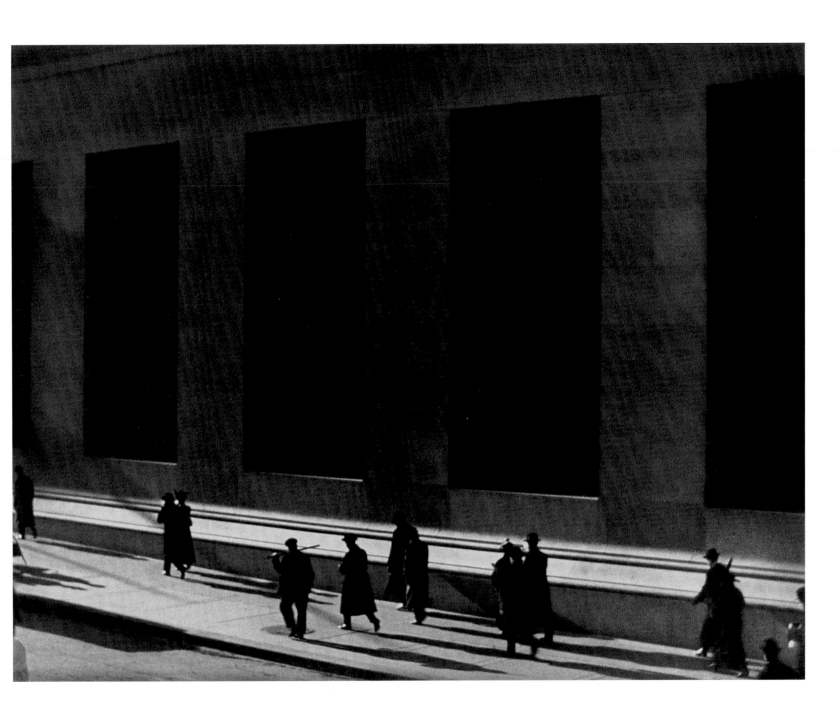

Plate 4. **Paul Strand** *Wall Street, New York*, 1915
Platinum palladium print, 10 × 12⅝ in. (25.4 × 32.1 cm)

Plate 5. **Paul Strand** *Truckman's House, New York*, 1920, printed later
Gelatin silver print, 9½ × 7⅜ in. (24.1 × 19.4 cm). The Jewish Museum, New York, Gift of Melissa Harris

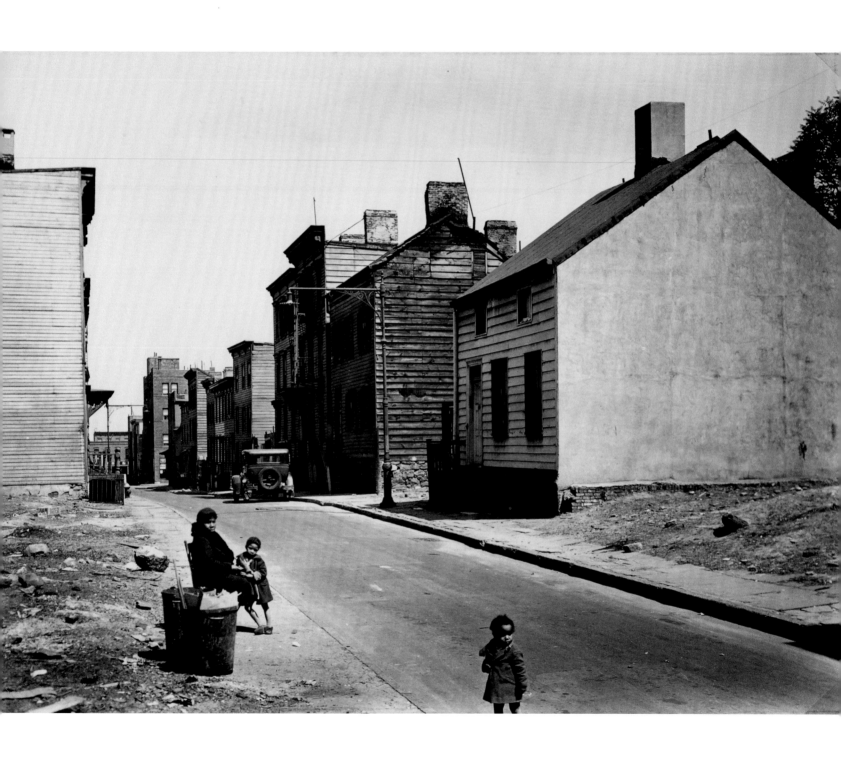

Plate 6. **Berenice Abbott** *Talman Street, Fort Greene, Brooklyn*, 1936, from *Changing New York*, 1935–39
Gelatin silver print, 7¼ × 9½ in. (18.4 × 24.1 cm). Columbus Museum of Art, Ohio, Photo League Collection, Museum Purchase with
funds provided by Elizabeth M. Ross, the Derby Fund, John S. and Catherine Chapin Kobacker, and the Friends of the Photo League

Plate 7. **Berenice Abbott** *Gunsmith, 6 Centre Market Place*, 1937, from *Changing New York*, 1935–39
Gelatin silver print, 9½ × 7½ in. (24.1 × 19.1 cm). Columbus Museum of Art, Ohio, Photo League Collection, Museum Purchase with funds provided by Elizabeth M. Ross, the Derby Fund, John S. and Catherine Chapin Kobacker, and the Friends of the Photo League

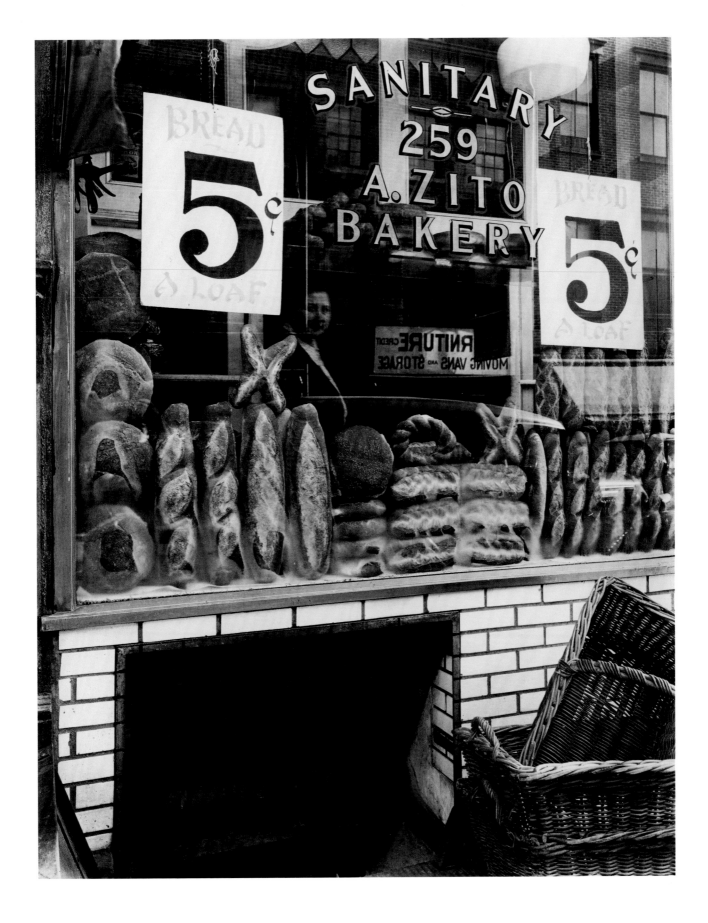

Plate 8. **Berenice Abbott** *Zito's Bakery, 259 Bleecker Street,* 1937, from *Changing New York,* 1935–39
Gelatin silver print, 9¾ × 7⅝ in. (24.8 × 19.4 cm). The Jewish Museum, New York, Purchase: Mimi and Barry J. Alperin Fund

96

Plate 9. **Arnold Eagle** *Third Avenue El, 18th Street Station*, 1935
Gelatin silver print, 13⅜ × 9⅛ in. (34 × 23.2 cm). The Jewish Museum, New York, Purchase: The Paul Strand Trust for the benefit of Virginia Stevens Gift

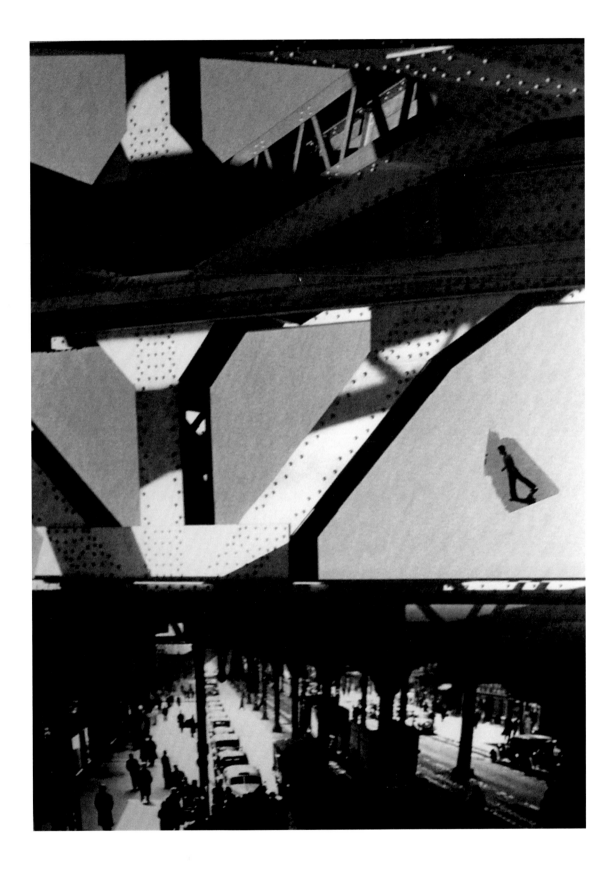

Plate 10. **Barbara Morgan** *Third Avenue El,* 1936, printed c. 1945
Gelatin silver print, 12 × 8½ in. (30.5 × 21.6 cm). Bruce Silverstein Gallery

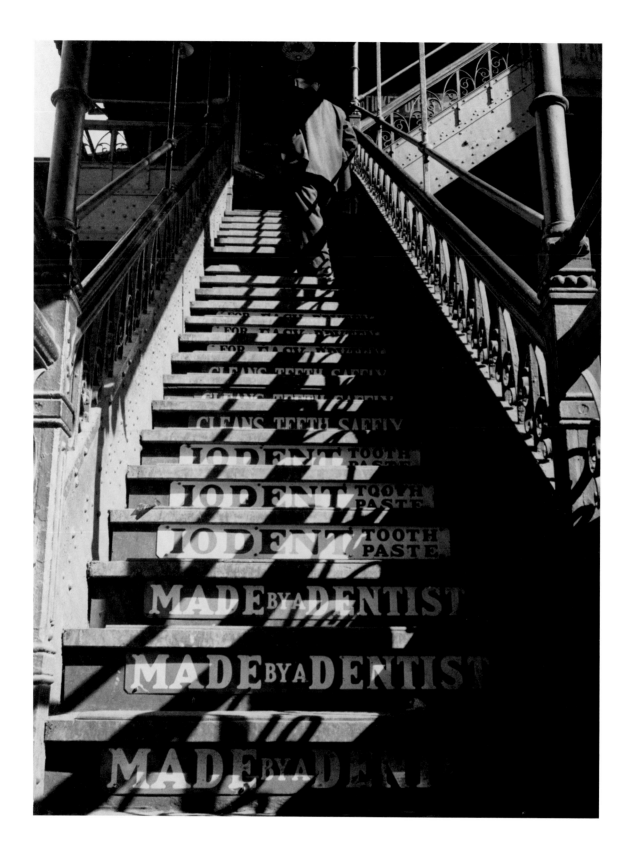

Plate 11. **Eliot Elisofon** *Untitled (Iodent Toothpaste Ads),* c. 1937
Gelatin silver print, 8⅞ × 6¾ in. (22.5 × 17.1 cm). The Jewish Museum, New York, Purchase: Mimi and Barry J. Alperin Fund

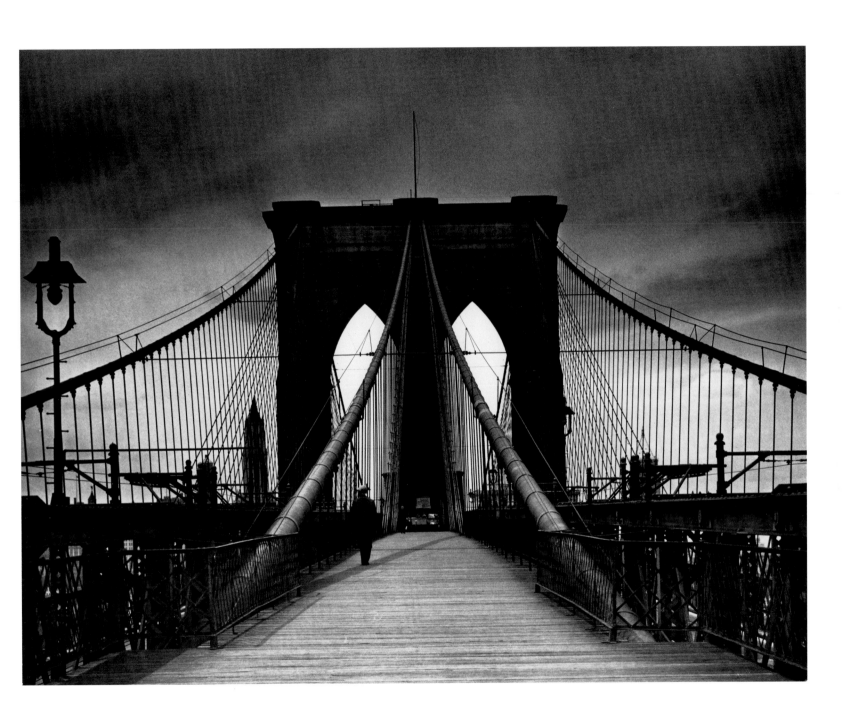

Plate 12. **Alexander Alland** *Untitled (Brooklyn Bridge),* c. 1938
Gelatin silver print, 8 × 9⅞ in. (20.3 × 25.1 cm). The Jewish Museum, New York, Purchase: William and Jane Schloss Family Foundation Fund

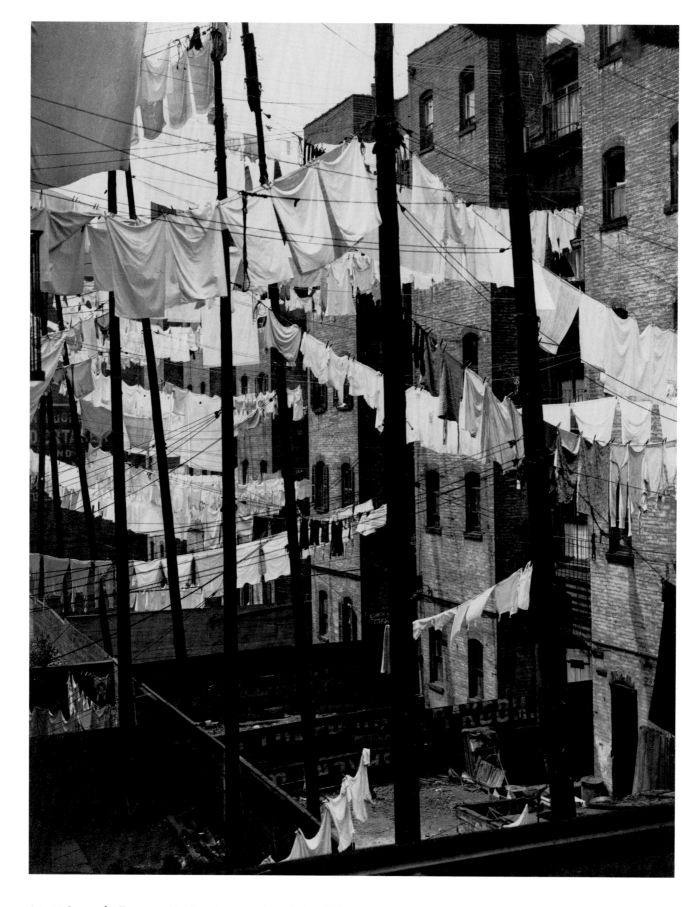

Plate 13. **Consuelo Kanaga** *Untitled (Tenements, New York)*, c. 1937
Gelatin silver print, 7¾ × 6⅛ in. (19.7 × 15.6 cm). The Jewish Museum, New York, Purchase: The Paul Strand Trust for the benefit of Virginia Stevens Gift

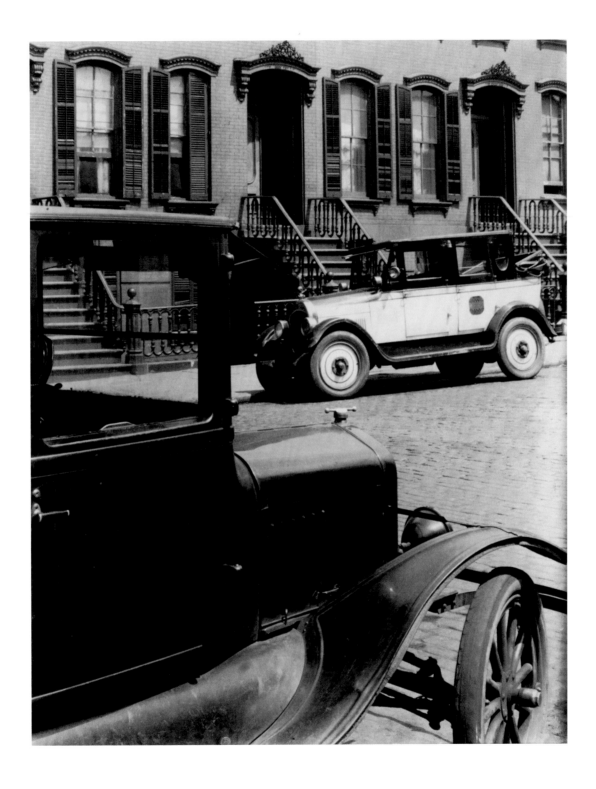

Plate 14. **Ralph Steiner** *Two Cars*, c. 1935

Gelatin silver print, 9½ × 7⅝ in. (24.1 × 19.4 cm). Columbus Museum of Art, Ohio, Photo League Collection, Museum Purchase with funds provided by Elizabeth M. Ross, the Derby Fund, John S. and Catherine Chapin Kobacker, and the Friends of the Photo League

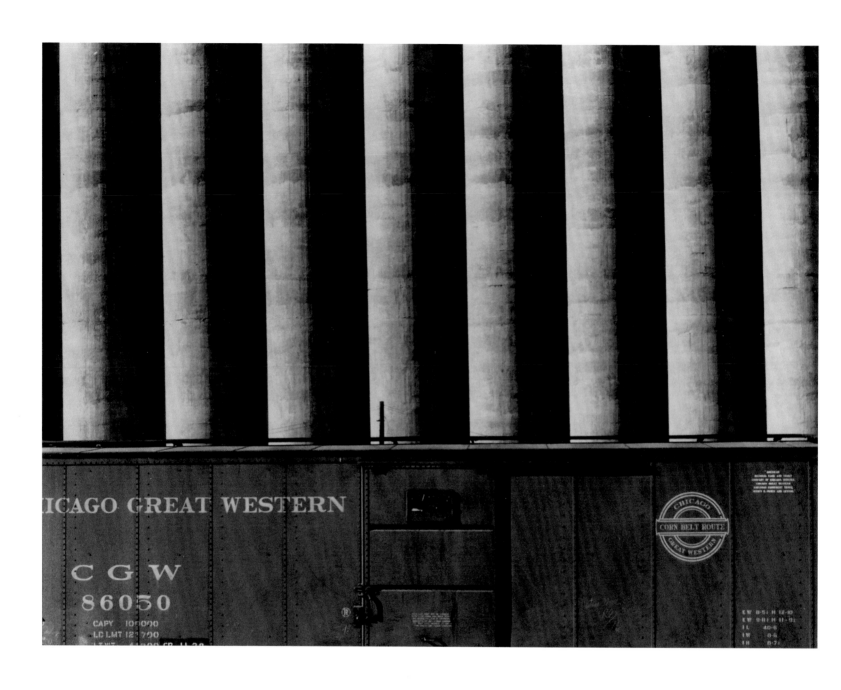

Plate 15. **John Vachon** *Freight Car and Grain Elevators, Omaha, Nebraska,* 1938
Gelatin silver print, 7 × 9¼ in. (17.8 × 23.5 cm). Columbus Museum of Art, Ohio, Photo League Collection, Museum Purchase with
funds provided by Elizabeth M. Ross, the Derby Fund, John S. and Catherine Chapin Kobacker, and the Friends of the Photo League

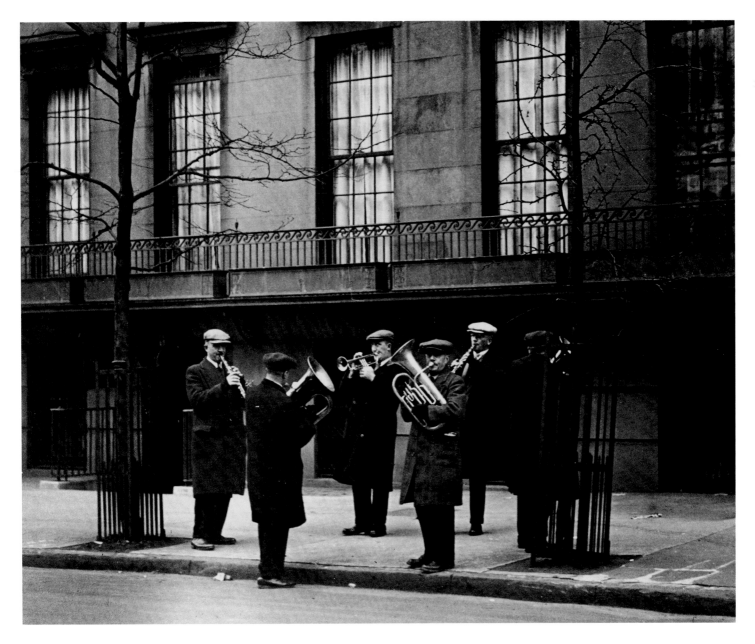

Plate 16. **Robert Disraeli** *Untitled (German Street Band),* 1934
Gelatin silver print, 7¾ × 9⅞ in. (19.7 × 25.1 cm). The Jewish Museum, New York, Purchase: The Paul Strand Trust for the benefit of Virginia Stevens Gift

Plate 17. **Harold Corsini** *Driller's Helper Cleans Hands, Union County, Kentucky,* 1944

Gelatin silver print, 7½ × 7½ in. (19.1 × 19.1 cm). Columbus Museum of Art, Ohio, Photo League Collection, Museum Purchase with funds provided by Elizabeth M. Ross, the Derby Fund, John S. and Catherine Chapin Kobacker, and the Friends of the Photo League

Plate 18. **Arthur Rothstein** *Wife and Child of a Sharecropper, Washington County, Arkansas, 1935*
Gelatin silver print, 9½ × 6¾ in. (24.1 × 17.1 cm). Columbus Museum of Art, Ohio, Photo League Collection, Museum Purchase with funds provided by Elizabeth M. Ross, the Derby Fund, John S. and Catherine Chapin Kobacker, and the Friends of the Photo League

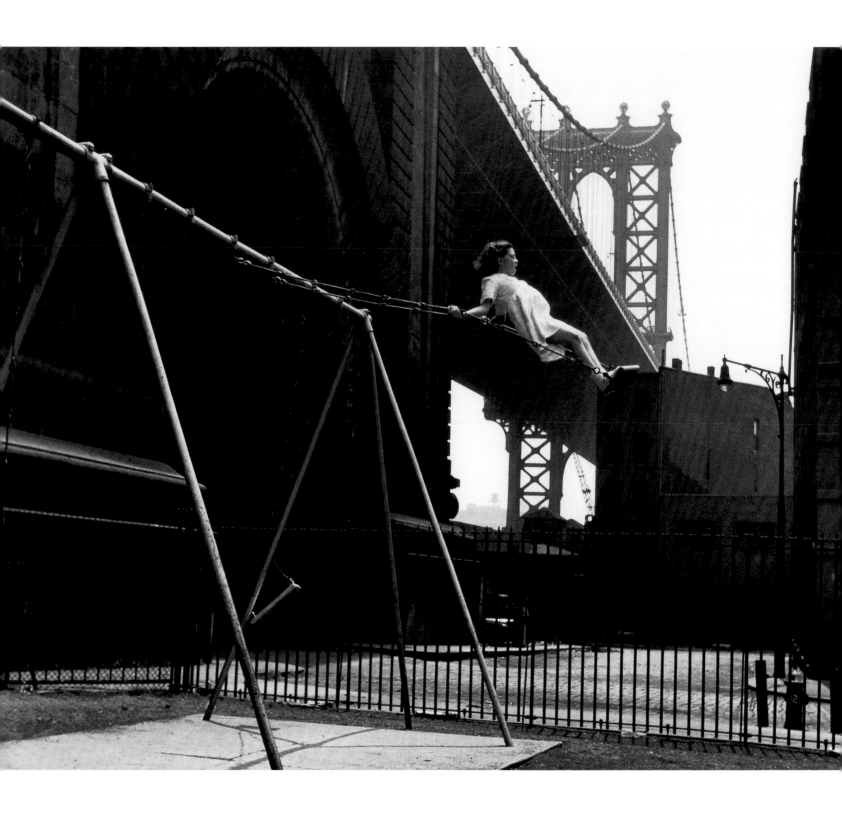

Plate 19. **Walter Rosenblum** *Girl on a Swing, New York*, 1938
Gelatin silver print, 6⅜ × 8 in. (16.2 × 20.3 cm). The Jewish Museum, New York, Gift of the Rosenblum Family

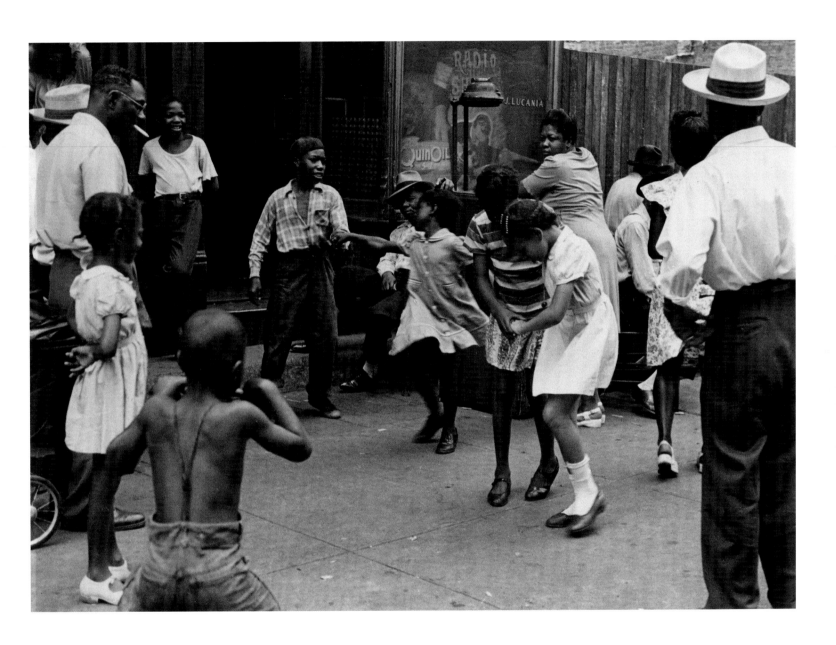

Plate 20. **Helen Levitt** *New York*, c. 1940
Gelatin silver print, 11 × 14 in. (27.9 × 35.6 cm). The Jewish Museum, New York, Purchase: Lillian Gordon Bequest

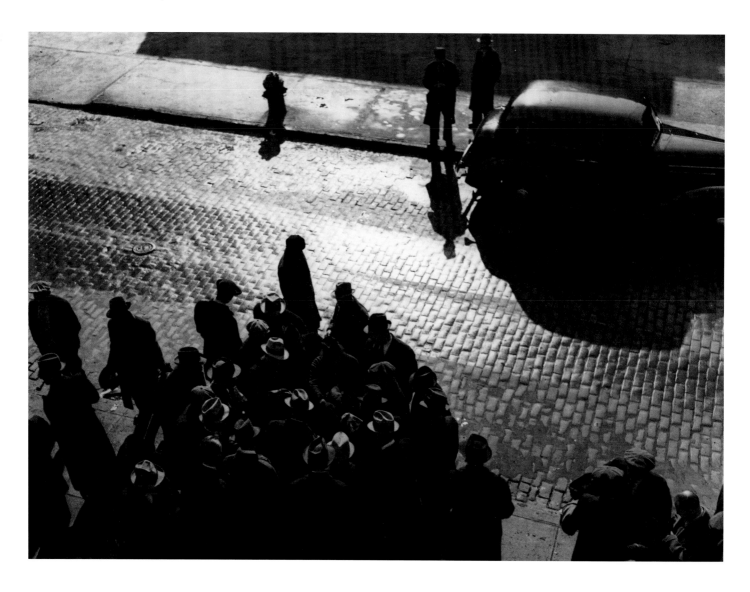

Plate 21. **Walter Rosenblum** *Flea Market, Pitt Street, New York,* 1938
Gelatin silver print, 7⅜ × 9½ in. (18.7 × 24.1 cm). Columbus Museum of Art, Ohio, Photo League Collection, Museum Purchase with funds
provided by Elizabeth M. Ross, the Derby Fund, John S. and Catherine Chapin Kobacker, and the Friends of the Photo League

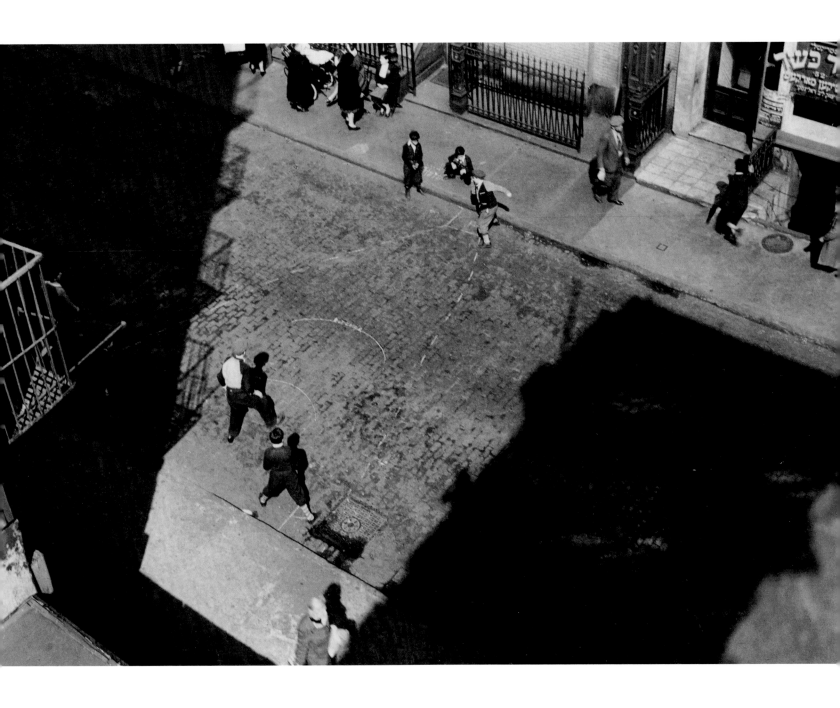

Plate 22. **Sidney Kerner** *Pitt Street, New York,* 1938
Gelatin silver print, 8⅜ × 12 in. (21.3 × 30.5 cm). Columbus Museum of Art, Ohio, Photo League Collection, Museum Purchase with funds provided by Elizabeth
M. Ross, the Derby Fund, John S. and Catherine Chapin Kobacker, and the Friends of the Photo League

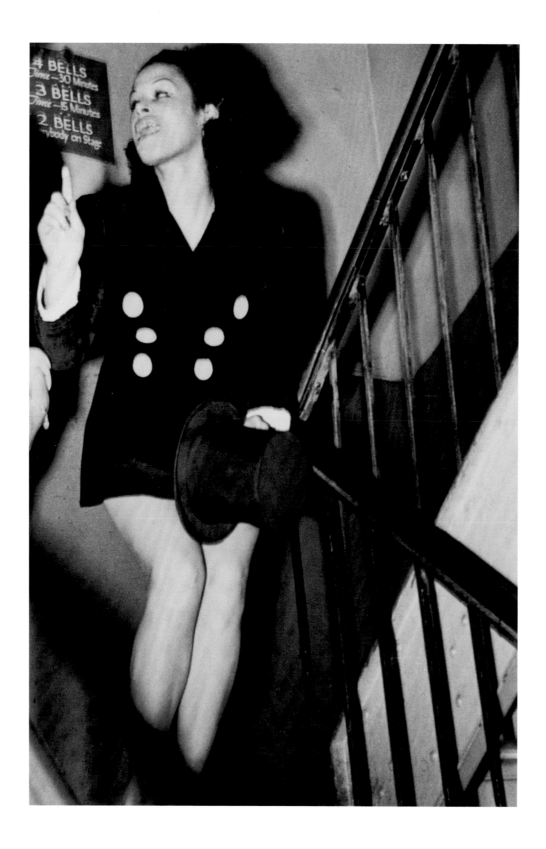

Plate 23. **Richard Lyon** *Cabaret Dancer Going on the Stage*, 1937, from *Harlem Document*, 1936–40
Gelatin silver print, 9¼ × 6⅛ in. (23.5 × 15.6 cm). Columbus Museum of Art, Ohio, Photo League Collection, Museum Purchase with
funds provided by Elizabeth M. Ross, the Derby Fund, John S. and Catherine Chapin Kobacker, and the Friends of the Photo League

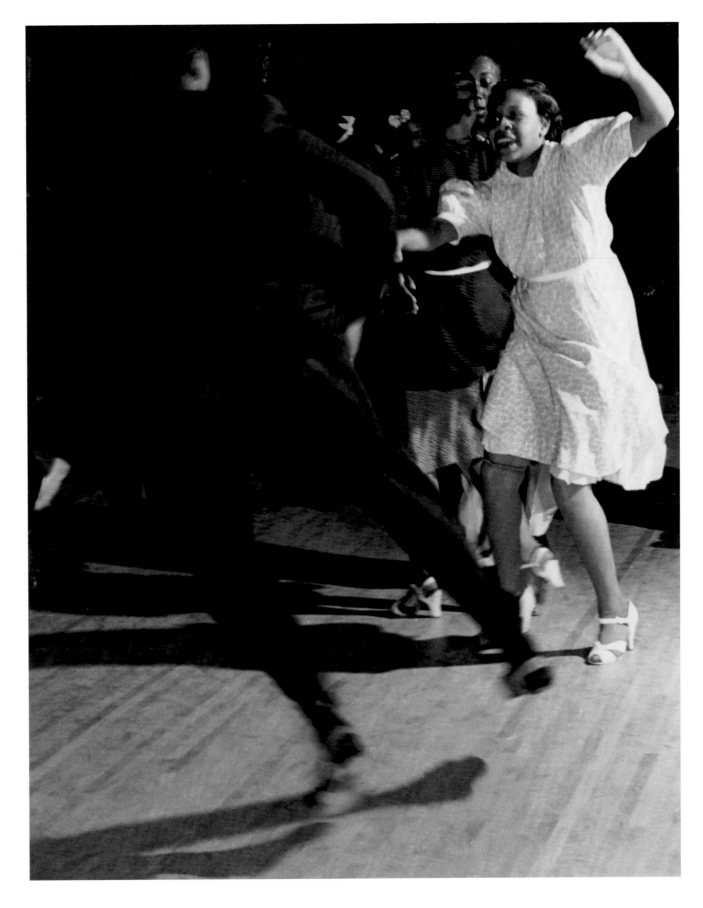

Plate 24. **Sid Grossman** *Harlem, New York,* c. 1936, from *Harlem Document,* 1936–40
Gelatin silver print, 9⅜ × 7⅜ in. (23.8 × 18.7 cm). The Jewish Museum, New York, Purchase: The Paul Strand Trust for the benefit of Virginia Stevens Gift

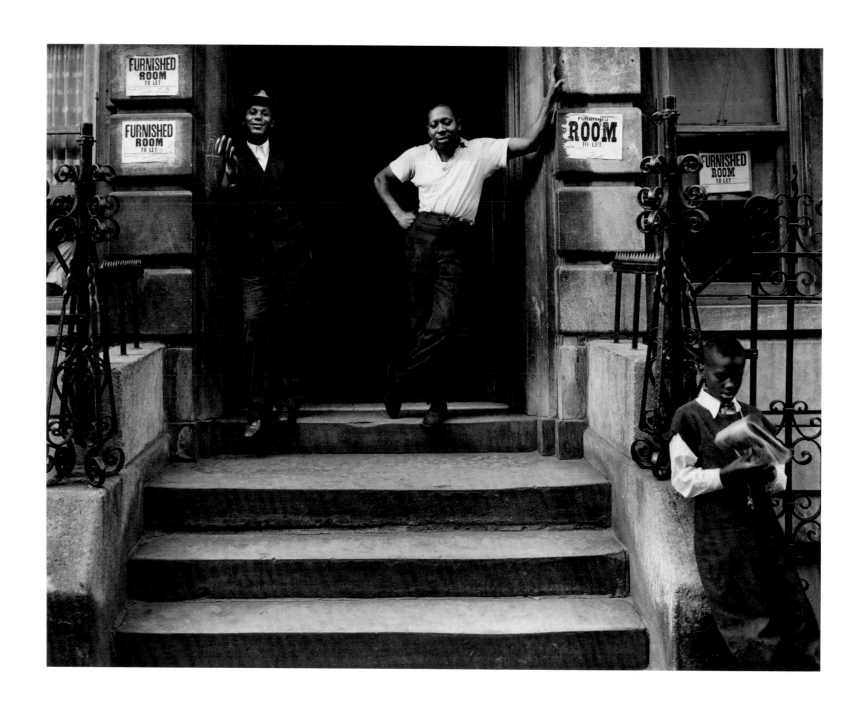

Plate 25. **Max Yavno** *Harlem*, c. 1940, from *Harlem Document*, 1936–40
Gelatin silver print, 10½ × 13⅜ in. (26.7 × 34 cm). The Jewish Museum, New York, Purchase: Photography Acquisitions Committee Fund

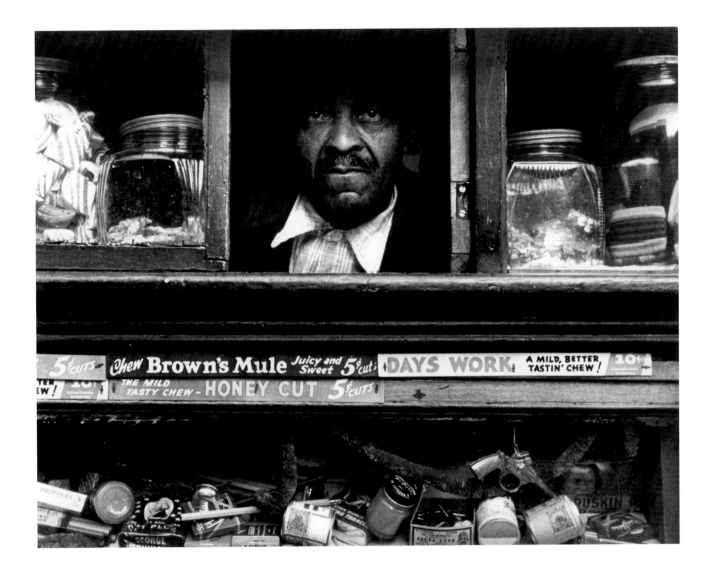

Plate 26. **Morris Engel** *Harlem Merchant, New York*, 1937, from *Harlem Document*, 1936–40
Gelatin silver print, 7⅜ × 9½ in. (18.7 × 24.1 cm). Columbus Museum of Art, Ohio, Photo League Collection, Museum Purchase with funds provided by Elizabeth M. Ross, the Derby Fund, John S. and Catherine Chapin Kobacker, and the Friends of the Photo League

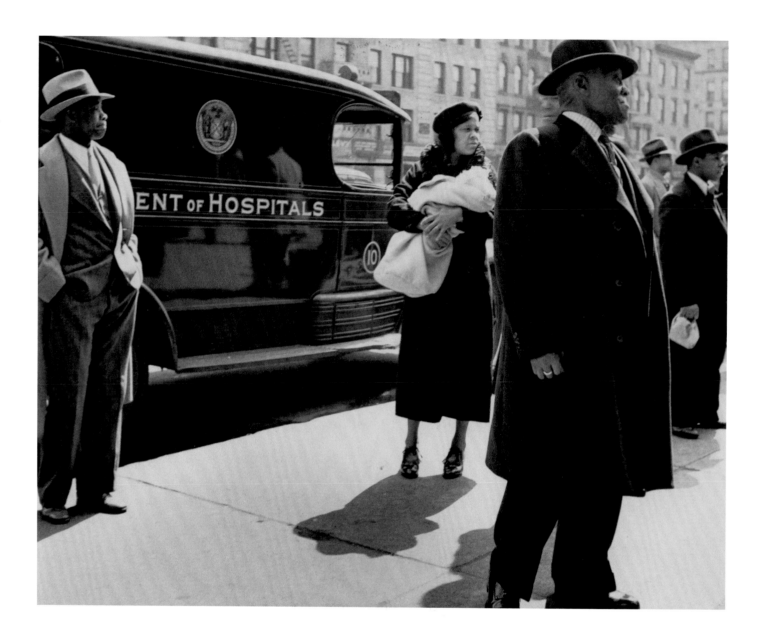

Plate 27. **Lucy Ashjian** *Untitled (Group in Front of Ambulance)*, from *Harlem Document*, 1936–40
Gelatin silver print, 7 × 8¾ in. (17.8 × 22.2 cm). Columbus Museum of Art, Ohio, Photo League Collection, Museum Purchase with
funds provided by Elizabeth M. Ross, the Derby Fund, John S. and Catherine Chapin Kobacker, and the Friends of the Photo League

Plate 28. **Lucy Ashjian** *Untitled (Steps)*, 1936–40
Gelatin silver print, 3¾ × 4¾ in. (9.5 × 12.1 cm). The Jewish Museum, New York, Gift of Christine Tate

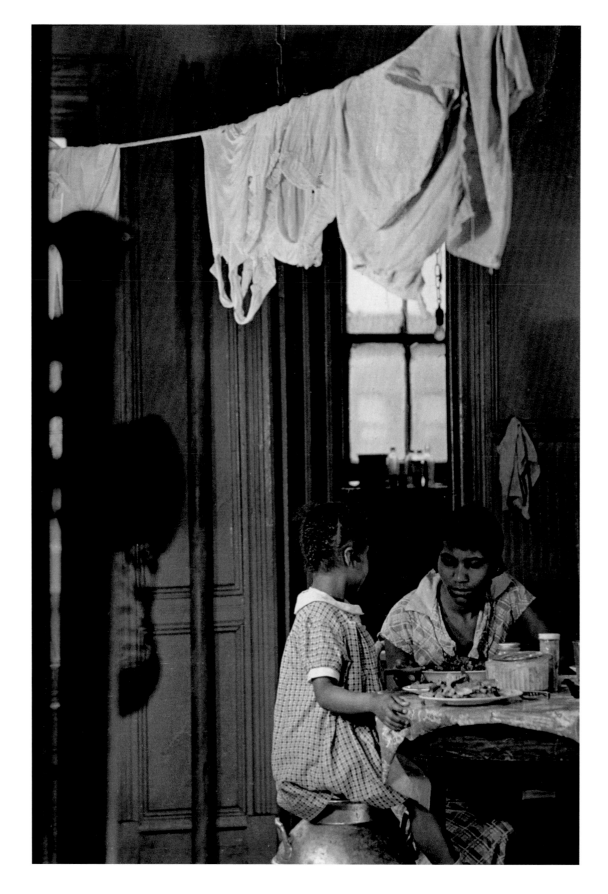

Plate 29. **Aaron Siskind** *Untitled (Kitchen Scene),* c. 1937, from *Harlem Document,* 1936–40
Gelatin silver print, 7⅜ × 5 in. (18.7 × 12.7 cm). Columbus Museum of Art, Ohio, Photo League Collection, Museum Purchase with
funds provided by Elizabeth M. Ross, the Derby Fund, John S. and Catherine Chapin Kobacker, and the Friends of the Photo League

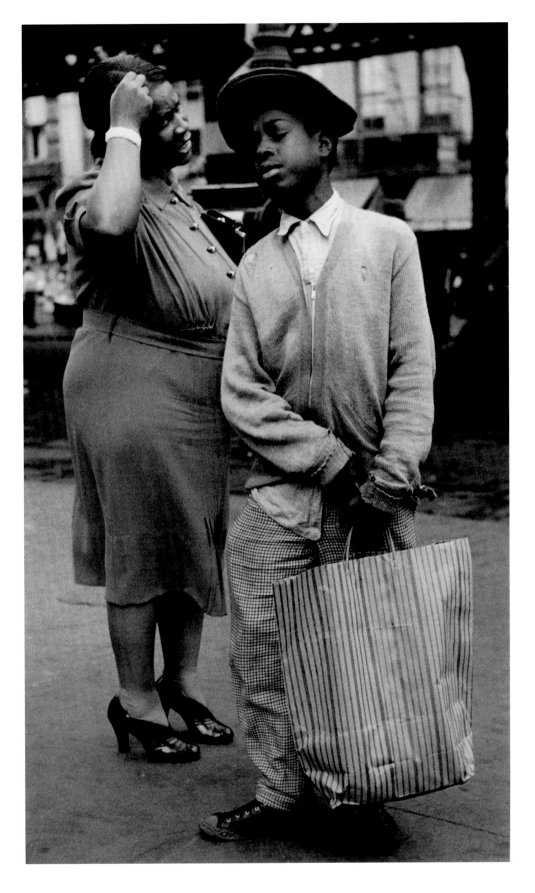

Plate 30. **Morris Engel** *Shopping, Ninth Avenue, New York, 1938*
Gelatin silver print, 13⅜ × 8⅛ in. (34 × 20.6 cm). Columbus Museum of Art, Ohio, Photo League Collection, Museum Purchase with
funds provided by Elizabeth M. Ross, the Derby Fund, John S. and Catherine Chapin Kobacker, and the Friends of the Photo League

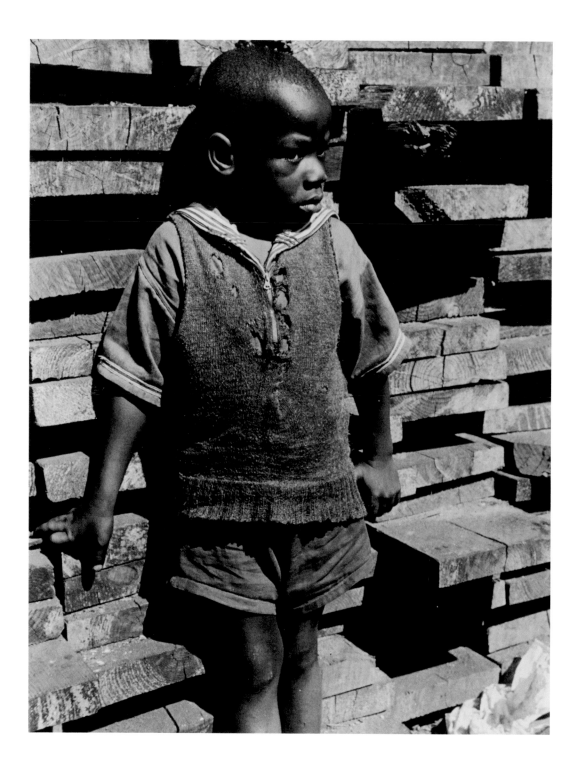

Plate 31. **Aaron Siskind** *Untitled*, c. 1940, from *Harlem Document*, 1936–40

Gelatin silver print, 13⅛ × 10⅜ in. (33.3 × 26.4 cm). Columbus Museum of Art, Ohio, Photo League Collection, Museum Purchase with funds provided by Elizabeth M. Ross, the Derby Fund, John S. and Catherine Chapin Kobacker, and the Friends of the Photo League

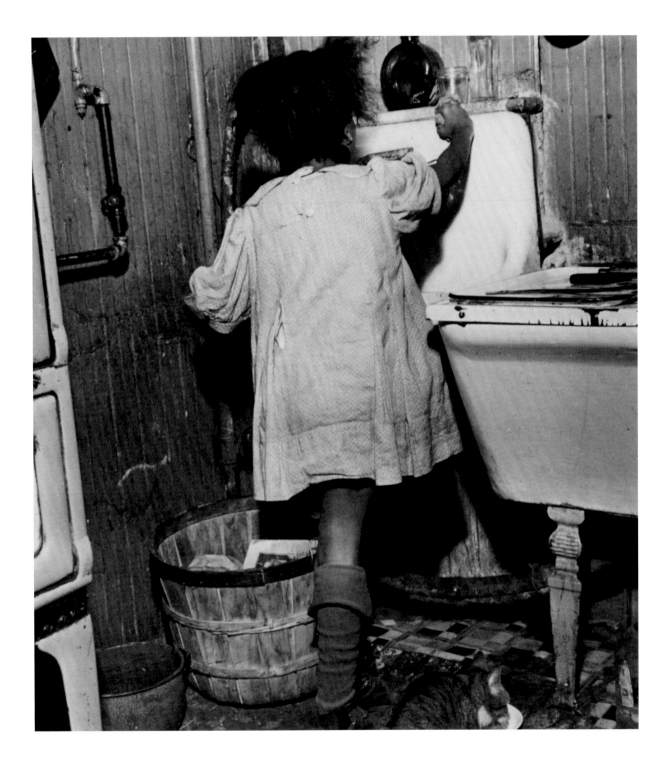

Plate 32. **Jack Manning** *Violet Greene Cleaning House*, c. 1939, from *Harlem Document*, 1936–40
Gelatin silver print, 8½ × 7¾ in. (21.6 × 19.7 cm). Columbus Museum of Art, Ohio, Photo League Collection, Museum Purchase with
funds provided by Elizabeth M. Ross, the Derby Fund, John S. and Catherine Chapin Kobacker, and the Friends of the Photo League

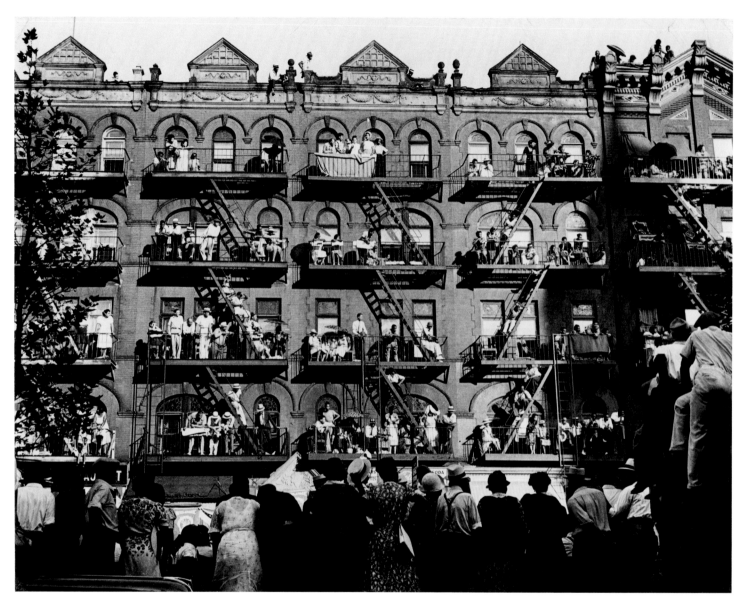

Plate 33. **Jack Manning** *Elks Parade*, 1938, from *Harlem Document*, 1936–40
Gelatin silver print, 10⅛ × 13 in. (25.7 × 33 cm). The Jewish Museum, New York, Purchase: Horace W. Goldsmith Foundation Fund

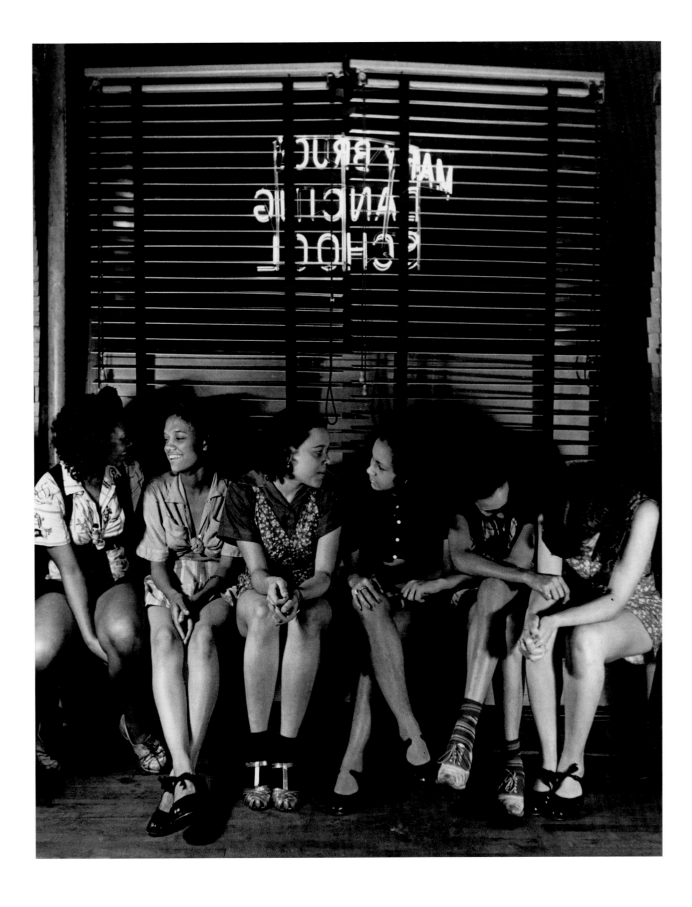

Plate 34. **Sol Prom (Solomon Fabricant)** *Untitled (Dancing School),* 1938, from *Harlem Document,* 1936–40
Gelatin silver print, 9⅞ × 7⅞ in. (25.1 × 20 cm). The Jewish Museum, New York, Purchase: Horace W. Goldsmith Foundation Fund

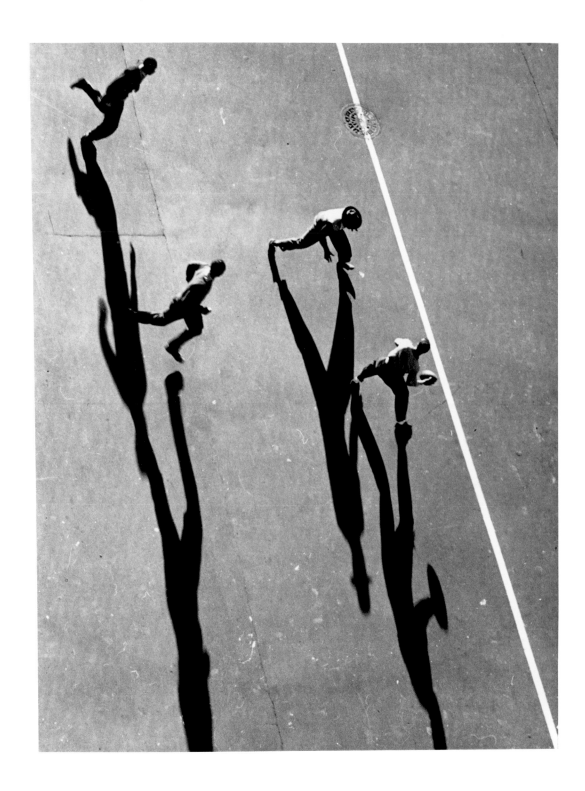

Plate 35. **Harold Corsini** *Playing Football,* c. 1939, from *Harlem Document,* 1936–40
Gelatin silver print, 9¼ × 7 in. (23.3 × 17.8 cm). George Eastman House, International Museum of Photography and Film, Rochester, New York, Gift of Aaron Siskind

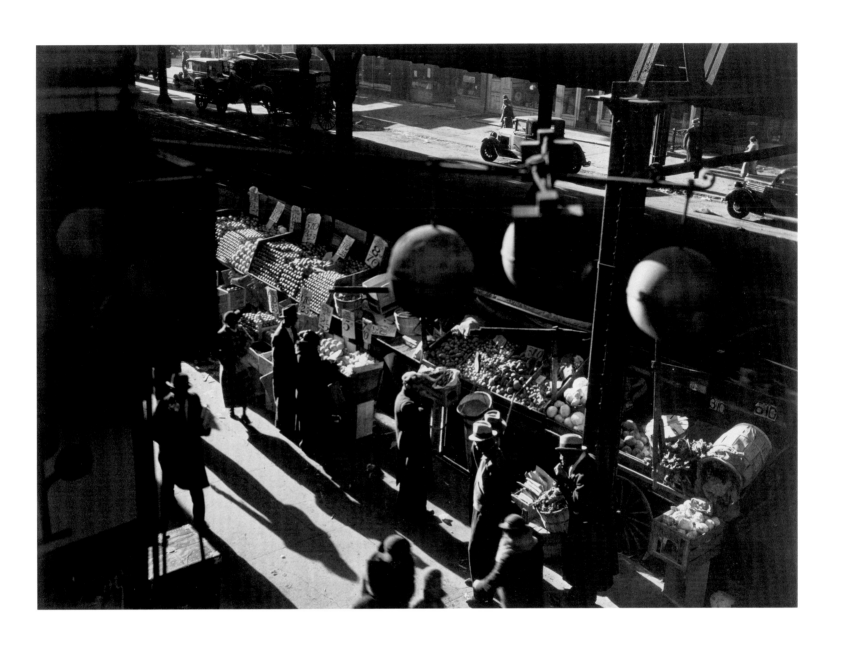

Plate 36. **Aaron Siskind** *Street Market*, 1937, printed later, from *Harlem Document*, 1936–40
Gelatin silver print, 11 × 14 in. (27.9 × 35.6 cm). The Jewish Museum, New York, Purchase: Lillian Gordon Bequest

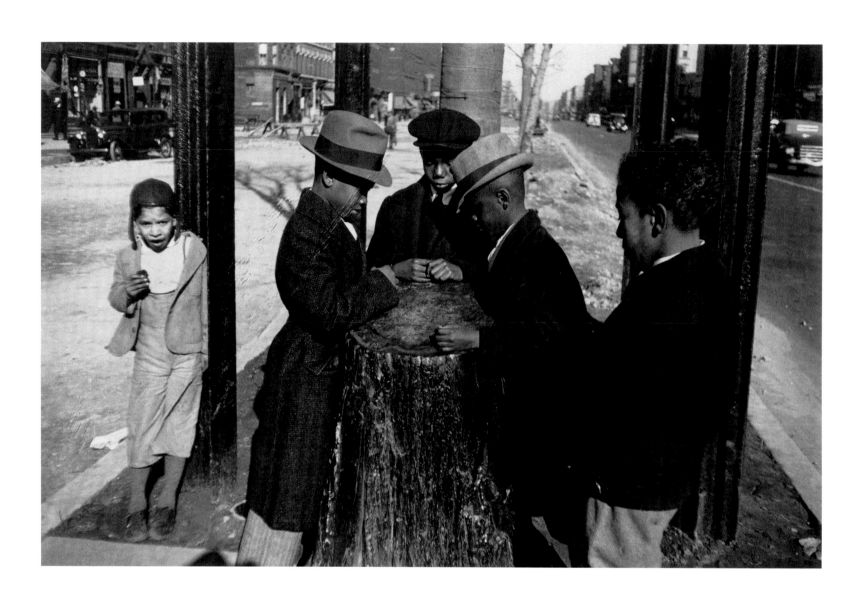

Plate 37. **Aaron Siskind** *The Wishing Tree*, 1937, printed later, from *Harlem Document*, 1936–40
Gelatin silver print, 11 × 14 in. (27.9 × 35.6 cm). The Jewish Museum, New York, Purchase: Lillian Gordon Bequest

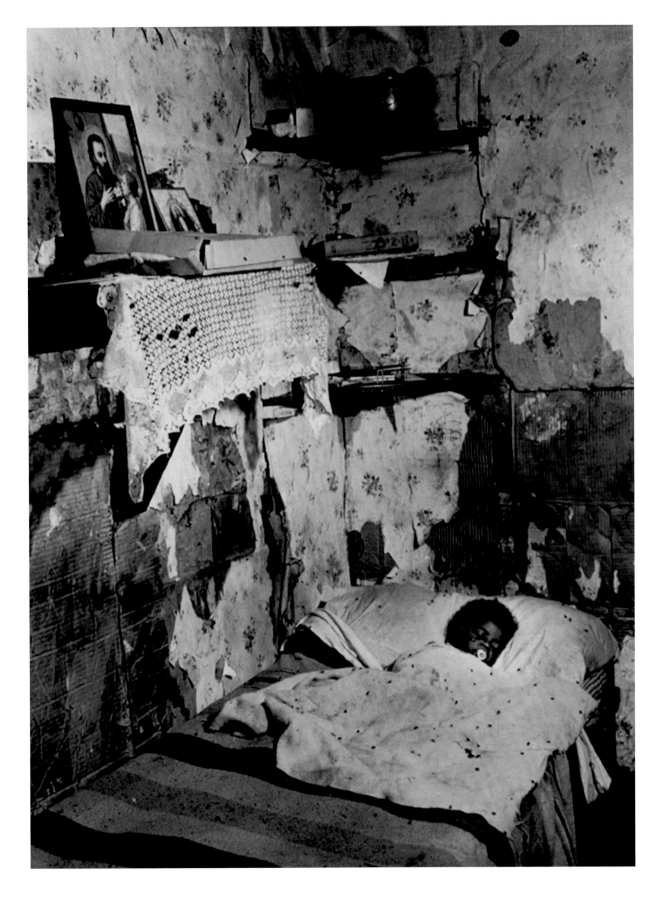

Plate 38. **Jack Delano** *Interior of New FSA Client Edward Gont's Home, Dameron, Maryland,* 1940
Gelatin silver print, 9½ × 7¼ in. (24.1 × 18.4 cm). Columbus Museum of Art, Ohio, Photo League Collection, Museum Purchase with funds
provided by Elizabeth M. Ross, the Derby Fund, John S. and Catherine Chapin Kobacker, and the Friends of the Photo League

126

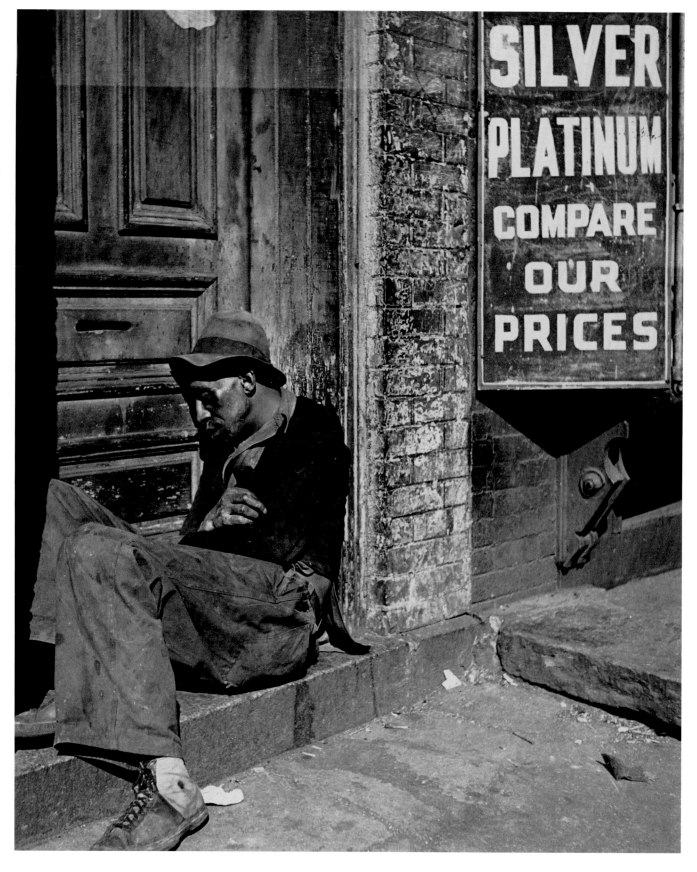

Plate 39. **Rolf Tietgens** *Untitled (Broome and Bowery),* c. 1938
Gelatin silver print, 9⅜ × 7⅝ in. (23.8 × 19.4 cm). Columbus Museum of Art, Ohio, Photo League Collection, Museum Purchase with funds
provided by Elizabeth M. Ross, the Derby Fund, John S. and Catherine Chapin Kobacker, and the Friends of the Photo League

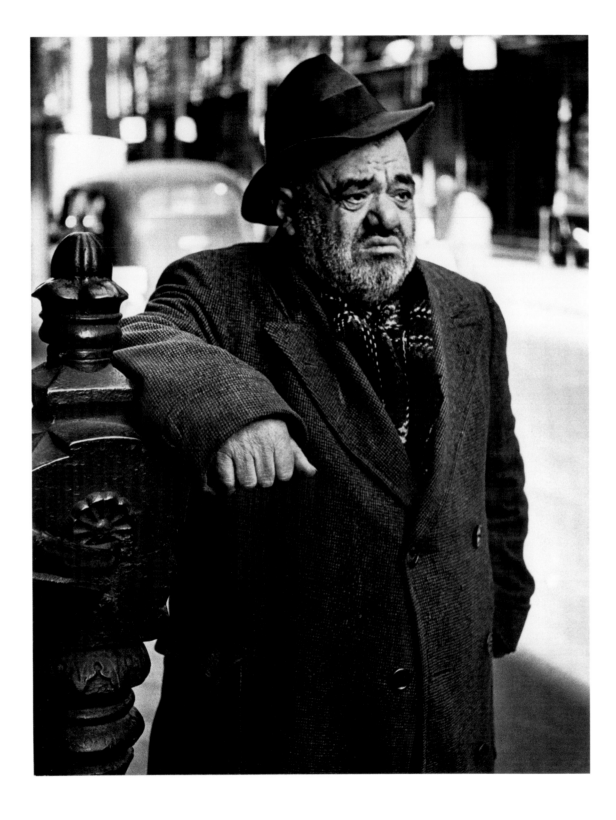

Plate 40. **Lisette Model** *Lower East Side*, c. 1940
Gelatin silver print, 19½ × 15¼ in. (49.5 × 38.7 cm). The Jewish Museum, New York, Gift of Howard Greenberg

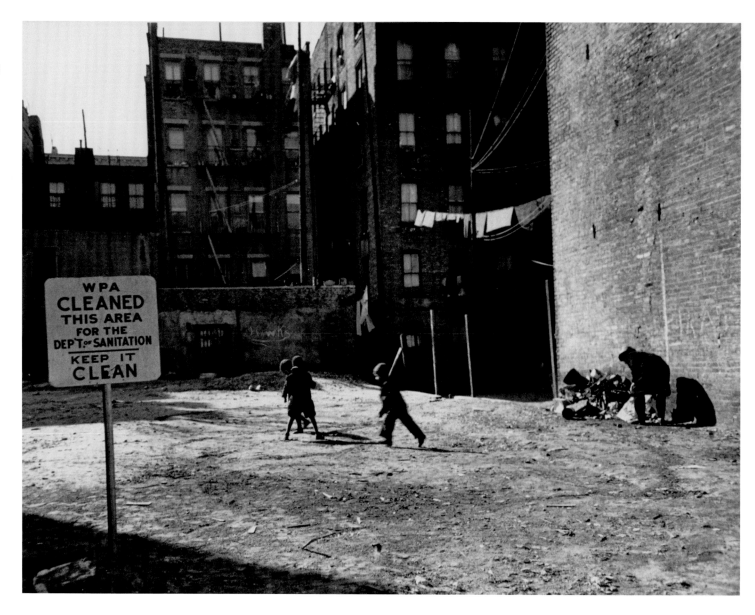

Plate 41. **Eliot Elisofon** *WPA Cleaned This Area . . . Keep It Clean,* c. 1940

Gelatin silver print, 10⅜ × 13¼ in. (26.4 × 33.7 cm). Columbus Museum of Art, Ohio, Photo League Collection, Museum Purchase with funds provided by Elizabeth M. Ross, the Derby Fund, John S. and Catherine Chapin Kobacker, and the Friends of the Photo League

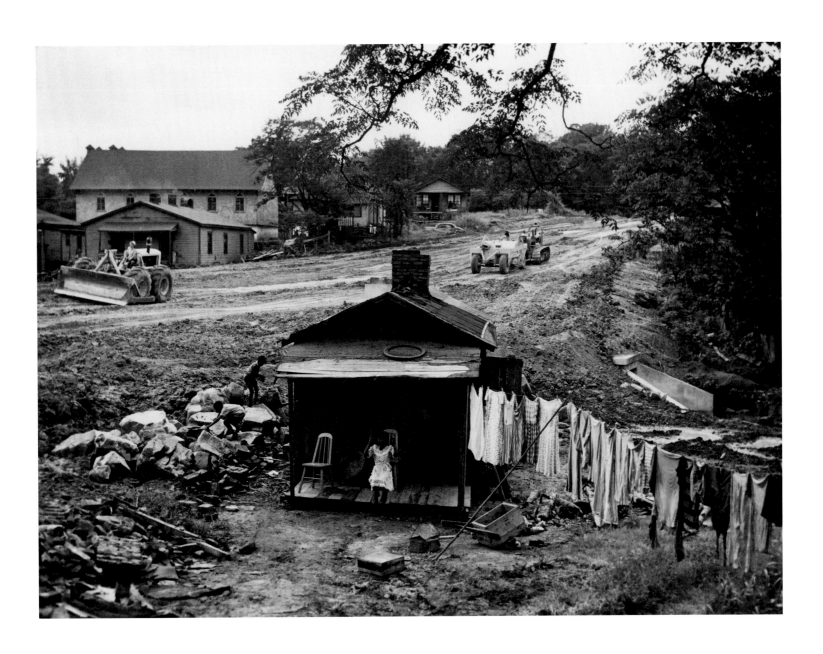

Plate 42. **Rosalie Gwathmey** *Untitled (Kids Playing in Rural South),* c. 1940
Gelatin silver print, 7⅜ × 9⅝ in. (18.7 × 24.4 cm). The Jewish Museum, New York, Purchase: The Paul Strand Trust for the benefit of Virginia Stevens Gift

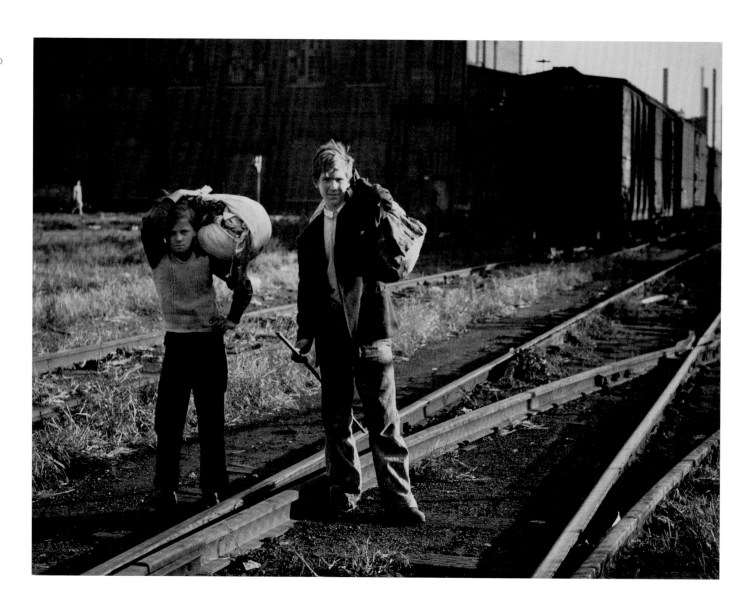

Plate 43. **John Ebstel** *Railroad Siding, Philadelphia,* 1940
Gelatin silver print, 10½ × 13⅝ in. (26.7 × 34.6 cm). Columbus Museum of Art, Ohio, Photo League Collection, Museum Purchase with funds provided by Elizabeth M. Ross, the Derby Fund, John S. and Catherine Chapin Kobacker, and the Friends of the Photo League

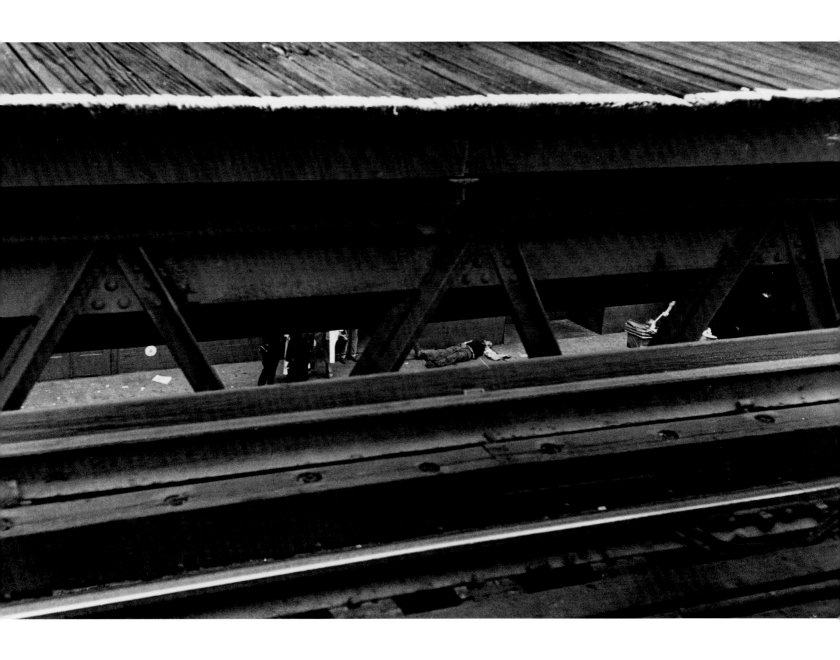

Plate 44. **George S. Zimbel** *Dead Man Under Third Avenue El,* 1951
Gelatin silver print, 8¼ × 13 in. (21 × 33 cm). The Jewish Museum, New York, Purchase: Horace W. Goldsmith Foundation Fund

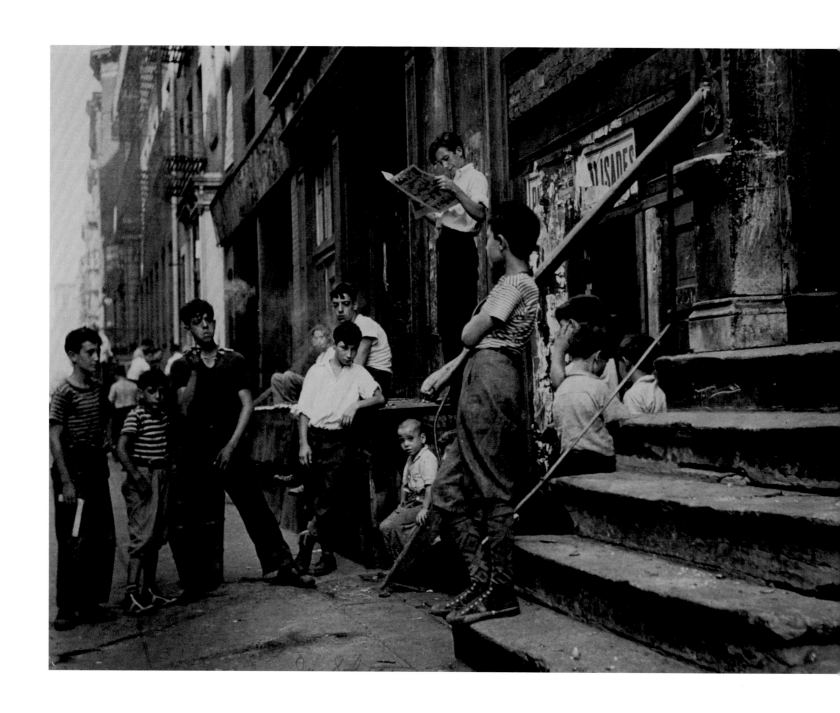

Plate 45. **Joe Schwartz** *Sullivan Midgets 1, Greenwich Village*, c. 1939
Gelatin silver print, 16 × 20 in. (40.6 × 50.8 cm). Columbus Museum of Art, Ohio, Photo League Collection, Museum Purchase with
funds provided by Elizabeth M. Ross, the Derby Fund, John S. and Catherine Chapin Kobacker, and the Friends of the Photo League

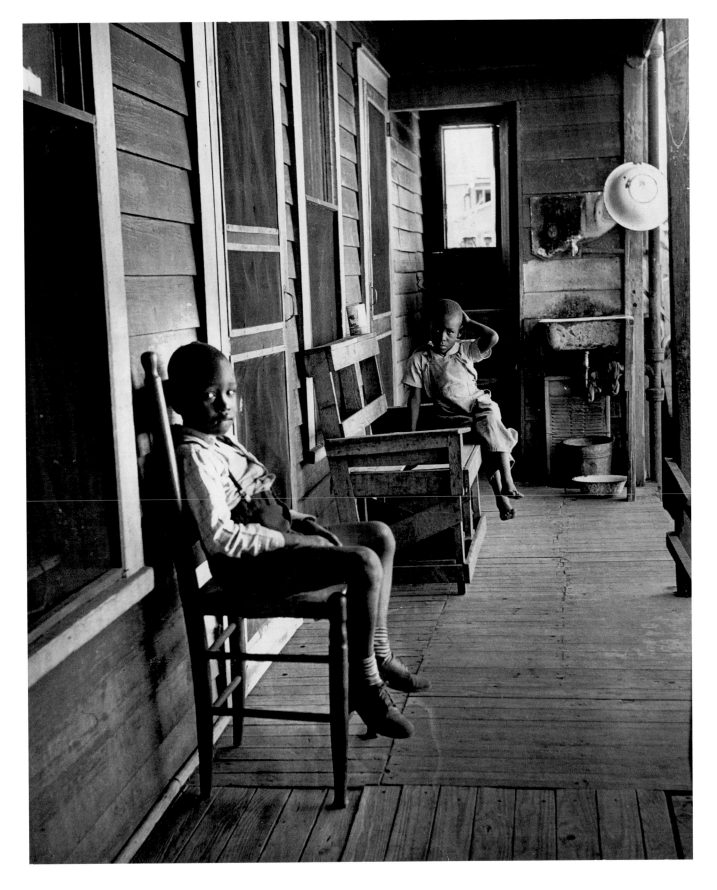

Plate 46. **Marynn Older Ausubel** *On the Porch*, c. 1940

Gelatin silver print, 8⅞ × 7⅜ in. (22.5 × 18.7 cm). Columbus Museum of Art, Ohio, Photo League Collection, Museum Purchase with funds provided by Elizabeth M. Ross, the Derby Fund, John S. and Catherine Chapin Kobacker, and the Friends of the Photo League

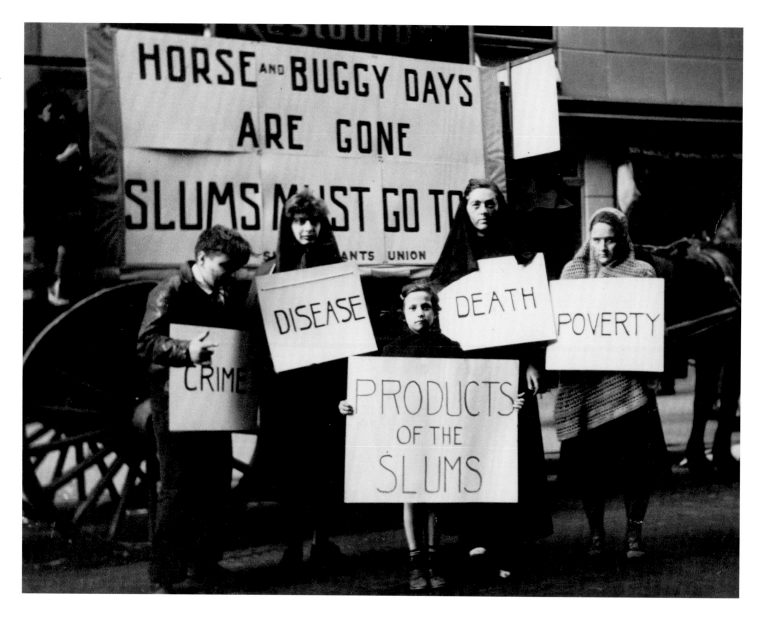

Plate 47. **Joe Schwartz** *Slums Must Go! May Day Parade, New York*, c. 1936

Gelatin silver print, 10⅛ × 13⅛ in. (25.5 × 33.3 cm). Columbus Museum of Art, Ohio, Photo League Collection, Museum Purchase with funds provided by Elizabeth M. Ross, the Derby Fund, John S. and Catherine Chapin Kobacker, and the Friends of the Photo League

135

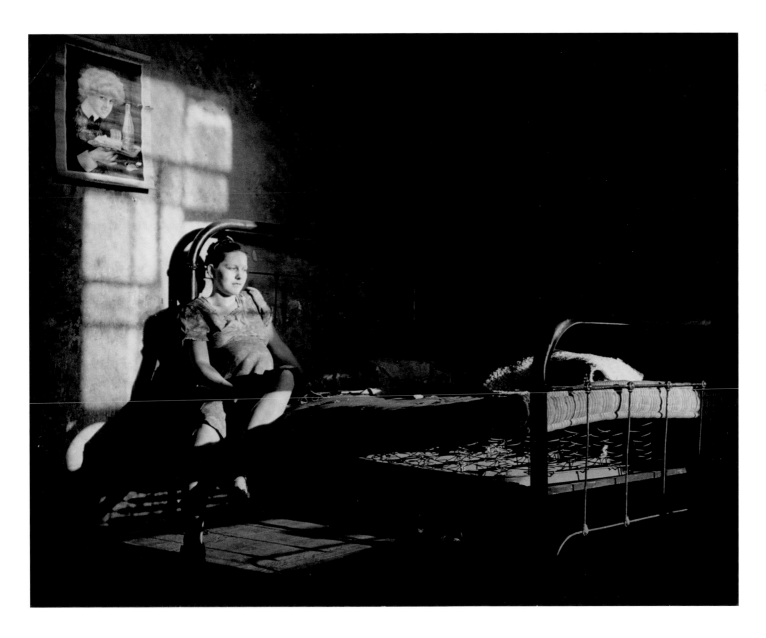

Plate 48. **Eliot Elisofon** *Child Bride, Age 15, Memphis, Tennessee,* c. 1940
Gelatin silver print, 10¼ × 13 in. (26 × 33 cm). Columbus Museum of Art, Ohio, Photo League Collection, Museum Purchase with funds
provided by Elizabeth M. Ross, the Derby Fund, John S. and Catherine Chapin Kobacker, and the Friends of the Photo League

136

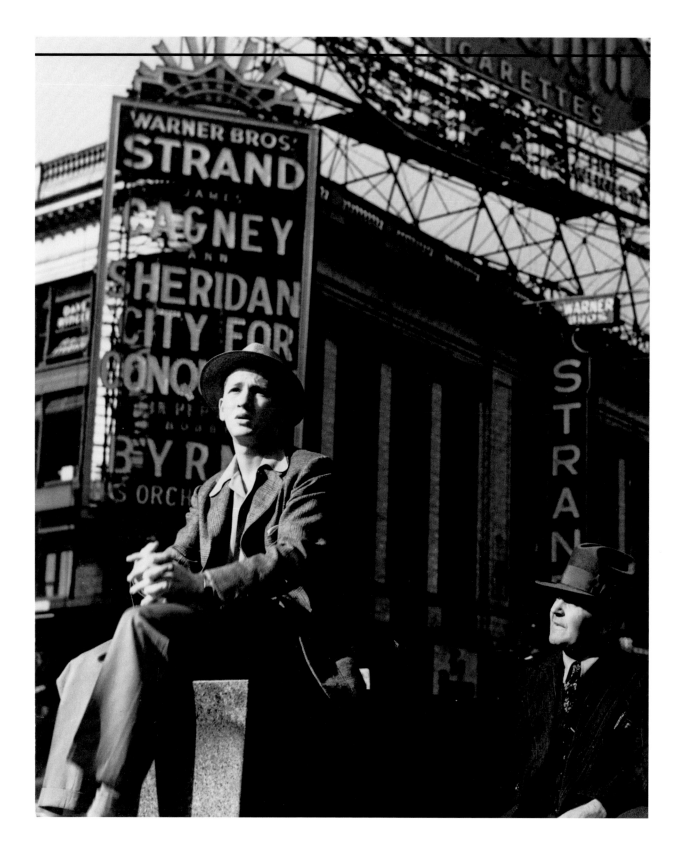

Plate 49. **Lou Stoumen** *Sitting in Front of the Strand, Times Square*, 1940
Gelatin silver print, 9½ × 7¾ in. (24.1 × 19.7 cm). The Jewish Museum, New York, Purchase: B. Gerald Cantor,
Lady Kathleen Epstein, Louis E. and Rosalyn M. Shecter Gifts, by exchange

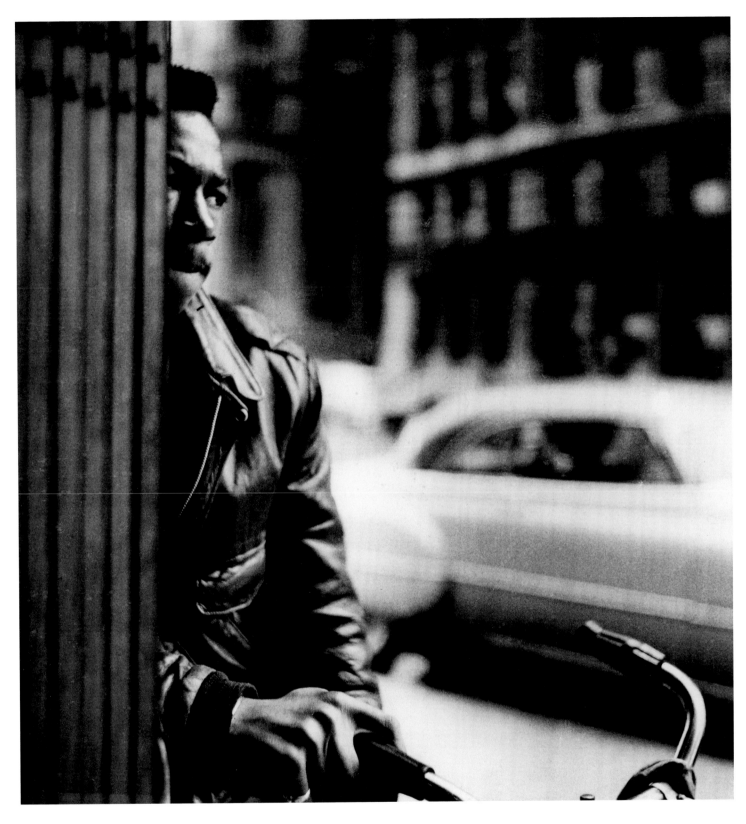

Plate 50. **Louis Stettner** *Untitled (Young Man with Bicycle)*, c. 1940
Gelatin silver print, 5⅝ × 5¼ in. (14.3 × 13.3 cm). The Jewish Museum, New York, Purchase: Photography Acquisitions Committee Fund

Plate 51. **Arnold Newman** *Untitled*, c. 1940
Gelatin silver print, 7⅝ × 9⅝ in. (19.4 × 24.4 cm). The Jewish Museum, New York, Purchase:
Horace W. Goldsmith Foundation Fund

Plate 52. **Bill Witt** *Abstract of Chairs and Fences*, 1940
Gelatin silver print, 5¾ × 6 in. (14.6 × 15.2 cm). The Jewish Museum, New York, Purchase: Photography Acquisitions Committee Fund

Plate 53. **Weegee** *New York Patrolman George Scharnikow Who Saved Little Baby, New York,* 1938
Gelatin silver print, 10 × 8 in. (25.4 × 20.3 cm). The Jewish Museum, New York, Purchase: Photography Acquisitions Committee Fund

Plate 54. **Weegee** *Manuel Jimenez Lies Wounded in the Lap of Manuelda Hernandez,* 1941
Gelatin silver print, 10⅜ × 13¼ in. (26.4 × 33.7 cm). Columbus Museum of Art, Ohio, Photo League Collection, Museum Purchase with
funds provided by Elizabeth M. Ross, the Derby Fund, John S. and Catherine Chapin Kobacker, and the Friends of the Photo League

Plate 55. **Rosalie Gwathmey** *Shout Freedom, Charlotte, North Carolina,* c. 1948
Gelatin silver print, 7⅞ × 6¾ in. (20 × 17.1 cm). Columbus Museum of Art, Ohio, Photo League Collection, Museum Purchase with
funds provided by Elizabeth M. Ross, the Derby Fund, John S. and Catherine Chapin Kobacker, and the Friends of the Photo League

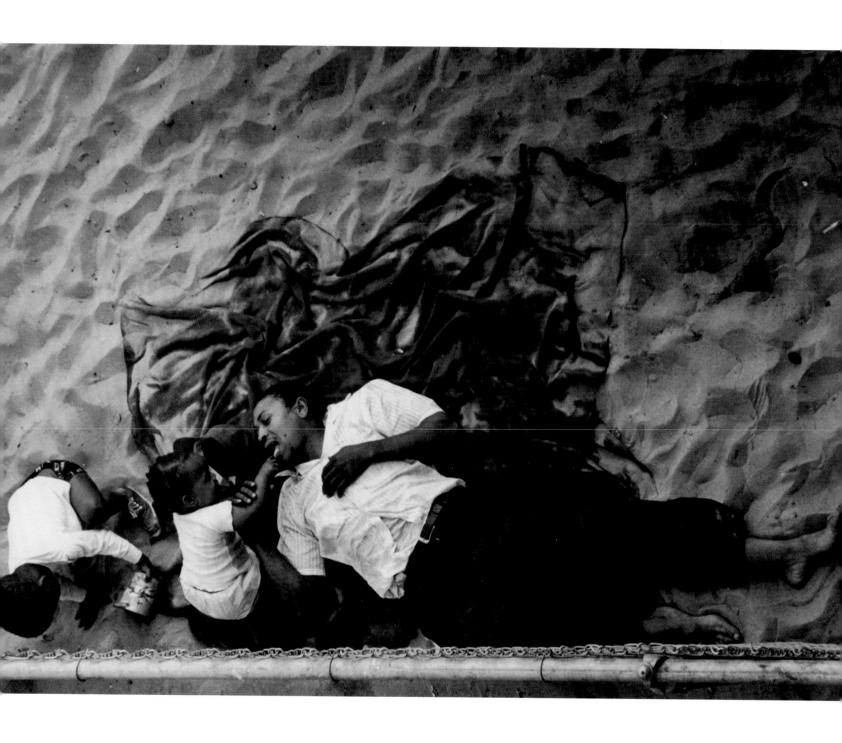

Plate 56. **Lou Bernstein** *Father and Children, Coney Island,* 1943

Gelatin silver print, 18 × 22 in. (45.7 × 55.9 cm). Columbus Museum of Art, Ohio, Photo League Collection, Museum Purchase with
funds provided by Elizabeth M. Ross, the Derby Fund, John S. and Catherine Chapin Kobacker, and the Friends of the Photo League

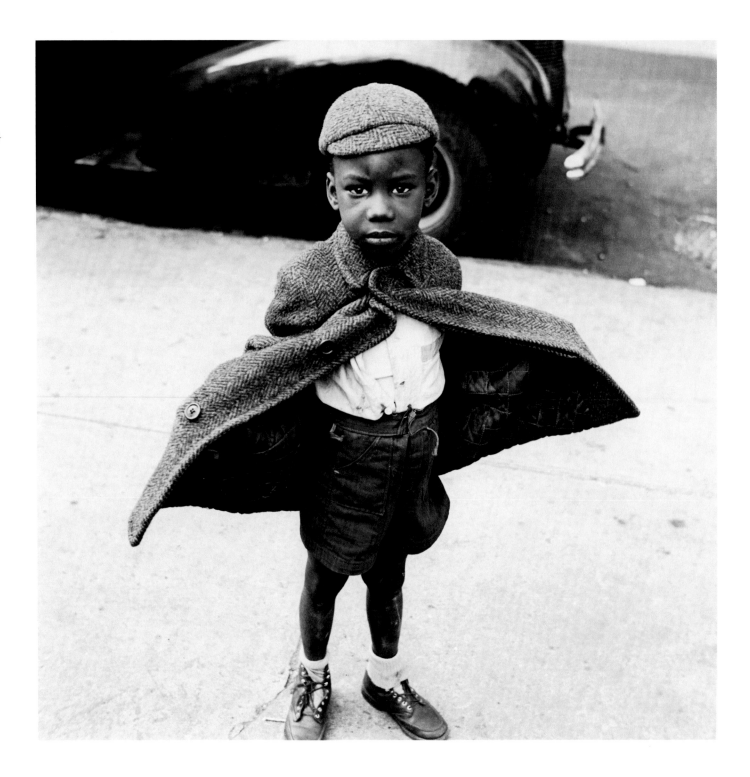

Plate 57. **Jerome Liebling** *Butterfly Boy, New York,* 1949
Gelatin silver print, 9½ × 9½ in. (24.1 × 24.1 cm). The Jewish Museum, New York, Purchase: Mimi and Barry J. Alperin Fund

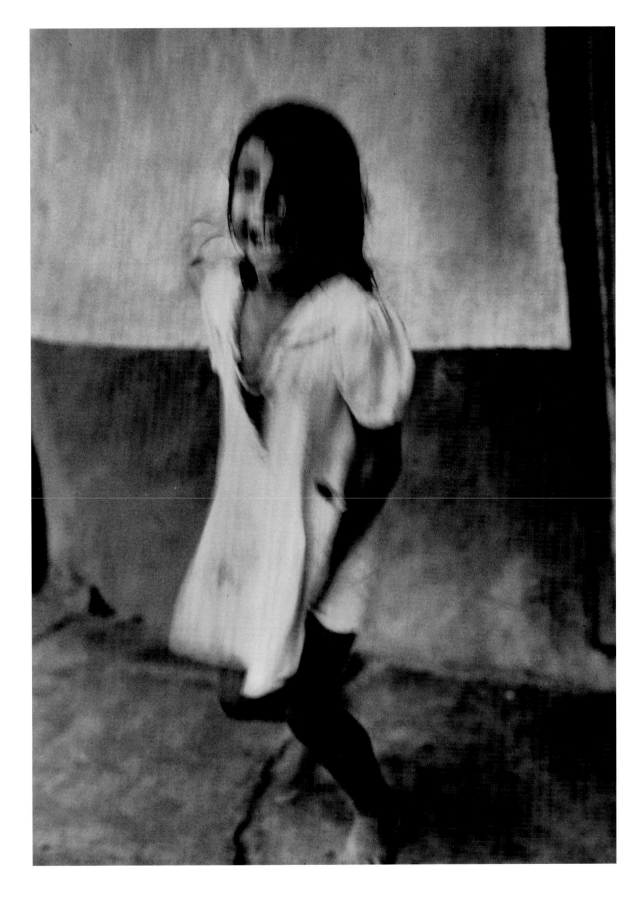

Plate 58. **Sid Grossman** *Jumping Girl, Aguadulce, Panama*, c. 1945
Gelatin silver print, 13½ × 10¼ in. (34.3 × 26 cm). Columbus Museum of Art, Ohio, Photo League Collection, Museum Purchase with
funds provided by Elizabeth M. Ross, the Derby Fund, John S. and Catherine Chapin Kobacker, and the Friends of the Photo League

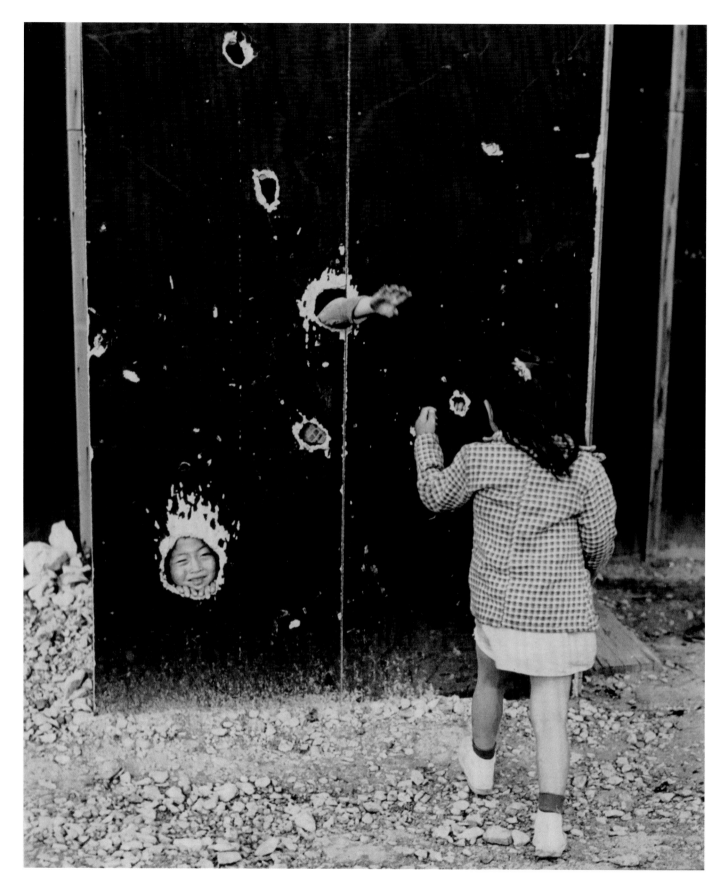

Plate 59. **Godfrey Frankel** *Heart Mountain War Relocation Authority, Cody, Wyoming,* 1945
Gelatin silver print, 13¼ × 10⅝ in. (33.7 × 27 cm). Columbus Museum of Art, Ohio, Photo League Collection, Museum Purchase with funds provided by Elizabeth M. Ross, the Derby Fund, John S. and Catherine Chapin Kobacker, and the Friends of the Photo League

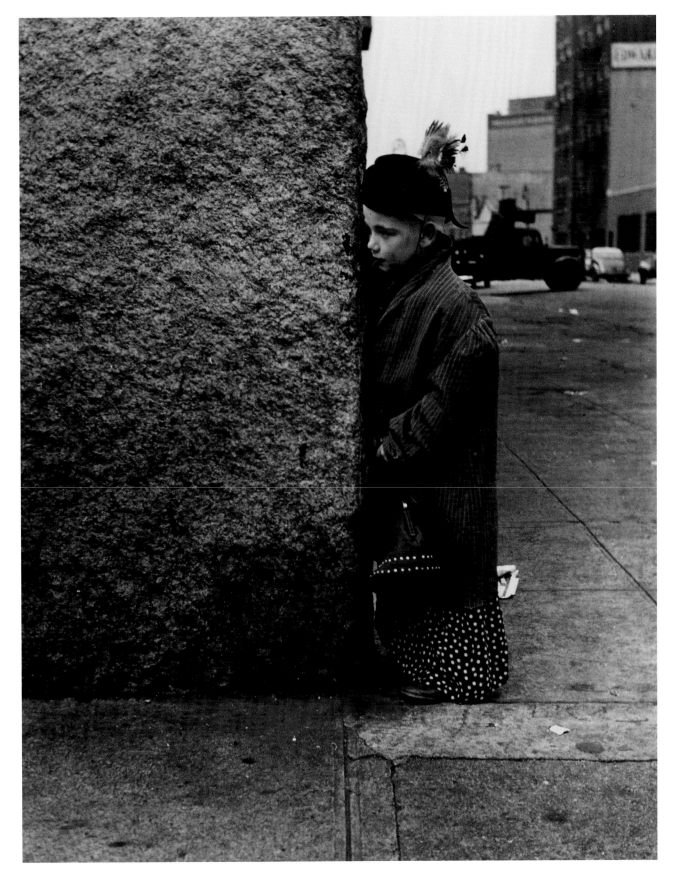

Plate 60. **Morris Huberland** *Halloween, Greenwich Village*, c. 1945

Gelatin silver print, 13 × 10⅛ in. (33 × 25.7 cm). Columbus Museum of Art, Ohio, Photo League Collection, Museum Purchase with funds provided by Elizabeth M. Ross, the Derby Fund, John S. and Catherine Chapin Kobacker, and the Friends of the Photo League

148

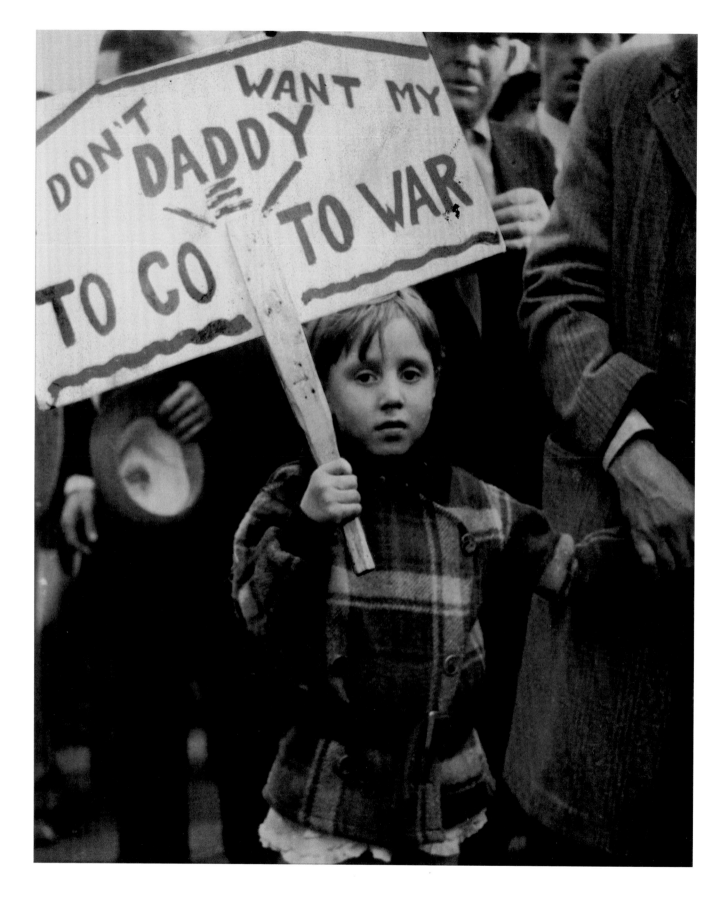

Plate 61. **David Robbins** *Antiwar Demonstration,* c. 1941

Gelatin silver print, 20 × 16 in. (50.8 × 40.6 cm). Columbus Museum of Art, Ohio, Photo League Collection, Museum Purchase with funds provided by Elizabeth M. Ross, the Derby Fund, John S. and Catherine Chapin Kobacker, and the Friends of the Photo League

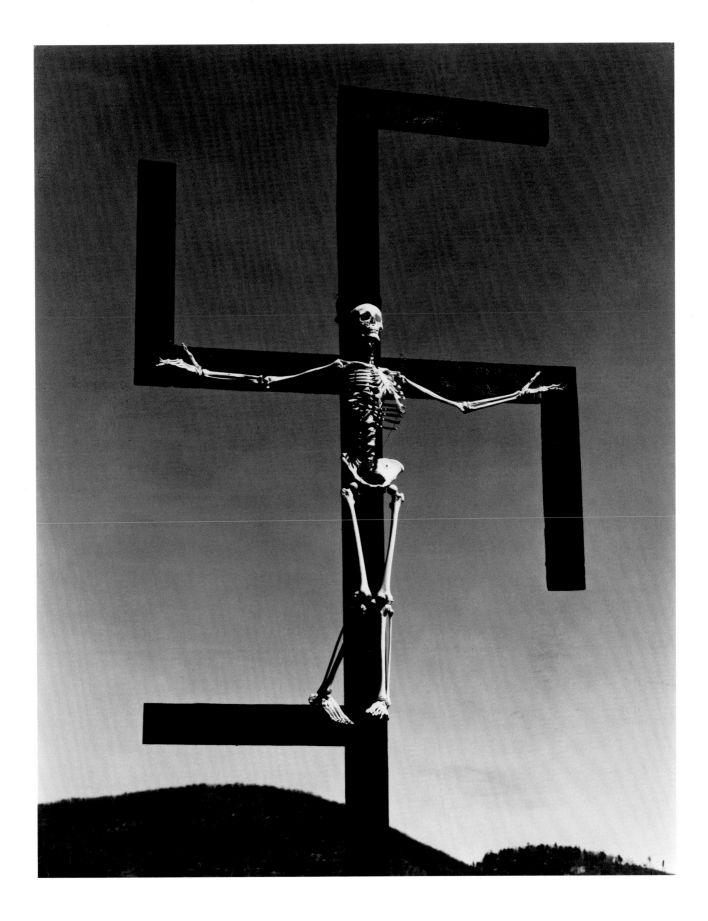

Plate 62. **Paul Strand** *Swastika (a.k.a. Hitlerism),* 1938
Gelatin silver print, 9½ × 7⅜ in. (24.1 × 19.4 cm). The Jewish Museum, New York, Purchase: Horace W. Goldsmith Foundation Fund

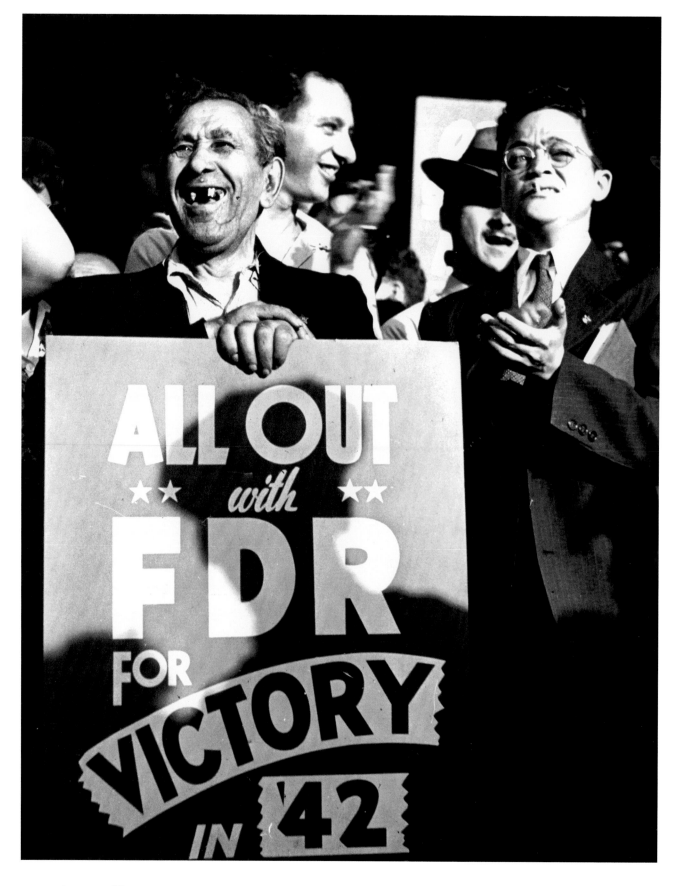

Plate 63. **George Gilbert** *Untitled,* from *American Faces,* 1942

Gelatin silver print, 20½ × 16½ in. (52.1 × 41.9 cm). Columbus Museum of Art, Ohio, Photo League Collection, Museum Purchase with funds provided by Elizabeth M. Ross, the Derby Fund, John S. and Catherine Chapin Kobacker, and the Friends of the Photo League

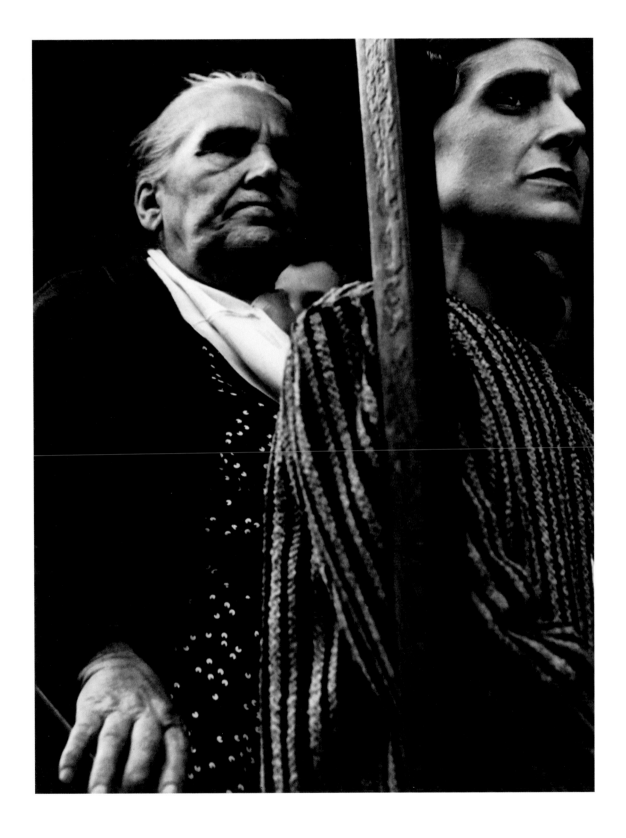

Plate 64. **Lisette Model** *They Honor Their Sons, New York,* c. 1940

Gelatin silver print, 13 × 9⅞ in. (33 × 25.1 cm). Columbus Museum of Art, Ohio, Photo League Collection, Museum Purchase with funds provided by Elizabeth M. Ross, the Derby Fund, John S. and Catherine Chapin Kobacker, and the Friends of the Photo League

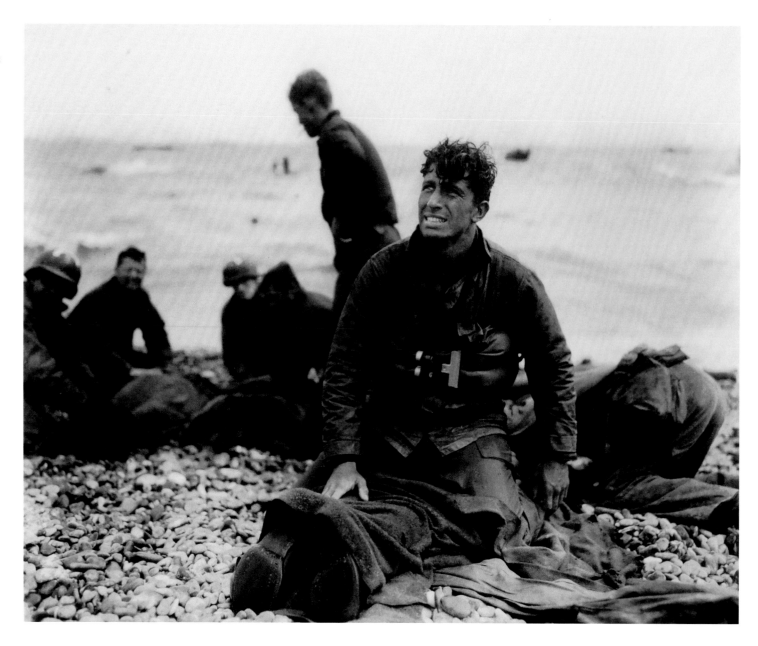

Plate 65. **Walter Rosenblum** *D-Day Rescue, Omaha Beach*, 1944
Gelatin silver print, 17 × 21 in. (43.2 × 53.3 cm). Columbus Museum of Art, Ohio, Photo League Collection, Museum Purchase with
funds provided by Elizabeth M. Ross, the Derby Fund, John S. and Catherine Chapin Kobacker, and the Friends of the Photo League

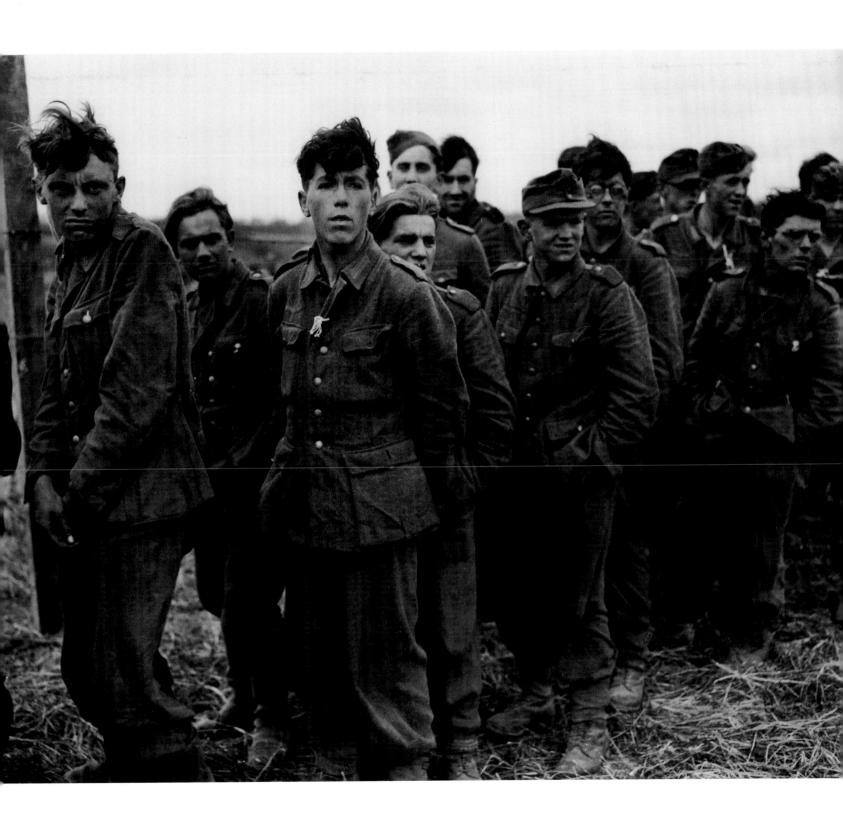

Plate 66. **Walter Rosenblum** *German Prisoners of War, Normandy, 1944*
Gelatin silver print, 7¾ × 9⅝ in. (19.7 × 24.4 cm). Columbus Museum of Art, Ohio, Photo League Collection, Museum Purchase with
funds provided by Elizabeth M. Ross, the Derby Fund, John S. and Catherine Chapin Kobacker, and the Friends of the Photo League

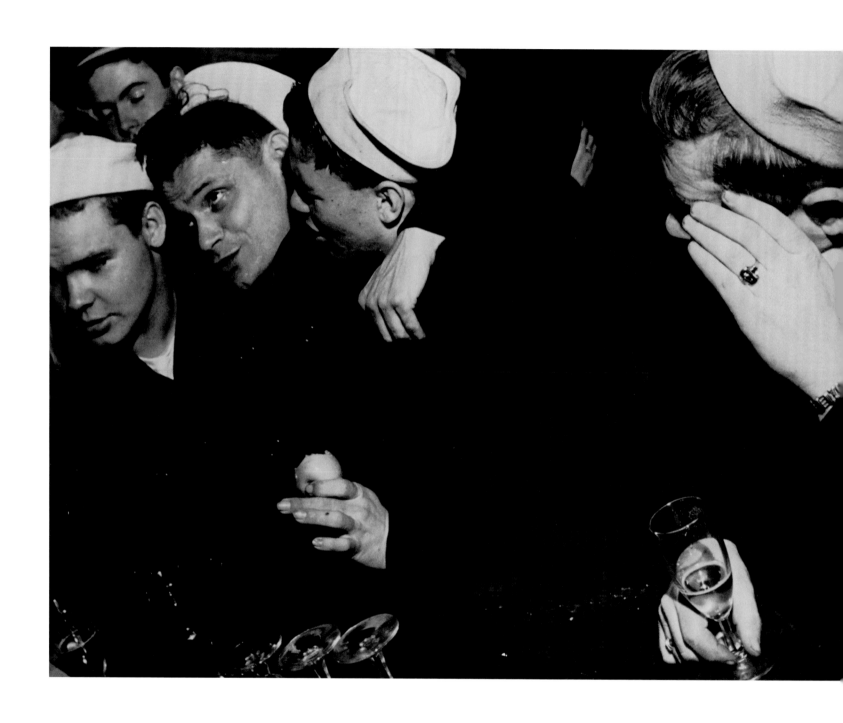

Plate 67. **Lisette Model** *Nick's*, c. 1942

Gelatin silver print, 9½ × 13⅛ in. (24.1 × 33.3 cm). Columbus Museum of Art, Ohio, Photo League Collection, Museum Purchase with funds provided by Elizabeth M. Ross, the Derby Fund, John S. and Catherine Chapin Kobacker, and the Friends of the Photo League

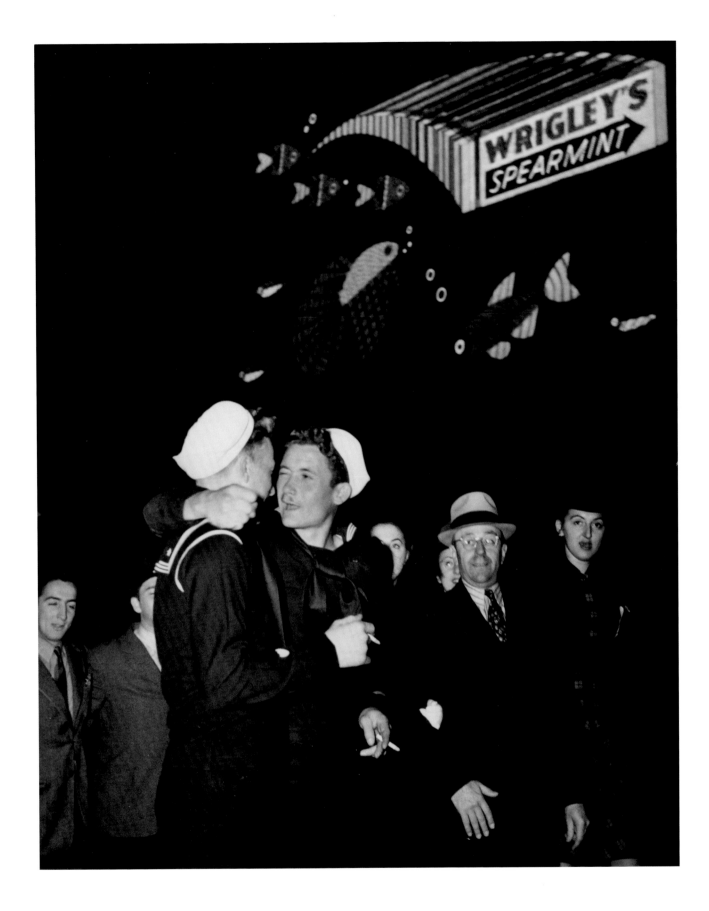

Plate 68. **Lou Stoumen** *Sailors, Times Square,* c. 1940
Gelatin silver print, 9⅞ × 7⅞ in. (25.1 × 20 cm). Columbus Museum of Art, Ohio, Photo League Collection, Museum Purchase with
funds provided by Elizabeth M. Ross, the Derby Fund, John S. and Catherine Chapin Kobacker, and the Friends of the Photo League

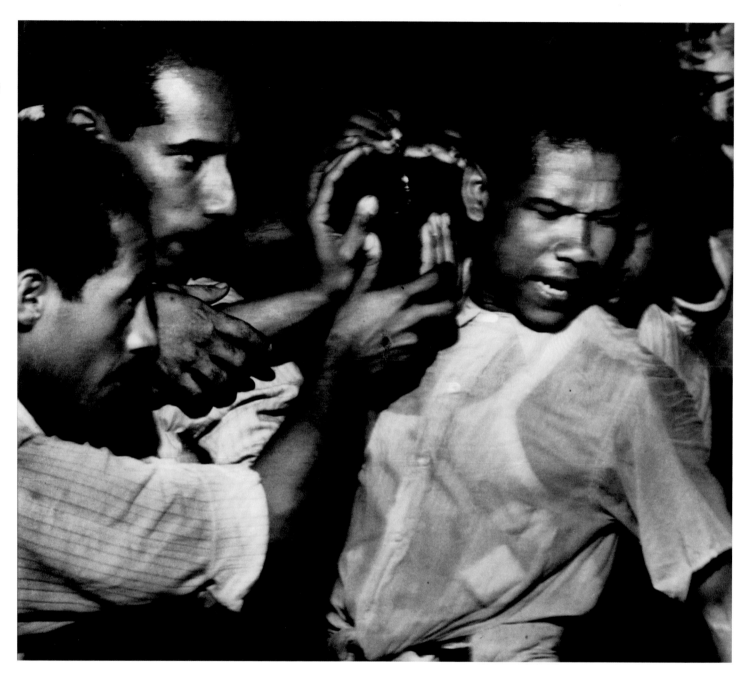

Plate 69. **Sid Grossman** *Black Christ Festival, Portobelo, Panama*, 1945

Gelatin silver print, 10½ × 12 in. (26.6 × 30.6 cm). Columbus Museum of Art, Ohio, Photo League Collection, Museum Purchase with funds provided by Elizabeth M. Ross, the Derby Fund, John S. and Catherine Chapin Kobacker, and the Friends of the Photo League

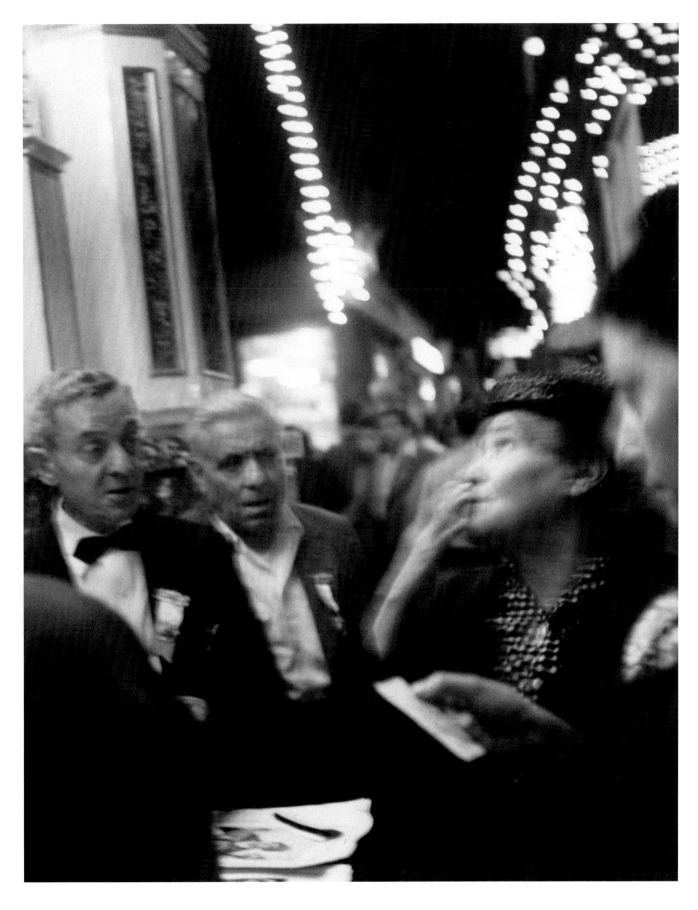

Plate 70. **Sid Grossman** *Mulberry Street,* 1948
Gelatin silver print, 13¼ × 10⅝ in. (33.7 × 27 cm). The Jewish Museum, New York, Purchase: Lillian Gordon Bequest

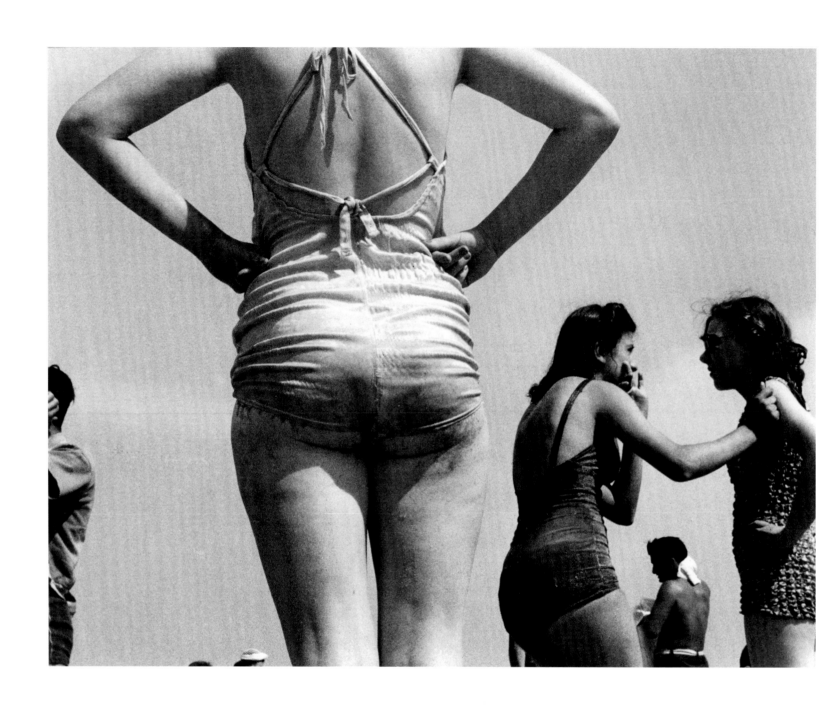

Plate 71. **Morris Engel** *Women on the Beach, Coney Island,* 1938
Gelatin silver print, 7½ × 9½ in. (19 × 24.1 cm). Columbus Museum of Art, Ohio, Photo League Collection, Museum Purchase with
funds provided by Elizabeth M. Ross, the Derby Fund, John S. and Catherine Chapin Kobacker, and the Friends of the Photo League

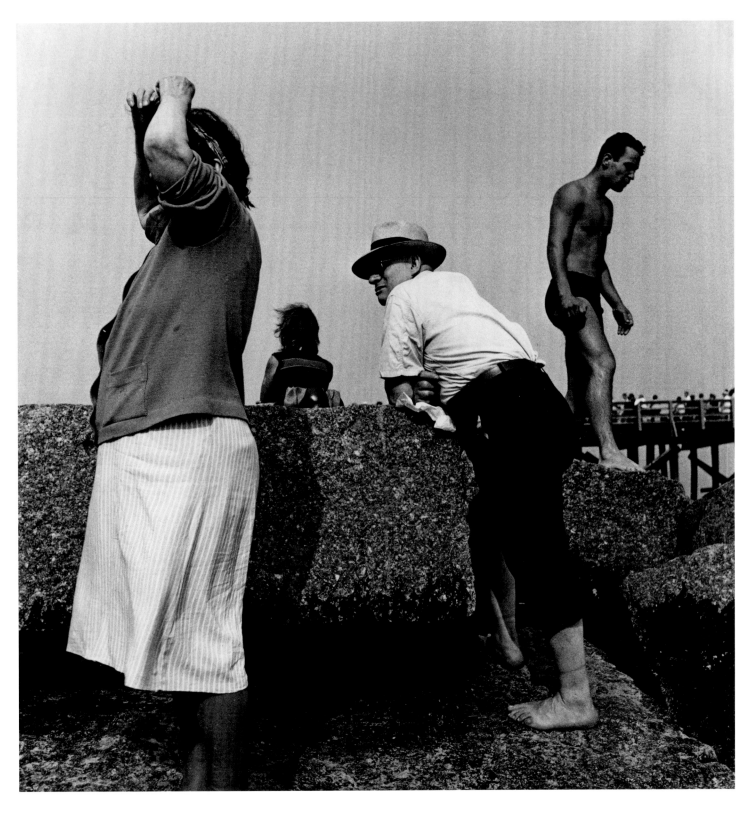

Plate 72. **Harold Feinstein** *Rocky Beach*, c. 1945
Gelatin silver print, 10⅜ × 10 in. (26.4 × 25.4 cm). The Jewish Museum, New York, Purchase:
Gay Block and Malka Drucker Fund of the Houston Jewish Community Foundation

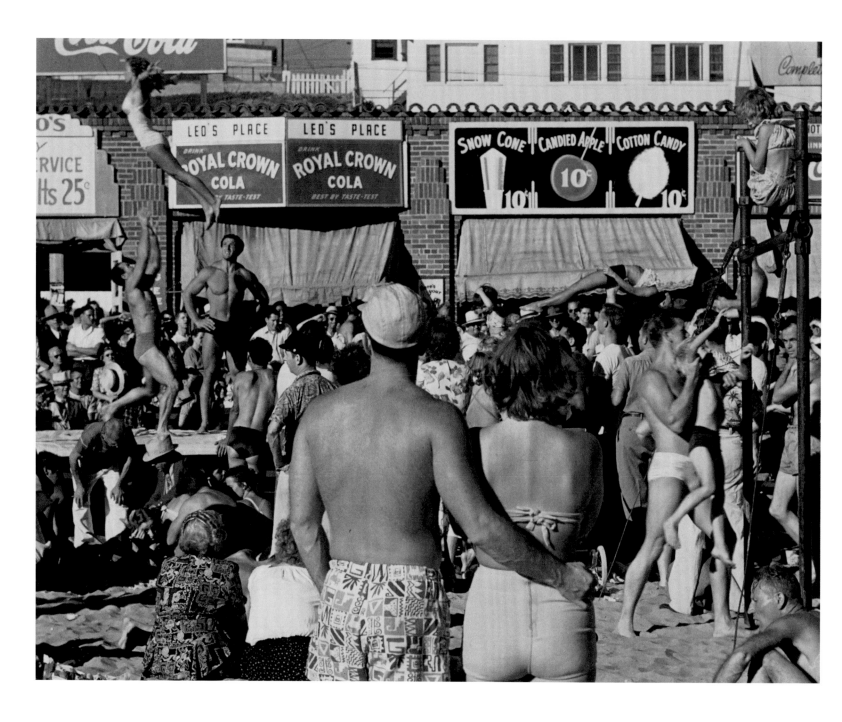

Plate 73. **Max Yavno** *Muscle Beach, Santa Monica, California*, 1949

Gelatin silver print, 7½ × 9½ in. (19.1 × 24.1 cm). Columbus Museum of Art, Ohio, Photo League Collection, Museum Purchase with funds provided by Elizabeth M. Ross, the Derby Fund, John S. and Catherine Chapin Kobacker, and the Friends of the Photo League

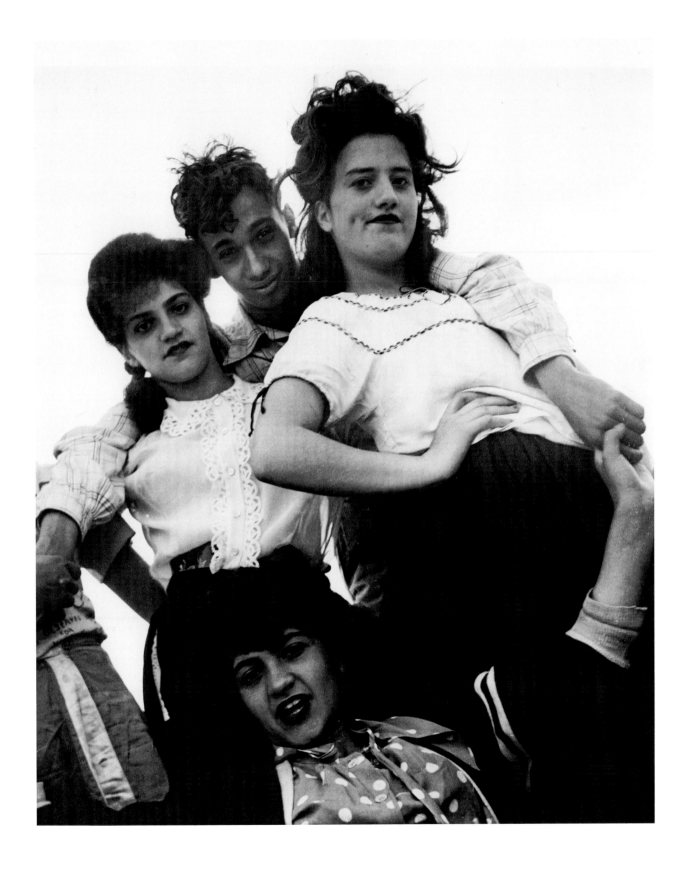

Plate 74. **Sid Grossman** *Coney Island,* c. 1947
Gelatin silver print, 9⅜ × 7⅞ in. (23.8 × 20 cm). The Jewish Museum, New York, Purchase: The Paul Strand Trust for the benefit of Virginia Stevens Gift

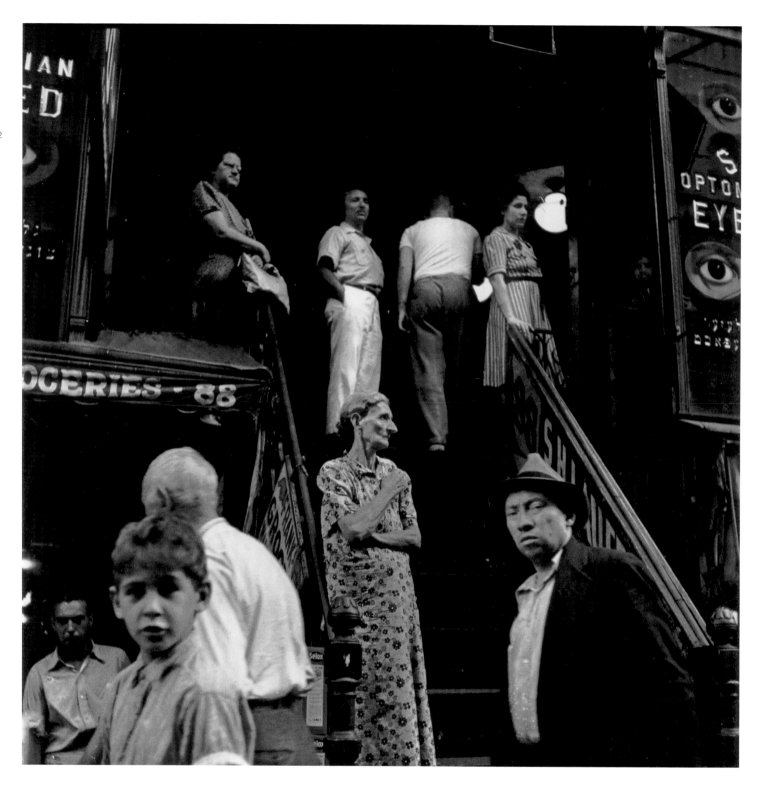

Plate 75. **Sol Libsohn** *Hester Street*, 1945

Gelatin silver print, 10⅛ × 10 in. (25.7 × 25.4 cm). Columbus Museum of Art, Ohio, Photo League Collection, Museum Purchase with funds provided by Elizabeth M. Ross, the Derby Fund, John S. and Catherine Chapin Kobacker, and the Friends of the Photo League

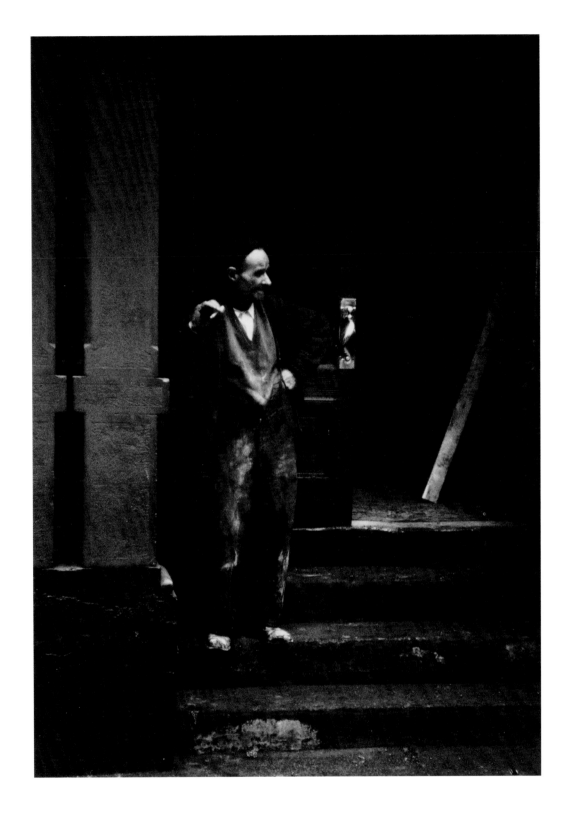

Plate 76. **Sol Libsohn** *29th Street West of Sixth,* 1949
Gelatin silver print, 13 × 9¼ in. (33 × 23.5 cm). The Jewish Museum, New York, Purchase: Esther Leah Ritz Bequest

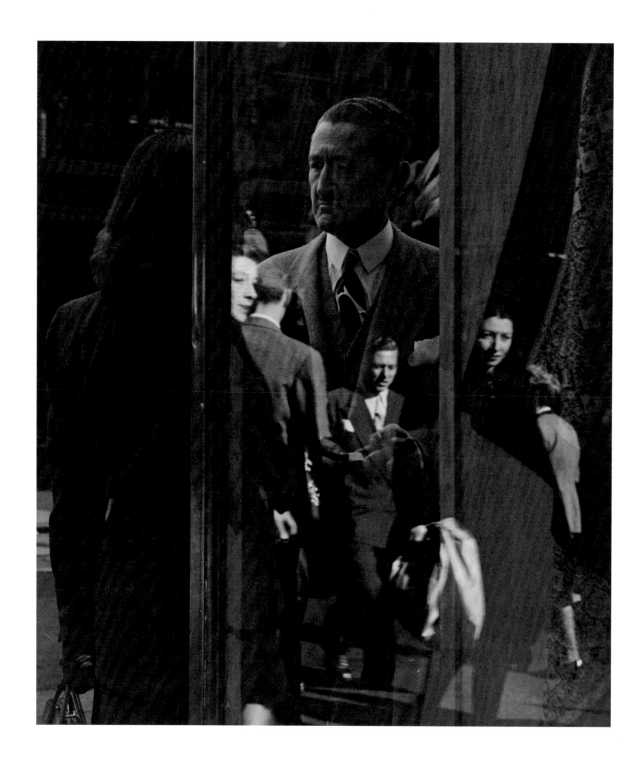

Plate 77. **Nancy Bulkeley** *Madison Avenue*, c. 1946
Gelatin silver print, 8⅛ × 7⅛ in. (20.6 × 18.1 cm). The Jewish Museum, New York, Purchase: The Paul Strand Trust for the benefit of Virginia Stevens Gift

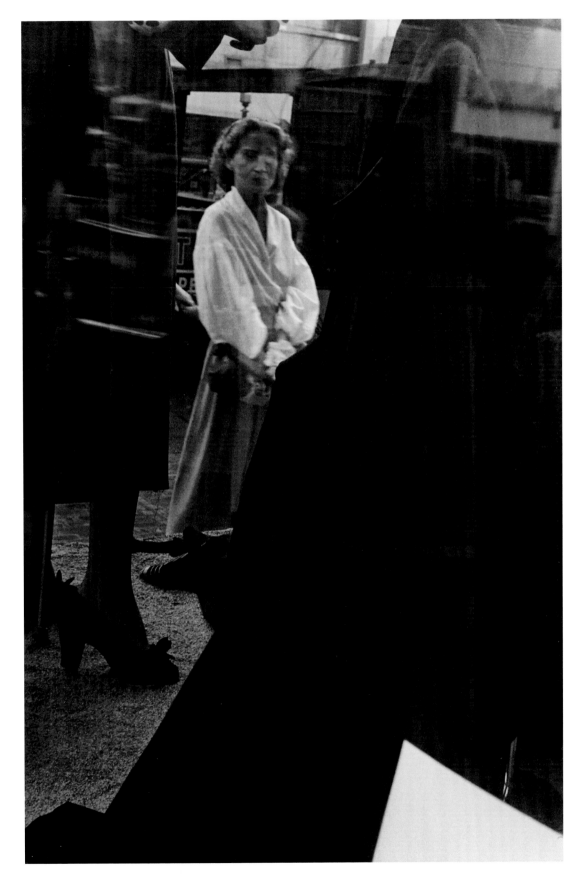

Plate 78. **Sy Kattelson** *Woman in Window Reflections*, c. 1950

Gelatin silver print, 13½ × 9 in. (34.3 × 22.9 cm). Columbus Museum of Art, Ohio, Photo League Collection, Museum Purchase with
funds provided by Elizabeth M. Ross, the Derby Fund, John S. and Catherine Chapin Kobacker, and the Friends of the Photo League

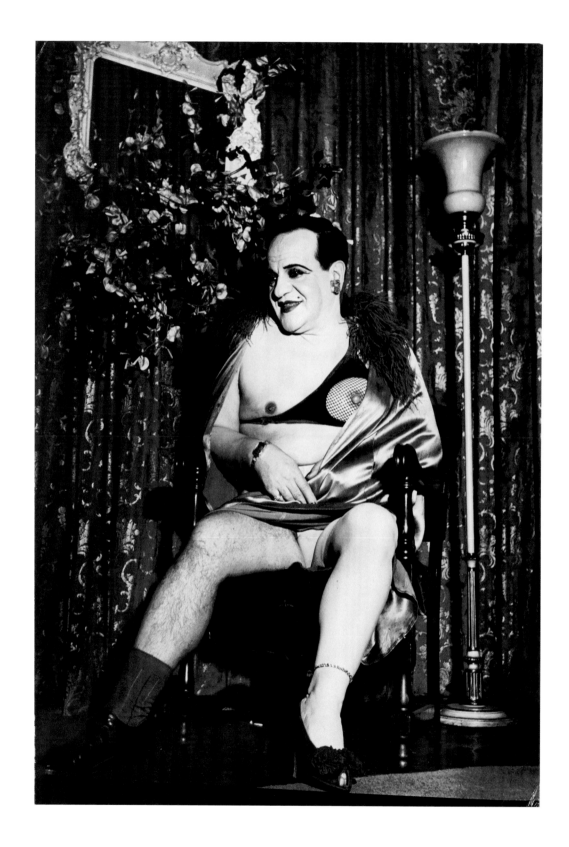

Plate 79. **Lisette Model** *Albert-Alberta, Hubert's Forty-second Street Flea Circus, New York,* c. 1945
Gelatin silver print, 30¾ × 21⅛ in. (78.1 × 53.7 cm). The Jewish Museum, New York, Purchase: Photography Acquisitions Committee Fund

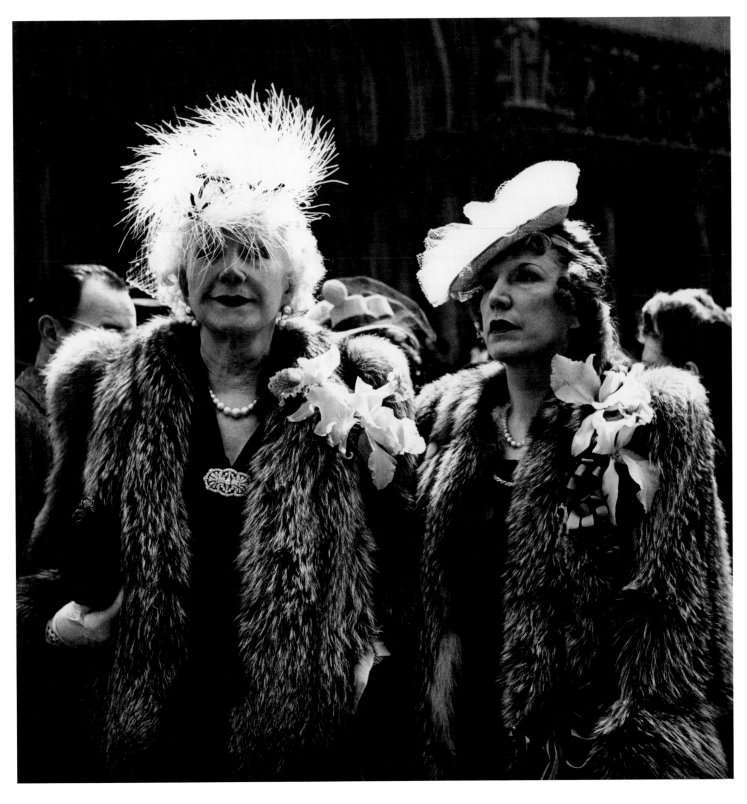

Plate 80. **Elizabeth Timberman** *Easter Sunday*, 1944
Gelatin silver print, 10½ × 10¼ in. (26.7 × 26 cm). The Jewish Museum, New York, Purchase: Photography Acquisitions Committee Fund

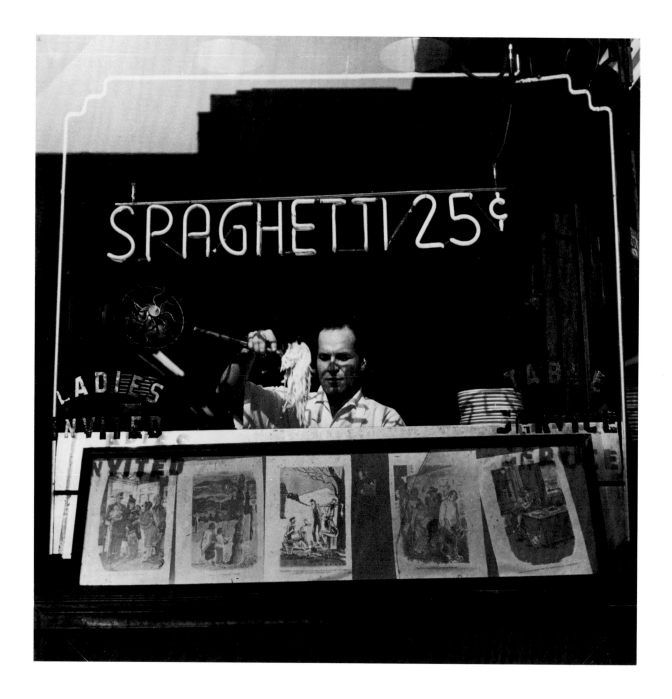

Plate 81. **Ida Wyman** *Spaghetti 25 Cents, New York,* 1945
Gelatin silver print, 7¾ × 7¾ in. (19.7 × 19.7 cm). The Jewish Museum, New York, Purchase: Photography Acquisitions Committee Fund

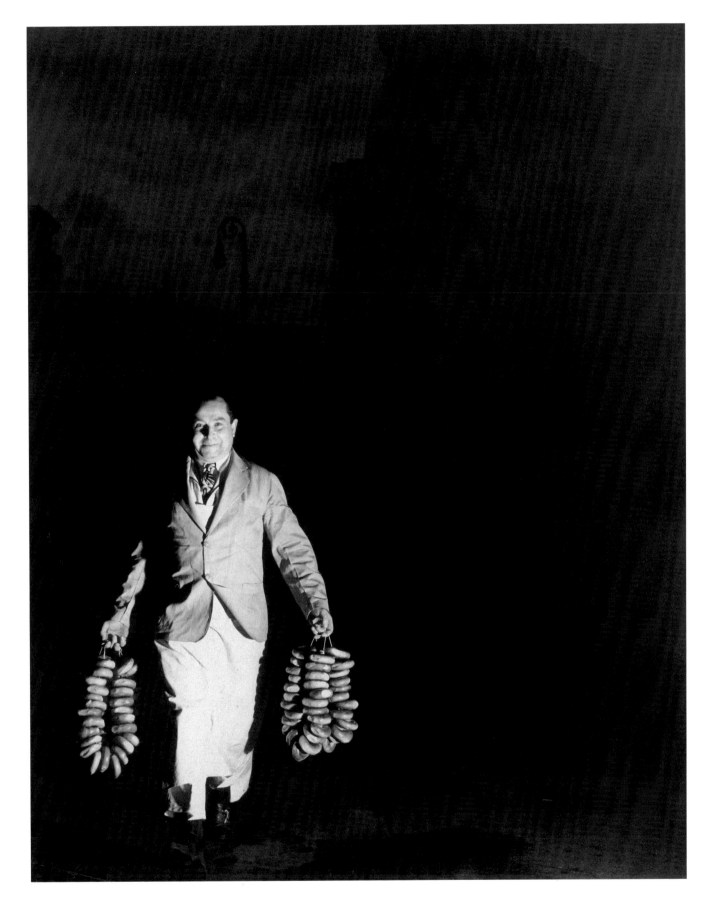

Plate 82. **Weegee** *Max Is Rushing in the Bagels to a Restaurant on Second Avenue for the Morning Trade*, c. 1940
Gelatin silver print, 14¾ × 18⅞ in. (37.5 × 48 cm). The Jewish Museum, New York, Purchase: Joan B. and Richard L. Barovick Family Foundation and Bunny and Jim Weinberg Gifts

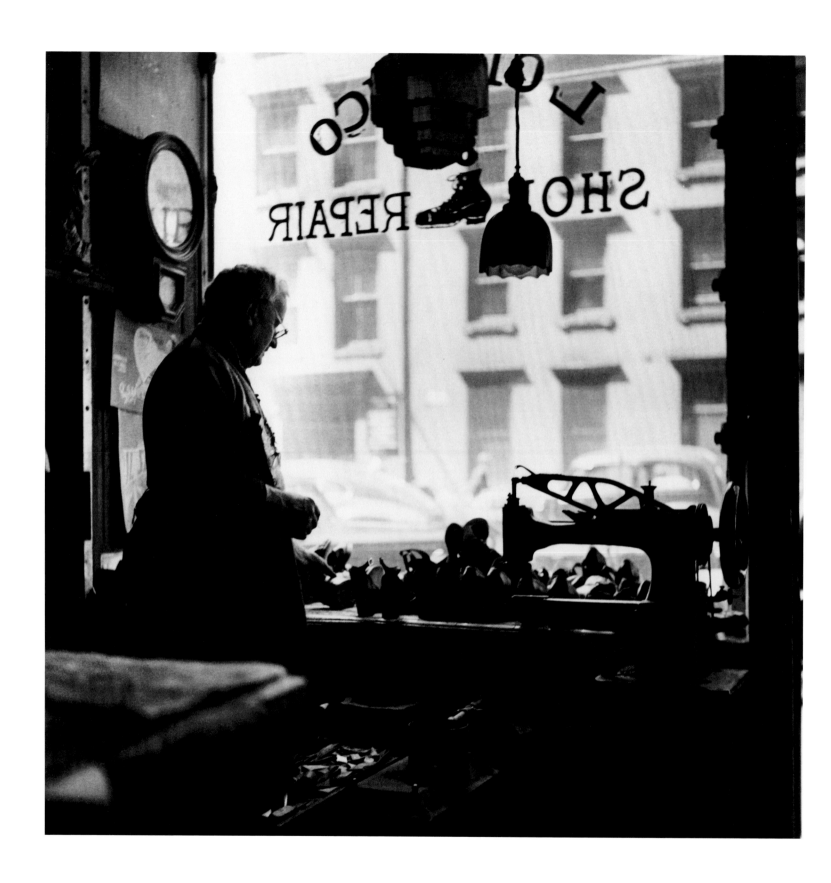

Plate 83. **Rebecca Lepkoff** *Shoemaker,* 1947
Gelatin silver print, 5⅜ × 5⅜ in. (13.7 × 13.7 cm). The Jewish Museum, New York, Gift of the Artist

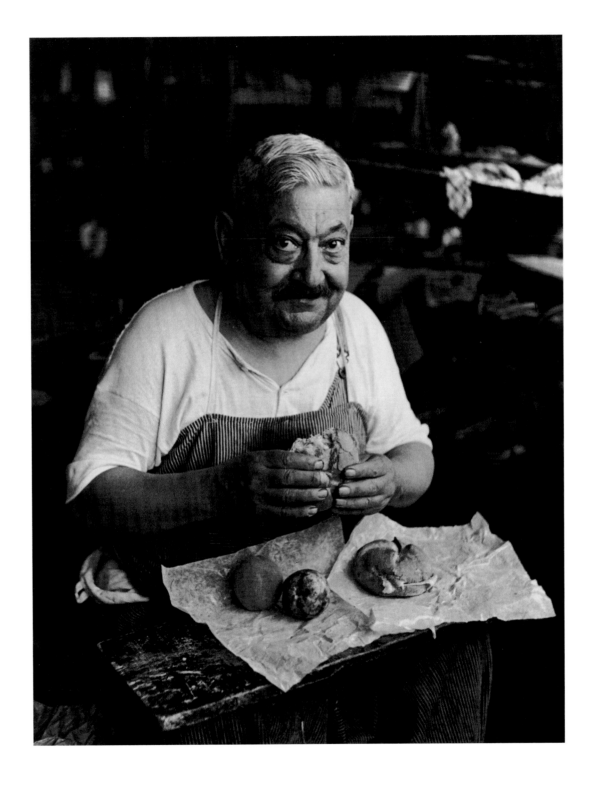

Plate 84. **Bernard Cole** *Shoemaker's Lunch,* 1944
Gelatin silver print, 9⅜ × 7⅜ in. (23.8 × 18.7 cm). The Jewish Museum, New York, Purchase: The Paul Strand Trust for the benefit of Virginia Stevens Gift

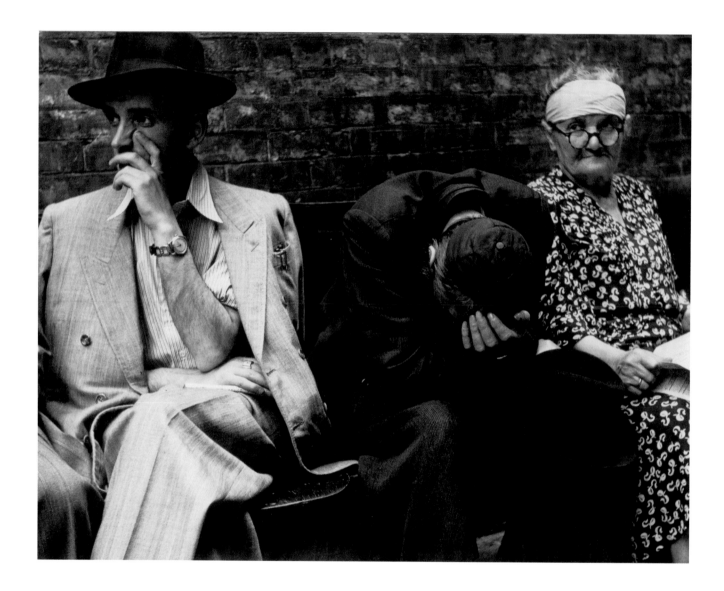

Plate 85. **Sonia Handelman Meyer** *Hebrew Immigration Aid Society*, c. 1946
Gelatin silver print, 7⅝ × 9¾ in. (19.4 × 24.8 cm). The Jewish Museum, New York, Purchase: Mimi and Barry J. Alperin in memory of Max Alperin

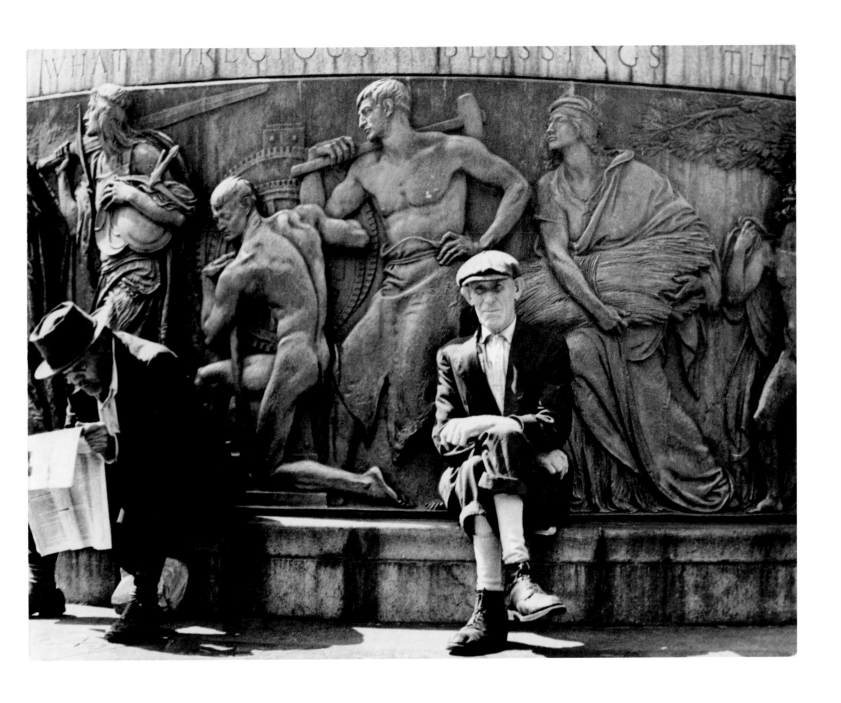

Plate 86. **Morris Huberland** *Union Square, New York*, c. 1942
Gelatin silver print, 7½ × 9¾ in. (19.1 × 24.8 cm). The Jewish Museum, New York, Purchase: Mimi and Barry J. Alperin Fund

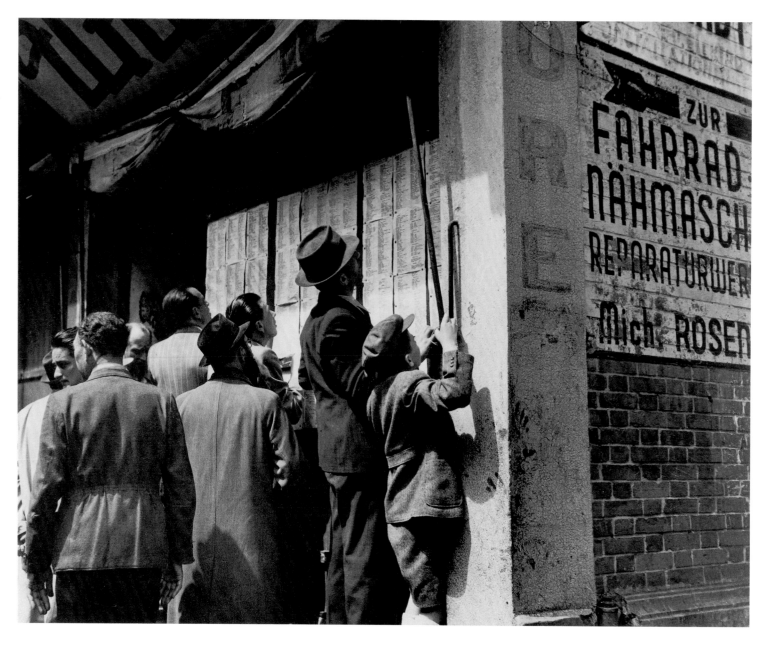

Plate 87. **Arthur Rothstein** *Refugees Looking at List of Survivors, Shanghai, China, 1946*
Gelatin silver print, 11 × 14 in. (27.9 × 35.6 cm). The Jewish Museum, New York, Gift of Arthur Rothstein Family

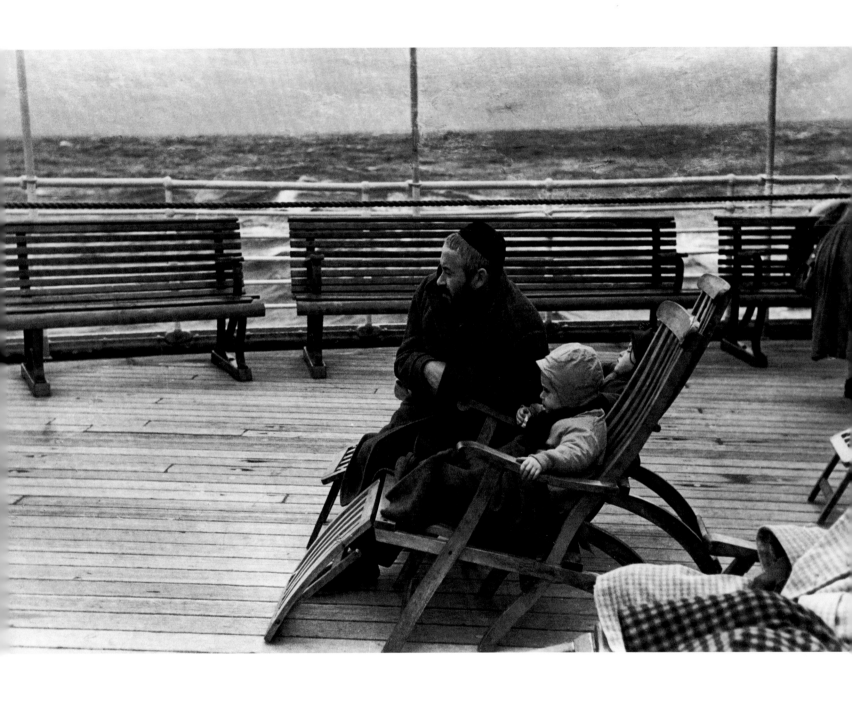

Plate 88. **Louis Stettner** *Coming to America*, c. 1951
Gelatin silver print, 9¼ × 14 in. (23.5 × 35.6 cm). The Jewish Museum, New York, Purchase: Photography Acquisitions Committee Fund

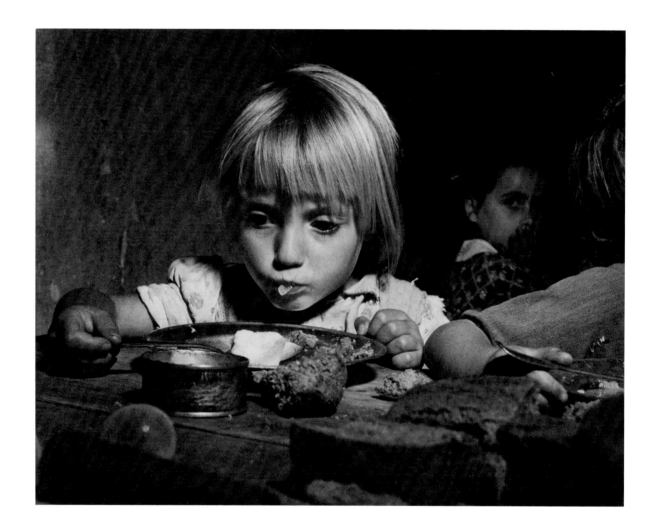

Plate 89. **Myron Ehrenberg** *Untitled (Greek Girl)*, c. 1946
Gelatin silver print, 10½ × 13⅜ in. (26.7 × 34 cm). The Jewish Museum, New York, Purchase: The Paul Strand Trust for the benefit of Virginia Stevens Gift

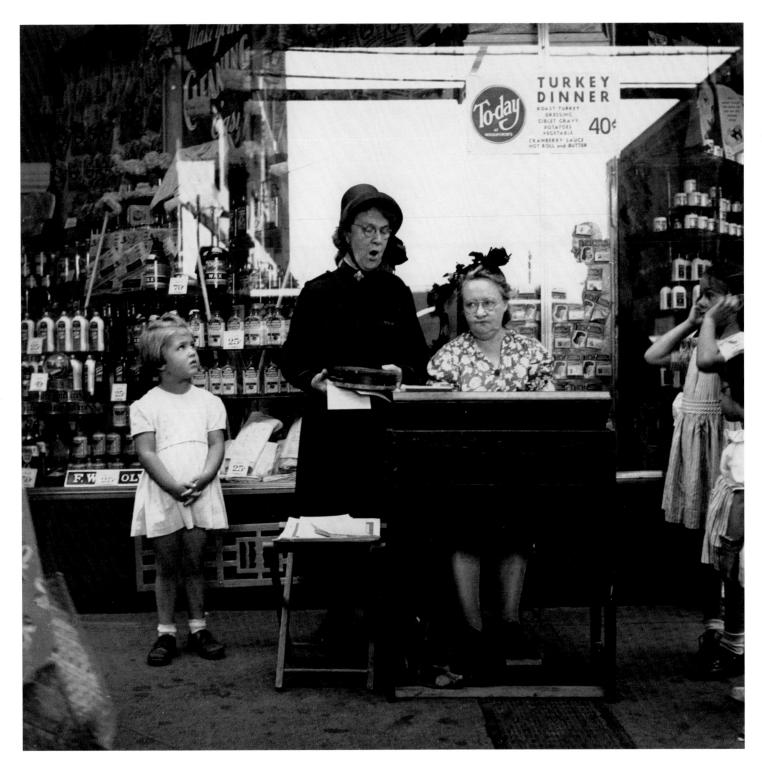

Plate 90. **Lee Sievan** *Salvation Army Lassie in Front of a Woolworth Store,* c. 1940
Gelatin silver print, 10½ × 10⅞ in. (26.7 × 27.6 cm). The Jewish Museum, New York, Purchase: Horace W. Goldsmith Foundation Fund

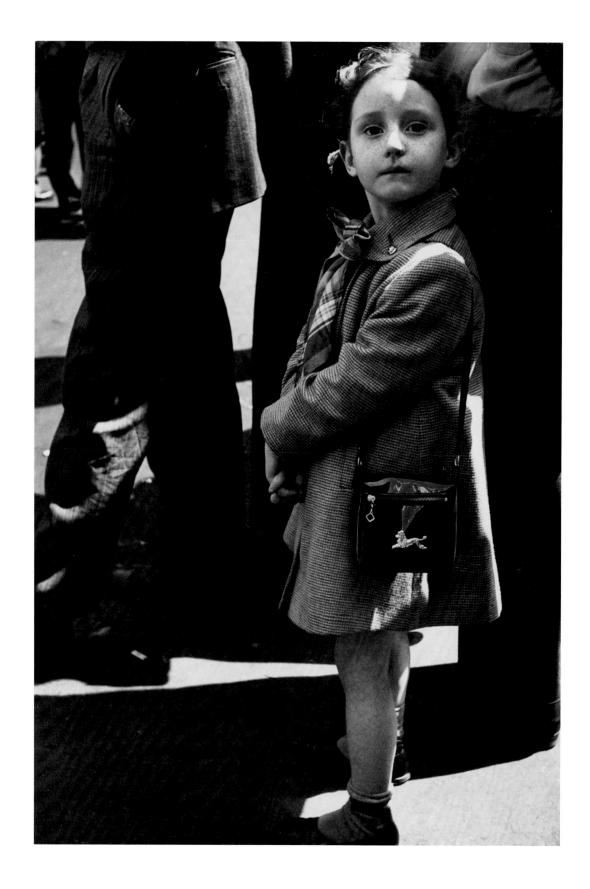

Plate 91. **Ann Cooper** *Girl Along a Parade Sideline, New York*, 1950
Gelatin silver print, 13¾ × 9¼ in. (34.9 × 23.5 cm). The Jewish Museum, New York, Purchase: The Paul Strand Trust for the benefit of Virginia Stevens Gift

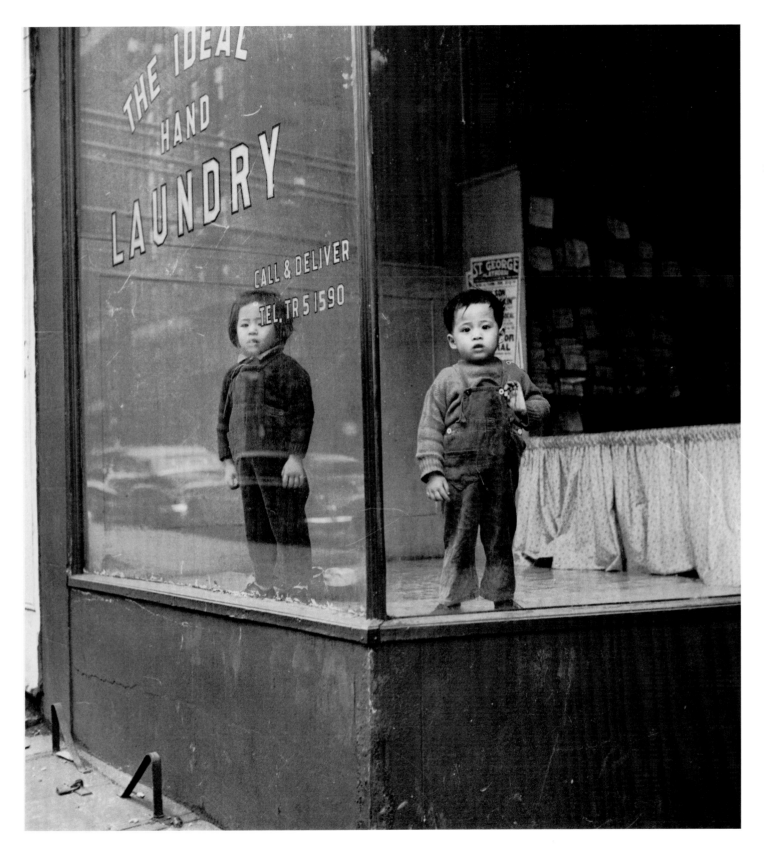

Plate 92. **Arthur Leipzig** *Ideal Laundry,* 1946
Gelatin silver print, 10 × 8 in. (25.4 × 20.3 cm). The Jewish Museum, New York, Purchase: Esther Leah Ritz Bequest

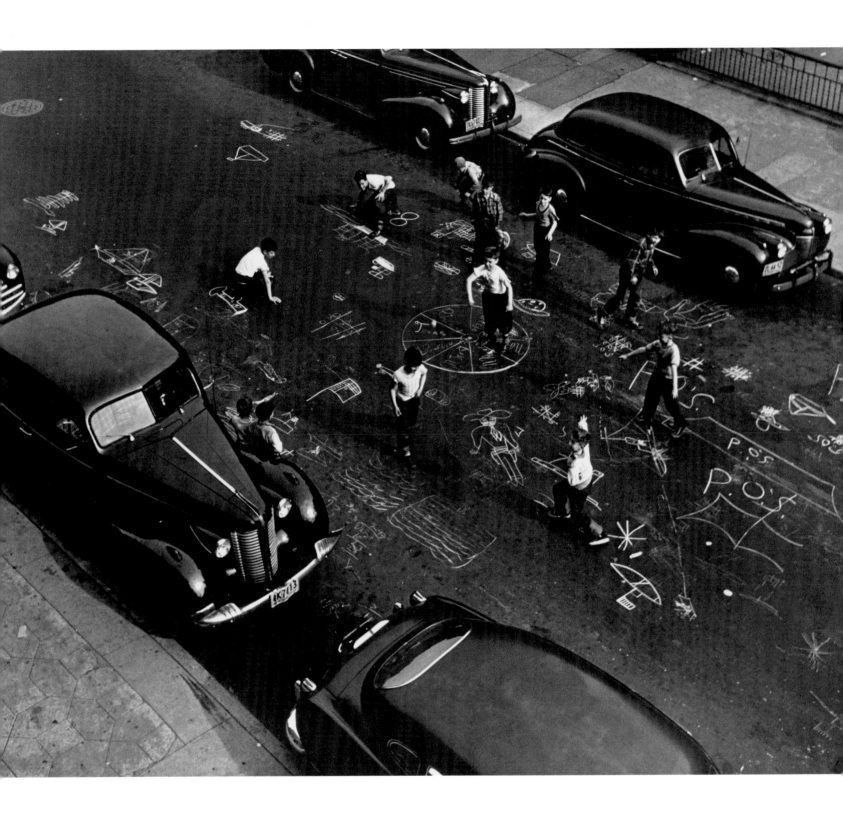

Plate 93. **Arthur Leipzig** *Chalk Games, Prospect Place, Brooklyn*, 1950
Gelatin silver print, 14 × 17¾ in. (35.6 × 45.1 cm). The Jewish Museum, New York, Purchase: Rictavia Schiff Bequest

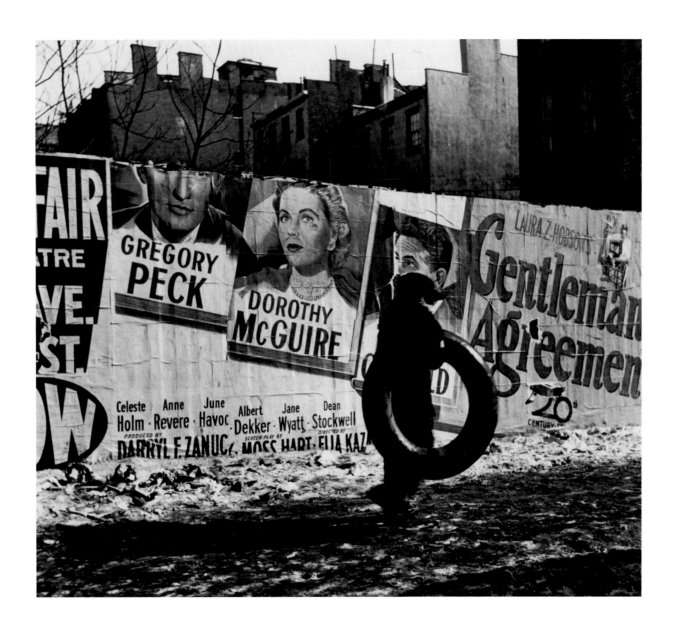

Plate 94. **Rebecca Lepkoff** *Lower East Side*, 1947

Gelatin silver print, 10⅝ × 11⅞ in. (27 × 30.2 cm). Columbus Museum of Art, Ohio, Photo League Collection, Museum Purchase with funds provided by Elizabeth M. Ross, the Derby Fund, John S. and Catherine Chapin Kobacker, and the Friends of the Photo League

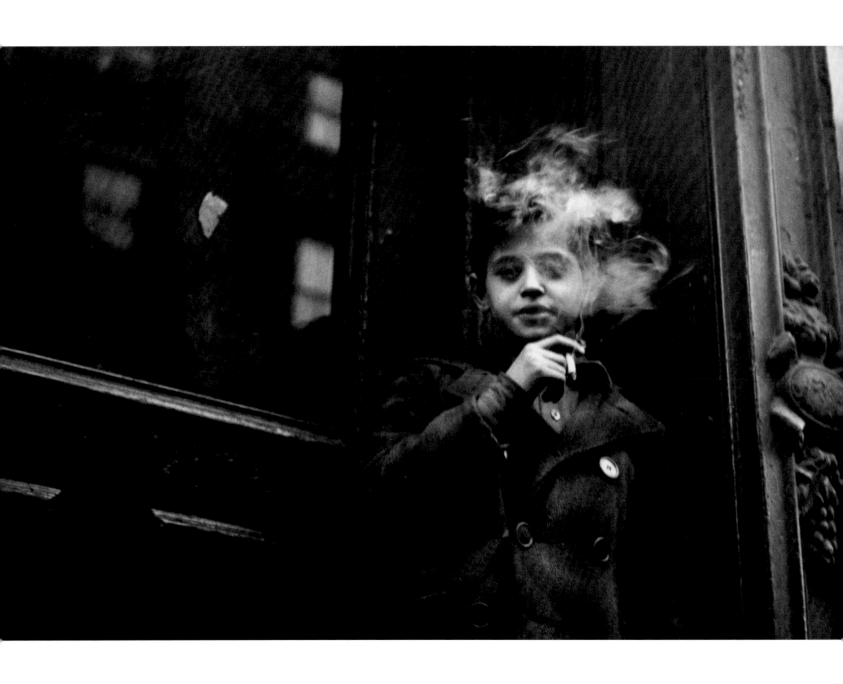

Plate 95. **Sandra Weiner** *East 26th Street*, 1948, printed later

Gelatin silver print, 6¼ × 9⅜ in. (15.9 × 23.8 cm). Columbus Museum of Art, Ohio, Photo League Collection, Museum Purchase with funds provided by Elizabeth M. Ross, the Derby Fund, John S. and Catherine Chapin Kobacker, and the Friends of the Photo League

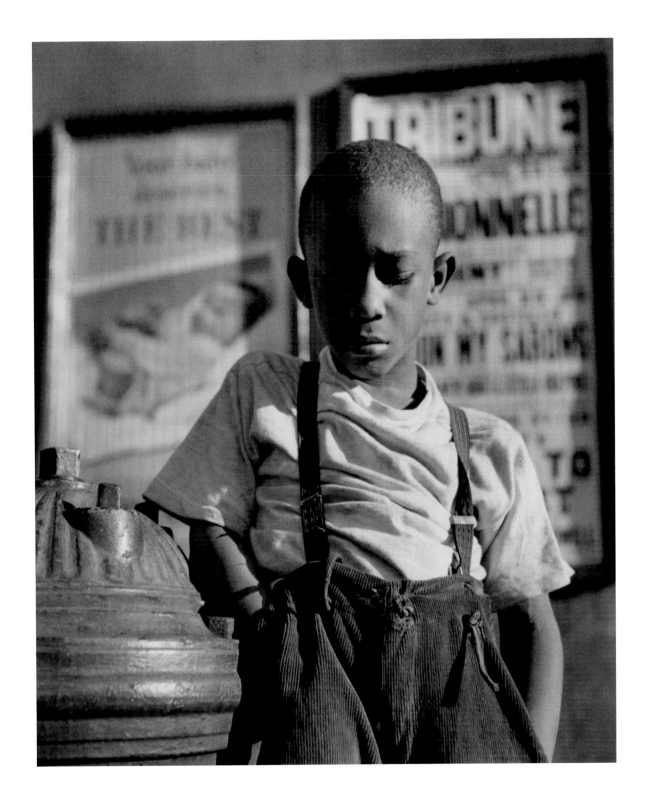

Plate 96. **Rae Russel** *Young Boy and Fire Hydrant,* 1947
Gelatin silver print, 12¾ × 10½ in. (32.4 × 26.7 cm). Columbus Museum of Art, Ohio, Photo League Collection, Museum Purchase, Derby Fund

184

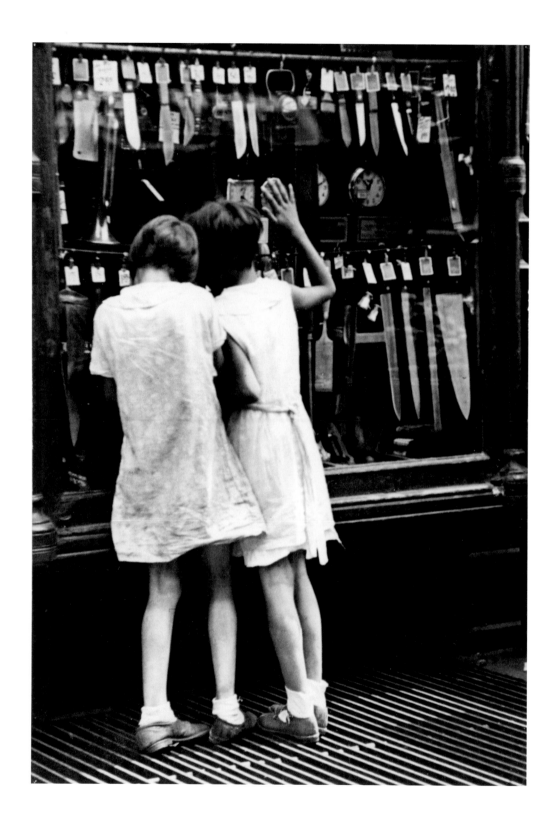

Plate 97. **Robert Disraeli** *Two Girls Looking in Cutlery Shop, New York,* c. 1950
Gelatin silver print, 8 × 5½ in. (20.3 × 14 cm). Columbus Museum of Art, Ohio, Photo League Collection, Museum Purchase with funds
provided by Elizabeth M. Ross, the Derby Fund, John S. and Catherine Chapin Kobacker, and the Friends of the Photo League

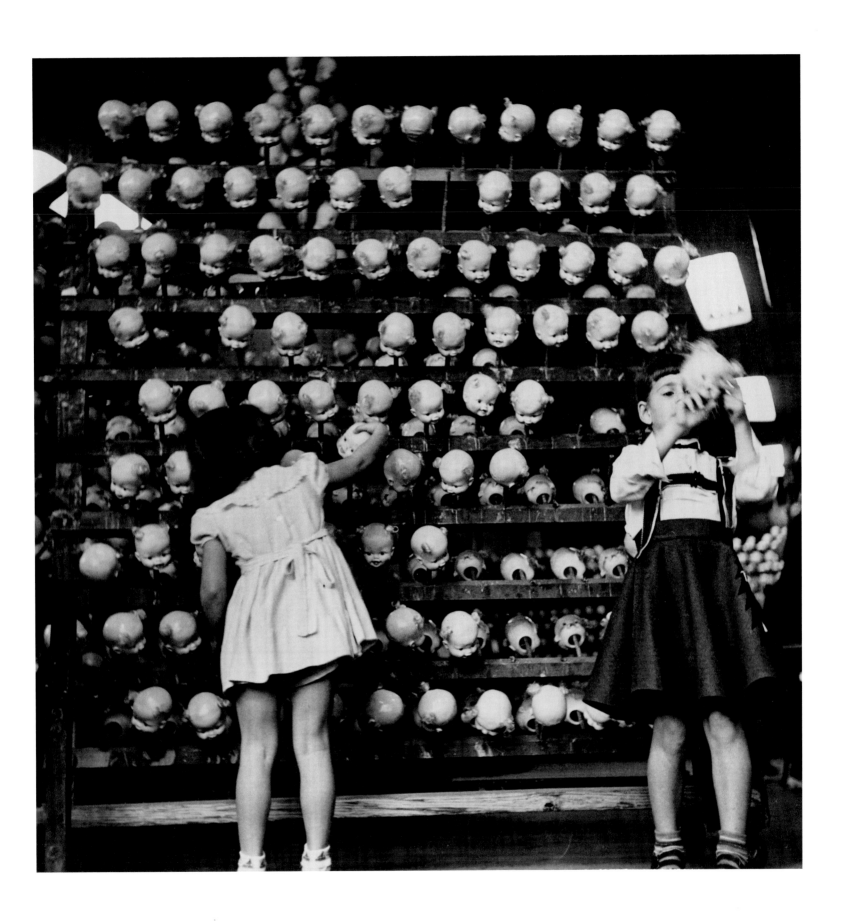

Plate 98. **Arthur Leipzig** *Doll Factory*, 1949
Gelatin silver print, 10⅝ × 10⅜ in. (27 × 26.4 cm). The Jewish Museum, New York, Purchase: Esther Leah Ritz Bequest

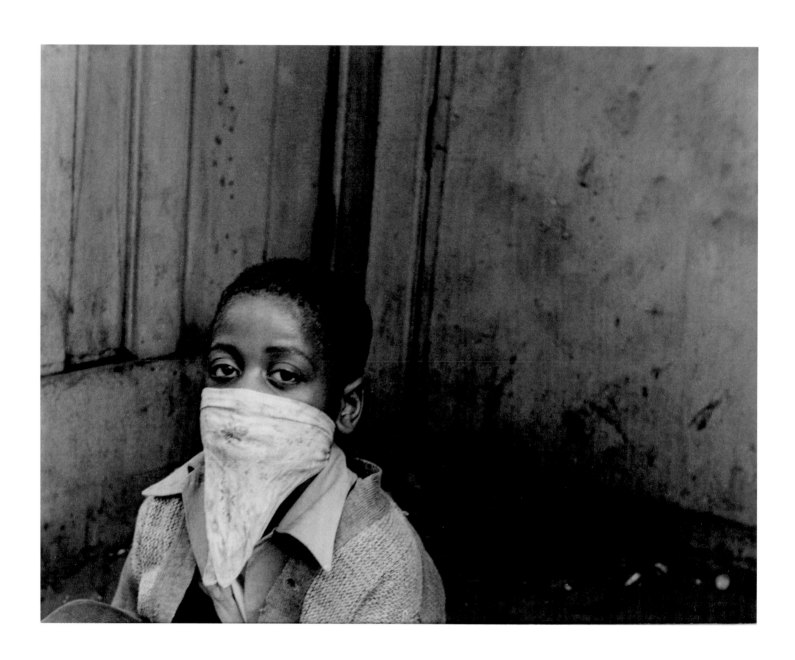

Plate 99. **Sonia Handelman Meyer** *Boy in Mask, Harlem,* 1945
Gelatin silver print, 10¼ × 13¼ in. (26 × 33.7 cm). Columbus Museum of Art, Ohio, Photo League Collection, Museum Purchase, Derby Fund

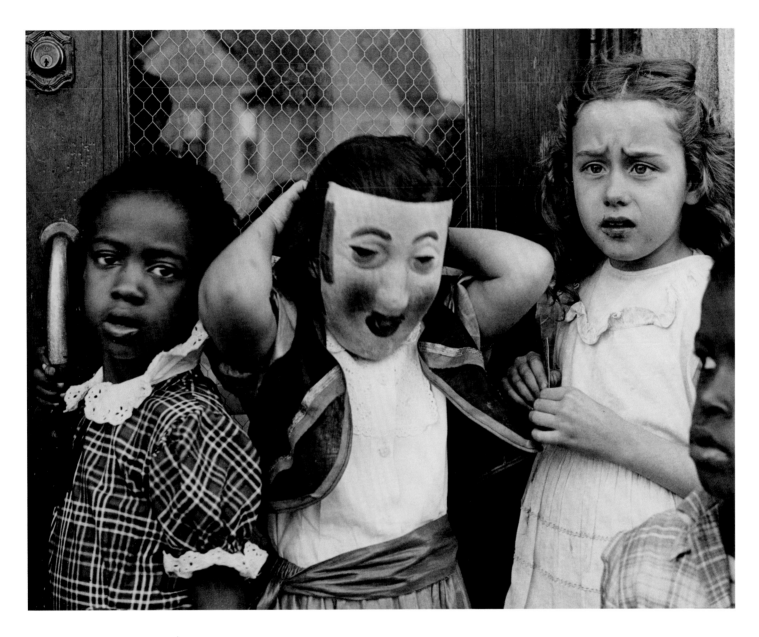

Plate 100. **Marvin E. Newman** *Halloween, South Side,* 1951
Gelatin silver print, 7¼ × 9¼ in. (18.4 × 23.5 cm). The Jewish Museum, New York, Purchase: Photography Acquisitions Committee Fund

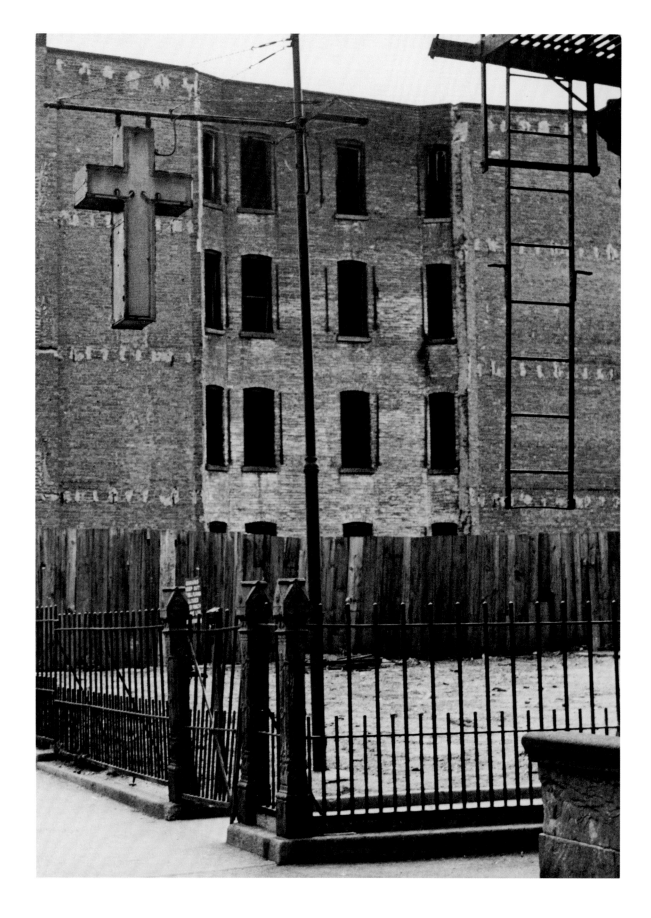

Plate 101. **N. Jay Jaffee** *Untitled,* c. 1949
Gelatin silver print, 9½ × 6¾ in. (24.1 × 17.1 cm). The Jewish Museum, New York, Gift of Howard Greenberg

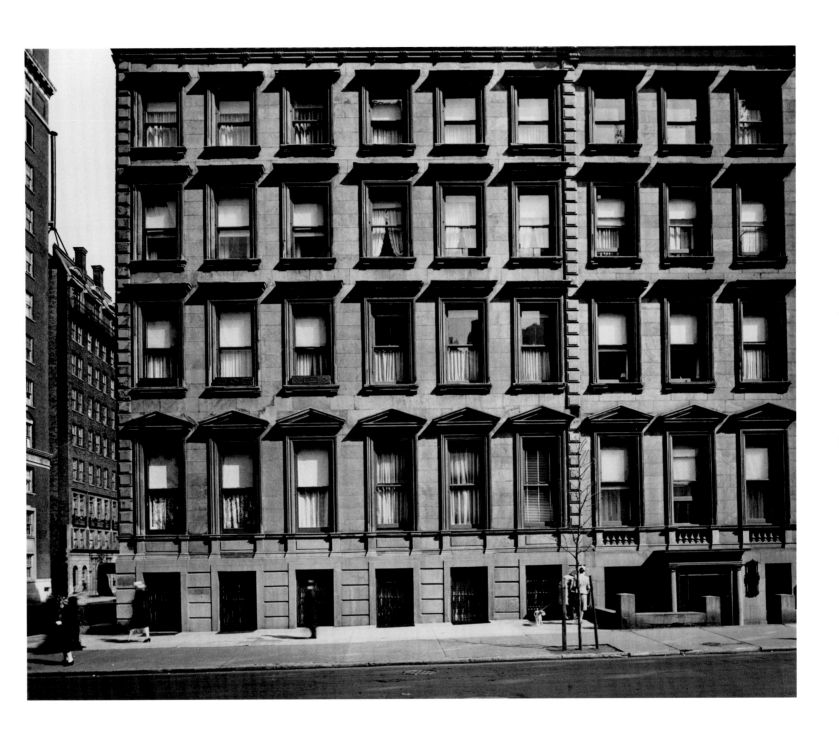

Plate 102. **Phyllis Dearborn Massar** *New York*, c. 1950
Gelatin silver print, 5⅞ × 7⅛ in. (14.9 × 18.1 cm). The Jewish Museum, New York, Purchase: The Paul Strand Trust for the benefit of Virginia Stevens Gift

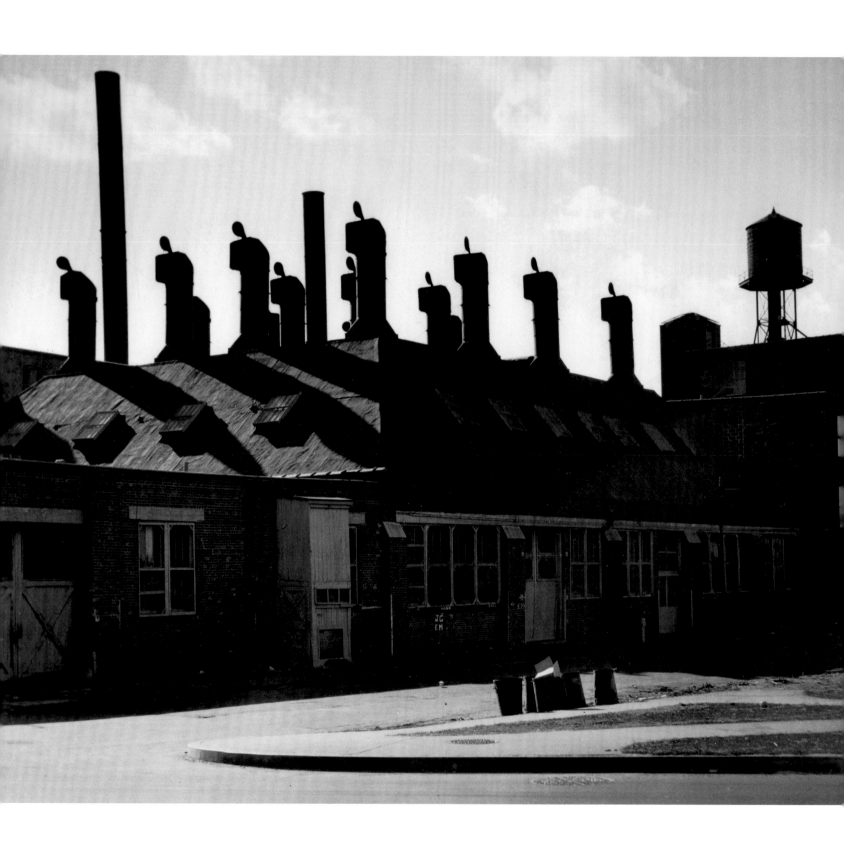

Plate 103. **Jack Lessinger** *Untitled (Rooftop)*, c. 1950
Gelatin silver print, 6⅜ × 7¾ in. (16.2 × 19.7 cm). The Jewish Museum, New York, Purchase: Esther Leah Ritz Bequest

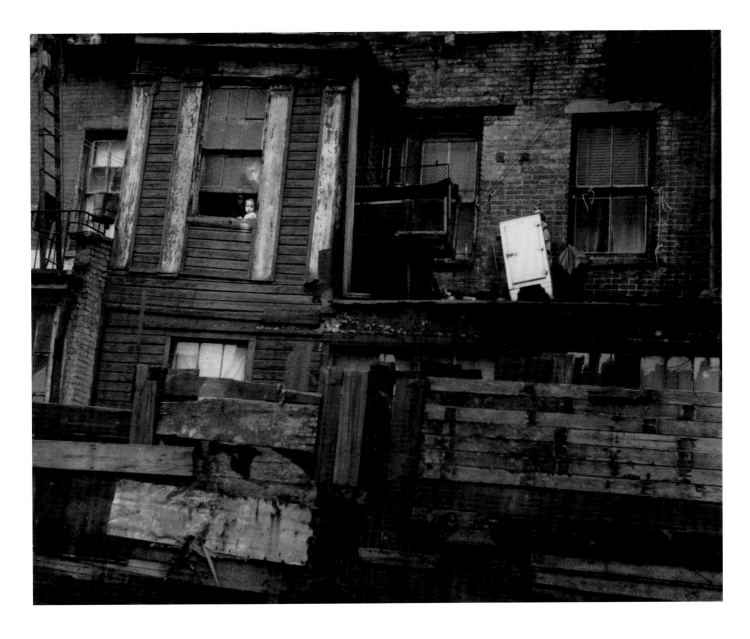

Plate 104. **Leo Goldstein** *Untitled (Tenement Facade),* c. 1950
Gelatin silver print, 4⅝ × 5¾ in. (11.7 × 14.6 cm). The Jewish Museum, New York, Purchase: The Paul Strand Trust for the benefit of Virginia Stevens Gift

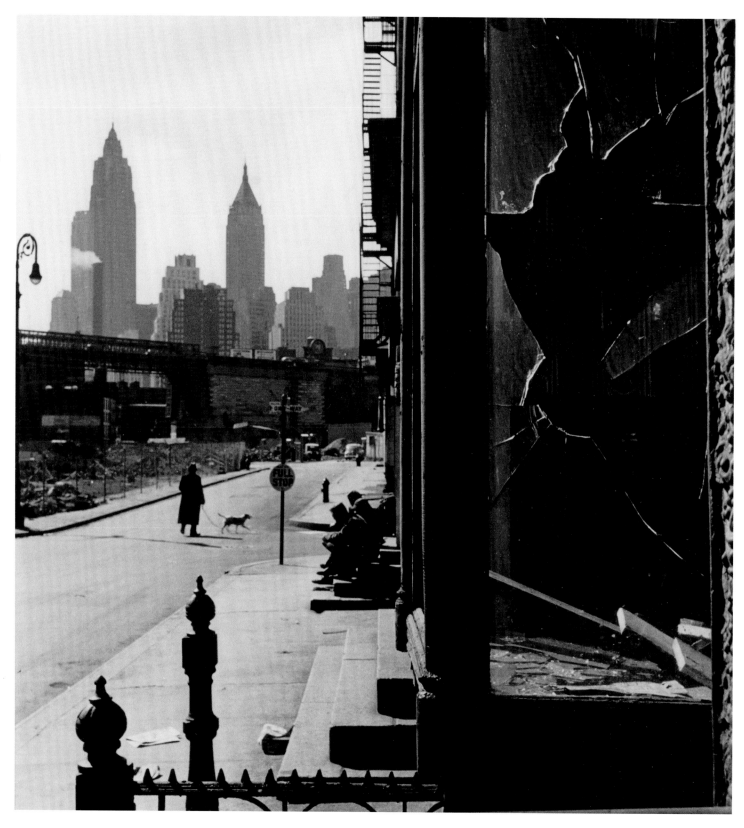

Plate 105. **Rebecca Lepkoff** *Broken Window on South Street, New York, 1948*
Gelatin silver print, 8 × 7½ in. (20.3 × 19.1 cm). Columbus Museum of Art, Ohio, Photo League Collection, Museum Purchase with funds
provided by Elizabeth M. Ross, the Derby Fund, John S. and Catherine Chapin Kobacker, and the Friends of the Photo League

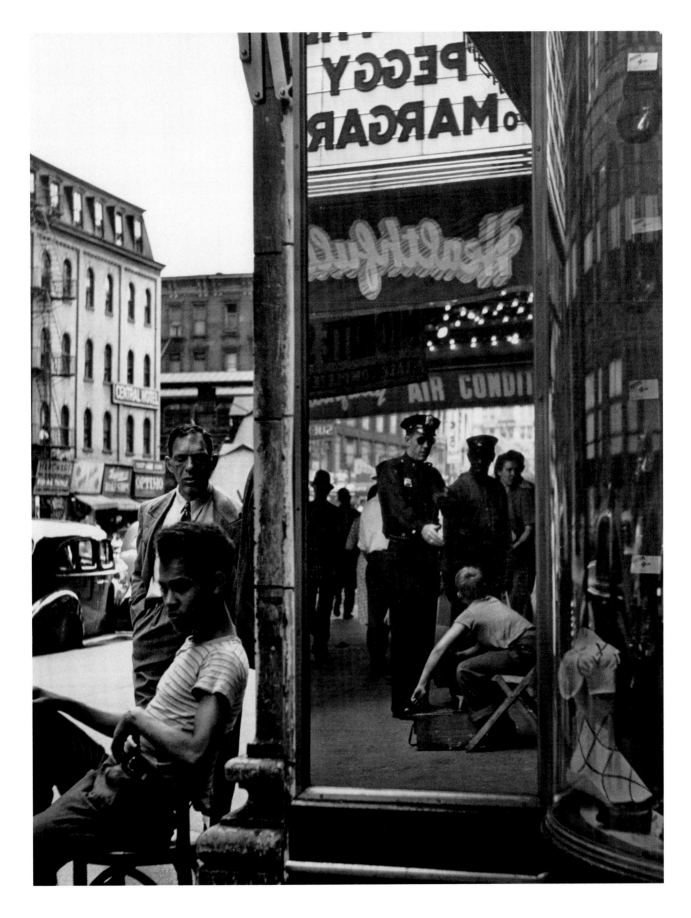

Plate 106. **Morris Engel** *Shoeshine Boy with Cop, 14th Street, New York, 1947*
Gelatin silver print, 13⅜ × 10⅜ in. (34 × 26.4 cm). The Jewish Museum, New York, Purchase: Photography Acquisitions Committee Fund

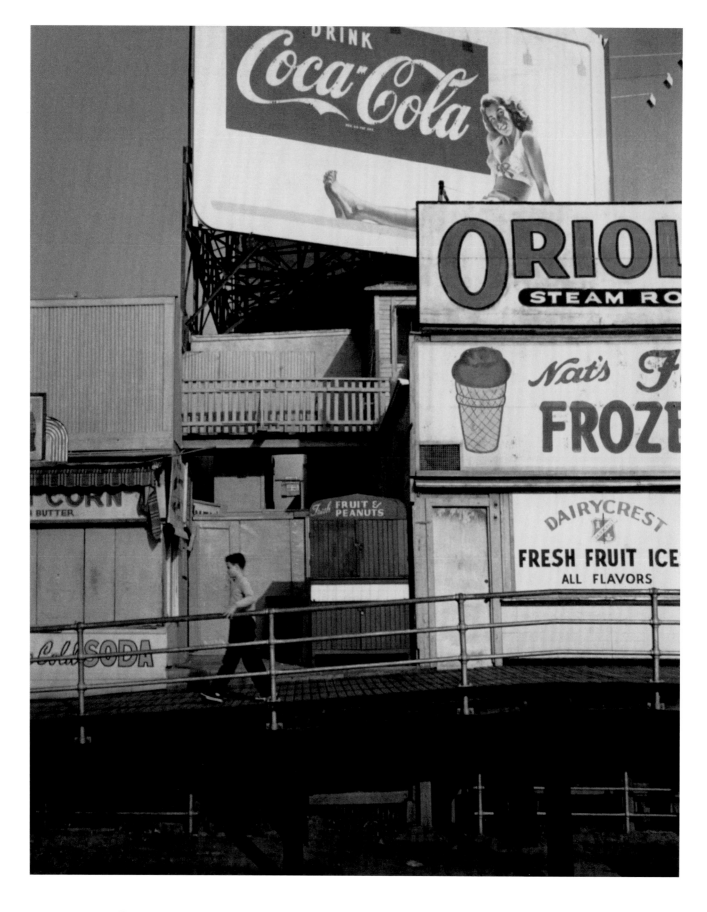

Plate 107. **Martin Elkort** *Boardwalk Billboards,* 1949
Gelatin silver print, 9⅞ × 8⅛ in. (25.1 × 20.6 cm). Columbus Museum of Art, Ohio, Photo League Collection, Museum Purchase, Derby Fund

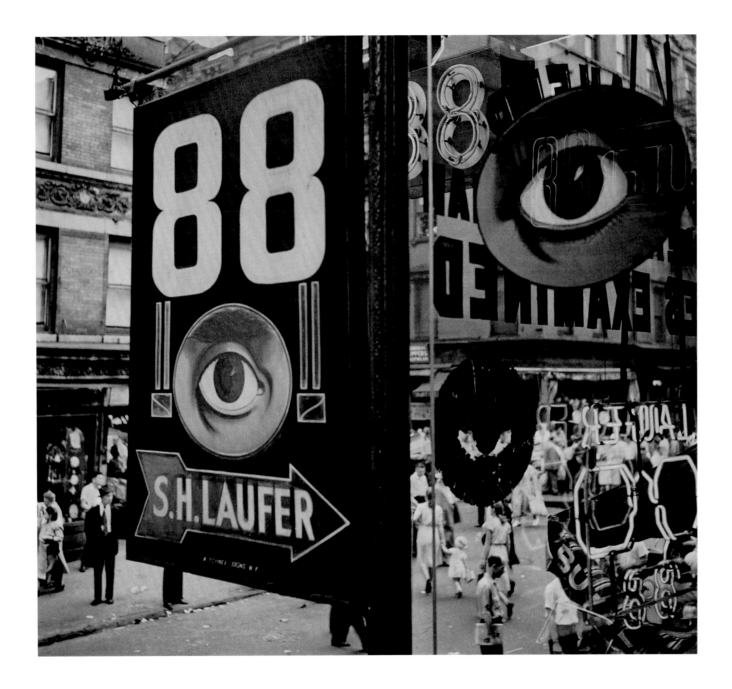

Plate 108. **Bill Witt** *The Eye, Lower East Side*, 1948
Gelatin silver print, 7½ × 8¼ in. (19.1 × 21 cm). Columbus Museum of Art, Ohio, Photo League Collection, Museum Purchase with
funds provided by Elizabeth M. Ross, the Derby Fund, John S. and Catherine Chapin Kobacker, and the Friends of the Photo League

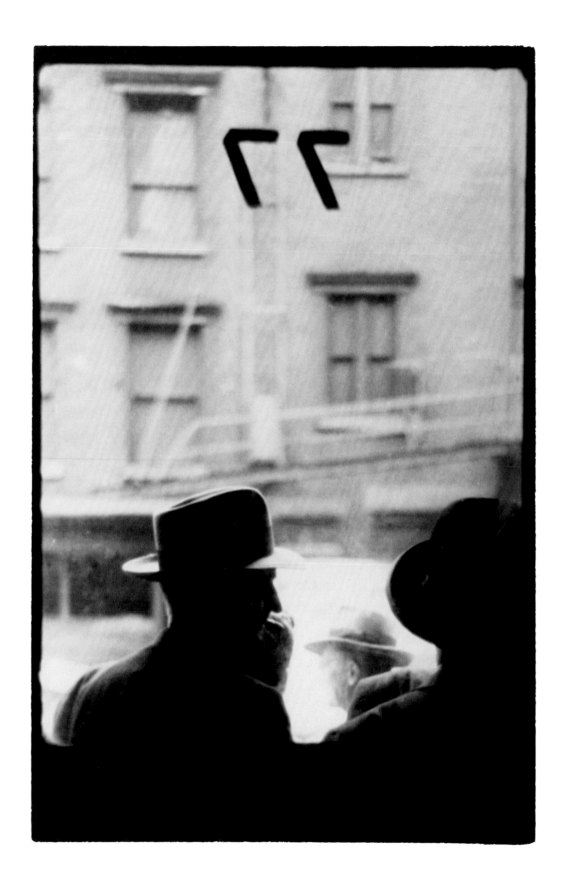

Plate 109. **David Vestal** *77 East 10th Street, New York,* 1949
Gelatin silver print, 10½ × 6⅞ in. (26.7 × 17.5 cm). The Jewish Museum, New York, Purchase:
B. Gerald Cantor, Lady Kathleen Epstein, Louis E. and Rosalyn M. Shecter Gifts, by exchange

Plate 110. **Weegee** *Empire State Building,* c. 1945
Gelatin silver print, 14⅛ × 11¼ in. (35.9 × 28.6 cm). The Jewish Museum, New York, Purchase:
Horace W. Goldsmith Foundation and Photography Acquisitions Committee Funds

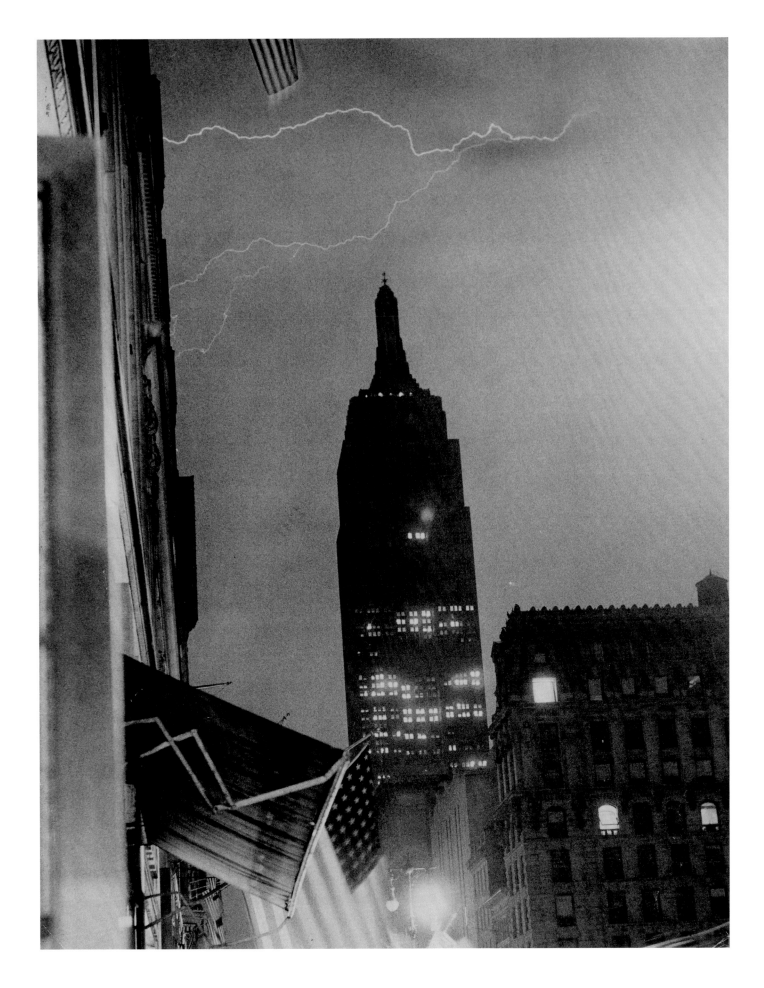

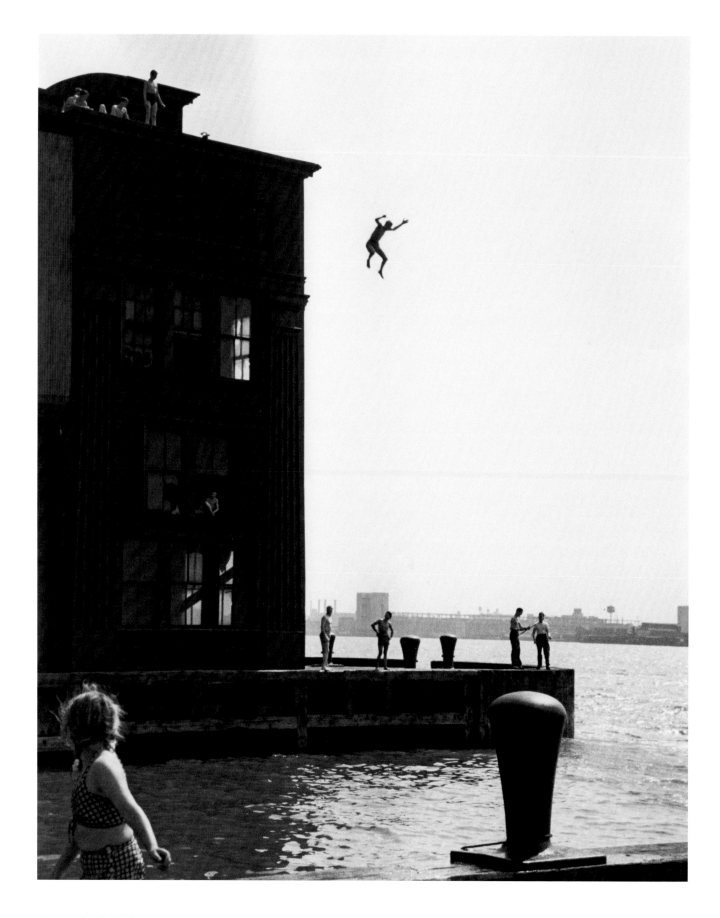

Plate 111. **Ruth Orkin** *Boy Jumping into Hudson River,* 1948
Gelatin silver print, 13⅛ × 10½ in. (33.3 × 26.7 cm). The Jewish Museum, New York, Purchase: Horace W. Goldsmith Foundation Fund

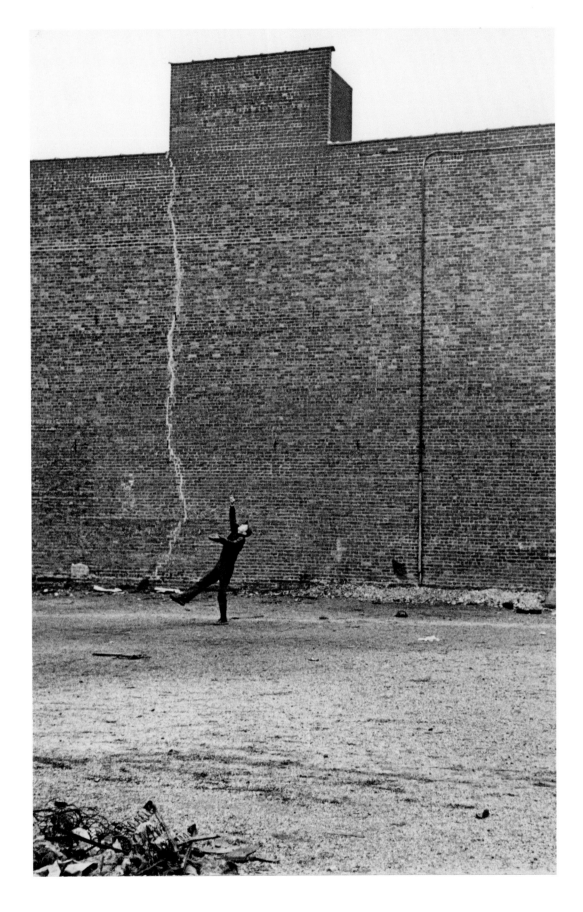

Plate 112. **Tosh Matsumoto** *Untitled,* c. 1950
Gelatin silver print, 10⅛ × 6½ in. (25.7 × 16.5 cm). The Jewish Museum, New York, Gift of Howard Greenberg

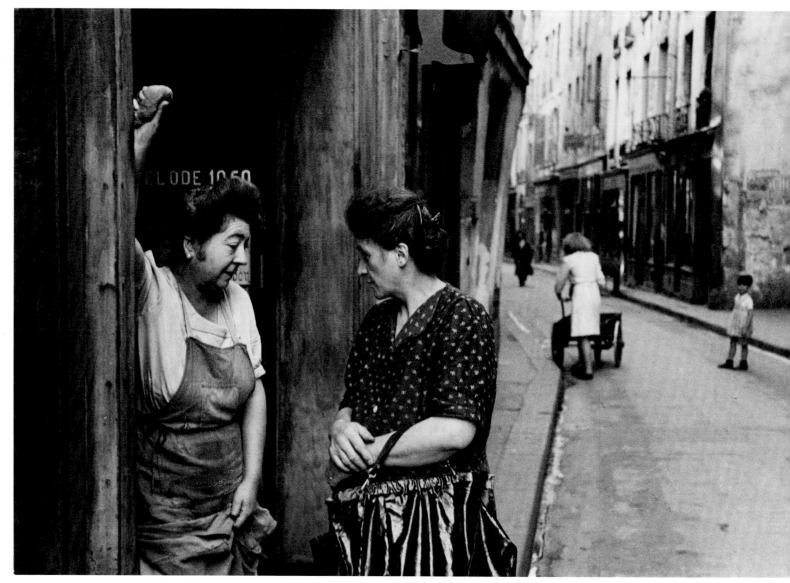

Plate 113. **Rudy Burckhardt** *Paris*, 1947
Gelatin silver print, 6½ × 9⅝ in. (16.5 × 24.4 cm). The Jewish Museum, New York, Gift of Howard Greenberg

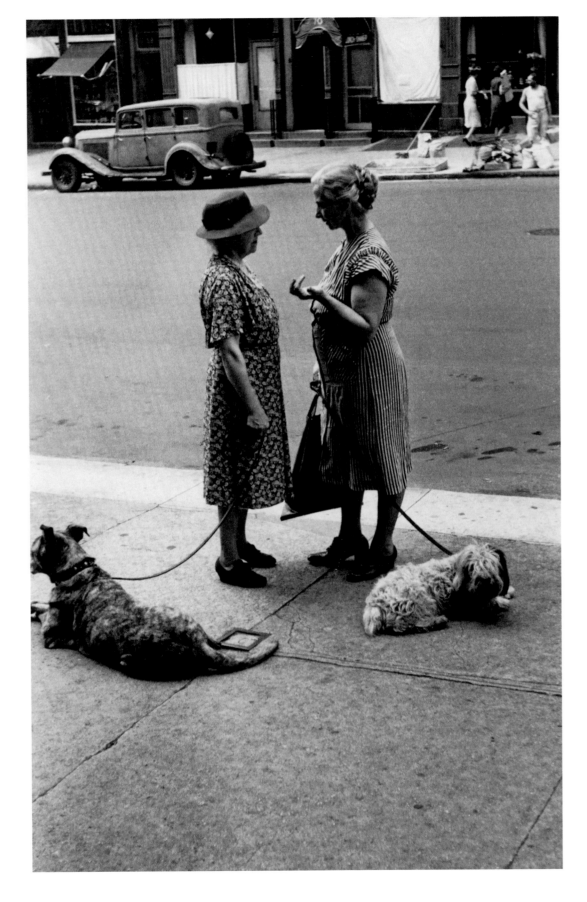

Plate 114. **Dan Weiner** *East End Avenue*, 1950
Gelatin silver print, 7⅛ × 4⅝ in. (18.1 × 11.7 cm). The Jewish Museum, New York, Purchase: Photography Acquisitions Committee Fund

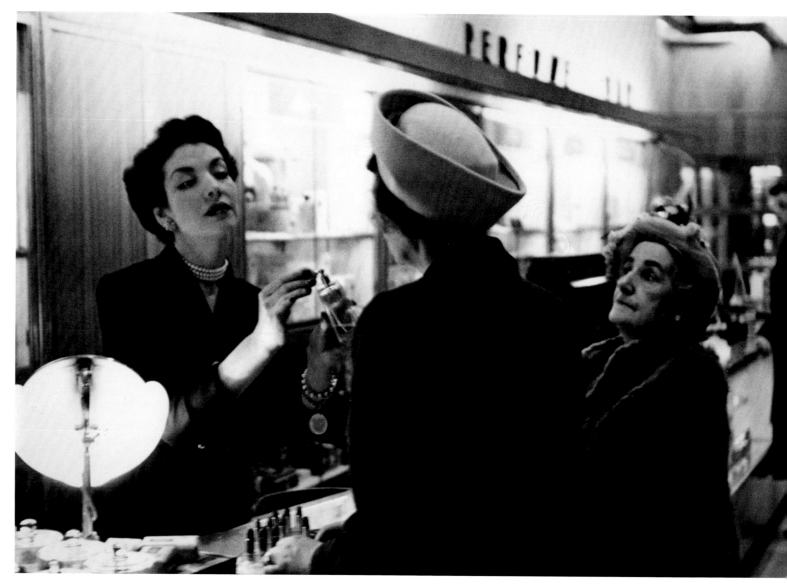

Plate 115. **Dan Weiner** *Women at Perfume Counter*, c. 1948
Gelatin silver print, 9⅜ × 13½ in. (23.8 × 34.3 cm). Columbus Museum of Art, Ohio, Photo League Collection, Museum Purchase with
funds provided by Elizabeth M. Ross, the Derby Fund, John S. and Catherine Chapin Kobacker, and the Friends of the Photo League

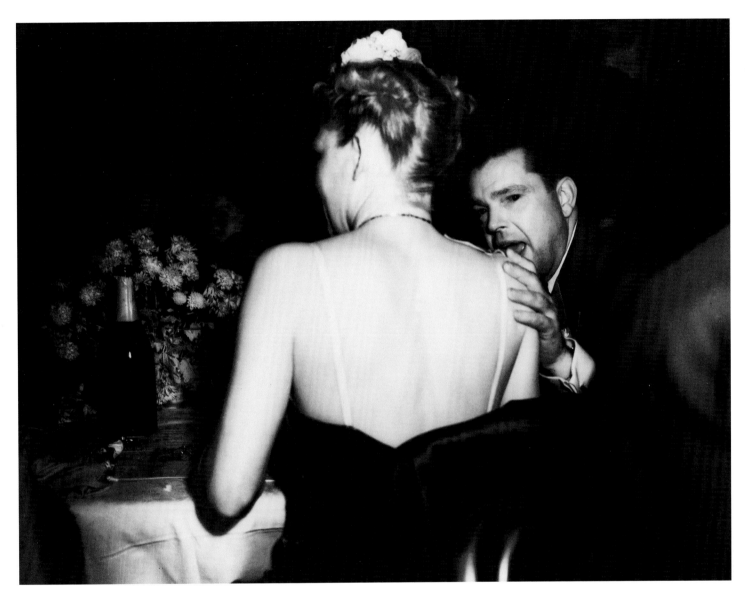

Plate 116. **Weegee** *Woman at the Met*, 1943
Gelatin silver print, 10⅞ × 14 in. (27.6 × 35.6 cm). The Jewish Museum, New York, Purchase: Photography Acquisitions Committee Fund

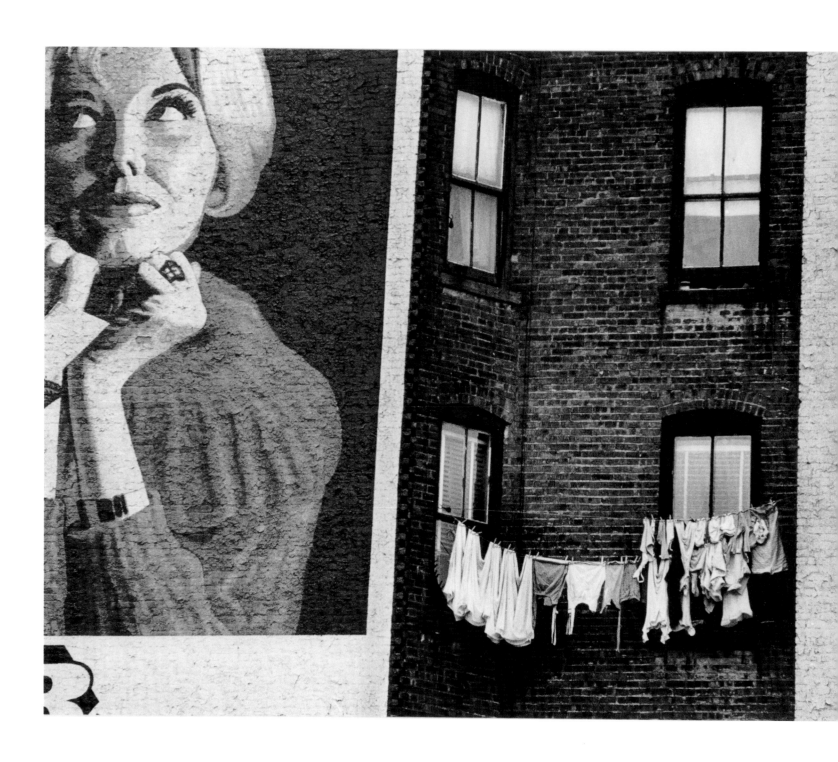

Plate 117. **Erika Stone** *Lower Eastside Facade,* 1947
Gelatin silver print, 10½ × 13¼ in. (26.7 × 33.7 cm). Columbus Museum of Art, Ohio, Photo League Collection, Museum Purchase with
funds provided by Elizabeth M. Ross, the Derby Fund, John S. and Catherine Chapin Kobacker, and the Friends of the Photo League

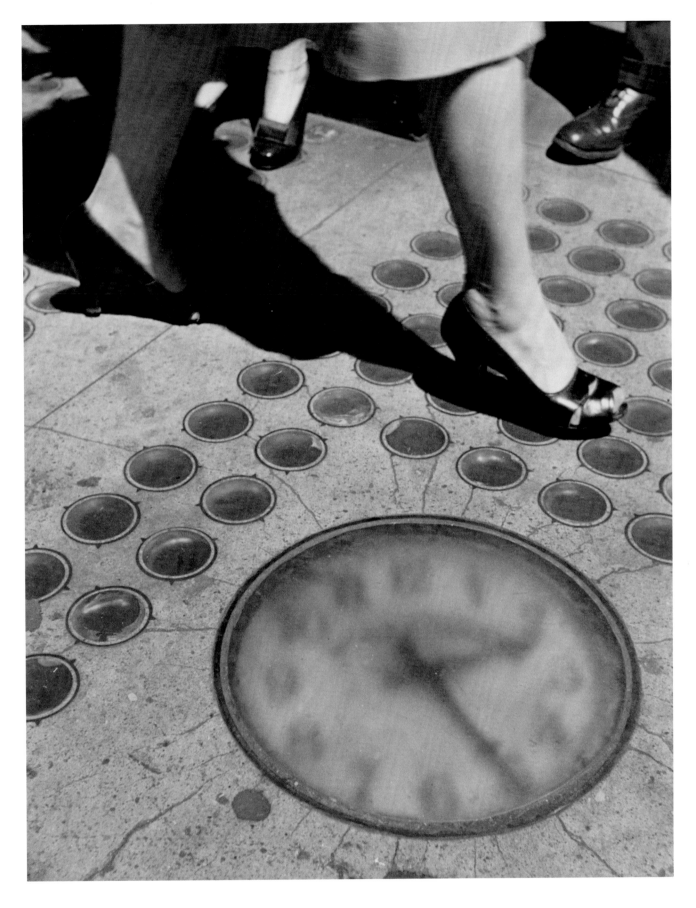

Plate 118. **Ida Wyman** *Sidewalk Clock, New York,* 1947
Gelatin silver print, 9⅝ × 7½ in. (29.1 × 24.4 cm). Columbus Museum of Art, Ohio, Photo League Collection, Museum Purchase, Derby Fund

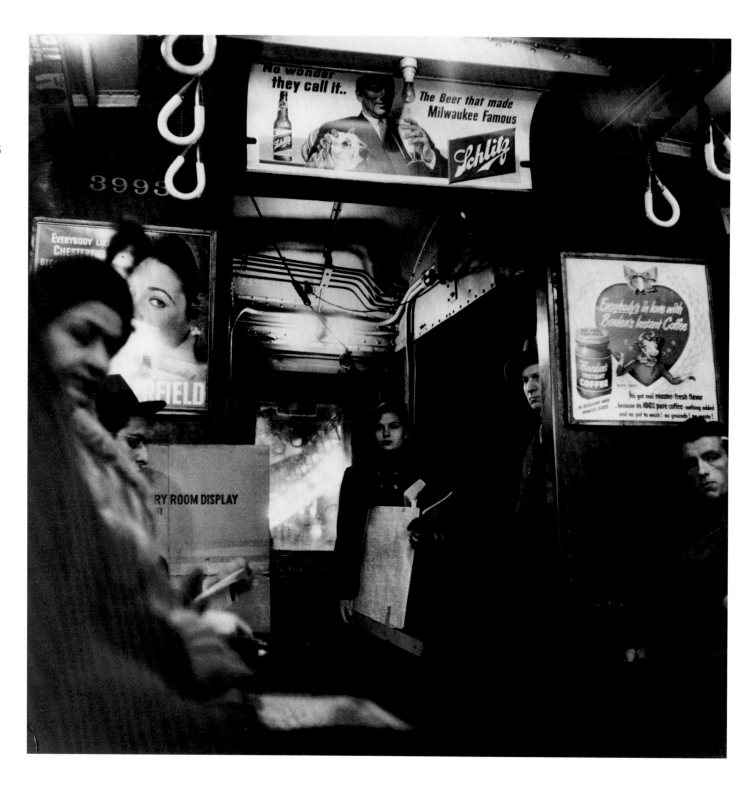

Plate 119. **Sy Kattelson** *Untitled (Subway Car),* 1949
Gelatin silver print, 10⅝ × 10⅝ in. (27 × 27 cm). The Jewish Museum, New York, Purchase: The Paul Strand Trust for the benefit of Virginia Stevens Gift

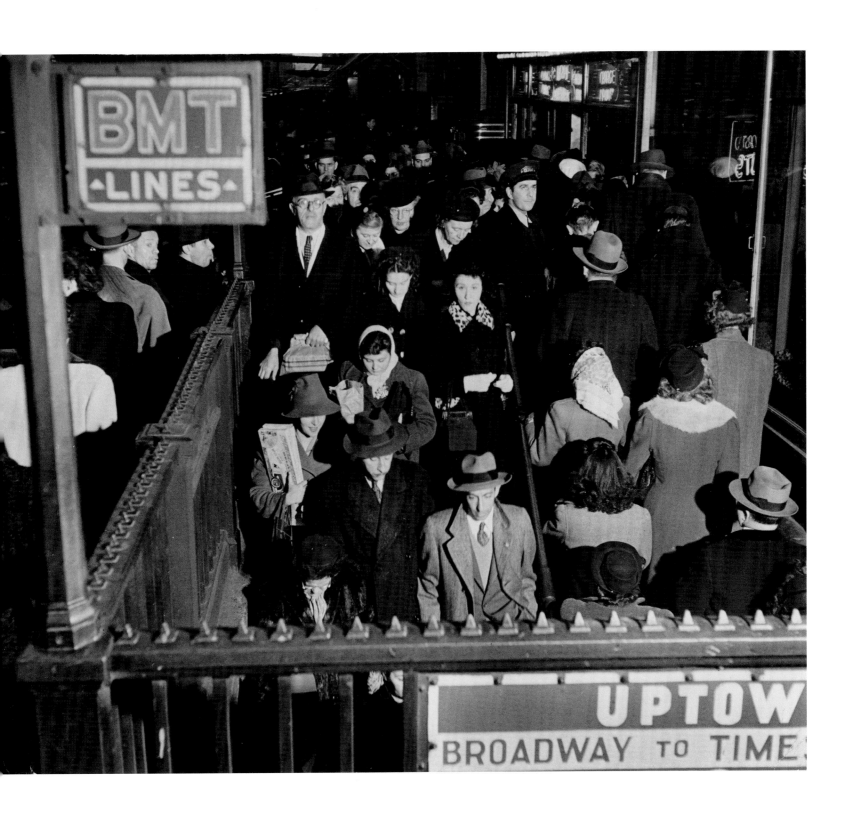

Plate 120. **David Robbins** *Subway Station,* c. 1944
Gelatin silver print, 11⅛ × 13¼ in. (28.3 × 33.7 cm). The Jewish Museum, New York, Purchase: Horace W. Goldsmith Foundation Fund

208

Plate 121. **Sy Kattelson** *Republican Convention,* 1948
Gelatin silver print, 10¾ × 13½ in. (27.3 × 34.3 cm). Columbus Museum of Art, Ohio, Photo League Collection, Museum Purchase with
funds provided by Elizabeth M. Ross, the Derby Fund, John S. and Catherine Chapin Kobacker, and the Friends of the Photo League

209

Plate 122. **Dan Weiner** *At the Ceremonies for the Laying of the United Nations Building's Cornerstone,* 1949
Gelatin silver print, 10⅝ × 13¼ in. (27 × 33.7 cm). The Jewish Museum, New York, Purchase: Photography Acquisitions Committee Fund

Plate 123. **Jerome Liebling** *May Day, New York*, 1948
Gelatin silver print, 6¾ × 7⅝ in. (17.1 × 19.4 cm). Columbus Museum of Art, Ohio, Photo League Collection, Museum Purchase with
funds provided by Elizabeth M. Ross, the Derby Fund, John S. and Catherine Chapin Kobacker, and the Friends of the Photo League

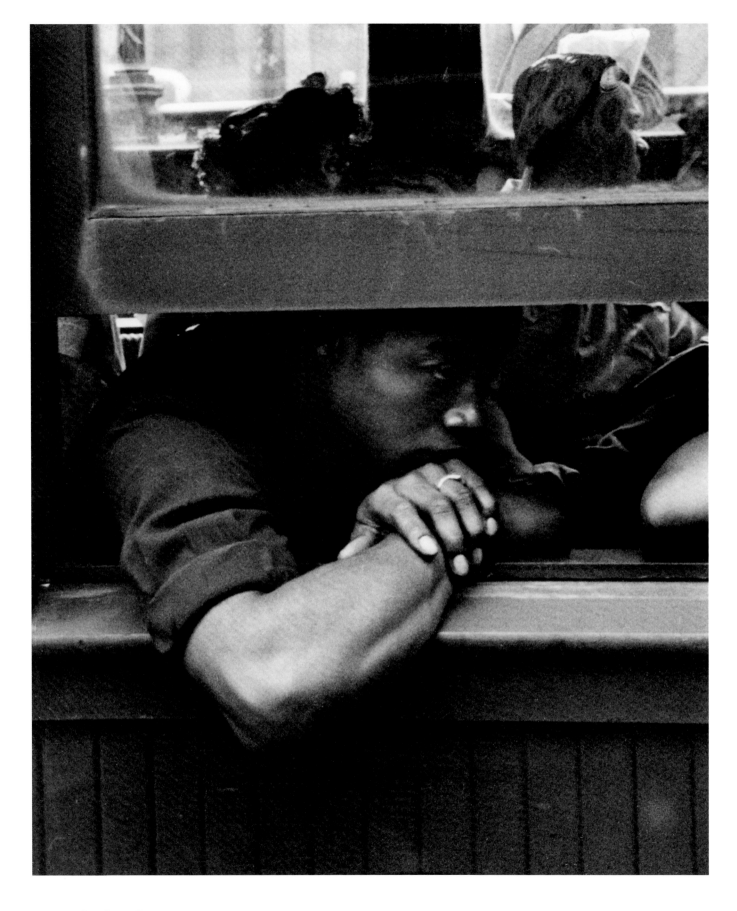

Plate 124. **Marvin E. Newman** *Third Avenue El,* 1949
Gelatin silver print, 4½ × 3⅝ in. (11.4 × 9.2 cm). Columbus Museum of Art, Ohio, Photo League Collection, Museum Purchase, Derby Fund

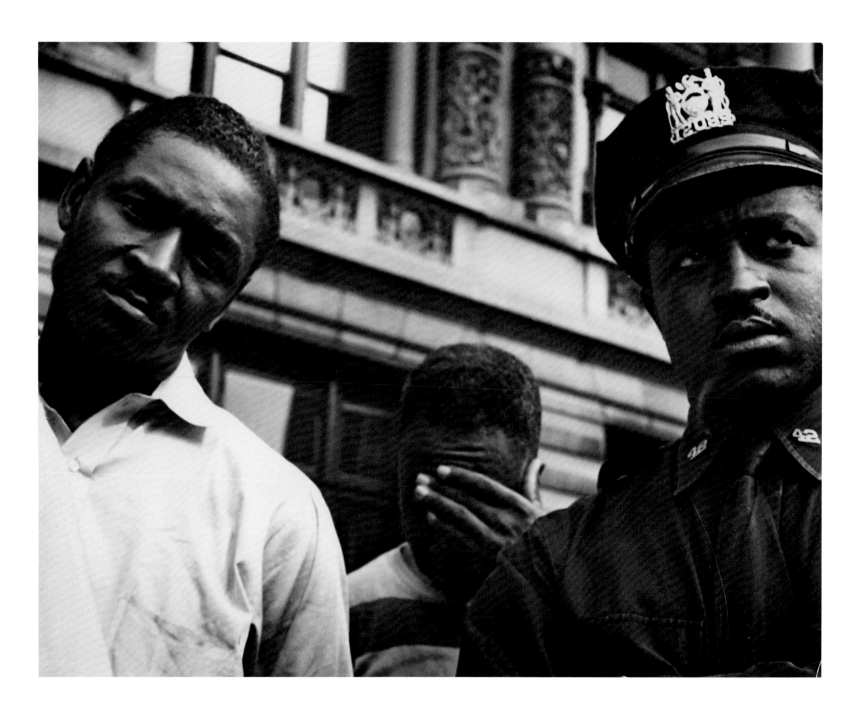

Plate 125. **Sonia Handelman Meyer** *Anti-Lynching Rally, Madison Square Park,* 1946
Gelatin silver print, 7⅜ × 9½ in. (18.7 × 24.1 cm). Columbus Museum of Art, Ohio, Photo League Collection, Gift of the Artist

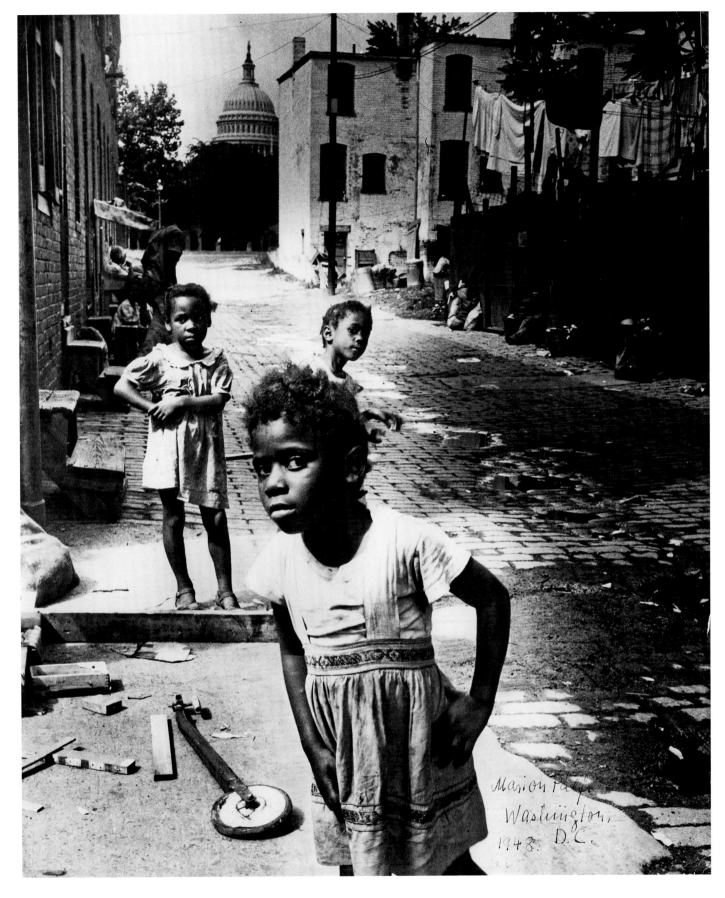

Plate 126. **Marion Palfi** *In the Shadow of the Capitol*, 1948
Gelatin silver print, 17 × 14 in. (43.2 × 35.6 cm). The Jewish Museum, New York, Purchase: Photography Acquisitions Committee Fund

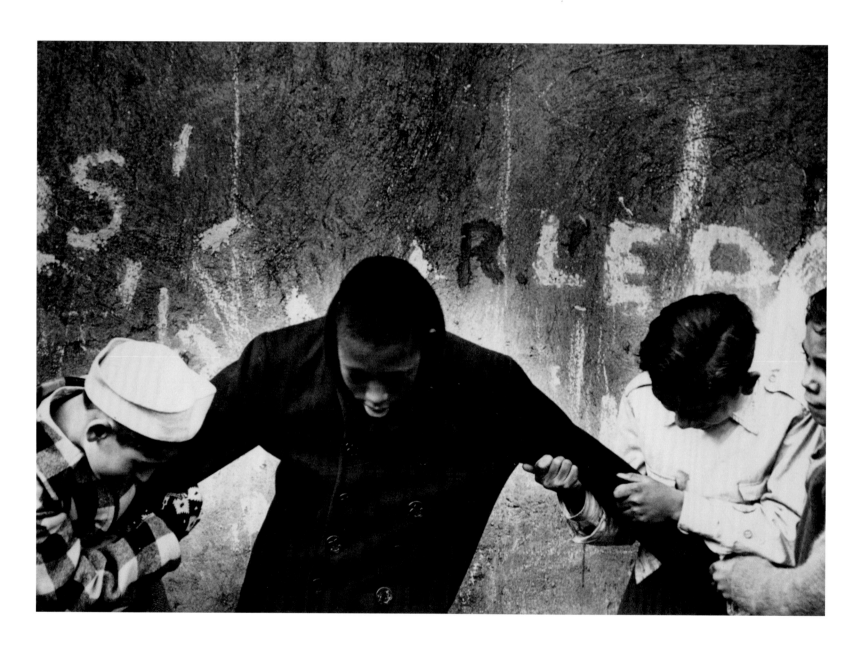

Plate 127. **Vivian Cherry** *Game of Lynching, East Harlem*, 1947
Gelatin silver print, 6¼ × 9 in. (15.9 × 22.9 cm). Columbus Museum of Art, Ohio, Photo League Collection, Museum Purchase, Derby Fund

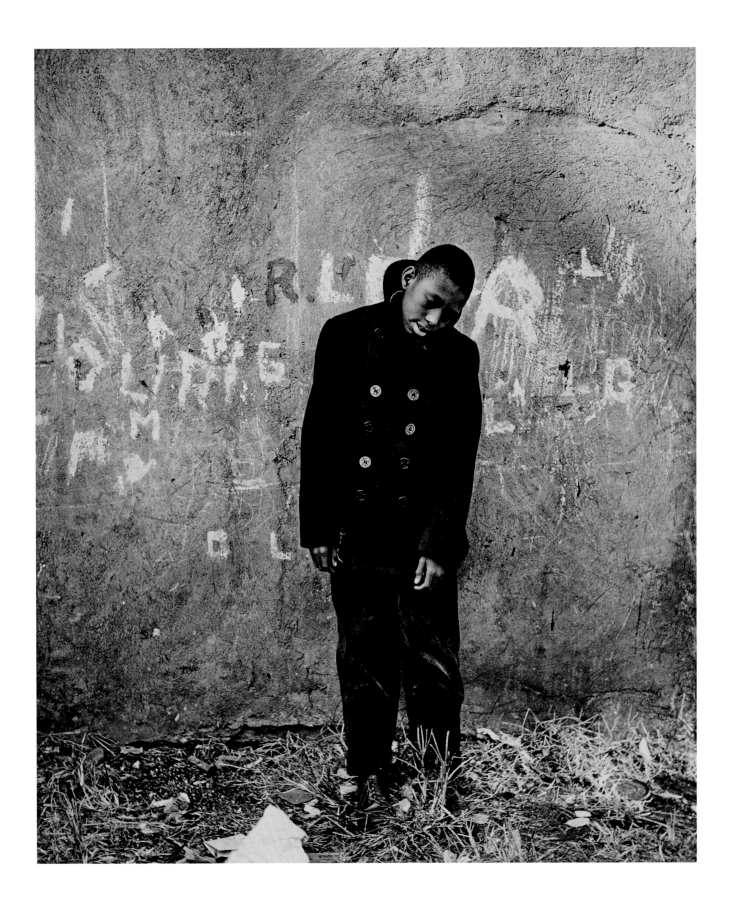

Plate 128. **Vivian Cherry** *Game of Lynching, East Harlem,* 1947, printed later
Gelatin silver print, 14 × 11 in. (35.6 × 27.9 cm). The Jewish Museum, New York, Purchase: Photography Acquisitions Committee Fund

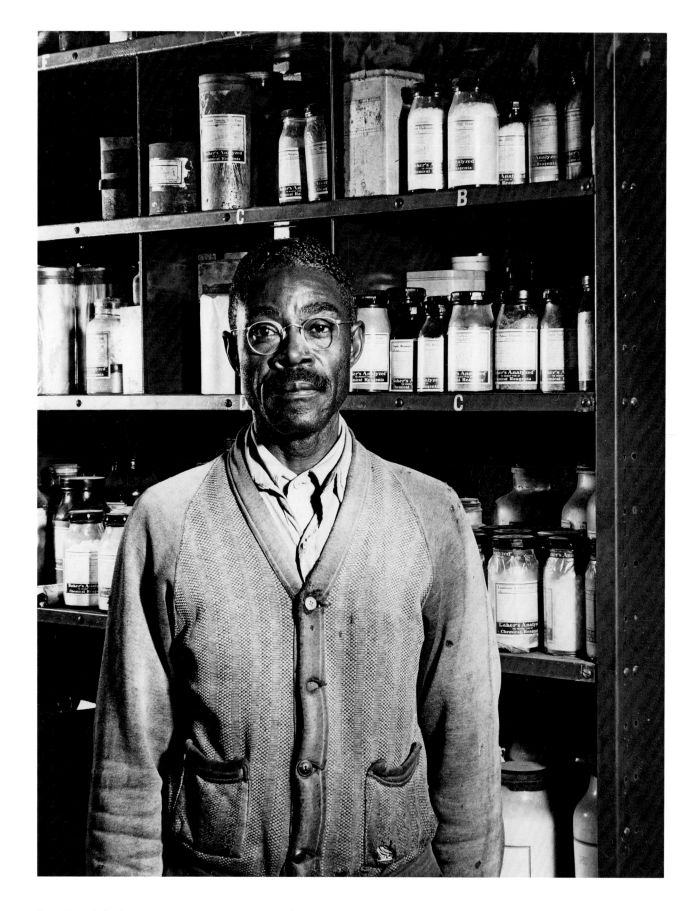

Plate 129. **Edwin Rosskam** *Stock Room Porter, Esso Laboratory, Baton Rouge, Louisiana, 1944*
Gelatin silver print, 13⅝ × 10½ in. (34.6 × 26.7 cm). The Jewish Museum, New York, Purchase: William and Jane Schloss Family Foundation Fund

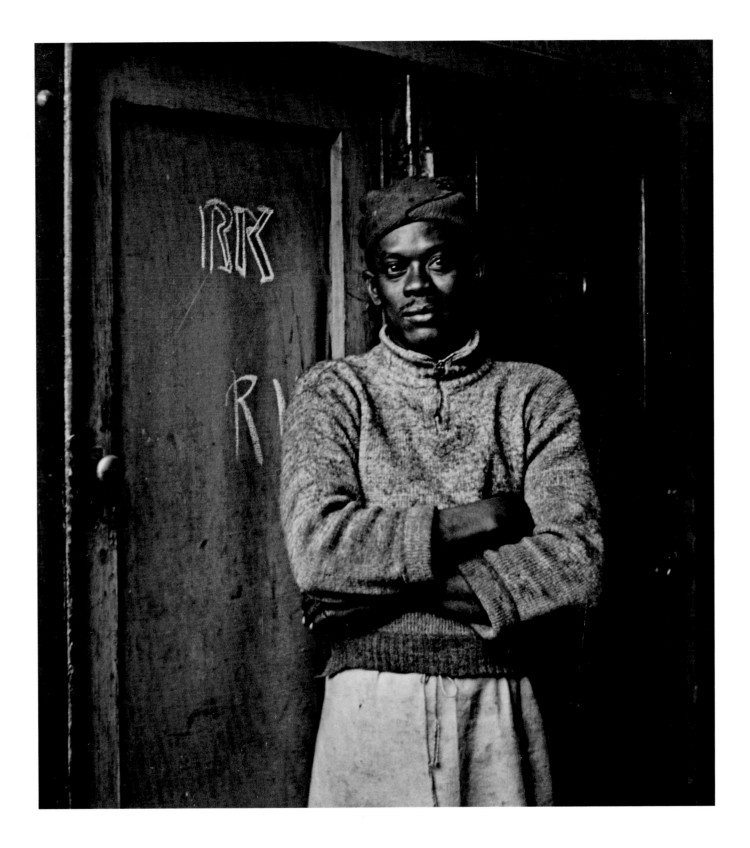

Plate 130. **Bea Pancoast** *Untitled,* 1950
Gelatin silver print, 5 × 4⅝ in. (12.7 × 11.7 cm). The Jewish Museum, New York, Purchase: Horace W. Goldsmith Foundation Fund

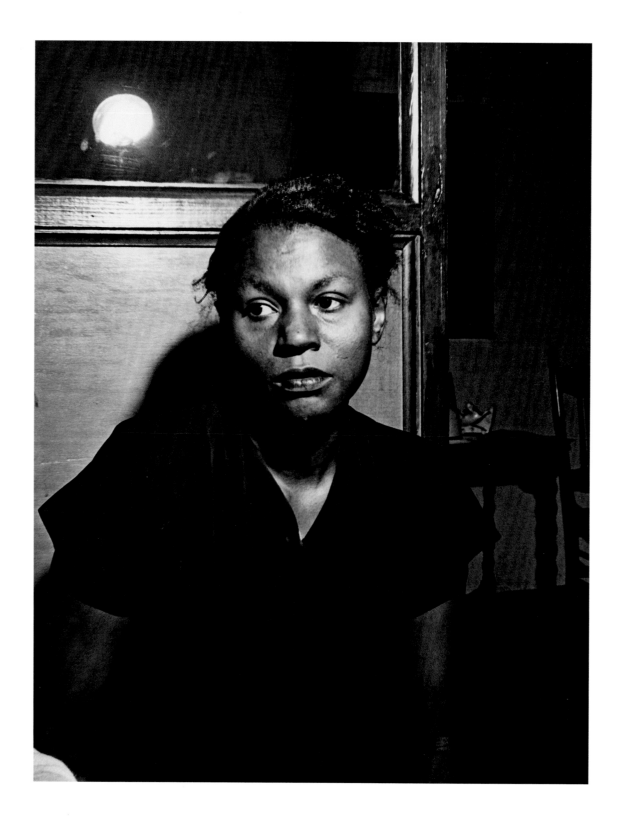

Plate 131. **Marion Palfi** *Wife of the Lynch Victim,* from *There Is No More Time,* 1949
Gelatin silver print, 13⅜ × 10½ in. (34 × 26.7 cm). The Jewish Museum, New York, Purchase: William and Jane Schloss Family Foundation Fund

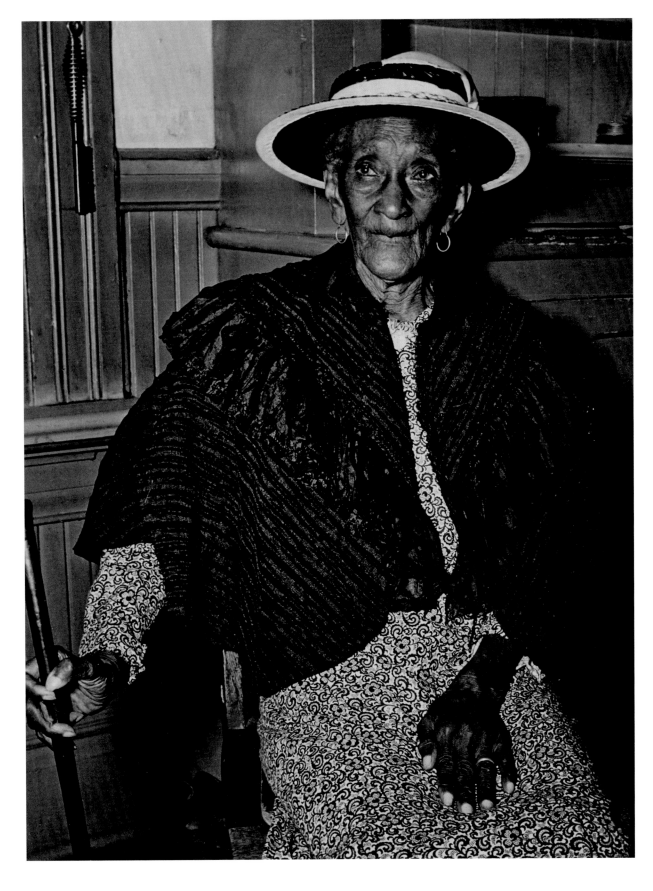

Plate 132. **Rosalie Gwathmey** *Untitled (Sunday Dress),* c. 1945
Gelatin silver print, 13¼ × 10 in. (33.7 × 25.4 cm). Columbus Museum of Art, Ohio, Photo League Collection, Museum Purchase with
funds provided by Elizabeth M. Ross, the Derby Fund, John S. and Catherine Chapin Kobacker, and the Friends of the Photo League

220

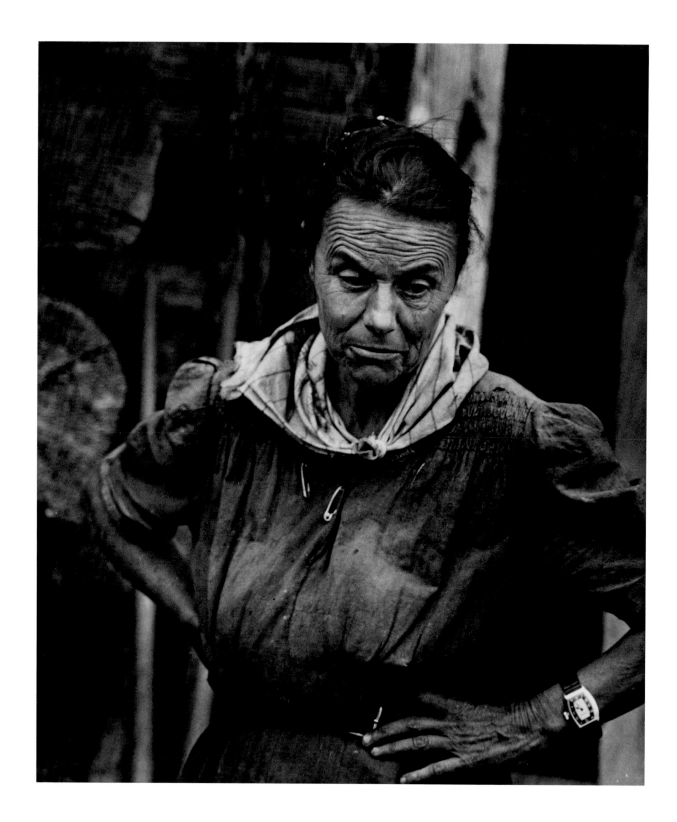

Plate 133. **W. Eugene Smith** *Untitled,* from *Folk Singers,* 1947
Gelatin silver print, 12¼ × 10½ in. (31.1 × 26.7 cm). The Jewish Museum, New York, Purchase: Photography Acquisitions Committee Fund

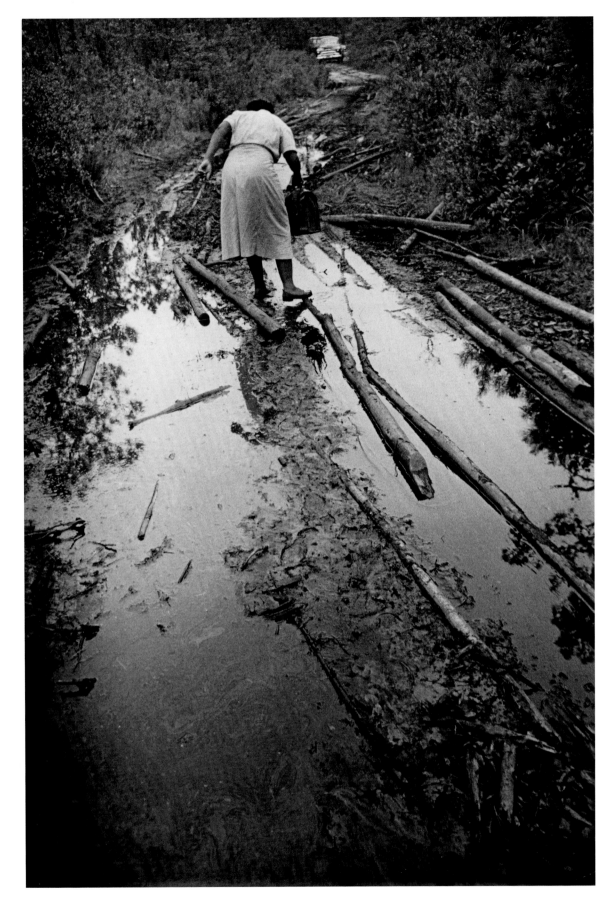

Plate 134. **W. Eugene Smith** *Untitled (Nurse Midwife)*, 1951
Gelatin silver print, 13⅜ × 9⅛ in. (34 × 23.2 cm). The Jewish Museum, New York, Purchase: Photography Acquisitions Committee Fund

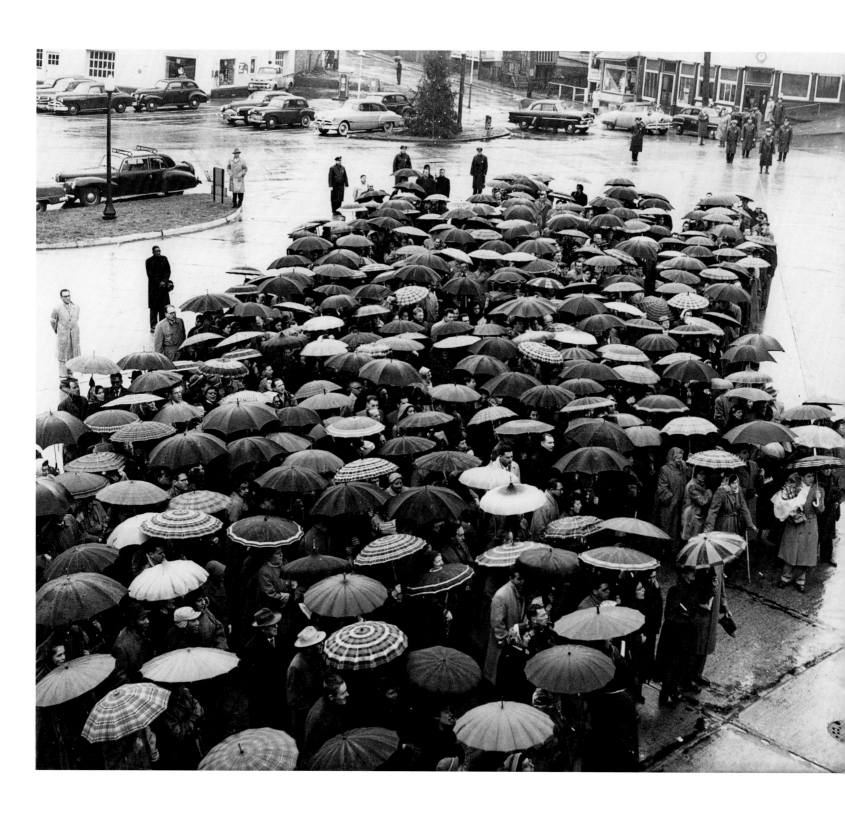

Plate 135. **Edward Schwartz** *Seeking Clemency for Julius and Ethel Rosenberg, Ossining, New York, 1952*
Gelatin silver print, 8 × 9½ in. (20.2 × 24.1 cm). Columbus Museum of Art, Ohio, Photo League Collection, Gift of Stephen Daiter Gallery, Chicago

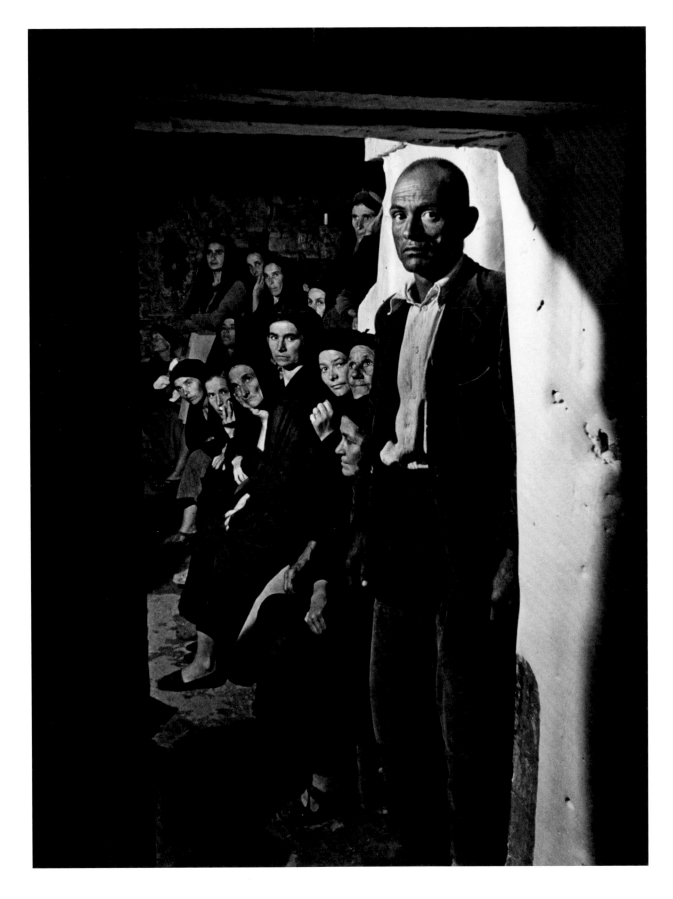

Plate 136. **W. Eugene Smith** *Entrance to the Spanish Wake,* 1951
Gelatin silver print, 13¼ × 10¼ in. (33.7 × 26 cm). Columbus Museum of Art, Ohio, Photo League Collection, Museum Purchase with
funds provided by Elizabeth M. Ross, the Derby Fund, John S. and Catherine Chapin Kobacker, and the Friends of the Photo League

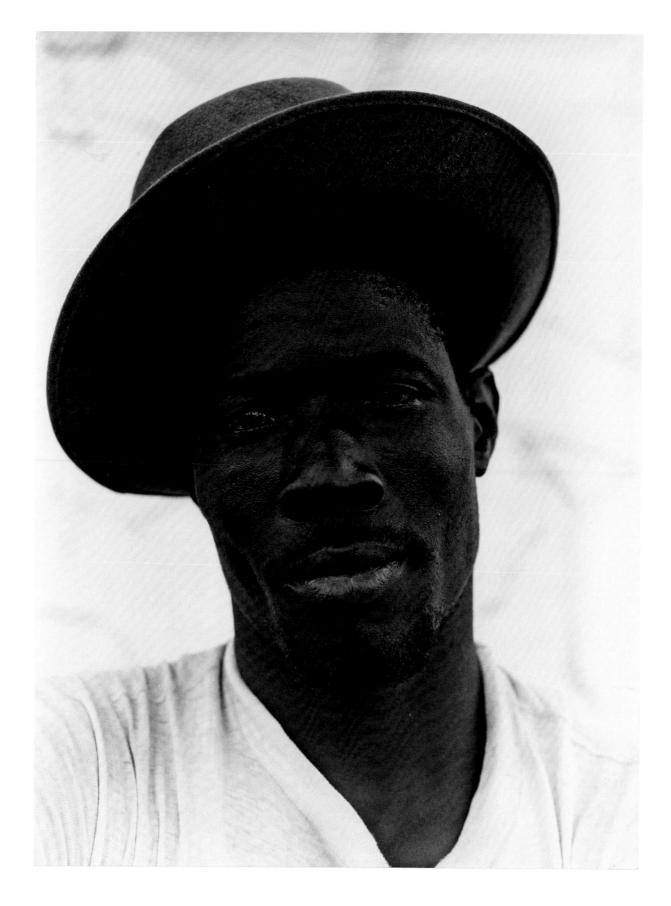

Plate 137. **Jerome Liebling** *Bahamian Migrant Worker*, 1953
Gelatin silver print, 12½ × 9⅜ in. (31.8 × 23.8 cm). The Jewish Museum, New York, Gift of Marvin E. Newman

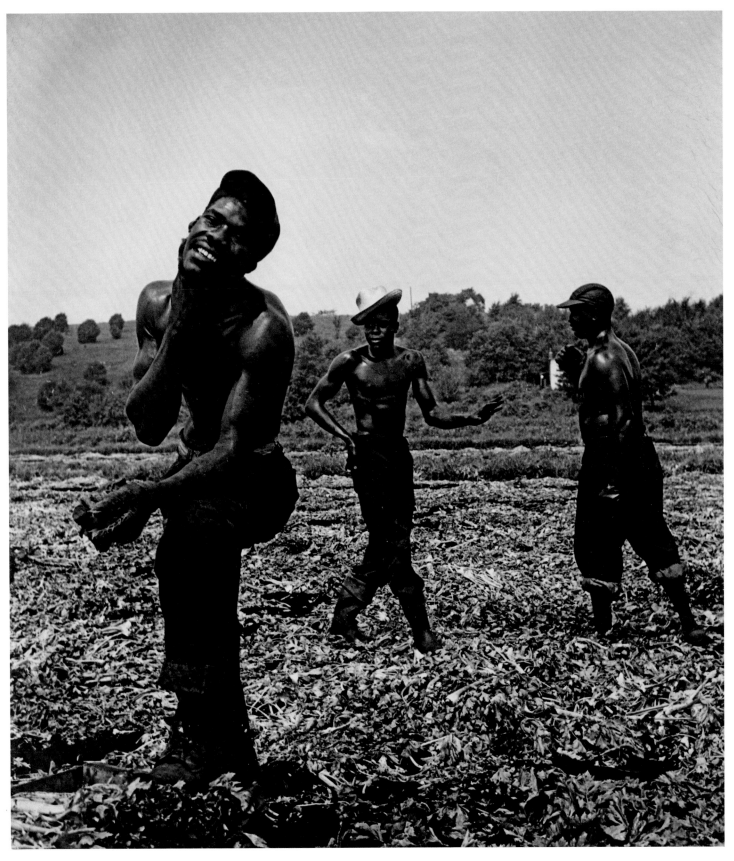

Plate 138. **Gabriella Langendorf** *Untitled (Three Men Working in a Field),* c. 1948
Gelatin silver print, 12 × 10½ in. (30.5 × 26.7 cm). The Jewish Museum, New York, Purchase: Esther Leah Ritz Bequest

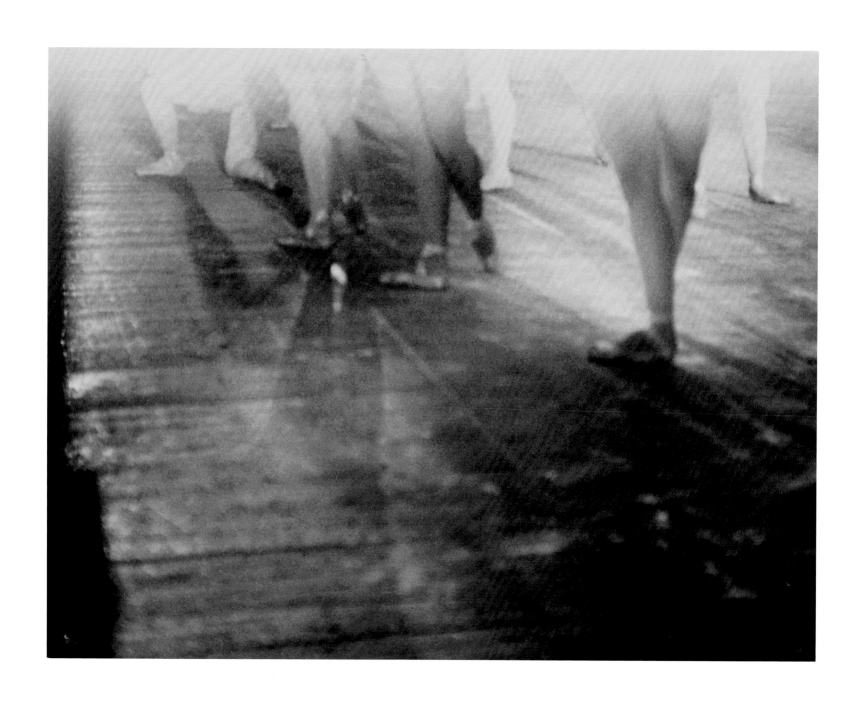

Plate 139. **Larry Colwell** *Nutcracker, Ballet Russe de Monte Carlo, Hartford, Connecticut,* 1947
Gelatin silver print, 10⅝ × 13⅝ in. (27 × 34.6 cm). Columbus Museum of Art, Ohio, Photo League Collection, Museum Purchase with funds provided by Elizabeth M. Ross, the Derby Fund, John S. and Catherine Chapin Kobacker, and the Friends of the Photo League

Plate 140. **Lou Bernstein** *Dancers in Shadows*, 1947
Gelatin silver print, 9 × 12 in. (22.9 × 30.5 cm). Columbus Museum of Art, Ohio, Photo League Collection, Museum Purchase with
funds provided by Elizabeth M. Ross, the Derby Fund, John S. and Catherine Chapin Kobacker, and the Friends of the Photo League

Plate 141. **Ann Zane Shanks** *City Hall Station*, 1955
Gelatin silver print, 12⅜ × 9¼ in. (31.4 × 23.5 cm). The Jewish Museum, New York, Gift of Howard Greenberg

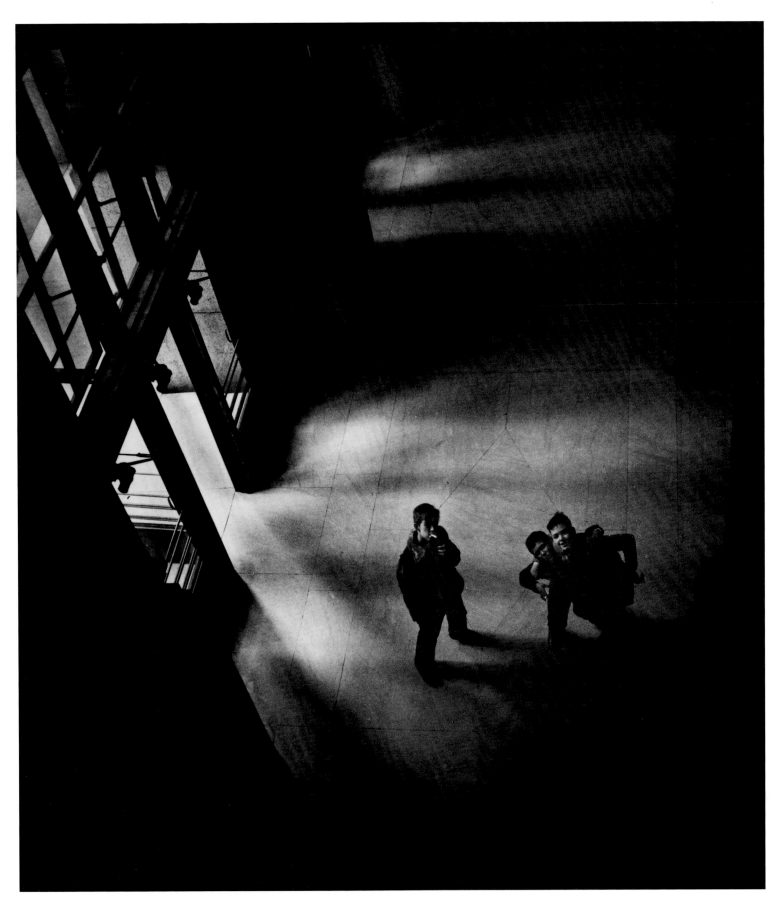

Plate 142. **Larry Silver** *Penn Station*, 1951, printed later

Gelatin silver print, 14 × 11 in. (35.6 × 27.9 cm). The Jewish Museum, New York, Gift of Bruce Silverstein

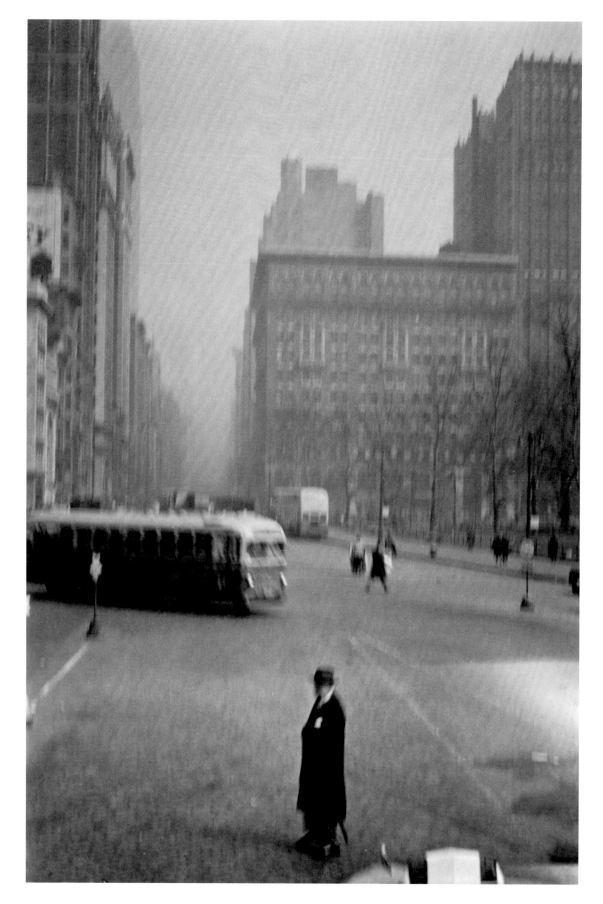

Plate 143. **Lida Moser** *Fifth Avenue and 23rd Street, New York, 1949*
Gelatin silver print, 5⅞ × 4 in. (14.9 × 10.2 cm). Columbus Museum of Art, Ohio, Photo League Collection, Museum Purchase with
funds provided by Elizabeth M. Ross, the Derby Fund, John S. and Catherine Chapin Kobacker, and the Friends of the Photo League

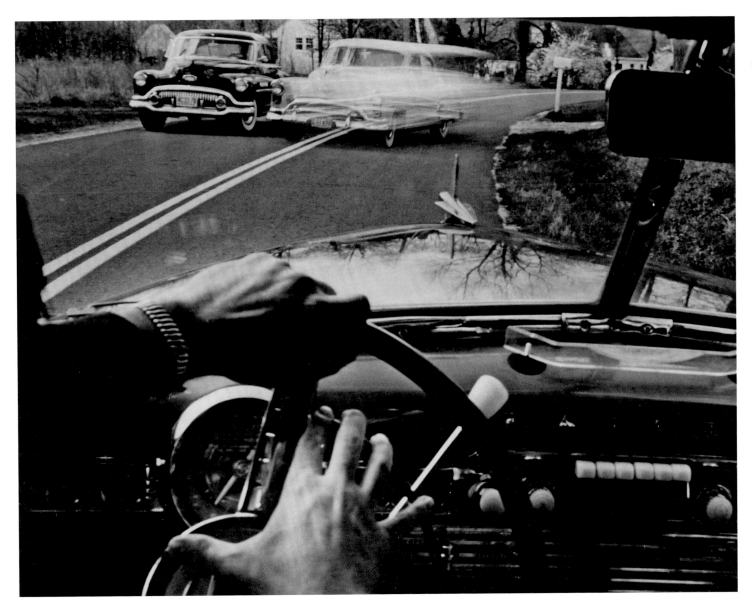

Plate 144. **Arnold Eagle** *Car Passing Car*, c. 1950

Gelatin silver print, 9½ × 12½ in. (24.1 × 31.8 cm). Columbus Museum of Art, Ohio, Photo League Collection, Museum Purchase with funds provided by Elizabeth M. Ross, the Derby Fund, John S. and Catherine Chapin Kobacker, and the Friends of the Photo League

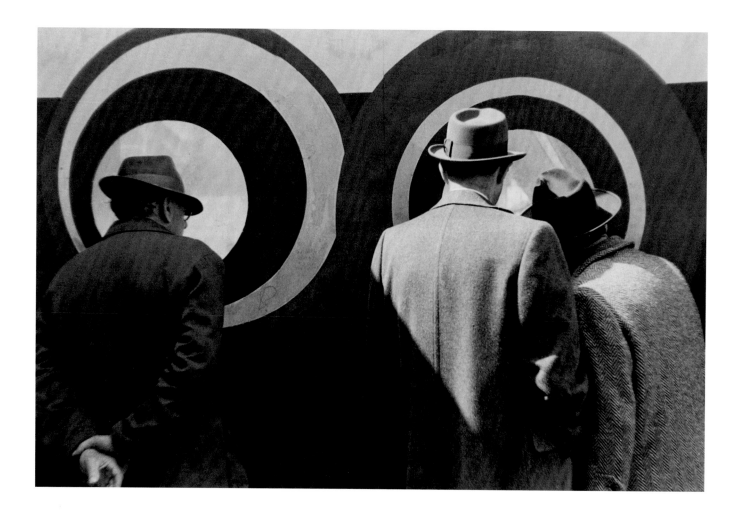

Plate 145. **Louis Stettner** *Men Looking at Concentric Circles, New York,* 1951
Gelatin silver print, 16 × 20 in. (40.6 × 50.8 cm). Columbus Museum of Art, Ohio, Photo League Collection, Museum Purchase with
funds provided by Elizabeth M. Ross, the Derby Fund, John S. and Catherine Chapin Kobacker, and the Friends of the Photo League

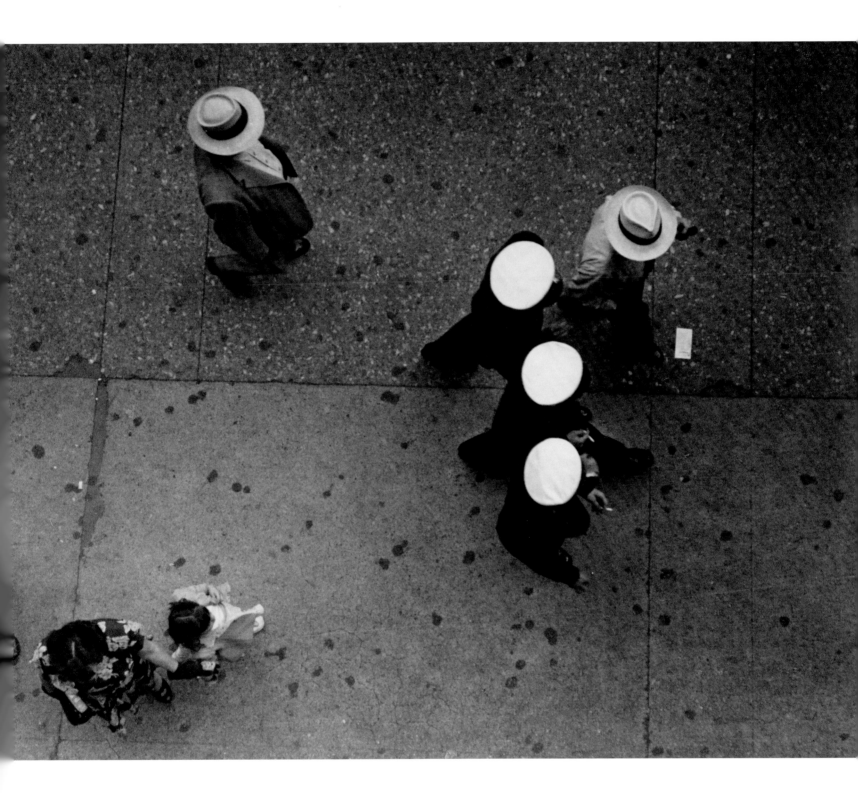

Plate 146. **Ruth Orkin** *Times Square, from Astor Hotel,* 1950
Gelatin silver print, 7½ × 9½ in. (19.1 × 24.1 cm). The Jewish Museum, New York, Purchase: Horace W. Goldsmith Foundation Fund

234

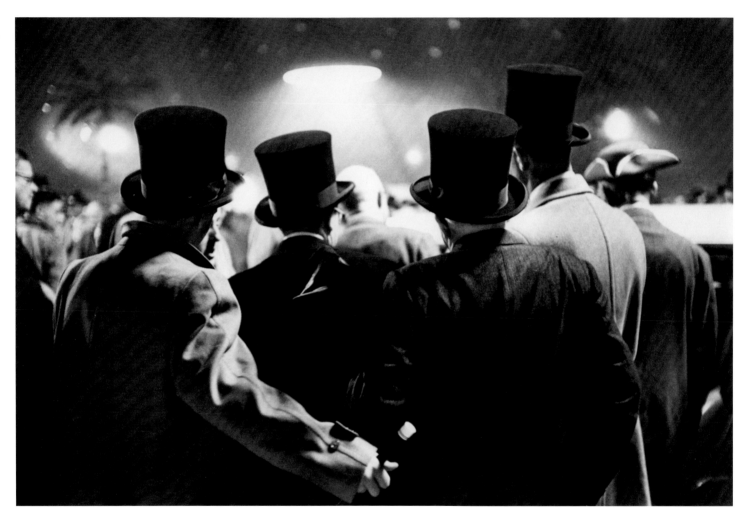

Plate 147. **Dan Weiner** *Autorama Top Hats*, c. 1950
Gelatin silver print, 9 × 13⅝ in. (22.9 × 34.6 cm). Columbus Museum of Art, Ohio, Photo League Collection, Museum Purchase with
funds provided by Elizabeth M. Ross, the Derby Fund, John S. and Catherine Chapin Kobacker, and the Friends of the Photo League

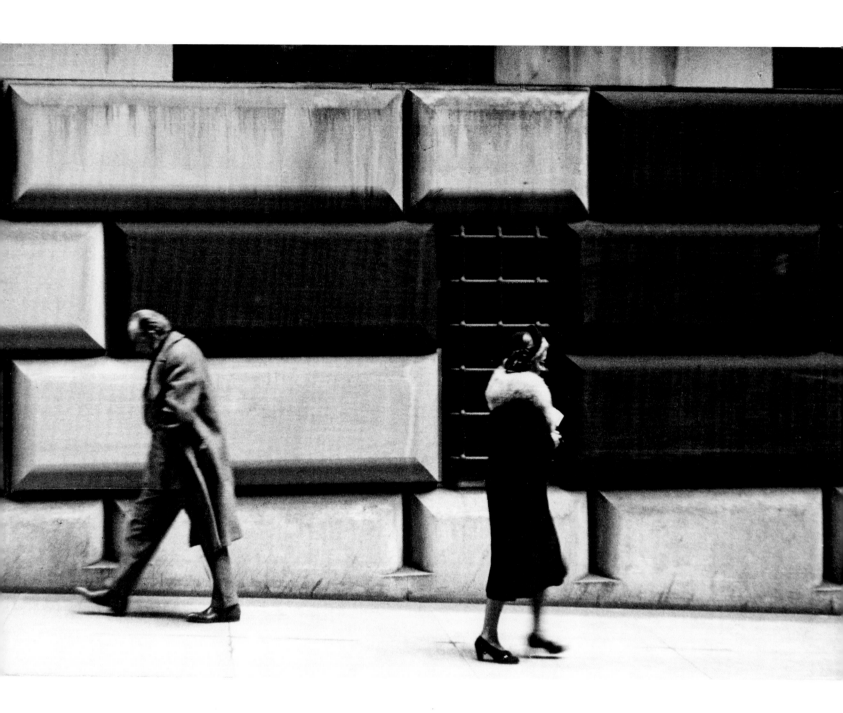

Plate 148. **Sam Mahl** *Untitled*, 1949
Gelatin silver print, 6⅝ × 9½ in. (16.8 × 24.1 cm). The Jewish Museum, New York, Purchase: Esther Leah Ritz Bequest

236

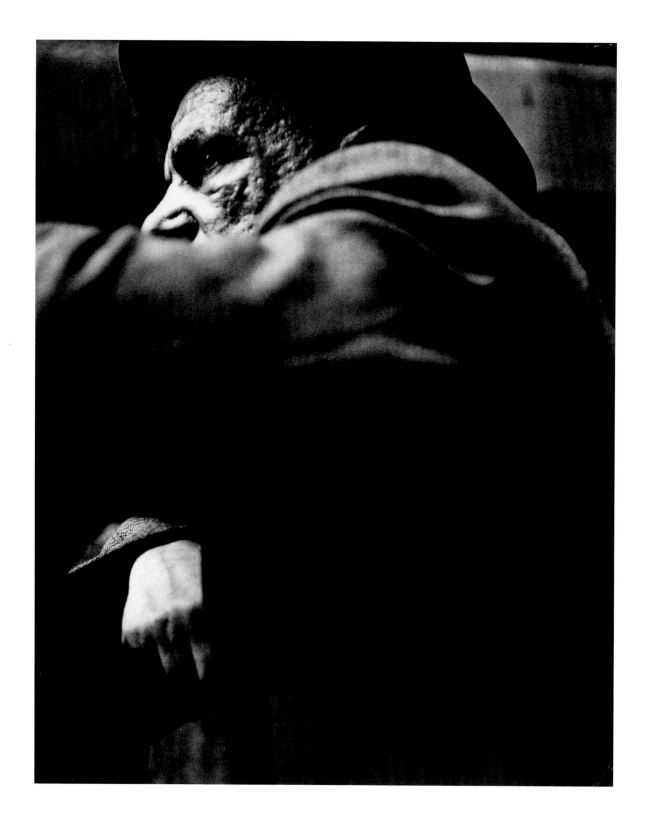

Plate 149. **Leon Levinstein** *Brooding Man,* undated

Gelatin silver print, 22 × 18 in. (55.9 × 45.7 cm). Columbus Museum of Art, Ohio, Photo League Collection, Museum Purchase with funds provided by Elizabeth M. Ross, the Derby Fund, John S. and Catherine Chapin Kobacker, and the Friends of the Photo League

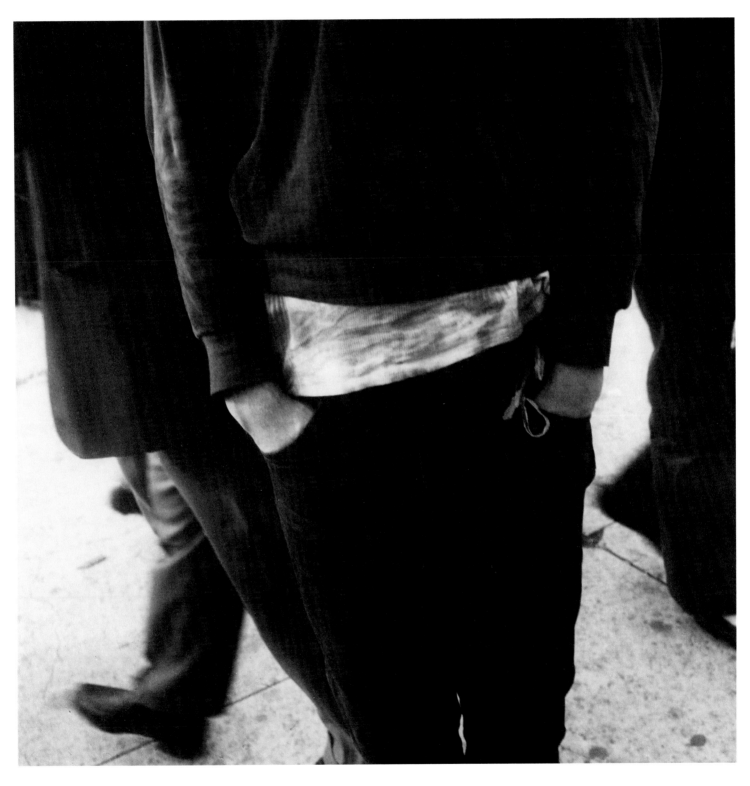

Plate 150. **Leon Levinstein** *Untitled (Hands in Pockets)*, undated
Gelatin silver print, 10¼ × 10¼ in. (26 × 26 cm). The Jewish Museum, New York, Purchase: Esther Leah Ritz Bequest

Abbott, Berenice, and Elizabeth McCausland. *Changing New York*, 1939. Repr. as *New York in the Thirties*. New York: Dover, 1973.

Adams, Robert, and Maren Stange. *Paul Strand: Essays on His Life and Work*. New York: Aperture, 1990.

BIBLIOGRAPHY

Alexander, William. *Film on the Left: American Documentary Film from 1931 to 1942*. Princeton, NJ: Princeton University Press, 1981.

Anreus, Alejandro, Diana L. Linden, and Jonathan Weinberg. *The Social and the Real: Political Art of the 1930s in the Western Hemisphere*. Refiguring Modernism 4. University Park, PA: Pennsylvania State University Press, 2006.

Austin, Thomas, and Wilma de Jong. *Rethinking Documentary: New Perspectives, New Practices*. Berkshire, U.K.: Open University Press, 2008.

Baro, Gene. *Inward Image: Photographs by N. Jay Jaffee*. New York: Brooklyn Museum, 1981.

Barry, Les. "The Legend of Sid Grossman." *Popular Photography* 47, no. 5 (November 1961): 51–94.

Barth, Miles, ed. *Weegee's World*. Boston: Bulfinch, 1997.

Baskind, Samantha. "Weegee's Jewishness." *History of Photography* 34, no. 1 (February 2010): 60–78.

Berger, Maurice. *For All the World to See: Visual Culture and the Struggle for Civil Rights*. New Haven: Yale University Press, 2010.

———. "FSA: The Illiterate Eye." In *How Art Becomes History*. New York: HarperCollins, 1992. Reprints FSA: "The Illiterate Eye, Photographs from the Farm Security Administration." Exh. cat. New York: Hunter College Gallery, 1985.

Bethune, Beverly Moore. "A Case of Overkill: The FBI and the New York City Photo League." *Journalism History* 7 (Autumn–Winter 1980): 87–91.

Bezner, Lili Corbus. "Aaron Siskind: An Interview." *History of Photography* 16, no. 1 (1992): 28–33.

———. *Photography and Politics in America: From the New Deal into the Cold War*. Baltimore: John Hopkins University Press, 1999.

———. *Women of the Photo League: January 24–March 22, 1998*. Charlotte, NC: Light Factory, 1998.

Blair, Sara. *Harlem Crossroads: Black Writers and the Photograph in the Twentieth Century*. Princeton, NJ: Princeton University Press, 2007.

Blom, Benjamin. *New York: Photographs, 1850–1950*. New York: E. P. Dutton, 1982.

Böger, Astrid. *People's Lives, Public Images: The New Deal Documentary Aesthetic*. Tübingen, Germany: Gunter Narr, 2001.

Bourke-White, Margaret. *Portrait of Myself*. Boston: G. K. Hall, 1985.

Burckhardt, Rudy. Interview by Martica Sawin, January 14, 1993. Transcript. Archives of American Art, Smithsonian Institution, Washington, DC.

Caldwell, Erskine, and Margaret Bourke-White. *You Have Seen Their Faces*. New York: Modern Age, 1937.

Calomiris, Angela. *Red Masquerade: Undercover for the F.B.I.* Philadelphia: Lippincott, 1950.

Campbell, Russell. *Cinema Strikes Back: Radical Filmmaking in the United States, 1930–1942*. Studies in Cinema 20. Ann Arbor, MI: UMI Research Press, 1982.

———. "Film and Photo League Radical Cinema in the 30s: Introduction." *Jump Cut* 14 (1997): 23–25.

Capa, Cornell, and Sandra Weiner. *Dan Weiner*. New York: Grossman, 1974.

Carter, Michael. *Toward a Harlem Document*. New York: New School for Social Research, 1939.

———. "244,000 Native Sons." *Look* (May 21, 1940): 8.

Cherry, Vivian. *Helluva Town: New York City in the 1940s and 50s*. New York: PowerHouse, 2008.

Chiarenza, Carl. *Aaron Siskind: Pleasures and Treasures*. Boston: Little, Brown, 1982.

Chisholm, Brad. "Film and Photo League Exhibition Strategies." *Jump Cut* 37 (July 1992): 110–14.

Coles, Robert. *Doing Documentary Work*. New York: Oxford University Press, 1997.

Corn, Wanda M. "The New New York." *Art in America* 61 (1973): 58–65.

Cuddihy, John Murray. *The Ordeal of Civility: Freud, Marx, Levi-Strauss, and the Jewish Struggle with Modernity*. New York: Basic, 1974.

Daniel, Pete, Merry Foresta, Maren Stange, and Sally Stein. *Official Images: New Deal Photography*. Washington, DC: Smithsonian Institution Press, 1987.

Davis, Lisa E. "The FBI's Lesbian, Eleanor Roosevelt, and Other Tales from the Red Scare." In *Rethinking Marxism* 21, no. 4 (October 2009).

———. "Undercover Girl—The FBI's Lesbian: A Note on Resources." In *CLAGS News* (Center of Lesbian and Gay Studies, Graduate Center, City University of New York) 13, no. 2 (Summer 2003).

Dejardin, Fiona M. "The Photo League: Aesthetics, Politics, and the Cold War." Ph.D. diss., University of Delaware, 1993.

———. "The Photo League: Left-Wing Politics and the Popular Press." *History of Photography* (London) 18, no. 2 (Summer 1994).

Delano, Jack and Irene. Interview by Richard Doud, June 12, 1965. Transcript. Archives of American Art, Smithsonian Institution, Washington, DC.

Deschin, Jacob. "Best Work of League: Members Show Pictures in Their Own Way." *New York Times*, December 5, 1948, X21.

———. "The Candid Picture." *New York Times*, June 25, 1950, 83.

Dickstein, Morris. *Dancing in the Dark: A Cultural History of the Great Depression*. New York: W. W. Norton, 2009.

Dillon, Diane. "Focusing on the Fragment: Asymmetries of Gender, Race, and Class in the Photographs of Aaron Siskind." *Yale University Art Gallery Bulletin* (1990).

Documentary Photography. New York: Time-Life, 1972.

Douglas, Ann. *Terrible Honesty: Mongrel Manhattan in the 1920's*. New York: Farrar, Straus and Giroux, 1995.

Entin, Joseph. "Modernist Documentary: Aaron Siskind's *Harlem Document*." *Yale Journal of Criticism* 12, no. 2 (Fall 1999): 357–82.

Faber, Monika, and Gerald Matt, eds. *Lisette Model: Fotografien, 1934–1960*. Vienna: Kunsthalle Wien, 2000.

Featherstone, David, ed. *Observations: Essays on Documentary Photography*.

Carmel, CA: Friends of Photography, 1984.

Filmfront. December 1934–March 1935. Anthologized in Nathan Lyons, ed. *Photo Notes.* Rochester NY: Visual Studies Workshop, 1977.

Fisher, Andrea. *Let Us Now Praise Famous Women: Women Photographers for the U.S. Government, 1935–1944.* London: Pandora, 1987.

Fleischhauer, Carl, and Beverly W. Brannan, eds. *Documenting America, 1935–1943.* Berkeley: University of California Press, 1988.

Frankel, Godfrey. Interview by Merry Foresta, November 29, 1993. Transcript. Archives of American Art, Smithsonian Institution, Washington, DC.

Gates, Henry Louis, Jr. "Harlem on Our Minds." *Critical Inquiry* 24, no. 1 (Autumn 1997).

Geer, Lili Corbus, *Into the Light: Sonia Handelman Meyer, The Photo League Years.* Charlotte, NC: Hodges Taylor Gallery, 2007.

Gérin-Lajoie, Denyse, et al. "The Film and Photo League." *Ovo* 10, no. 40–41 (1981).

Goeser, Caroline. *Picturing the New Negro: Harlem Renaissance Print Culture and the Rise of Modern Black Identity.* Wichita: University Press of Kansas, 2007.

Goldberg, Vicki. *Margaret Bourke-White: A Biography.* New York: Harper and Row, 1986.

———. *The Power of Photography: How Photographs Changed Our Lives.* New York: Abbeville, 1991.

Goldsmith, Arthur A., Jr. "Game of Guns: The Camera Teams Up with Sociology in Vivian Cherry's Vivid Picture Story of Violence in Children's Play." *Photography* (July 1952): 66–69.

Goldstein, Judith L. "The Flaneur, the Street Photographer and Ethnographic Practice." *Contemporary Jewry* 28, no. 1 (2008): 121–24.

Goldstein, Robert Justin. *American Blacklist: The Attorney General's List of Subversive Organizations.* Lawrence, KS: University Press of Kansas, 2008.

Greenberg, Howard, and Neil C. Trager. *The Photo League, 1936–1951.* New Paltz, NY: College Art Gallery, 1981.

Grossman, Sid, and Millard Lampell.

Journey to the Cape. New York: Grove, 1959.

Gutman, Judith Mara. "Lewis Hine's Last Legacy." *New York Times Magazine,* April 17, 1983.

———. *Lewis W. Hine and the American Social Conscience.* New York: Walker, 1967.

———. "The Worker and the Machine: Lewis Hine's National Research Project Photographs." *Afterimage* (September 1989): 13–15.

Hambourg, Maria Morris, and Sandra S. Philips. *Helen Levitt.* San Francisco: San Francisco Museum of Modern Art, 1991.

Hammond, Anne, and Mike Weaver, eds. *History of Photography* (London) 18, no. 2 (Summer 1994). Special edition devoted to the Photo League.

Harrison, Helena A. "Photographs as Social Documents." *New York Times,* September 27, 1987, sec. L.

Hine, Lewis. Correspondence, 1938–1940, Elizabeth McCausland Papers, 1838–1980 (bulk 1920–60). Series 7.2, Box 22, Folder 15. Archives of American Art, Smithsonian Institution, Washington, DC.

Hine, Lewis Wickes, and Daile Kaplan. *Photo Story: Selected Letters and Photographs of Lewis W. Hine.* Washington: Smithsonian Institution Press, 1992.

Hughes, Jim. *W. Eugene Smith, Shadow and Substance: The Life and Work of an American Photographer* (New York: McGraw-Hill, 1989).

Jaffee, N. Jay. *Jay Jaffee: Photographs, 1947–1955.* Glen Oaks, NY: Jaffee, 1976.

Johnson, William S. "*Photo Notes* 1938–50: Annotated Author and Photographic Index." *History of Photography* (London) 18, no. 2 (Summer 1994).

———. *W. Eugene Smith, Master of the Photographic Essay.* Millerton, NY: Aperture, 1981.

Johnson, William S., Mark Rice, and Carla Williams. *1000 Photo Icons of the George Eastman House Collection.* Edited by Therese Mulligan and David Wooters. Los Angeles: Taschen, 2000.

Jussim, Estelle. "Propaganda and Persuasion." In David Featherstone, ed. *Observations: Essays on Documentary Photography.* Carmel, CA: Friends of Photography, 1984.

Kaplan, Daile. *Lewis Hine in Europe: The Lost Photographs.* New York: Abbeville, 1988.

Keller, Ulrich F. "The Myth of Art Photography: An Iconographic Analysis." *History of Photography* 9 (1985): 1–38.

———. "The Myth of Art Photography: A Sociological Analysis." *History of Photography* 8 (1984): 249–75.

Kirstein, Lincoln. "Photography in the United States." *Art in America in Modern Times.* Edited by Alfred H. Barr, Jr., and Holger Cahill. New York: Reynal and Hitchcock, 1934.

Kozloff, Max. *New York: Capital of Photography.* Exh. cat. New York: The Jewish Museum, and New Haven: Yale University Press, 2002.

Lange, Dorothea. Interview by Richard Doud, May 22, 1964. Transcript. Archives of American Art, Smithsonian Institution, Washington, DC.

Lee, Denny. "They Tried to Change the World, One Click at a Time." *New York Times,* February 17, 2002, sec. 14.

Lepkoff, Rebecca. *Life on the Lower East Side: Photographs by Rebecca Lepkoff, 1937–1950.* New York: Princeton Architectural Press, 2006.

Lesy, Michael. "May Day Parade: A Moral Parable Evoked by a Member of the Photo League." *Doubletake* (Summer 1999): 32.

Levitt, Laura. "The Objectivity of Strangers, Seeing and Being Seen on the Street: A Response to Deborah Dash Moore's 'On City Streets.'" *Contemporary Jewry* 28, no. 1 (October 2008): 114–20.

Libsohn, Sol. Interview by Gary Saretzky, under the auspices of the Monmouth, NJ, County Library Headquarters, January 28, 2000. Online at www.visitmonmouth.com/oralhistory/bios/LibsohnSol.htm, accessed March 9, 2011.

Liebling, Jerome. Interview by Greta Cunningham, September 12, 1997. Minnesota Public Radio. Audio and transcript. Online at http://news.minnesota.publicradio.org/features/199709/12_cunninghamg_liebling, accessed February 28, 2011.

Liebling, Jerome, Anne Halley, and Alan Trachtenberg. *Jerome Liebling: Photographs.* New York: Aperture, 1982.

Livingston, Jane. *The New York School: Photographs, 1936–1963.* New York: Stewart, Tabori, and Chang, 1992.

Lou Stoumen Caught in the Act: The Early Years. Petaluma, CA: Singer Photography, 1995.

Lyons, Nathan, ed. *Photo Notes.* February 1938–Spring 1950. Rochester, NY: Visual Studies Workshop, 1977.

Maddow, Ben. "Paul Strand's Monumental Presence." *American Art* 5 (Summer 1991): 48–67.

———. *The Photography of Max Yavno.* Berkeley: University of California Press, 1981.

McCausland, Elizabeth. "Portrait of a Photographer." *Survey Graphic* 27 (October 1938): 502–5.

———. "Two Exhibitions of a 'Photographic Season.'" *New York Times,* January 8, 1939, sec. E.

———. "Young Photographers Show New York City." *New York Times,* August 27, 1939, sec. E.

McElvaine, Robert S. *The Great Depression: America, 1929–1941.* New York: Times Books, 1984.

Meissner, Betsi. "Photo League." In *Original Sources: Art and Archives at the Center for Creative Photography.* Edited by Amy Rule and Nancy Solomon. Tucson, AZ: Center for Creative Photography, 2002.

Mellow, James. *Walker Evans.* New York: Basic, 1999.

Meltzer, Milton. *Dorothea Lange: A Photographer's Life.* New York: Farrar, Straus, Giroux, 1978.

Meltzer, Milton, and Bernard Cole. *The Eye of Conscience: Photographers and Social Change.* Chicago: Follett, 1974.

Millstein, Barbara Head, and Sarah M. Lowe. *Consuelo Kanaga: An American Photographer.* New York: Brooklyn Museum, 1992.

Model, Lisette. Samuel Wagstaff Papers, 1932–1985. Series 2: Writings. Project/Exhibition Proposals (Lisette Model: "The Visual Arts at Black Mountain College"), undated. Box 3, Folder 2. Archives of American Art, Smithsonian Institution, Washington, DC.

Moore, Deborah Dash. "On City Streets." *Contemporary Jewry* 28, no. 1 (October 2008): 84–108.

Mora, Gilles, and John T. Hill, eds. *W. Eugene Smith: Photographs 1934–1975.* New York: Harry N. Abrams, 1998.

Newhall, Beaumont. "A Backward Glance at Documentary." In David Featherstone, ed. *Observations: Essays on Documentary Photography.* Carmel, CA: Friends of Photography, 1984.

———. "Documentary Approach to Photography." *Parnassus* 10 (March 1938): 3–6.

———. *Focus: Memoirs of a Life in Photography.* Boston: Bulfinch, 1993.

———. Interview by Joseph Trovato, January 23, 1965. Transcript. Archives of American Art, Smithsonian Institution, Washington, DC.

———. "Photography and the Artist." *Parnassus* 6 (October 1934): 24–29.

———. *Photography: A Short Critical History.* New York: Museum of Modern Art, 1938.

Newhall, Nancy. *From Adams to Stieglitz: Pioneers of Modern Photography.* New York: Aperture Foundation, 1989.

O'Connor, Francis V., ed. *Art for the Millions: Essays from the 1930s by Artists and Administrators of the WPA Federal Art Project.* Greenwich, CT: New York Graphic Society, 1973.

Ollman, Leah. "The Photo League's Forgotten Past." *History of Photography* (London) 18, no. 2 (Summer 1994): 154–58.

Orvell, Miles. *American Photography.* Oxford: Oxford University Press, 2003.

———, ed. *John Vachon's America: Photographs and Letters from the Depression to World War II.* Berkeley: University of California Press, 2003.

Osman, Colin, ed. *Creative Camera* (London) 223–24 (July–August 1983). Special issue devoted to the Photo League.

Peters, Susan Dodge. "Elizabeth McCausland: On Photography." *Afterimage* 12 (May 1985): 10–12.

Petruck, Peninah R., ed. *The Camera Viewed: Writings on Twentieth-Century Photography.* Vol. 1, *Photography Before World War II.* New York: E. P. Dutton, 1979.

"The Photo League: A True Image of the World." *Documentary Photography.* New York: Time-Life, 1972.

Photo Notes. February 1938–Spring 1950. Anthologized in facsimile in Nathan Lyons, ed. *Photo Notes.* Rochester, NY: Visual Studies Workshop, 1977.

Pinson, Stephen C. *"Where Do We Go from Here?" The Photo League and Its Legacy (1936–2006).* New York: New York Public Library, 2006.

Porter, Russell. "Girl Aide of FBI Testifies of 7 Years as Communist." *New York Times,* April 27, 1949, 1.

Raeburn, John. *A Staggering Revolution: A Cultural History of Thirties Photography.* Urbana: University of Illinois Press, 2006.

Rice, Shelley, and Naomi Rosenblum. *Walter Rosenblum: Photographer.* Dresden, Germany: Verlag der Kunst, and Weingarten, Germany: Kunstverlag Weingarten, 1990.

Robinson, Gerald H. "The Photo League: Photography in the Cold War." *Photography, History and Science.* Nevada City, MT: Carl Mantz, 2006.

Rosalie Gwathmey: Photographs from the Forties. East Hampton, NY: Glenn Horowitz Bookseller, 1994.

Rosenblum, Naomi. *A History of Women Photographers.* New York: Abbeville, 1994, 2000.

———. *Photo League.* Madrid: Fundación Telefónica, 1999.

Rosenblum, Walter. "Lewis Hine, Paul Strand, and the Photo League." In Ken Light, *Witness in Our Time: Working Lives of Documentary Photographers.* Washington, DC: Smithsonian Institution Press, 2000.

Rothstein, Arthur. *Documentary Photography.* Stoneham, MA: Butterworth, 1986.

———. Interview by Richard Dowd, May 25, 1964. Transcript. Archives of American Art, Smithsonian Institution, Washington, DC.

Rudy Burckhardt: New York Photographs. New York: Tibor de Nagy Gallery, 2003.

Rutkoff, Peter M., and William B. Scott. *New School: A History of the New School for Social Research.* New York: Free Press, 1986.

Schwartz, Joe. *Folk Photography: Poems I've Never Written.* Atascadero, CA: Joe Schwartz, 2000.

Sekula, Allan. "Dismantling Modernism, Reinventing Documentary (Notes

on the Politics of Representation).” *Massachusetts Review* 19 (Winter 1978): 859–83.

Seltzer, Leo. “The Film and Photo League.” *Ovo* 10, no. 40–41 (1981): 10–13.

Shamis, Robert, and Max Kozloff. *The Moment of Exposure: Leon Levinstein.* Ottawa: National Gallery of Canada, 1995.

Siskind, Aaron. *Harlem Document: Photographs, 1932–1940.* Providence, RI: Matrix, 1981.

———. Interview by Barbara Shikler, September 28–October 2, 1982. Archives of American Art, Smithsonian Institution, Washington, DC.

Stange, Maren. *Symbols of Ideal Life: Social Documentary Photography in America, 1890–1950.* New York: Cambridge University Press, 1989.

———. “‘Symbols of Ideal Life’: Technology, Mass Media, and the FSA Documentary Project.” *Prospects* 11 (1987): 98.

Steichen, Edward, ed. *The Bitter Years: 1935–1941: Rural America as Seen by the Photographers of the Farm Security Administration.* New York: Museum of Modern Art, 1962.

Stein, Sally. “Women and Photography Between Feminism’s ‘Waves.’” In Cornelia Butler and Alexandra Schwartz, eds. *Modern Women: Women Artists at the Museum of Modern Art.* New York: Museum of Modern Art, 2010.

Steinorth, Karl. *Lewis Hine: Passionate Journey.* Zurich: Edition Stemmle, 1996.

Stettner, Louis. “Cézanne’s Apples and the Photo League: A Memoir.” *Aperture* 112 (Fall 1988): 14–35.

———. *Weegee.* New York: Knopf, 1977.

Stone, Erika. *Especially the People: Photographs by Erika Stone.* N.p.: Erika Stone, 2004.

———. *Mostly People: Photographs by a German Immigrant in New York.* Munich: Kehayoff, 2001.

Stott, William. *Documentary Expression and Thirties America.* New York: Oxford University Press, 1973. Repr. London: Oxford University Press, 1976.

Stoumen, Lou. *Times Square: 45 Years of Photography.* New York: Aperture, 1985.

Stourdzé, Sam, and Ann Thomas. *Lisette Model.* Paris: Editions Léo Scheer, 2002.

Stourdzé, Sam, Helen Gee, and A. D. Coleman. *Leon Levinstein: Obsession.* Paris: Editions Léo Scheer, 2000.

This Is the Photo League. New York: The Photo League, 1948.

Thomas, Ann. *Lisette Model.* Ottawa: National Gallery of Canada, 1990.

Troy, William. “Half a Loaf.” *Nation* (April 24, 1935): 491–92.

Tucker, Anne. “The Film and Photo League.” *Ovo* 10, no. 40–41 (1981): 3–9.

———. “A History of the Photo League: The Members Speak.” *History of Photography* (London) 18, no. 2 (Summer 1994): 174–84.

———. *Lou Stoumen: Caught in the Act: The Early Years, Vintage Photographs, 1932–1940.* Petaluma, CA: Singer Photography, 1995.

———. “Photographic Crossroads: The Photo League.” Special supplement. *Afterimage* 5 (April 1978): 3–4.

———. “Photographic Facts and Thirties America.” In David Featherstone, ed. *Observations: Essays on Documentary Photography.* Carmel, CA: Friends of Photography, 1984.

———. “The Photo League: A Center for Documentary Photography.” In Anne Tucker, Claire Cass, and Stephen Daiter. *This Was the Photo League: Compassion and the Camera from the Depression to the Cold War.* Chicago: Stephen Daiter Gallery, and Houston: John Cleary Gallery, 2001.

———. “The Photo League: Photography as a Social Force.” *Modern Photography* 43, no. 9 (September 1979): 88–93, 173–74, 180, 182, 184.

———. “Strand as Mentor.” In Robert Adams and Maren Stange, eds. *Paul Strand: Essays on His Life and Work.* New York: Aperture, 1990.

Tucker, Anne, Claire Cass, and Stephen Daiter. *This Was the Photo League: Compassion and the Camera from the Depression to the Cold War.* Chicago: Stephen Daiter Gallery, and Houston: John Cleary Gallery, 2001.

Vachon, John. *The Children of Esso,* 1948. Roy Emerson Stryker Papers, 1932–64. Archives of American Art, Smithsonian Institution, Washington, DC.

———. Interview by Richard Doud, April 28, 1964. Transcript. Archives of American Art, Smithsonian Institution, Washington, DC.

VanArragon, Elizabeth. “The Photo League: Views of Urban Experience in the 1930s and 1940s.” Ph.D. diss., University of Iowa, 2006.

Van Haaften, Julia. *Berenice Abbott, Photographer: A Modern Vision; A Selection of Photographs and Essays.* New York: New York Public Library, 1989.

———. *Vivian Cherry’s New York: Photographs by Vivian Cherry.* New York: PowerHouse, 2010.

Vigano, Enrica, ed. *Photo League: New York 1936–1951.* Trieste, Italy: Ramo d’Oro, 2001.

Weegee and Miles Barth. *Weegee’s World.* Boston: Little, Brown, and New York: International Center of Photography, 1997.

Weiner, Dan. *Dan Weiner, 1919–1959.* New York: Grossman, 1974.

Wenger, Beth S. “Mapping the City: A Response to Deborah Dash Moore’s ‘On City Streets.’” *Contemporary Jewry* 28, no. 1 (October 2008): 109–13.

———. “Memory as Identity: The Invention of the Lower East Side.” *American Jewish History* 85, no. 1 (1997): 3–27.

Westerbrook, Colin. *Bystander: A History of Street Photography.* Boston: Little, Brown, 1994.

Wolcott, Marion Post, Papers. Center for Creative Photography, Tucson, AZ.

Wood, Lewis. “90 Groups, Schools Named on US List as Being Disloyal.” *New York Times,* December 5, 1947, 1, 18.

Yavno, Max, and Ben Maddow. *The Photography of Max Yavno.* Berkeley: University of California Press, 1981.

Yochelson, Bonnie. *Berenice Abbott: Changing New York.* New York: New Press and Museum of the City of New York, 1997.

———. *The Committed Eye: Alexander Alland’s Photography.* New York: Museum of the City of New York, 1991.

Zelich, Cristina, and Ann Thomas. *Lisette Model.* Madrid: Fundación Mapfre, and Paris: Jeu de Paume, 2009.

All reasonable efforts have been made to identify and contact copyright holders, but in some cases these could not be traced. If you hold or administer rights for materials published here, please contact The Jewish Museum, Department of Publications. Any errors or omissions will be corrected in subsequent editions.

CREDITS AND PERMISSIONS

Works produced for the U.S. federal Farm Security Administration are in the public domain.

Works in the collection of The Jewish Museum were photographed for reproduction by Ardon Ben Hama and Richard Goodbody.

© Estate of Alexander Alland, Sr.: plate 12; © Aperture Foundation, Inc., Paul Strand Archive: plates 4, 5, 62; © 1998 Arizona Board of Regents, Center for Creative Photography: plates 126, 131; © Estate of Lucy Ashjian: plates 27, 28; figs. 33, 34, 36, pages 2–3, 6; loubernsteinlegacy.com: plates 56, 140; © John Broderick: plates 95, 114, 115, 122, 147; © Margaret Bourke-White, image provided by Time & Life Pictures/Getty Images: fig. 53; © 2010 Estate of Rudy Burckhardt, Artists Rights Society (ARS), New York: plate 113; © Estate of Angela Calomiris: fig. 47; © 1998 Center for Creative Photography, The University of Arizona Foundation: plates 25, 73; © Vivian Cherry: plates 127, 128, figs. 40, 41; © Bernard Cole: plate 84; © Estate of Harold Corsini: plates 17, 35; fig. 5, detail page 5; The Jewish Museum wishes to thank the Crisis Publishing Co., Inc., the publisher of the magazine of the National Association for the Advancement of Colored People, for the use of the images first published in the November 1912 and September 1917 issues of *Crisis Magazine*: figs. 25, 26; © Estate of Arnold Eagle: plates 9, 144; © Estate of John Ebstel: plate 43, fig. 65; © Estate of Myron Ehrenberg: plate 89; © Martin Elkort, Courtesy John Cleary Gallery: plate 107; © Estate of Morris Engel: plates 26, 30, 71, 106, figs. 22, 54; © Harold Feinstein: plate 72; © Robert Frank, from *The Americans*: figs. 15, 16, 28, 29; © Estate of Godfrey Frankel: plate 59; © George Gilbert: plate 63, fig. 56; © Howard Greenberg Gallery, New York: plates 24, 58, 69, 70, 74, 149, 150; figs. 3, 10–13, 14, 49, 67; © Estate of Rosalie Gwathmey/Licensed by VAGA, New York, NY: plates 42, 55, 132; © Bob Henriques/Magnum Photos: fig. 40; © Estate of Morris Huberland/Licensed by VAGA, New York, NY: plates 60, 86; fig. 14; © N. Jay Jaffee

Trust: plate 101; © Sy Kattelson: plates 78, 119, 121; fig. 37; © Sidney Kerner: plate 22; © Arthur Leipzig: plates 92, 93, 98; © Rebecca Lepkoff: plates 83, 94, 105; © Estate of Helen Levitt, Courtesy Laurence Miller Gallery, New York: plate 20; © Estate of Sol Libsohn: plates 75, 76; © Estate of Jerome Liebling: plates 57, 123, 137; © Estate of Sam Mahl: plate 148; © Estate of Jack Manning: plates 32, 33; fig. 19, pages 86–87; © Sonia Handelman Meyer: plates 85, 99, 125; figs. 37–39; © Lisette Model Foundation, Inc. (1983). Used by permission: plates 40, 64, 67, 79; figs. 7, 9; © Barbara Morgan Archive, Courtesy Bruce Silverstein Gallery: plate 10; © Lida Moser: plate 143; © Arnold Newman, collection of The Jewish Museum, New York/Getty Images: plate 51; © Marvin E. Newman: plates 100, 124; © 1947, 1948 The New York Times. All rights reserved. Used by permission and protected by the Copyright Laws of the United States. The printing, copying, redistribution, or retransmission of this Content without express written permission is prohibited: figs. 38, 55; © Estate of Ruth Orkin: plates 111, 146; © Photofest, Inc.: fig. 2; Courtesy Harry Ransom Humanities Research Center, The University of Texas at Austin: plates 11, 41, 48; © Estate of Sol Prom: plate 34; fig. 21; © Estate of Walter Rosenblum: plates 19, 21, 65, 66; figs. 49, 57; © Estate of Arthur Rothstein: plates 18, 87; fig. 48; © Estate of Rae Russel: plate 96, figs. 42–45; © Joe Schwartz: plates 45, 47; © Ann Zane Shanks: plate 141; © Estate of Lee Sievan: plate 90; © Larry Silver, Courtesy Bruce Silverstein Gallery: plate 142; © Aaron Siskind Foundation, Courtesy Bruce Silverstein Gallery: plates 29, 31, 36, 37; figs. 19, 20, 23, 30–32; © Heirs of W. Eugene Smith: plates 133, 134, 136; fig. 69; © Ralph Steiner, Courtesy Estate: plate 14; © Louis Stettner, Courtesy Bonni Benrubi Gallery: plates 50, 88, 145; © Erika Stone: plate 117; © Estate of Lou Stoumen and the Barry Singer Gallery: plates 49, 68; © Estate of Rolf Tietgens, Courtesy Keith de Lellis Gallery, New York: plate 39; © *U.S. Camera Annual*, 1941; image provided by Art & Architecture Collection, Miriam and Ira D. Wallach Division of Art, Prints and Photographs, The New York Public Library, Astor, Lenox and Tilden Foundations: fig. 5 (complete page); © Donna Mussenden VanDerZee: fig. 24; © David Vestal: plate 109; © Weegee, collection of The Jewish Museum, New York/Getty Images: plates 53, 82, 110, 116; © Weegee, collection of Columbus Museum of Art, Ohio/Getty Images: plate 54; © Weegee, collection of

the International Center of Photography/Getty Images: fig. 6; © Bill Witt, Courtesy Stephen Cohen Gallery: plates 52, 108; © Ida Wyman: plates 81, 118; © George S. Zimbel: plate 44.